MW01078440

THE
ILLUSTRATED TORAH

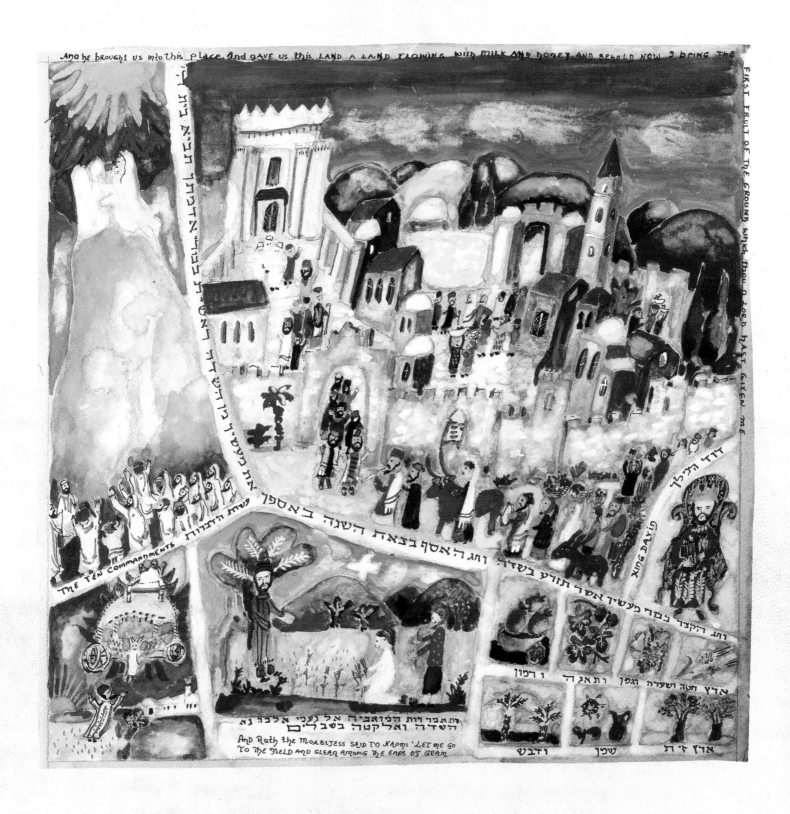

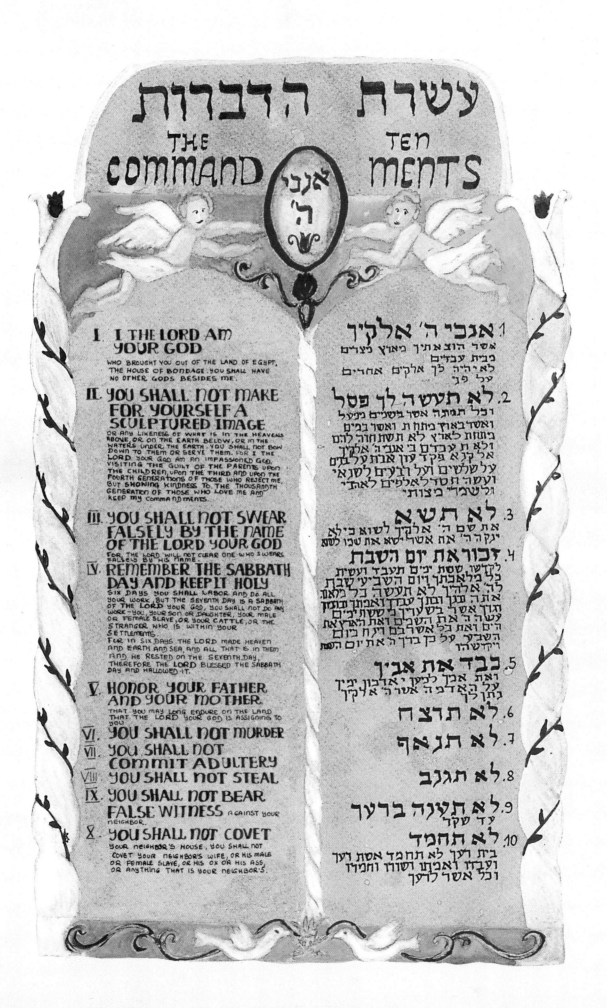

The Illustrated Torah

Illustrated Sidrot and Haftarot

Paintings by Michal Meron

With texts selected from the JPS TANAKH

Edited by Alon Baker

Introductory notes by Dr. Ellen Frankel

To my parents,
Ruth and Werner Meron, who have taught me to appreciate art.

Art: Copyright © by The Studio in Old Jaffa

Text: Copyright © by The Jewish Publication Society

Introductory notes: Copyright © Ellen Frankel

Published and produced in the year 2000 in Israel by The Studio in Old Jaffa
and Gefen Publishing House, Ltd.—Jerusalem

All rights reserved. No part of this publication may be reproduced or transmitted in any form or by any means, electronic or mechanical including photocopying, recording on any information storage and retrieval system, without prior permission in writing from the publishers.

05 04 03 02 01 00 9 8 7 6 5 4 3 2 1

Reproduction on page 1: *Matan Torah* by Michal Meron, from the series of *The Jewish Festivals*

Art and text layout: The Studio in Old Jaffa

Graphic design: Mattie Tuviahu

Photographer: Vladimir Godnik

Printing and binding: Keter Press Enterprises, Ltd.—Jerusalem

DISTRIBUTION

North America: Worldwide (exclusive of North America), Israel, and Jewish organizations

The Jewish Publication Society **The Studio in Old Jaffa** **Gefen Publishing House Ltd.**

2100 Arch Street, 2nd Floor 18 Masal Dagim Lane 12 New Street
Philadelphia, PA 19103 USA Old Jaffa, 68036 Israel Hewlett, NY, 11598 USA
800-234-3151 Ext. 5603 Tel/Fax 972-3 6835992 800-ISRLBKS (800-477-5257)
Jewishbook@aol.com baker@netvision.net.il gefenbooks@compuserve.com
www.jewishpub.org Isragefe@netvision.net.il

ISBN 965–7157–00–5

PRINTED IN ISRAEL

Table of Contents

Preface

This illustrated volume has emerged as a result of an international partnership: The Studio in Old Jaffa, publisher of the work of Israeli folk artist Michal Meron; Gefen Publishing House, Ltd., of Israel; and The Jewish Publication Society, in Philadelphia.

Working together, we have created an artistic Torah that can be enjoyed by both the young and the young-at-heart, both new B'nai Mitzvah, who have just reached their Jewish maturity, and their teachers, parents, and family members, who will guide them in the years to come.

The following anecdote may be perceived as being too informal for such a volume, but it will cue the readers on the main purpose of this book. While we were engaged in discussions with The Jewish Publication Society (JPS) for the use of its English translation of the Torah, I met in Los Angeles with Sam Schwartz, an acquaintance who represents top entertainers from the music world in the USA. I explained the concept behind the project; he glanced at the works of art and remarked that Michal had created something very unique. I was puzzled, surely Michal's works are very lively and whimsical but the file of artists—Jewish and non-Jewish— dealing with Torah themes is thick and spans over fifteen hundred years. My host continued his analysis and pointed out that Michal had made the Torah accessible to everybody, friendlier, "unplugged."

Michal Meron has created her paintings according to the *peshat* approach, an essentially didactic method that explains the "plain sense" of the Torah: What is written is what is meant. Without delving into deeper levels of meaning, Michal has brought her unique artistic interpretation to each *sidrah* (Torah portion) so that the main highlights of each episode come to life in a joyous, imaginative way. Even such dry technical *sidrot* as *Tazria* and *Metzora* come through Michal's kaleidoscope in a softer light.

The illustrated *sidrot* and *haftarot*, presented in this volume for the first time as full works of art or as single panels, originate from a body of fifty-four watercolors produced by Michal over a period of four years.

Publishing a new title is always a challenging process, a task that in large part is based on teamwork. Editing a religious work adds the awareness that this is not just a book. I must say I am very fortunate to have had the assistance of many talented people who have given their knowledge, effort, and professional dedication in order to fulfill this responsibility.

Luckily, this burden was also shared by JPS and I am deeply indebted for the beauty of their translation. The texts flow harmoniously in unison with the paintings and complement each other in a well-balanced way. They have been carefully selected to illuminate highlights in each *sidrah*, while leaving plenty of room for multiple interpretations. The goal has been to produce a user-friendly volume, helping readers become acquainted with the key points of

each *sidrah* in a straightforward yet sophisticated way. Leafing through these colorful pages should draw readers back to the main source: the Torah.

Since *Ma'amad Sinai* (the Revelation at Sinai), the Torah has been the cornerstone of Jewish identity— it is both the background and the focal point of Jewish life. Judaism cannot exist without the Torah and to be a Jew has no meaning when living outside of the Torah. And even though Jews differ in their level of Torah knowledge, the extent of their practice, and their religious commitment, nevertheless they all share a connection to Torah.

To enhance this connection, we present here a hands on approach to this most sacred of Jewish texts. This work, without being pretentious, can be an additional bridge that provides a glimpse into Jewish consciousness. We invite you to peer through Michal's magical windows of interpretation to gain a new understanding of our wonderful heritage.

Alon Baker, Editor
The Studio in Old Jaffa—Gefen Publishing House Ltd.
Iyar 5760/May 2000

Introduction

It is with great pride and joy that The Jewish Publication Society joins the Studio in Old Jaffa and Gefen Publishing House, Ltd. in publishing *The Illustrated Torah*. Michal Meron's enchanting paintings breathe new life into this ancient and venerable text, and refresh its enduring wisdom for new generations of Torah students.

Although JPS has published two English translations of the Hebrew Bible—the 1917 edition based on the King James Bible, and the 1985 edition derived more directly from the original masoretic text—the Society has never before produced an illustrated edition. Perhaps that is because Jews have historically been ambivalent about pairing art and sacred texts; perhaps we were just waiting for the right opportunity. When the Studio in Old Jaffa presented us with just such an opportunity, we found it hard to say no.

Although Michal understands her own approach to illustrating the biblical text as based on the *peshat* or plain sense of the words, it is clear that she is also a superb midrashist. For the Torah generally presents only a bare-bones account of even the most dramatic events—eleven verses to recount the story of the Tower of Babel; nine verses for Jacob wrestling with the angel; a single verse for the death of Miriam. Nothing about the characters' feelings, their thoughts, their physical responses. So little about the natural landscape, the clothing they wore, the houses they lived in, what they saw on their journeys. As an artist, Michal has no choice but to fill in these gaps through her imagination, to give color to the black-and-white world of the text, to animate the faces and places in the stories. And for that, we are in her debt.

A few words about the texts in this volume. Each *sidrah* (Torah portion) contains three kinds of interpretive elements: illustrations by Michal Meron, most containing quotations from the Hebrew text of the Torah or *haftarah* portion; quotations from the JPS translation of that *sidrah* or *haftarah*; and a short introductory section, summarizing the Torah portion. None of these three elements explains the whole of the *sidrah* or *haftarah*; each illuminates only part of the whole. And that is as it should be. We hope that you will find in these selections inspiration to delve deeper into each *sidrah*, to search for meaning not only within the words but also within your own hearts and imaginations. Michal Meron has certainly shown us how wonderfully it can be done.

Ellen Frankel, CEO and Editor-in-Chief
The Jewish Publication Society
March 2000 / Adar 5760

In the beginning, God created the world out of chaos. God declared all these creations good, and then God rested on the first Shabbat. The first human beings, Adam and Eve, lived peacefully in the Garden of Eden, until they disobeyed God's commands—"Do not eat from the Tree of the Knowledge of Good and Evil"—and were expelled from paradise. Their suffering continued when their son Cain killed his brother Abel. Ten generations later Noah was born.

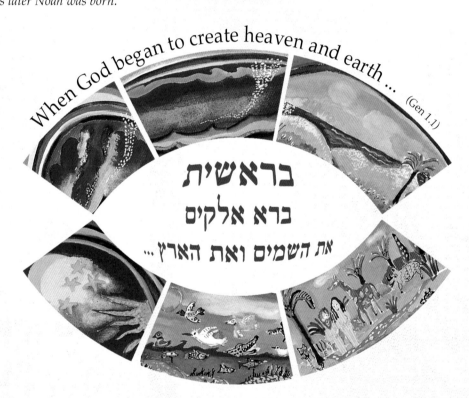

God said, "Let there be light"; and there was light. God saw that the light was good ... God said, "Let there be an expanse in the midst of the water, that it may separate water from water." God made the expanse, and it separated the water which was below the expanse from the water which was above the expanse. And it was so ... God said, "Let the water below the sky be gathered into one area, that the dry land may appear." And it was so. God called the dry land Earth, and the gathering of waters He called Seas ... And God said, "Let the earth sprout vegetation: seed-bearing plants, fruit trees of every kind on earth that bear fruit with the seed in it." And it was so ... God said, "Let there be lights in the expanse of the sky to separate day from night; they shall serve as signs for the set times—the days and the years; and they shall serve as lights in the expanse of the sky to shine upon the earth." And it was so. God made the two great lights, the greater light to dominate the day and the lesser light to dominate the night, and the stars ... God said, "Let the waters bring forth swarms of living creatures, and birds that fly above the earth across the expanse of the sky." ... God said, "Let the earth bring forth every kind of living creature: cattle, creeping things, and wild beasts of every kind." And it was so ... (Gen. 1.3–24)

BERESHIT

Bereshit

And God said, "Let us make man in our image, after our likeness. They shall rule the fish of the sea, the birds of the sky, the cattle, the whole earth, and all the creeping things that creep on earth." (Gen. 1.26)

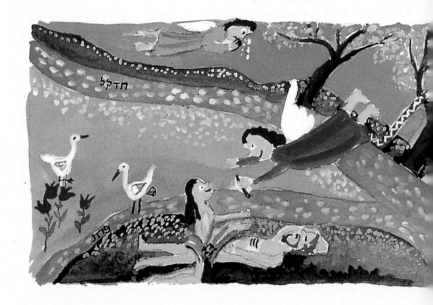

The Lord God planted a garden in Eden, in the east, and placed there the man whom He had formed. And from the ground the Lord God caused to grow every tree that was pleasing to the sight and good for food, with the tree of life in the middle of the garden, and the tree of knowledge of good and bad. (Gen. 2.8–9)

A river issues from Eden to water the garden, and it then divides and becomes four branches. The name of the first is Pishon, the one that winds through the whole land of Havilah, where the gold is. (The gold of that land is good; bdellium is there, and lapis lazuli.) The name of the second river is Gihon, the one that winds through the whole land of Cush. The name of the third river is Tigris, the one that flows east of Asshur. And the fourth river is the Euphrates. (Gen. 2.10–14)

And the Lord God commanded the man, saying, "Of every tree of the garden you are free to eat; but as for the tree of knowledge of good and bad, you must not eat of it; for as soon as you eat of it, you shall die." (Gen. 2.16–17)

The Lord God said, "It is not good for man to be alone; I will make a fitting helper for him."... So the Lord God cast a deep sleep upon the man; and, while he slept, He took one of his ribs and closed up the flesh at that spot. And the Lord God fashioned the rib that He had taken from the man into a woman; and He brought her to the man. (Gen. 2.18–22)

The two of them were naked, the man and his wife, yet they felt no shame. Now the serpent was the shrewdest of all the wild beasts that the Lord God had made. He said to the woman, "Did God really say: You shall not eat of any tree of the garden?" The woman replied to the serpent, "We may eat of the fruit of the other trees of the garden. It is only about fruit of the tree in the middle of the garden that God said: 'You shall not eat of it or touch it, lest you die.'" And the serpent said to the woman, "You are not going to die, but God knows that as soon as you eat of it your eyes will be opened and you will be like divine beings who know good and bad." When the woman saw that the tree was good for eating and a delight to the eyes, and that the tree was desirable as a source of wisdom, she took of its fruit and ate. She also gave some to her husband, and he ate. Then the eyes of both of them were opened and they

perceived that they were naked; and they sewed together fig leaves and made themselves loincloths. They heard the sound of the Lord God moving about in the garden at the breezy time of day; and the man and his wife hid from the Lord God among the trees of the garden ... The Lord God called out to the man and said to him, "Where are you?" He replied, "I heard the sound of You in the garden, and I was afraid because I was naked, so I hid." Then He asked, "Who told you that you were naked? (Gen. 2.25–3.11)

Because you did this, more cursed shall you be than all cattle and all the wild beasts: On your belly shall you crawl and dirt shall you eat all the days of your life. (Gen. 3.14)

And the Lord God said, "Now that the man has become like one of us, knowing good and bad, what if he should stretch out his hand and take also from the tree of life and eat, and live forever!" So the Lord God banished him from the garden of Eden, to till the soil from which he was taken. He drove the man out, and stationed east of the garden of Eden the cherubim and the fiery ever-turning sword, to guard the way to the tree of life. (Gen. 3.22–24)

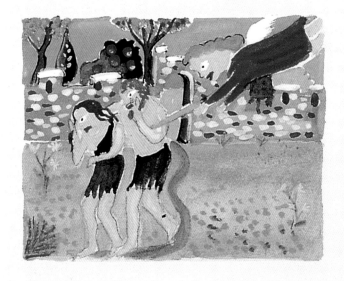

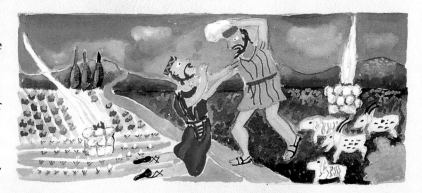

Now the man knew his wife Eve, and she conceived and bore Cain, saying, "I have gained a male child with the help of the Lord." She then bore his brother Abel. Abel became a keeper of sheep, and Cain became a tiller of the soil. In the course of time, Cain brought an offering to the Lord from the fruit of the soil; and Abel, for his part, brought the choicest of the firstlings of his flock. The Lord paid heed to Abel and his offering, but to Cain and his offering He paid no heed. Cain was much distressed and his face fell. And the Lord said to Cain, "Why are you distressed, and why is your face fallen? Surely, if you do right, there is uplift ... Cain said to his brother Abel ... And when they were in the field, Cain set upon his brother Abel and killed him. The Lord said to Cain, "Where is your brother Abel?" And he said, "I do not know. Am I my brother's keeper?" Then He said, "What have you done? Hark, your brother's blood cries out to Me from the ground! Therefore, you shall be more cursed than the ground, which opened its mouth to receive your brother's blood from your hand. (Gen. 4.1–11)

The Lord saw how great was man's wickedness on earth, and how every plan devised by his mind was nothing but evil all the time. And the Lord regretted that He had made man on earth, and His heart was saddened. The Lord said, "I will blot out from the earth the men whom I created—men together with beasts, creeping things, and birds of the sky; for I regret that I made them." But Noah found favor with the Lord. (Gen. 6.5–8)

Haftarat Bereshit

(Ashkenazim read Isaiah 42.5–43.10) (Sephardim read 42.5–43.21)

Thus said God the Lord, Who created the heavens and stretched them out, Who spread out the earth and what it brings forth, Who gave breath to the people upon it and life to those who walk thereon: I the Lord, in My grace, have summoned you, and I have grasped you by the hand. I created you, and appointed you a covenant people, a light of nations—opening eyes deprived of light, rescuing prisoners from confinement, from the dungeon those who sit in darkness. I am the Lord, that is My name; I will not yield My glory to another, nor My renown to idols. See, the things once

predicted have come, and now I foretell new things, announce to you ere they sprout up. Sing to the Lord a new song, His praise from the ends of the earth—you who sail the sea and you creatures in it, you coastlands and their inhabitants! (Isa. 42.5–10)

Then the earth became corrupt. God commanded Noah, the only upright man in his generation, to build an ark to save himself, his family, and two of every living thing, for a flood was about to destroy the earth. Noah did so. After forty days of rain, water covered the earth, drowning all life, except those inside the ark. A year later, the survivors emerged upon dry land. God sent a rainbow, a promise that no great flood like this would come again. Then human beings decided to challenge God by building a tower to heaven, but God babbled their language, and they scattered throughout the world. Ten generations later, Abram was born. He married Sarai, and they settled in Haran.

אלה תולדות נח
נח איש צדיק
תמים היה בדורותיו
את האלקים
התהלך-נח:

This is the line of Noah.—Noah was a righteous man; he was blameless in his age; Noah walked with God. (Gen. 6.9)

The earth became corrupt before God; the earth was filled with lawlessness. When God saw how corrupt the earth was, for all flesh had corrupted its ways on earth, God said to Noah, "I have decided to put an end to all flesh, for the earth is filled with lawlessness because of them: I am about to destroy them with the earth. Make yourself an ark of gopher wood ... For My part, I am about to bring the Flood—waters upon the earth—to destroy all flesh under the sky in which there is breath of life; everything on earth shall perish. But I will establish My covenant with you, and you shall enter the ark, with your sons, your wife, and your sons' wives. And of all that lives, of all flesh, you shall take two of each into the

BERESHIT

Noah

ark to keep alive with you; they shall be male and female. From birds of every kind, cattle of every kind, every kind of creeping thing on earth, two of each shall come to you to stay alive. For your part, take of everything that is eaten and store it away, to serve as food for you and for them." Noah did so; just as God commanded him, so he did ... "For in seven days' time I will make it rain upon the earth, forty days and forty nights, and I will blot out from the earth all existence that I created." And Noah did just as the Lord commanded him. Noah was six hundred years old when the Flood came, waters upon the earth. Noah, with his sons, his wife, and his sons' wives, went into the ark because of the waters of the Flood. (Gen. 6.11–7.7)

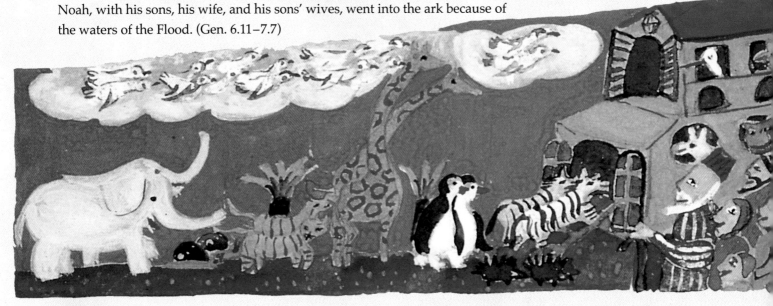

And on the seventh day the waters of the Flood came upon the earth ... The rain fell on the earth forty days and forty nights. That same day Noah and Noah's sons, Shem, Ham, and Japheth, went into the ark, with Noah's wife and the three wives of his sons—they and all beasts of every kind, all cattle of every kind, all creatures of every kind that creep on the earth, and all birds of every kind, every bird, every winged thing. They came to Noah into the ark, two each of all flesh in which there was breath of life. Thus they that entered comprised male and female of all flesh, as God had commanded him. And the Lord shut him in.
(Gen. 7.10–16)

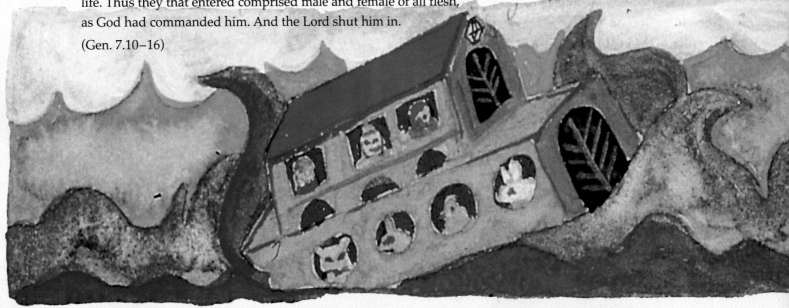

All existence on earth was blotted out—man, cattle, creeping things, and birds of the sky; they were blotted out from the earth. Only Noah was left, and those with him in the ark. And when the waters had swelled on the earth one hundred and fifty days, God remembered Noah and all the beasts and all the cattle that were with him in the ark, and God caused a wind to blow across the earth, and the waters subsided. The fountains of the deep and the floodgates of the sky

 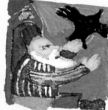 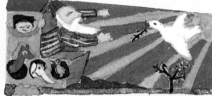

were stopped up, and the rain from the sky was held back; the waters then receded steadily from the earth. At the end of one hundred and fifty days the waters diminished, so that in the seventh month, on the seventeenth day of the month, the ark came to rest on the mountains of Ararat ... At the end of forty days, Noah opened the window of the ark that he had made and sent out the raven; it went to and fro until the waters had dried up from the earth ... He waited another seven days, and again sent out the dove from the ark. The dove came back to him toward evening, and there in its bill was a plucked-off olive leaf! Then Noah knew that the waters had decreased on the earth. (Gen. 7.23–8.11)

He waited still another seven days and sent the dove forth; and it did not return to him any more ... God spoke to Noah, saying, "Come out of the ark, together with your wife, your sons, and your sons' wives. 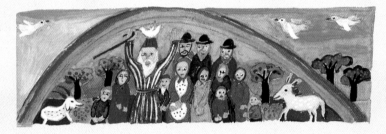 Bring out with you every living thing of all flesh that is with you: birds, animals, and everything that creeps on earth; and let them swarm on the earth and be fertile and increase on earth." So Noah came out, together with his sons, his wife, and his sons' wives. Every animal, every creeping thing, and every bird, everything that stirs on earth came out of the ark by families. (Gen. 8.12–19)

Then Noah built an altar to the Lord and, taking of every clean animal and of every clean bird, he offered burnt offerings on the altar ... God blessed Noah and his sons, and said to them, "Be fertile and increase, and fill the earth ... Every creature that lives shall be yours to eat; as with the green grasses, I give you all these. You must not, however, eat flesh with its life-blood in it. But for your own life-blood I will require a reckoning: I will require it of every beast; of man, too, will I require a reckoning for human life, of every man for that of his fellow man! Whoever sheds the blood of man, by man shall his blood be shed; for in His image did God make man. Be fertile, then, and increase; abound on the earth and increase on it ... I now establish My covenant with you and your offspring to come, and with every living

thing that is with you—birds, cattle, and every wild beast as well—all that have come out of the ark, every living thing on earth. I will maintain My covenant with you: never again shall all flesh be cut off by the waters of a flood, and never again shall there be a flood to destroy the earth." (Gen. 8.20–9.11)

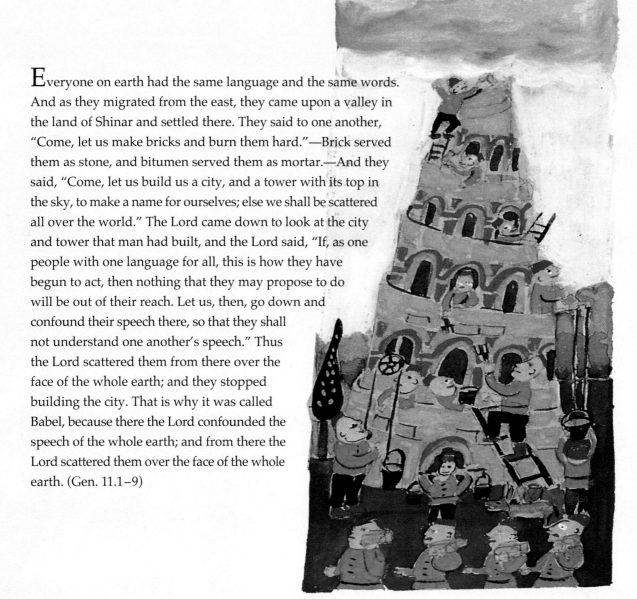

Everyone on earth had the same language and the same words. And as they migrated from the east, they came upon a valley in the land of Shinar and settled there. They said to one another, "Come, let us make bricks and burn them hard."—Brick served them as stone, and bitumen served them as mortar.—And they said, "Come, let us build us a city, and a tower with its top in the sky, to make a name for ourselves; else we shall be scattered all over the world." The Lord came down to look at the city and tower that man had built, and the Lord said, "If, as one people with one language for all, this is how they have begun to act, then nothing that they may propose to do will be out of their reach. Let us, then, go down and confound their speech there, so that they shall not understand one another's speech." Thus the Lord scattered them from there over the face of the whole earth; and they stopped building the city. That is why it was called Babel, because there the Lord confounded the speech of the whole earth; and from there the Lord scattered them over the face of the whole earth. (Gen. 11.1–9)

Haftarat Noah

(Ashkenazim read Isaiah 54.1–55.5) (Sephardim read 54.1–55.10)

Shout, O barren one, you who bore no child! Shout aloud for joy, you who did not travail! For the children of the wife forlorn shall outnumber those of the espoused—said the Lord. Enlarge the site of your tent, extend the size of your dwelling, do not stint! Lengthen the ropes, and drive the pegs firm. For you shall spread out to the right and the left; your offspring shall dispossess nations and shall people the desolate towns. Fear not, you shall not be shamed; do not cringe, you shall not be disgraced. For you shall forget the reproach of your youth, and remember no more the shame of your widowhood. (Isa. 54.1–4)

God called Abram to leave his home and go to the land of Canaan. So Abram and Sarai, together with their nephew Lot, settled in Canaan. God blessed Abram, promising him countless descendants, and made a covenant with him. But Sarai was barren. She gave Abram her maid Hagar to bear a child in her place, and Hagar gave birth to a son, Ishmael. God promised Abram that Sarai too would soon bear a son. Then God changed Abram's name to Abraham, and Sarai's name to Sarah. When Ishmael was thirteen and Abraham was ninety-nine, Abraham circumcised himself, his son, and all the males of his household.

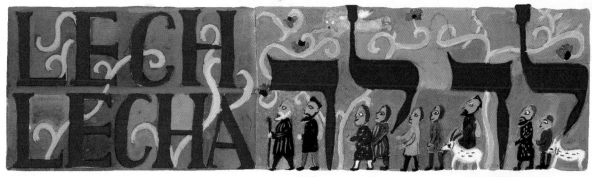

The Lord said to Abram, "Go forth from your native land and from your father's house to the land that I will show you. (Gen. 12.1)

ויאמר ה' אל אברם לך לך
מארצך וממולדתך ומבית אביך
אל הארץ אשר אראך:

 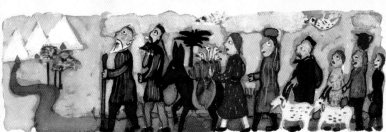

There was a famine in the land, and Abram went down to Egypt to sojourn there, for the famine was severe in the land. As he was about to enter Egypt, he said to his wife Sarai, "I know what a beautiful woman you are. If the Egyptians see you, and think, 'She is his wife,' they will kill me and let you live. Please say that you are my sister, that it may go well with me because of you, and that I may remain alive thanks to you." When Abram entered Egypt, the Egyptians saw how very beautiful the woman was. Pharaoh's courtiers saw her and praised her to Pharaoh, and the woman was taken into Pharaoh's palace. And because of her, it went well with Abram; he acquired sheep, oxen, asses, male and female slaves, she-asses, and camels. But the Lord afflicted Pharaoh and his household with mighty plagues on account of Sarai, the wife of Abram. Pharaoh sent for Abram and said, "What is this you have done to me! Why did you not tell me that she was your wife? Why did you say, 'She is my sister, so that I took her as my wife? Now, here is your wife; take her and begone!" And Pharaoh put men in charge of him, and they sent him off with his wife and all that he possessed. From Egypt, Abram went up into the Negeb, with his wife and all that he possessed, together with Lot. Now Abram was very rich in cattle,

silver, and gold. And he proceeded by stages from the Negeb as far as Bethel, to the place where his tent had been formerly, between Bethel and Ai, the site of the altar that he had built there at first; and there Abram invoked the Lord by name. Lot, who went with Abram, also had flocks and herds and tents, so that the land could not support them staying together ... Abram said to Lot, "Let there be no strife between you and me, between my herdsmen and yours, for we are kinsmen. Is not the whole land before you? Let us separate: if you go north, I will go south; and if you go south, I will go north." ... So Lot chose for himself the whole plain of the Jordan, and Lot journeyed eastward. Thus they parted from each other; Abram remained in the land of Canaan, while Lot settled in the cities of the Plain, pitching his tents near Sodom. Now the inhabitants of Sodom were very wicked sinners against the Lord. (Gen. 12.10–13.13)

Now, when King Amraphel of Shinar, King Arioch of Ellasar, King Chedorlaomer of Elam, and King Tidal of Goiim made war on King Bera of Sodom, King Birsha of Gomorrah, King Shinab of Admah, King Shemeber of Zeboiim, and the king of Bela, which is Zoar ... Now the Valley of Siddim was dotted with bitumen pits; and the kings of Sodom and Gomorrah, in their flight, threw themselves into them, while the rest escaped to the hill country. [The invaders] seized all the wealth of Sodom and Gomorrah and all their provisions, and went their way. They also took Lot, the son of Abram's brother, and his possessions, and departed; for he had settled in Sodom. A fugitive brought the news to Abram the Hebrew ... When Abram heard that his kinsman had been taken captive, he mustered his retainers, born into his household, numbering three hundred and eighteen, and went in pursuit as far as Dan ... He brought back all the possessions; he also brought back his kinsman Lot and his possessions, and the women and the rest of the people. When he returned from defeating Chedorlaomer and the kings with him, the king of Sodom came out to meet him in the Valley of Shaveh ... He blessed him, saying, "Blessed be Abram of God Most High, Creator of heaven and earth. And blessed be God Most High, Who has delivered your foes into your hand." (Gen. 14.1–20)

Some time later, the word of the Lord came to Abram in a vision. He said, "Fear not, Abram, I am a shield to you; Your reward shall be very great." But Abram said, "O Lord God, what can You give me, seeing that I shall die childless ..." When the sun set and it was very dark, there appeared a smoking oven, and a flaming torch which passed between those pieces. On that day the Lord made a covenant with Abram, saying, "To your offspring I assign this land, from the river of Egypt to the great river, the river Euphrates: the Kenites, the Kenizzites, the Kadmonites, the Hittites, the Perizzites, the Rephaim, the Amorites, the Canaanites, the Girgashites, and the Jebusites." Sarai, Abram's wife, had borne him no children. She had an Egyptian maidservant whose name was Hagar. And Sarai said to Abram, "Look, the Lord has kept me from bearing ..." So Sarai, Abram's wife, took her maid, Hagar the Egyptian—after Abram had dwelt in the land of Canaan ten years—and gave her to her husband Abram as concubine. He cohabited with Hagar and she conceived; and when she saw that she had conceived, her mistress was lowered in her esteem. And Sarai said to Abram, "The wrong done me is your fault! I myself put my maid in your bosom; now that she sees that she is pregnant, I am lowered in her esteem. The Lord decide between you and me!" Abram said to Sarai, "Your maid is in your hands. Deal with her as you think right." Then Sarai treated her harshly, and she ran away from her. An angel of the Lord found her by a spring of water in the wilderness, the spring on the road to Shur, and said, "Hagar, slave of Sarai, where have you come from, and where are you going?" And she said, "I am running away from my mistress Sarai." And the angel of the Lord said to her, "Go back to your mistress, and submit to her harsh treatment." ... The angel of the Lord said to her further, "Behold, you are with child and shall bear a son; you shall call him Ishmael." (Gen. 15.1–16.11)

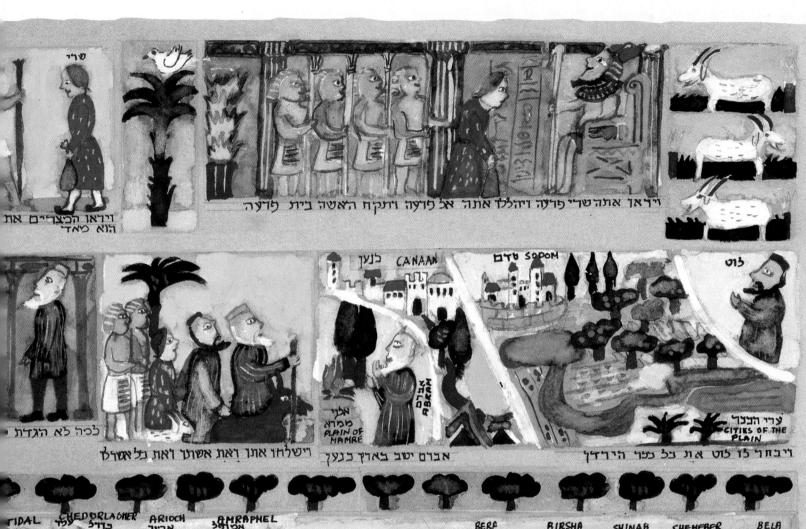

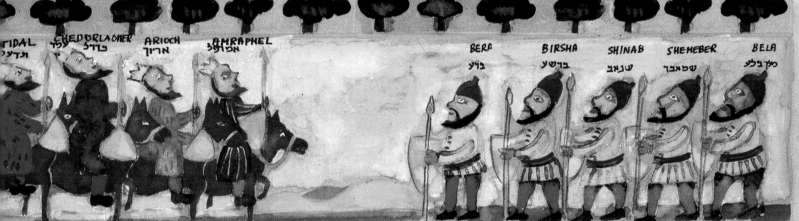

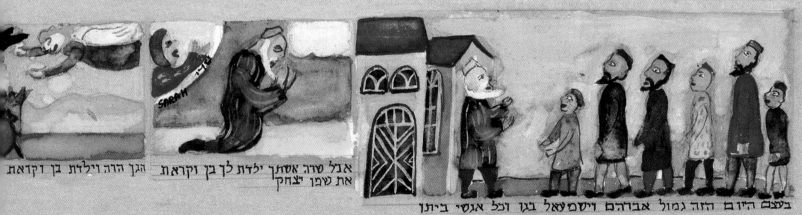

Abram threw himself on his face; and God spoke to him further, "As for Me, this is My covenant with you: You shall be the father of a multitude of nations. And you shall no longer be called Abram, but your name shall be Abraham, for I make you the father of a multitude of nations. I will make you exceedingly fertile, and make nations of you; and kings shall come forth from you ..." God further said to Abraham, "As for you, you and your offspring to come throughout the ages shall keep My covenant. Such shall be the covenant between Me and you and your offspring to follow which you shall keep: every male among you shall be circumcised. You shall circumcise the flesh of your foreskin, and that shall be the sign of the covenant between Me and you. And throughout the generations, every male among you shall be circumcised at the age of eight days ..." And God said to Abraham, "As for your wife Sarai, you shall not call her Sarai, but her name shall be Sarah. I will bless her; indeed, I will give you a son by her. I will bless her so that she shall give rise to nations; rulers of peoples shall issue from her." Abraham threw himself on his face and laughed, as he said to himself, "Can a child be born to a man a hundred years old, or can Sarah bear a child at ninety?" And Abraham said to God, "O that Ishmael might live by Your favor!" God said, "Nevertheless, Sarah your wife shall bear you a son, and you shall name him Isaac; and I will maintain My covenant with him as an everlasting covenant for his offspring to come. As for Ishmael, I have heeded you. I hereby bless him. I will make him fertile and exceedingly numerous. He shall be the father of twelve chieftains, and I will make of him a great nation. But My covenant I will maintain with Isaac, whom Sarah shall bear to you at this season next year." And when He was done speaking with him, God was gone from Abraham. Then Abraham took his son Ishmael, and all his homeborn slaves and all those he had bought, every male in Abraham's household, and he circumcised the flesh of their foreskins on that very day, as God had spoken to him. Abraham was ninety-nine years old when he circumcised the flesh of his foreskin, and his son Ishmael was thirteen years old when he was circumcised in the flesh of his foreskin. Thus Abraham and his son Ishmael were circumcised on that very day; and all his household, his homeborn slaves and those that had been bought from outsiders, were circumcised with him. (Gen. 17.3–27)

Haftarat Lech Lecha

(Isaiah 40.27–41.16)

Why do you say, O Jacob, why declare, O Israel, "My way is hid from the Lord, my cause is ignored by my God"? Do you not know? Have you not heard? The Lord is God from of old, Creator of the earth from end to end, He never grows faint or weary, His wisdom cannot be fathomed. He gives strength to the weary, fresh vigor to the spent. Youths may grow faint and weary, and young men stumble and fall; but they who trust in the Lord shall renew their strength as eagles grow new plumes: they shall run and not grow weary, they shall march and not grow faint. (Isa. 40.27–31)

One day three divine messengers came to Abraham and Sarah, telling them that they would soon have a son. God then told Abraham that the wicked cities of Sodom and Gomorrah were to be destroyed. Abraham argued with God to spare Sodom, and God agreed—if at least ten righteous people could be found there. But the two divine messengers who went to Lot's house in Sodom failed to find even ten. So Lot, his two daughters, and his wife fled the doomed city, but his wife looked back and became a pillar of salt. Sarah gave birth to a son, whom she and Abraham named Isaac. When Sarah saw Ishmael mocking Isaac, she had Abraham banish Hagar and Ishmael to the desert. God protected them, and blessed Ishmael, promising to make him a great nation. God then tested Abraham, commanding him to sacrifice Isaac. But when Abraham bound Isaac on the altar to kill him, an angel held back the knife, and God blessed Abraham yet again.

וירא אליו ה' באלני ממרא והוא יושב פתח האהל כחם היום:

The Lord appeared to him by the terebinths of Mamre; he was sitting at the entrance of the tent as the day grew hot. (Gen. 18.1)

Looking up, he saw three men standing near him. As soon as he saw them, he ran from the entrance of the tent to greet them and, bowing to the ground, he said, "My lords, if it please you, do not go on past your servant …" They said to him, "Where is your wife Sarah?" And he replied, "There, in the tent." Then one said, "I will return to you next year, and your wife Sarah shall have a son!" Sarah was listening at the entrance of the tent, which was behind him. Now Abraham and Sarah were old, advanced in years; Sarah had stopped having the periods of women. And Sarah laughed to herself, saying, "Now that I am withered, am I to have enjoyment—with my husband so old?" Then the Lord said to Abraham, "Why did Sarah laugh, saying, 'Shall I in truth bear a child, old as I am?' Is anything too wondrous for the Lord? I will return to you at the same season next year, and Sarah shall have a son." Sarah lied, saying, "I did not laugh," for she was frightened. But He replied, "You did laugh." (Gen. 18.2–15)

Then the Lord said, "The outrage of Sodom and Gomorrah is so great, and their sin so grave! I will go down to see whether they have acted altogether according to the outcry that has reached Me; if not, I will take note." The men went on from there to Sodom, while Abraham remained standing before the Lord. Abraham came forward and said, "Will You sweep away the innocent along with the guilty? What if there should be fifty innocent within the city; will You then wipe out the place and not forgive it for the sake of the innocent fifty who are in it? Far be it from You to do such a thing, to bring death upon the innocent as well as the guilty, 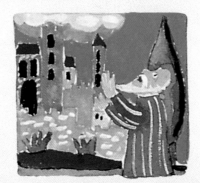 so that innocent and guilty fare alike. Far be it from You! Shall not the Judge of all the earth deal justly?" And the Lord answered, "If I find within the city of Sodom fifty innocent ones, I will forgive the whole place for their sake." Abraham spoke up, saying, "Here I venture to speak to my Lord, I who am but dust and ashes: What if the fifty innocent should lack five? Will You destroy the whole city for want of the five?" And He answered, "I will not destroy if I find forty-five there." But he spoke to Him again, and said, "What if forty should be found there?" And He answered, "I will not do it, for the sake of the forty." And he said, "Let not my Lord be angry if I go on: What if thirty should be found there?" And He answered, "I will not do it if I find thirty there." And he said, "I venture again to speak to my Lord: What if twenty should be found there?" And He answered, "I will not destroy, for the sake of the twenty." And he said, "Let not my Lord be angry if I speak but this last time: What if ten should be found there?" And He answered, "I will not destroy, for the sake of the ten." When the Lord had finished speaking to Abraham, He departed; and Abraham returned to his place. (Gen. 18.20–33)

The two angels arrived in Sodom in the evening, as Lot was sitting in the gate of Sodom. When Lot saw them, he rose to greet them and, bowing low with his face to the ground, he said, "Please, my lords, turn aside to your servant's house to spend the night, and bathe your feet; then you may be on your way early." ... They had not yet lain down, when the townspeople, the men of Sodom, young and old— all the people to the last man—gathered about the house. And they shouted to Lot and said to him, "Where are the men who came to you tonight? Bring them out to us, that we may be intimate with 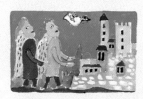 them." So Lot went out to them to the entrance, shut the door behind him, and said, "I beg you, my friends, do not commit such a wrong. Look, I have two daughters who have not known a man. Let me bring them out to you, and you may do to them as you please; but do not do anything to these men, since they have come under the shelter of my roof."

But they said, "Stand back! The fellow," they said, "came here as an alien, and already he acts the ruler! Now we will deal worse with you than with them." 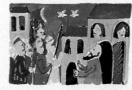 And they pressed hard against the person of Lot, and moved forward to break the door. But the men stretched out their hands and pulled Lot into the house 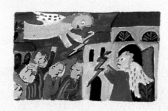 with them, and shut the door. And the people who were at the entrance of the house, young and old, they struck with blinding light, so that they were helpless to find the entrance. Then the men said to Lot, "Whom else have you here? Sons-in-law, your sons and daughters, or anyone else that you have in the city—bring them out of the place. For we are about to destroy

this place; because the outcry against them before the Lord has become so great that the Lord has sent us to destroy it." So Lot went out and spoke to his sons-in-law, who had married his daughters, and said, "Up, get out of this place, for the Lord is about to destroy the city." But he seemed to his sons-in-law as one who jests. As dawn broke, the angels urged Lot on, saying, "Up, take your wife and your two remaining daughters, lest you be swept away because of the iniquity of the city ..." But Lot said to them ... "Look, that town there is near enough to flee to; it is such a little place! Let me flee there ..." As the sun rose upon the earth and Lot entered Zoar, the Lord rained upon Sodom and Gomorrah sulfurous fire from the Lord out of heaven. He annihilated those cities and the entire Plain, and all the inhabitants of the cities and the vegetation of the ground. Lot's wife looked back, and she thereupon turned into a pillar of salt. (Gen. 19.1–26)

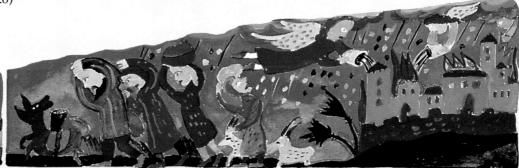

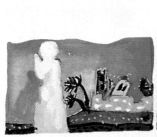

The Lord took note of Sarah as He had promised, and the Lord did for Sarah as He had spoken. Sarah conceived and bore a son to Abraham in his old age, at the set time of which God had spoken ... The child grew up and was weaned, and Abraham held a great feast on the day that Isaac was weaned. Sarah saw the son whom Hagar the Egyptian had borne to Abraham playing. She said to Abraham, "Cast out that slave-woman and her son, for the son of that slave shall not share in the inheritance with my son Isaac." ... Early next morning Abraham took some bread and a skin of water, and gave them to Hagar. He placed them over her shoulder, together with the child, and sent her away. And she wandered about in the wilderness of Beer-sheba. When the water was gone from the skin, she left the child under one of the bushes, and went and sat down at a distance, a bowshot away; for she thought, "Let me not look on as the child dies." And sitting thus afar, she burst into tears. God heard the cry of the boy, and an angel of God called to Hagar from

heaven and said to her, "What troubles you, Hagar? Fear not, for God has heeded the cry of the boy where he is. Come, lift up the boy and hold him by the hand, for I will make a great nation of him." Then God opened her eyes and she saw a well of water. She went and filled the skin with water, and let the boy drink. (Gen. 21.1–19)

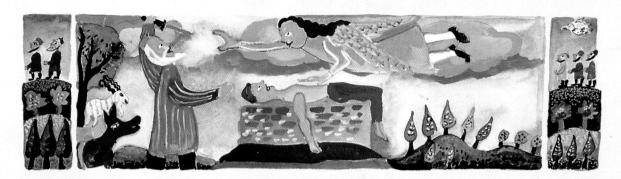

Some time afterward, God put Abraham to the test. He said to him, "Abraham," and he answered, "Here I am." And He said, "Take your son, your favored one, Isaac, whom you love, and go to the land of Moriah, and offer him there as a burnt offering on one of the heights that I will point out to you ..." They arrived at the place of which God had told him. Abraham built an altar there; he laid out the wood; he bound his son Isaac; he laid him on the altar, on top of the wood. And Abraham picked up the knife to slay his son. Then an angel of the Lord called to him from heaven: "Abraham! Abraham!" And he answered, "Here I am." And he said, "Do not raise your hand against the boy, or do anything to him. For now I know that you fear God, since you have not withheld your son, your favored one, from Me." (Gen. 22.1–12)

Haftarat Vayera

(Ashkenazim read 2 Kings 4.1–37) (Sephardim read 2 Kings 4.1–23)

A certain woman, the wife of one of the disciples of the prophets, cried out to Elisha: "Your servant my husband is dead, and you know how your servant revered the Lord. And now a creditor is coming to seize my two children as slaves." Elisha said to her, "What can I do for you? Tell me, what have you in the house?" She replied, "Your maidservant has nothing at all in the house, except a jug of oil." "Go," he said, "and borrow vessels outside, from all your neighbors, empty vessels, as many as you can. Then go in and shut the door behind you and your children, and pour oil into all those vessels, removing each one as it is filled." She went away and shut the door behind her and her children. They kept bringing

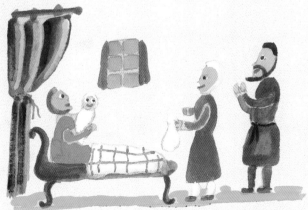

vessels to her and she kept pouring. When the vessels were full, she said to her son, "Bring me another vessel." He answered her, "There are no more vessels"; and the oil stopped. She came and told the man of God, and he said, "Go sell the oil and pay your debt, and you and your children can live on the rest." (2 Kings 4.1–7)

And Elisha said, "At this season next year, you will be embracing a son." (2 Kings 4.16)

Sarah died, and Abraham bought a burial cave for her in Machpelah. Then Abraham sent his servant Eliezer to his brother Nahor's house to find a wife for Isaac among his own people. At the well there, Eliezer encountered Nahor's granddaughter Rebekah, and finding her worthy and willing, brought her back to marry Isaac. Then Abraham took a new wife, Keturah, and fathered six more sons.

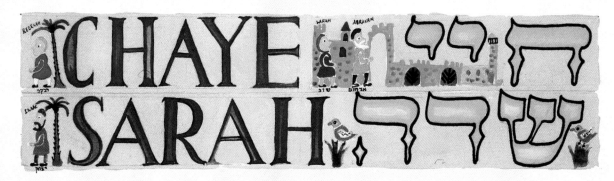

ויהיו חיי שרה מאה שנה ועשרים שנה ושבע שנים שני חיי שרה:

Sarah's lifetime—the span of Sarah's life—came to one hundred and twenty-seven years. (Gen. 23.1)

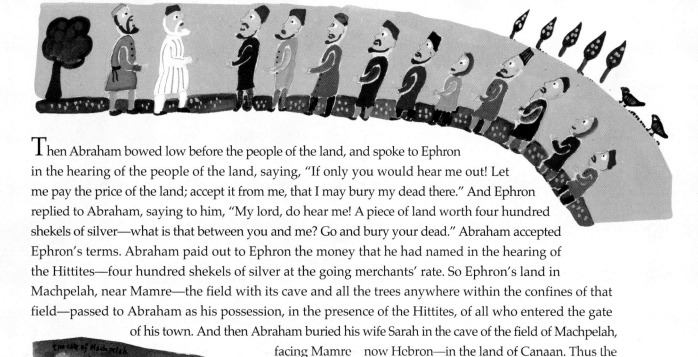

Then Abraham bowed low before the people of the land, and spoke to Ephron in the hearing of the people of the land, saying, "If only you would hear me out! Let me pay the price of the land; accept it from me, that I may bury my dead there." And Ephron replied to Abraham, saying to him, "My lord, do hear me! A piece of land worth four hundred shekels of silver—what is that between you and me? Go and bury your dead." Abraham accepted Ephron's terms. Abraham paid out to Ephron the money that he had named in the hearing of the Hittites—four hundred shekels of silver at the going merchants' rate. So Ephron's land in Machpelah, near Mamre—the field with its cave and all the trees anywhere within the confines of that field—passed to Abraham as his possession, in the presence of the Hittites, of all who entered the gate of his town. And then Abraham buried his wife Sarah in the cave of the field of Machpelah, facing Mamre now Hebron—in the land of Canaan. Thus the field with its cave passed from the Hittites to Abraham, as a burial site.

(Gen. 23.12–20)

BERESHIT

Chaye Sarah

And Abraham said to the senior servant of his household, who had charge of all that he owned, "Put your hand under my thigh and I will make you swear by the Lord, the God of heaven and the God of the earth, that you will not take a wife for my son from the daughters of the Canaanites among whom I dwell, but will go to the land of my birth and get a wife for my son Isaac." (Gen. 24.2–4)

The Lord, the God of heaven, who took me from my father's house and from my native land, who promised me on oath, saying, 'I will assign this land to your offspring'—He will send His angel before you, and you will get a wife for my son from there. (Gen. 24.7)

Then the servant took ten of his master's camels and set out, taking with him all the bounty of his master; and he made his way to Aram-naharaim, to the city of Nahor. He made the camels kneel down by the well outside the city, at evening time, the time when women come out to draw water. And he said, "O Lord, God of my master Abraham, grant me good fortune this day, and deal graciously with my master Abraham: Here I stand by the spring as the daughters of the townsmen come out to draw water; let the maiden to whom I say, 'Please, lower your jar that I may drink,' and who replies, 'Drink, and I will also water your camels'—let her be the one whom You have decreed for Your servant Isaac. Thereby shall I know that You have dealt graciously with my master." He had scarcely finished speaking, when Rebekah, who was born to Bethuel, the son of Milcah the wife of Abraham's brother Nahor, came out with her jar on her shoulder. The maiden was very beautiful, a virgin whom no

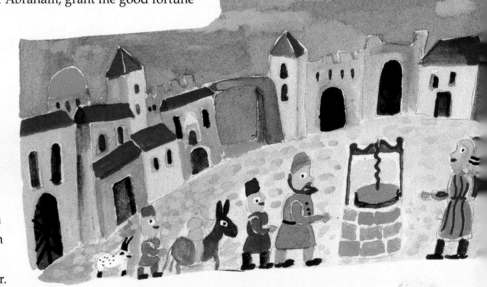

man had known. She went down to the spring, filled her jar, and came up. The servant ran toward her and said, "Please, let me sip a little water from your jar." "Drink, my lord," she said, and she quickly lowered her jar upon her hand and let him drink. When she had let him drink his fill, she said, "I will also draw for your camels, until they finish drinking." Quickly emptying her jar into the trough, she ran back to the well to draw, and she drew for all his camels. (Gen. 24.10–20)

"Pray tell me," he said, "whose daughter are you? Is there room in your father's house for us to spend the night?" She replied, "I am the daughter of Bethuel the son of Milcah, whom she bore to Nahor." And she went on, "There is plenty of straw and feed at home, and also room to spend the night." The man bowed low in homage to the Lord and said, "Blessed be the Lord, the God of my master Abraham, who has not withheld His steadfast faithfulness from my master. For I have been guided on my errand by the Lord, to the house of my master's kinsmen." (Gen. 24.23–27)

"I am Abraham's servant," he began. "The Lord has greatly blessed my master, and he has become rich: He has given him sheep and cattle, silver and gold, male and female slaves, camels and asses. And Sarah, my master's wife, bore my master a son in her old age, and he has assigned to him everything he

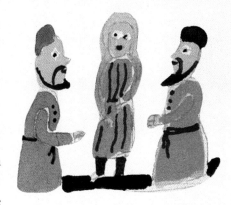

owns. Now my master made me swear, saying, 'You shall not get a wife for my son from the daughters of the Canaanites in whose land I dwell; but you shall go to my father's house, to my kindred, and get a wife for my son.' And I said to my master, 'What if the woman does not follow me?' He replied to me, 'The Lord, whose ways I have followed, will send His angel with you and make your errand successful; and you will get a wife for my son from my kindred, from my father's house. Thus only shall you be freed from my adjuration: if, when you come to my kindred, they refuse you—only then shall you be freed from my adjuration.'

"I came today to the spring, and I said: O Lord, God of my master Abraham, if You would indeed grant success to the errand on which I am engaged! As I stand by the spring of water, let the young woman who comes out to draw and to whom I say, 'Please, let me drink a little water from your jar,' and who answers, 'You may drink, and I will also draw for your camels'— let her be the wife whom the Lord has decreed for my master's son.' I had scarcely finished praying in my heart, when Rebekah came out with her jar on her shoulder, and went down to the spring and drew. And I said to her, 'Please give me a drink.' She quickly lowered her jar and said, 'Drink, and I will also water your camels.' So I drank, and she also watered the camels. I inquired of her, 'Whose daughter are you?' And she said, 'The daughter of Bethuel, son of Nahor, whom Milcah bore to him.' And I put the ring on her nose and the bands on her arms. Then I bowed low in homage to the Lord and blessed the Lord, the God of my master Abraham, who led me on the right way to get the daughter of my master's brother for his son. And now, if you mean to treat my master with true kindness, tell me; and if not, tell me also, that I may turn right or left." ... He said to them, "Do not delay me, now that the Lord has made my errand successful. Give me leave that I may go to my master." And they said, "Let us call the girl and ask for her reply." They called Rebekah and said to her, "Will you go with this man?" And she said, "I will." (Gen. 24.34–58)

Isaac had just come back from the vicinity of Beer-lahai-roi, for he was settled in the region of the Negeb. And Isaac went out walking in the field toward evening and, looking up, he saw camels approaching. Raising her eyes, Rebekah saw Isaac. She alighted from the camel and said to the servant, "Who is that man walking in the field toward us?" And the servant said, "That is my master." So she took her veil and covered herself. The servant told Isaac all the things that he had done. Isaac then brought her into the tent of his mother Sarah, and he took Rebekah as his wife. Isaac loved her, and thus found comfort after his mother's death. (Gen. 24.62–67)

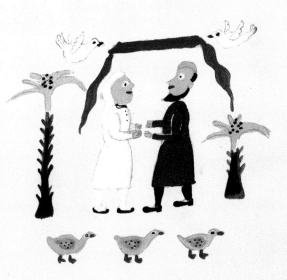

Haftarat Chaye Sarah

(1 Kings 1.1–31)

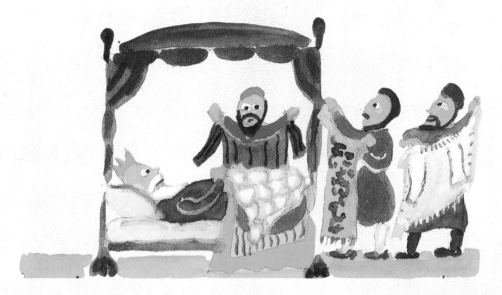

King David was now old, advanced in years; and though they covered him with bed clothes, he never felt warm. His courtiers said to him, "Let a young virgin be sought for my lord the king, to wait upon Your Majesty and be his attendant; and let her lie in your bosom, and my lord the king will be warm." So they looked for a beautiful girl throughout the territory of Israel. They found Abishag the Shunammite and brought her to the king. The girl was exceedingly beautiful. She became the king's attendant and waited upon him; but the king was not intimate with her. Now Adonijah son of Haggith went about boasting, "I will be king!" He provided himself with chariots and horses, and an escort of fifty outrunners. His father had never scolded him: "Why did you do that?" He was the one born after Absalom and, like him, was very handsome. He conferred with Joab son of Zeruiah and with the priest Abiathar, and they supported Adonijah; but the priest Zadok, Benaiah son of Jehoiada, the prophet Nathan, Shimei and Rei, and David's own fighting men did not side with Adonijah. Adonijah made a sacrificial feast of sheep, oxen, and fatlings at the Zoheleth stone which is near En-rogel; he invited all his brother princes and all the king's courtiers of the tribe of Judah; but he did not invite the prophet Nathan, or Benaiah, or the fighting men, or his brother Solomon. (1 Kings 1.1–10)

Isaac and Rebekah became parents to twins. Esau became a hunter, while Jacob stayed in the camp. Isaac favored Esau; Rebekah favored Jacob. One day Esau sold his birthright to his younger brother Jacob in exchange for some lentil stew. When the time came for the old and blind Isaac to bless Esau before he died, Rebekah disguised Jacob as his older brother so he received the blessing meant for Esau. Fearful of Esau's revenge, Jacob fled to Rebekah's brother Laban's house in Haran.

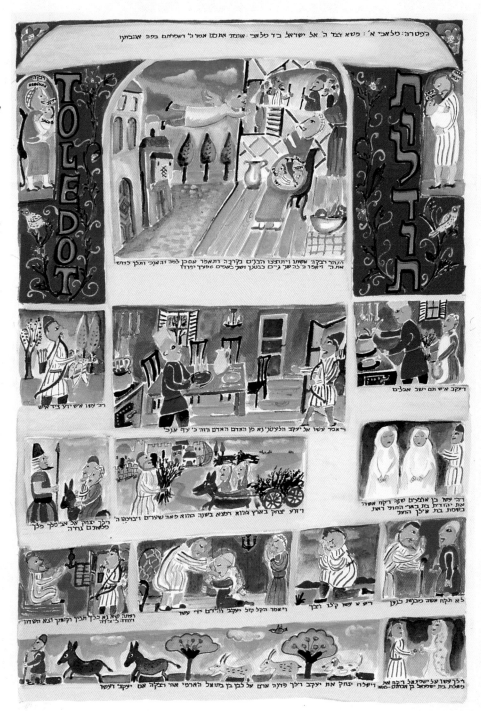

וְאֵלֶּה תּוֹלְדֹת יִצְחָק
בֶּן אַבְרָהָם, אַבְרָהָם
הוֹלִיד אֶת יִצְחָק:

This is the story of Isaac, son of Abraham. Abraham begot Isaac. (Gen 25.19)

Isaac was forty years old when he took to wife Rebekah, daughter of Bethuel the Aramean of Paddan-aram, sister of Laban the Aramean. Isaac pleaded with the Lord on behalf of his wife, because she was barren; and the Lord responded to his plea, and his wife Rebekah conceived. But the children struggled in her womb, and she said, "If so, why do I exist?" She went to inquire of the Lord, and the Lord answered her, "Two nations are in your womb, two separate peoples shall issue from your body; one

BERESHIT

Toledot

people shall be mightier than the other, and the older shall serve the younger." When her time to give birth was at hand, there were twins in her womb. The first one emerged red, like a hairy mantle all over; so they named him Esau. Then his brother emerged, holding on to the heel of Esau; so they named him Jacob. Isaac was sixty years old when they were born. (Gen. 25.20–26)

When the boys grew up, Esau became a skillful hunter, a man of the outdoors; but Jacob was a mild man who stayed in camp. Isaac favored Esau because he had a taste for game; but Rebekah favored Jacob. Once when Jacob was cooking a stew, Esau came in from the open, famished. And Esau said to Jacob, "Give me some of that red stuff to gulp down, for I am famished"—which is why he was named Edom. Jacob said, "First sell me your birthright." And Esau said, "I am at the point of death, so of what use is my birthright to me?" But Jacob said, "Swear to me first." So he swore to him, and sold his birthright to Jacob. Jacob then gave Esau bread and lentil stew; he ate and drank, and he rose and went away. Thus did Esau spurn the birthright. There was a famine in the land— aside from the previous famine that had occurred in the days of Abraham—and Isaac went to Abimelech, king of the Philistines, in Gerar. The Lord had appeared to him and said, "Do not go down to Egypt; stay in the land which I point out to you. Reside in this land, and I will be with you and bless you; I will assign all these lands to you and to your heirs, fulfilling the oath that I swore to your father Abraham. I will make your heirs as

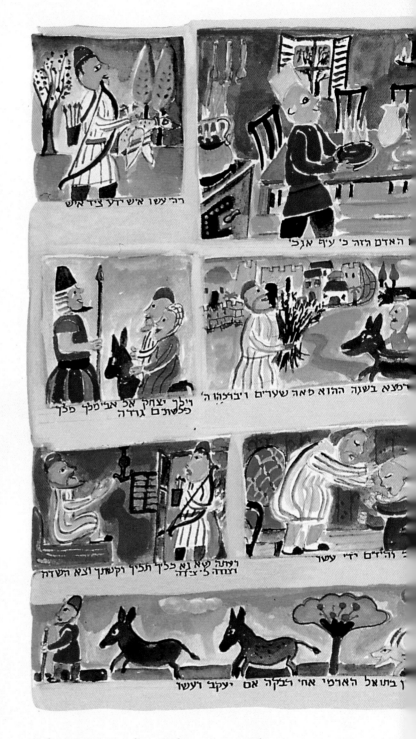

numerous as the stars of heaven, and assign to your heirs all these lands, so that all the nations of the earth shall bless themselves by your heirs—inasmuch as Abraham obeyed Me and kept My charge: My commandments, My laws, and My teachings." ... Isaac sowed in that land and reaped a hundredfold the same year. The Lord blessed him. (Gen. 25.27–26.12)

When Esau was forty years old, he took to wife Judith daughter of Beeri the Hittite, and Basemath daughter of Elon the Hittite; and they were a source of bitterness to Isaac and Rebekah. When Isaac was old and his eyes were too dim to see, he called his older son Esau and said ... "Take your gear, your quiver and bow, and go out into the open and hunt me some game. Then prepare a dish for me such as I like,

32

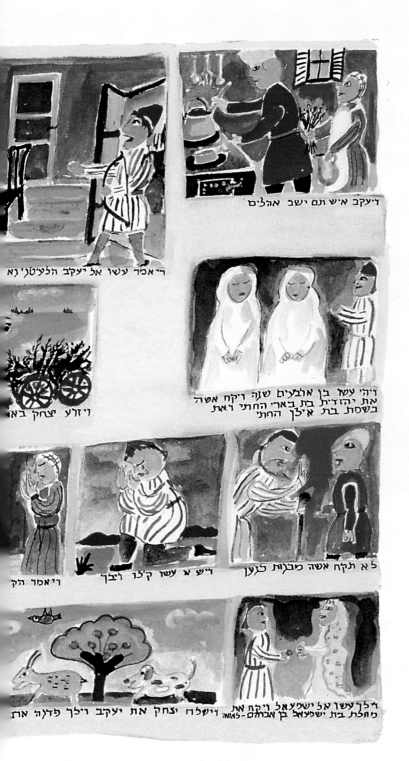

דיעקב איש תם ישב אהלים

ריאמר עשו אל יעקב הלעיטני נא

ויזרע יצחק בא

ויהי עשו בן ארבעים שנה ויקח אשה את יהודית בת בארי החתי ואת בשמת בת אילן החתי

ויאמר הק

ריש א עשו קלן ליבך

לא תקח אשה מבנות לנען

וילך עשו אל ישמעאל ויקח את מחלת בת ישמעאל בן אברהם־לאשה וישלח יצחק את יעקב וילך פדנה ארם

and bring it to me to eat, so that I may give you my innermost blessing before I die." Rebekah had been listening as Isaac spoke to his son Esau. When Esau had gone out into the open to hunt game to bring home, Rebekah said to her son Jacob, "I overheard your father speaking to your brother Esau, saying, 'Bring me some game and prepare a dish for me to eat, that I may bless you, with the Lord's approval, before I die.' Now, my son, listen carefully as I instruct you. Go to the flock and fetch me two choice kids, and I will make of them a dish for your father, such as he likes. Then take it to your father to eat, in order that he may bless you before he dies." Jacob answered his mother Rebekah, "But my brother Esau is a hairy man and I am smooth-skinned. If my father touches me, I shall appear to him as a trickster and bring upon myself a curse, not a blessing." But his mother said to him, "Your curse, my son, be upon me! Just do as I say and go fetch them for me." ... Rebekah then took the best clothes of her older son Esau, which were there in the house, and had her younger son Jacob put them on; and she covered his hands and the hairless part of his neck with the skins of the kids. Then she put in the hands of her son Jacob the dish and the bread that she had prepared. He went to his father and said, "Father." And he said, "Yes, which of my sons are you?" Jacob said to his father, "I am Esau, your first-born; I have done as you told me. Pray sit up and eat of my game, that you may give me your innermost blessing." ... So Jacob drew close to his father Isaac, who felt him and wondered. "The voice is the voice of Jacob, yet the hands are the hands of Esau." He did not recognize him, because his hands were hairy like those of his brother Esau; and so he blessed him. No sooner had Jacob left the presence of his father Isaac—after Isaac had finished blessing Jacob—than his brother Esau came back from his hunt. He too prepared a dish and brought it to his father. And he said to his father, "Let my father sit up and eat of his son's game, so that you may give me your innermost blessing." His father Isaac said to him, "Who are you?" And he said, "I am your son, Esau, your first-born!" Isaac was seized with very violent trembling. "Who was it then," he demanded, "that hunted game and brought it to me? Moreover, I ate of it before you came, and I blessed him; now he must remain blessed!" When Esau heard his father's words, he burst into wild and bitter sobbing, and said to his father, "Bless me too, Father!" But he answered, "Your brother came with guile and took away your blessing." ... And Esau said to his father,

"Have you but one blessing, Father? Bless me too, Father!" And Esau wept aloud ... Now Esau harbored a grudge against Jacob because of the blessing which his father had given him, and Esau said to himself, "Let but the mourning period of my father come, and I will kill my brother Jacob." When the words of her older son Esau were reported to Rebekah, she sent for her younger son Jacob and said to him, "Your brother Esau is consoling himself by planning to kill you. Now, my son, listen to me. Flee at once to Haran, to my brother Laban ..." Rebekah said to Isaac, "I am disgusted with my life because of the Hittite women. If Jacob marries a Hittite woman like these, from among the native women, what good will life be to me?" So Isaac sent for Jacob and blessed him. He instructed him, saying, "You shall not take a wife from among the Canaanite women ..." Then Isaac sent Jacob off, and he went to Paddan-aram, to Laban the son of Bethuel the Aramean, the brother of Rebekah, mother of Jacob and Esau ... So Esau went to Ishmael and took to wife, in addition to the wives he had, Mahalath the daughter of Ishmael son of Abraham, sister of Nebaioth. (Gen. 26.34–28.9)

Haftarat Toledot

(Malachi 1.1–2.7)

A pronouncement: The word of the Lord to Israel through Malachi. I have shown you love, said the Lord. But you ask, "How have You shown us love?" After all—declares the Lord—Esau is Jacob's brother; yet I have accepted Jacob and have rejected Esau. I have made his hills a desolation, his territory a home for beasts of the desert. If Edom thinks, "Though crushed, we can build the ruins again," thus said the Lord of Hosts: They may build, but I will tear down. And so they shall be known as the region of wickedness, the people damned forever of the Lord. Your eyes shall behold it, and you shall declare, "Great is the Lord beyond the borders of Israel!" A son should honor his father, and a slave his master. Now if I am a father, where is the honor due Me? And if I am a master, where is the reverence due Me?— said the Lord of Hosts to you, O priests who scorn My name. But you ask, "How have we scorned Your name?" You offer defiled food on My altar. But you ask, "How have we defiled You?" By saying, "The table of the Lord can be treated with scorn." When you present a blind animal for sacrifice—it doesn't matter! When you present a lame or sick one—it doesn't matter! Just offer it to your governor: Will he accept you? Will he show you favor?—said the Lord of Hosts. And now implore the favor of God! Will He be gracious to us? This is what you have done—will He accept any of you? (Mal. 1.1–9)

In the desert, Jacob dreamed of a ladder stretching between heaven and earth, with angels going up and down. In his dream, God promised to bless him with many descendants and divine favor. Jacob named this place Bethel. Arriving in Haran, Jacob met his cousin Rachel at the well, and asked his uncle Laban for his daughter Rachel's hand. Laban demanded seven years of service from Jacob, but when the time was up, he tricked Jacob, marrying him instead to Rachel's older sister Leah. Jacob worked another seven years for Rachel. Rachel remained barren, but Leah bore Jacob six sons and a daughter. Bilhah, Rachel's handmaid, and Zilpah, Leah's handmaid, each bore Jacob two sons on their mistresses' behalf. Then Rachel gave birth to a son, Joseph. Finally, after twenty years away from home, Jacob left for Canaan with his wives, eleven sons, and one daughter.

Jacob left Beer-sheba, and set out for Haran.
(Gen. 28.10)

ויצא יעקב מבאר שבע וילך חרנה:

He came upon a certain place and stopped there for the night ... He had a dream; a stairway was set on the ground and its top reached to the sky, and angels of God were going up and down on it. And the Lord was standing beside him and He said, "I am the Lord, the God of your father Abraham and the God of Isaac: the ground on which you are lying I will assign to you and to your offspring. Your descendants shall be as the dust of the earth; you shall spread out to the west and to the east, to the north and to the south. All the families of the earth shall bless themselves by you and your descendants.

Remember, I am with you: I will protect you wherever you go and will bring you back to this land. I will not leave you until I have done what I have promised you." ... Jacob resumed his journey and came to the land of the Easterners. (Gen. 28.11–29.1)

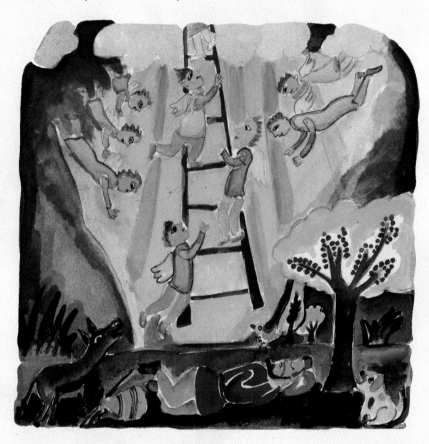

There before his eyes was a well in the open. Three flocks of sheep were lying there beside it, for the flocks were watered from that well ... Rachel came with her father's flock; for she was a shepherdess. And when Jacob saw Rachel, the daughter of his uncle Laban, and the flock of his uncle Laban, Jacob went up and rolled the stone off the mouth of the well, and watered the flock of his uncle Laban. Then Jacob kissed Rachel, and broke into tears. Jacob told Rachel that he was her father's kinsman, that he was Rebekah's son; and she ran and told her father. On hearing the news of his sister's son Jacob, Laban ran

to greet him; he embraced him and kissed him, and took him into his house ... When he had stayed with him a month's time, Laban said to Jacob, "Just because you are a kinsman, should you serve me for nothing? Tell me, what shall your wages be?" Now Laban had

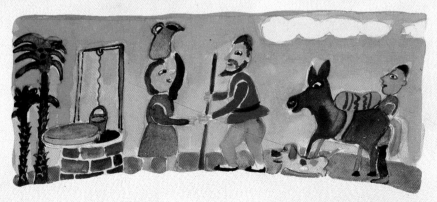

two daughters; the name of the older one was Leah, and the name of the younger was Rachel. Leah had weak eyes; Rachel was shapely and beautiful. Jacob loved Rachel; so he answered, "I will serve you seven years for your younger daughter Rachel." Laban said, "Better that I give her to you than that I should give her to an outsider. Stay with me." So Jacob served seven years for Rachel and they seemed to him but a few days because of his love for her. Then Jacob said to Laban, "Give me my wife, for my time is fulfilled ..." And Laban gathered all the people of the place and made a feast. When evening came, he took his daughter Leah and brought her to him; and he cohabited with her ... When morning came, there was Leah! So he said to Laban, "What is this you have done to me? I was in your service for Rachel! Why did you deceive me?" Laban said, "It is not the practice in our place to marry off the younger before the older. Wait until the bridal week of this one is over and we will give you that one too, provided you serve me another seven years." Jacob did so ... And Jacob cohabited with Rachel also; indeed, he loved Rachel more than Leah. And he served him another seven years. (Gen. 29.2–30)

The Lord saw that Leah was unloved and he opened her womb; but Rachel was barren. Leah conceived and bore a son, and named him Reuben ... She conceived again and bore a son ... She named him Simeon. Again she conceived and bore a son and ... He was named Levi. She conceived again and bore a son, and ... She named him Judah. Then she stopped bearing. When Rachel saw that she had borne Jacob no children, she became envious of her sister; and Rachel said to Jacob, "Give me children, or I shall die." Jacob was incensed at Rachel, and said, "Can I take the place of God, who has denied you fruit of the womb?" She said, "Here is my maid Bilhah. Consort with her, that she may bear on my knees and that through her I too may have children." ... Bilhah conceived and bore Jacob a son. And Rachel ... Named him Dan. Rachel's maid Bilhah conceived again and bore Jacob a second son. And Rachel ... Named him Naphtali. When Leah saw that she had stopped bearing, she took her maid Zilpah and gave her to Jacob as concubine. And when Leah's maid Zilpah bore Jacob a son ... Leah ... named him Gad. When Leah's maid Zilpah bore Jacob a second son, Leah ... Named him Asher ... When Jacob came home from the field in the evening, Leah went out to meet him and said, "You are to sleep with me" ... And he lay with her that night ... And she conceived and bore him a fifth son. And Leah ... Named him Issachar. When Leah conceived again and bore Jacob a sixth son, Leah ... Named him Zebulun. Last, she bore him a daughter, and named her Dinah. Now God remembered Rachel; God heeded her and opened her womb. She conceived and bore a son, and ... Named him Joseph, which is to say, "May the Lord add another son for me." (Gen. 29.31–30.24)

BERESHIT

Vayetze

After Rachel had borne Joseph, Jacob said to Laban, "Give me leave to go back to my own homeland. Give me my wives and my children, for whom I have served you, that I may go ..." But Laban said to him ... "What shall I pay you?" And Jacob said, "Pay me nothing! If you will do this thing for me, I will again pasture and keep your flocks: let me pass through your whole flock today, removing from there every speckled and spotted animal—every dark-colored sheep and every spotted and speckled goat. Such shall be my wages. In the future when you go over my wages, let my honesty toward you testify for me: if there are among my goats any that are not speckled or spotted or any sheep that are not dark-colored, they got there by theft." And Laban said, "Very well, let it be as you say." But that same day he removed the streaked and spotted he-goats and all the speckled and spotted she-goats—every one that had white on it—and all the dark-colored sheep, and left them in the charge of his sons. And he put a distance of three days' journey between himself and Jacob, while Jacob was pasturing the rest of Laban's flock. Jacob then got fresh shoots of poplar, and of almond and plane, and peeled white stripes in them, laying bare the white of the shoots. The rods that he had peeled he set up in front of the goats in the troughs, the water receptacles, that the goats came to drink from. Their mating occurred when they came to drink, and since the goats mated by the rods, the goats brought forth streaked, speckled, and spotted young. But Jacob dealt separately with the sheep; he made these animals face the streaked or wholly dark-colored animals in Laban's flock. And so he produced special flocks for himself, which he did not put with Laban's flocks. Moreover, when the sturdier animals were mating, Jacob would place the rods in the troughs, in full view of the animals, so that they mated by the rods; but with the feebler animals he would not place them there. Thus the feeble ones went to Laban and the sturdy to Jacob. So the man grew exceedingly prosperous, and came to own large flocks, maidservants and menservants, camels and asses. (Gen. 30.25–43)

Now he heard the things that Laban's sons were saying: "Jacob has taken all that was our father's, and from that which was our father's he has built up all this wealth." Jacob also saw that Laban's manner toward him was not as it had been in the past. Then the Lord said to Jacob, "Return to the land of your fathers where you were born, and I will be with you." ... "Once, at the mating time of the flocks, I had a dream in which I saw that the he-goats mating with the flock were streaked, speckled, and mottled. And in the dream an angel of God said to me, 'Jacob!' 'Here,' I answered. And he said, 'Note well that all the he-goats which are mating with the flock are streaked, speckled, and mottled; for I have noted all that Laban has been doing to you ...'" Then Rachel and Leah answered him, saying, "Have we still a share in the inheritance of our father's house? Surely, he regards us as outsiders, now that he has sold us and has used up our purchase price. Truly, all the wealth that God has taken away from our father belongs to us and to our children. Now then, do just as God has told you." Thereupon Jacob put his children and wives on camels; and he drove off all his livestock and all the wealth that he had amassed ... To go to

his father Isaac in the land of Canaan.
Meanwhile Laban had gone to shear his
sheep, and Rachel stole her father's
household idols ... On the third day, Laban
was told that Jacob had fled. So he took his
kinsmen with him and pursued him a
distance of seven days, catching up with
him in the hill country of Gilead. But God
appeared to Laban the Aramean in a dream
by night and said to him, "Beware of
attempting anything with Jacob, good or
bad." ... "Why did you flee in secrecy and
mislead me and not tell me? I would have
sent you off with festive music, with
timbrel and lyre. You did not even let me

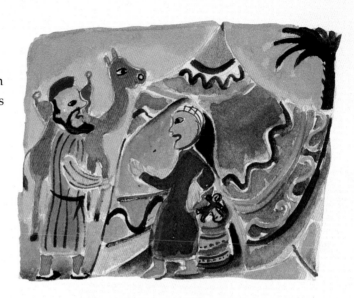

kiss my sons and daughters good-by! It was a foolish thing for you to do. I have it in my power to do
you harm; but the God of your father said to me last night, 'Beware of attempting anything with Jacob,
good or bad.' Very well, you had to leave because you were longing for your father's house; but why
did you steal my gods?" (Gen. 31.1–30)

Jacob answered Laban, saying, "I was afraid because I thought you would take your daughters from
me by force. But anyone with whom you find your gods shall not remain alive! In the presence of our
kinsmen, point out what I have of yours and take it." Jacob, of course, did not know that Rachel had
stolen them. So Laban went into Jacob's tent and Leah's tent and the tents of the two maidservants; but
he did not find them. Leaving Leah's tent, he entered Rachel's tent. Rachel, meanwhile,
had taken the idols and placed them in the camel cushion and sat on
them; and Laban rummaged through the tent without finding
them. For she said to her father, "Let not my lord take it

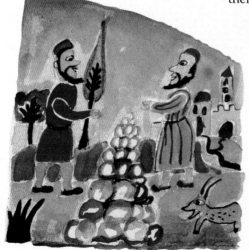

amiss that I cannot rise before you, for the period of
women is upon me." Thus he searched, but could not
find the household idols ... Then Laban spoke up and
said to Jacob, "The daughters are my daughters, the
children are my children, and the flocks are my flocks;
all that you see is mine. Yet what can I do now about my
daughters or the children they have borne? Come, then,
let us make a pact, you and I, that there may be a witness
between you and me." ... And Laban declared, "This
mound is a witness between you and me this day." That
is why it was named Gal-ed. (Gen. 31.31–48)

Haftarat Vayetze

(Ashkenazim read Hosea 12.13–14.10)

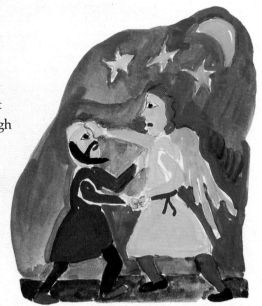

Then Jacob had to flee to the land of Aram; there Israel served for a wife, for a wife he had to guard [sheep]. But when the Lord brought Israel up from Egypt, it was through a prophet; through a prophet they were guarded. Ephraim gave bitter offense, and his Lord cast his crimes upon him and requited him for his mockery. When Ephraim spoke piety, he was exalted in Israel; but he incurred guilt through Baal, and so he died. And now they go on sinning; they have made them molten images, idols, by their skill, from their silver, wholly the work of craftsmen. Yet for these they appoint men to sacrifice; they are wont to kiss calves! (Hosea 12.13–13.2)

(Sephardim read Hosea 11.7–12.12)

For My people persists in its defection from Me; when it is summoned upward, it does not rise at all. How can I give you up, O Ephraim? How surrender you, O Israel? How can I make you like Admah, render you like Zeboiim? I have had a change of heart, all My tenderness is stirred. I will not act on My wrath, will not turn to destroy Ephraim. For I am God, not man, the Holy One in your midst: I will not come in fury. The Lord will roar like a lion, and they shall march behind Him; when He roars, His children shall come fluttering out of the west. They shall flutter from Egypt like sparrows, from the land of Assyria like doves; and I will settle them in their homes—declares the Lord. (Hosea 11.7–11)

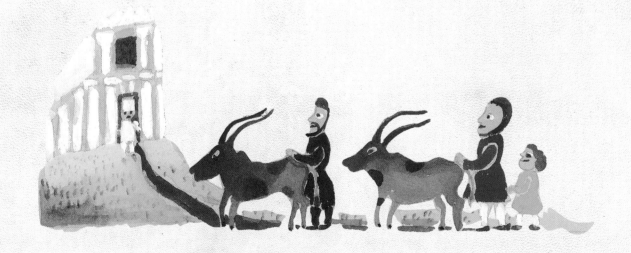

Vayishlach 32.4–36.43

The night before meeting his brother Esau after an absence of twenty years, Jacob struggled with a divine being and wrested from him a new name, Israel, Yisra'el, Struggler with God. The next day Esau and Jacob met and reconciled. Soon after they settled in Canaan, Jacob's only daughter Dinah was raped by a local chieftain Shechem, and Dinah's brothers took revenge by massacring all the men in the city of Shechem. Some time after this, Rachel gave birth to a second son, Benjamin, but she died in childbirth, and Jacob buried her there on the road to Bethlehem. Then Isaac died, and Jacob and Esau buried him.

וישלח יעקב מלאכים לפניו אל עשו אחיו ארצה שעיר שדה אדום:

Jacob sent messengers ahead to his brother Esau in the land of Seir, the country of Edom.... (Gen. 32.4)

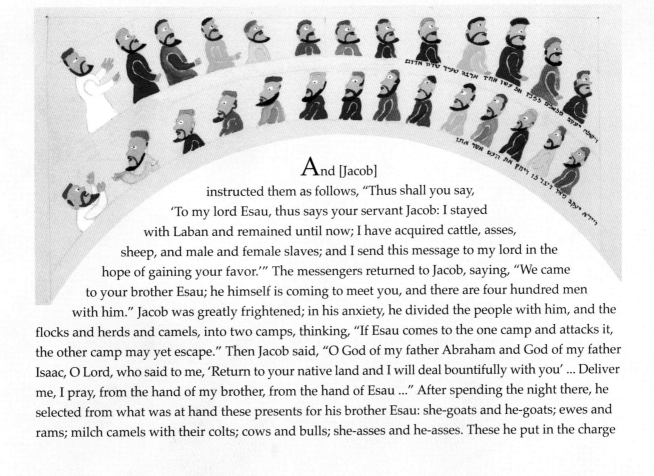

And [Jacob]
instructed them as follows, "Thus shall you say,
'To my lord Esau, thus says your servant Jacob: I stayed
with Laban and remained until now; I have acquired cattle, asses,
sheep, and male and female slaves; and I send this message to my lord in the
hope of gaining your favor.'" The messengers returned to Jacob, saying, "We came
to your brother Esau; he himself is coming to meet you, and there are four hundred men
with him." Jacob was greatly frightened; in his anxiety, he divided the people with him, and the
flocks and herds and camels, into two camps, thinking, "If Esau comes to the one camp and attacks it,
the other camp may yet escape." Then Jacob said, "O God of my father Abraham and God of my father
Isaac, O Lord, who said to me, 'Return to your native land and I will deal bountifully with you' ... Deliver
me, I pray, from the hand of my brother, from the hand of Esau ..." After spending the night there, he
selected from what was at hand these presents for his brother Esau: she-goats and he-goats; ewes and
rams; milch camels with their colts; cows and bulls; she-asses and he-asses. These he put in the charge

Vayishlach

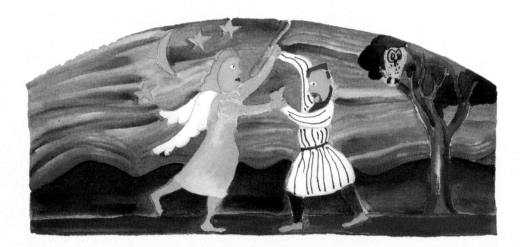

of his servants ... He instructed the one in front as follows, "When my brother Esau meets you and asks you, 'Whose man are you? Where are you going? And whose [animals] are these ahead of you?' you shall answer, 'Your servant Jacob's; they are a gift sent to my lord Esau; and [Jacob] himself is right behind us.'" He gave similar instructions to the second one, and the third, and all the others who followed the drove ... And so the gift went on ahead, while he remained in camp that night. (Gen. 32.5–22)

That same night he arose, and taking his two wives, his two maidservants, and his eleven children, he crossed the ford of the Jabbok. After taking them across the stream, he sent across all his possessions. Jacob was left alone. And a man wrestled with him until the break of dawn. When he saw that he had not prevailed against him, he wrenched Jacob's hip at its socket, so that the socket of his hip was strained as he wrestled with him. Then he said, "Let me go, for dawn is breaking." But he answered, "I will not let you go, unless you bless me." Said the other, "What is your name?" He replied, "Jacob." Said he, "Your name shall no longer be Jacob, but Israel, for you have striven with beings divine and human, and have prevailed." Jacob asked, "Pray tell me your name." But he said, "You must not ask my name!" And he took leave of him there. So Jacob named the place Peniel, meaning, "I have seen a divine being face to face, yet my life has been preserved." The sun rose upon him as he passed Penuel, limping on his hip. That is why the children of Israel to this day do not eat the thigh muscle that is on the socket of the hip, since Jacob's hip socket was wrenched at the thigh muscle. Looking up, Jacob saw Esau coming, accompanied by four hundred men. He divided the children among Leah, Rachel, and the two maids ... He himself went on ahead and bowed low to the ground seven times until he was near his brother. Esau ran to greet him. He embraced him and, falling on his neck, he kissed him; and they wept ... Jacob said ...

"Please accept my present which has been brought to you, for God has favored me and I have plenty." And when he urged him, he accepted ... Jacob arrived safe in the city of Shechem which is in the land of Canaan. (Gen. 32.23–33.18)

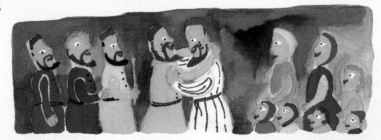

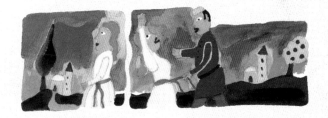

Now Dinah, the daughter whom Leah had borne to Jacob, went out to visit the daughters of the land. Shechem son of Hamor the Hivite, chief of the country, saw her, and took her and lay with her by force. Being strongly drawn to Dinah daughter of Jacob, and in love with the maiden, he spoke to the maiden tenderly. So Shechem said to his father Hamor, "Get me this girl as a wife." Jacob heard that he had defiled his daughter Dinah; but since his sons were in the field with his cattle, Jacob kept silent until they came home. Then Shechem's father Hamor came out to Jacob to speak to him. Meanwhile Jacob's sons, having heard the news, came in from the field. The men were distressed and very angry, because he had committed an outrage in Israel by lying with Jacob's daughter—a thing not to be done. And Hamor spoke with them, saying, "My son Shechem longs for your daughter. Please give her to him in marriage …" Jacob's sons answered Shechem and his father Hamor—speaking with guile because he had defiled their sister Dinah—and said to them, "We cannot do this thing, to give our sister to a man who is uncircumcised, for that is a disgrace among us. Only on this condition will we agree with you; that you will become like us in that every male among you is circumcised. Then we will give our daughters to you and take your daughters to ourselves; and we will dwell among you and become as one kindred. But if you will not listen to us and become circumcised, we will take our daughter and go." Their words pleased Hamor and Hamor's son Shechem. And the youth lost no time in doing

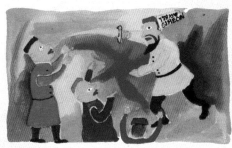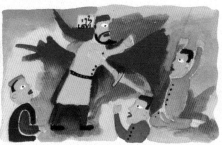

the thing, for he wanted Jacob's daughter. Now he was the most respected in his father's house. So Hamor and his son Shechem went to the public place of their town and spoke to their fellow townsmen, saying, "These people are our friends; let them settle in the land and move about in it, for the land is large enough for them; we will take their daughters to ourselves as wives and give our daughters to them …" All who went out of the gate of his town heeded Hamor and his son Shechem, and all males, all those who went out of the gate of his town, were circumcised. On the third day, when they were in pain, Simeon and Levi, two of Jacob's sons, brothers of Dinah, took each his sword, came upon the city unmolested, and slew all the males. They put Hamor and his son Shechem to the sword, took Dinah out of Shechem's house, and went away. The other sons of Jacob came upon the slain and plundered the town, because their sister had been defiled. They seized their flocks and herds and asses, all that was inside the town and outside; all their wealth, all their children, and their wives, all that was in the houses, they took as captives and booty. Jacob said to Simeon and Levi, "You have brought trouble on me, making me odious among the inhabitants of the land, the Canaanites and the Perizzites; my men are few in number, so that if they unite against me and attack me, I and my house will be destroyed." But they answered, "Should our sister be treated like a whore?" (Gen. 34.1–31)

God said to Jacob, "Arise, go up to Bethel and remain there; and build an altar there to the God who appeared to you when you were fleeing from your brother Esau." ... God appeared again to Jacob on his arrival from Paddan-aram, and He blessed him. God said to him, "You whose name is Jacob, you shall be called Jacob no more, but Israel shall be your name." Thus He named him Israel. And God said to him, "I am El Shaddai. Be fertile and increase; a nation, yea an assembly of nations, shall descend from you ..." They set out from Bethel; but when they were still some distance short of Ephrath, Rachel was in childbirth, and she had hard labor. When her labor was at its hardest, the midwife said to her, "Have no fear, for it is another boy for you." But as she breathed her last—for she was dying—she named him Ben-oni; but his father called him Benjamin. Thus Rachel died. She was buried on the road to Ephrath ... And Jacob came to his father Isaac at Mamre, at Kiriath-arba—now Hebron—where Abraham and Isaac had sojourned. Isaac was a hundred and eighty years old when he breathed his last and died. He was gathered to his kin in ripe old age; and he was buried by his sons Esau and Jacob. (Gen. 35.1–29)

Haftarat Vayishlach

(Ashkenazim read Hosea 11.7–12.12)

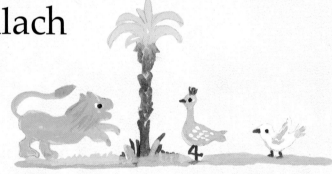

For My people persists in its defection from Me; when it is summoned upward, it does not rise at all. How can I give you up, O Ephraim? How surrender you, O Israel? How can I make you like Admah, render you like Zeboiim? I have had a change of heart, all My tenderness is stirred. I will not act on My wrath, will not turn to destroy Ephraim. For I am God, not man, the Holy One in your midst: I will not come in fury ... The Lord will roar like a lion, and they shall march behind Him; when He roars, His children shall come fluttering out of the west. They shall flutter from Egypt like sparrows, from the land of Assyria like doves; and I will settle them in their homes—declares the Lord. (Hos. 11.7–11)

(Sephardim read Obadiah 1.1–21)

The prophecy of Obadiah. We have received tidings from the Lord, and an envoy has been sent out among the nations: "Up! Let us rise up against her for battle." Thus said my Lord God concerning Edom:

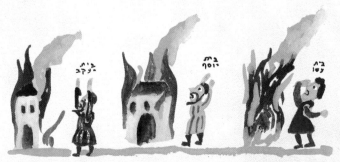

I will make you least among nations, you shall be most despised ... The House of Jacob shall be fire, and the House of Joseph flame, and the House of Esau shall be straw; they shall burn it and devour it, and no survivor shall be left of the House of Esau—for the Lord has spoken. (Obad. 1.1–18)

Jacob favored Joseph above all his sons, and made him a coat of many colors. Jacob had dreams in which his brothers and parents bowed down to him, and when he told his brothers, they hated him. Plotting to kill him, they threw him into a pit and stained his coat of many colors with sheep's blood. They then sold him to a caravan of Ishmaelites, who carried him down to Egypt and sold him to Potiphar, one of Pharaoh's courtiers. Jacob bitterly mourned Joseph's death. Falsely accused by Potiphar's wife, Joseph was thrown into prison where he became overseer of all the prisoners. When his fellow prisoners, Pharaoh's chief baker and cupbearer, told him their dreams, he predicted death for the one and freedom for the other. But the cupbearer forgot about Joseph when he regained his freedom.

וישב יעקב בארץ מגורי אביו בארץ כנען:

Now Jacob was settled in the land where his father had sojourned, the land of Canaan. (Gen. 37.1)

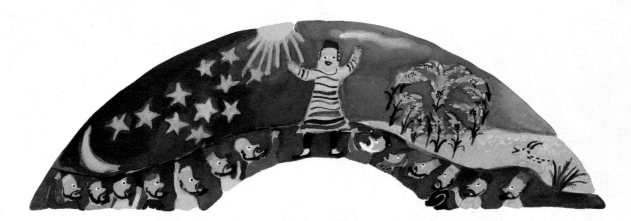

At seventeen years of age, Joseph tended the flocks with his brothers, as a helper to the sons of his father's wives Bilhah and Zilpah. And Joseph brought bad reports of them to their father. Now Israel loved Joseph best of all his sons, for he was the child of his old age; and he had made him an ornamented tunic. And when his brothers saw that their father loved him more than any of his brothers, they hated him so that they could not speak a friendly word to him. Once Joseph had a dream which he told to his brothers; and they hated him even more. He said to them, "Hear this dream which I have dreamed:

BERESHIT

Vayeshev

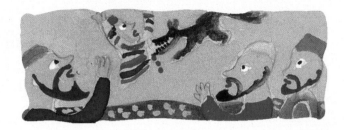

There we were binding sheaves in the field, when suddenly my sheaf stood up and remained upright; then your sheaves gathered around and bowed low to my sheaf." His brothers answered, "Do you mean to reign over us? Do you mean to rule over us?" And they hated him even more for his talk about his dreams. He dreamed another dream and told it to his brothers, saying, "Look, I have had another dream: And this time, the sun, the moon, and eleven stars were bowing down to me." And when he told it to his father and brothers, his father berated him. "What," he said to him, "is this dream you have dreamed? Are we to come, I and your mother and your brothers, and bow low to you to the ground?" So his brothers were wrought up at him, and his father kept the matter in mind ... So Joseph followed his brothers and found them at Dothan. They saw him from afar, and before he came close to them they conspired to kill him. They said to one another, "Here comes that dreamer! Come now, let us kill him and throw him into one of the pits; and we can say, 'A savage beast devoured him.' We shall see what comes of his dreams!" But when Reuben heard it, he tried to save him from them. He said, "Let us not take his life." And Reuben went on, "Shed no blood! Cast him into that pit out in the wilderness, but do not touch him yourselves" ... When Joseph came up to his brothers, they stripped Joseph of his tunic, the ornamented tunic that he was wearing, and took him and cast him into the pit. The pit was empty; there was no water in it. Then they sat down to a meal. Looking up, they saw a caravan of Ishmaelites coming from Gilead, their camels bearing gum, balm, and ladanum to be taken to Egypt. Then Judah said to his brothers, "What do we 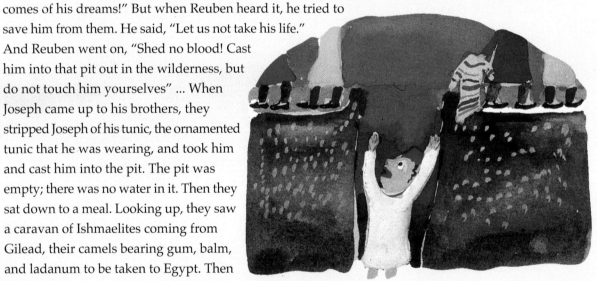 gain by killing our brother and covering up his blood? Come, let us sell him to the Ishmaelites ..." His brothers agreed. When Midianite traders passed by, they pulled Joseph up out of the pit. They sold Joseph for twenty pieces of silver to the Ishmaelites, who brought Joseph to Egypt. When Reuben returned to the pit and saw that Joseph was not in the pit, he rent his clothes. Returning to his brothers, he said, "The boy is gone! Now, what am I to do?" Then they took Joseph's tunic, slaughtered a kid, and dipped the tunic in the blood. They had the ornamented tunic taken to their father, and they said, "We found this. Please examine it; is it your son's tunic or not?" He recognized it, and said, "My son's tunic! A savage beast devoured him! Joseph was torn by a beast!" Jacob rent his clothes, put sackcloth on his

loins, and observed mourning for his son many days. All his sons and daughters sought to comfort him; but he refused to be comforted ... The Midianites, meanwhile, sold him in Egypt to Potiphar, a courtier of Pharaoh and his chief steward. (Gen. 37.2–36)

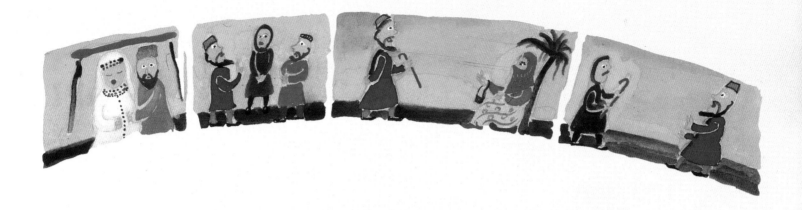

About that time Judah left his brothers and camped near a certain Adullamite whose name was Hirah. There Judah saw the daughter of a certain Canaanite whose name was Shua, and he married her and cohabited with her. She conceived and bore a son, and he named him Er. She conceived again and bore a son, and named him Onan. Once again she bore a son, and named him Shelah ... Judah got a wife for Er his first-born; her name was Tamar. But Er, Judah's first-born, was displeasing to the Lord, and the Lord took his life. Then Judah said to Onan, "Join with your brother's wife and do your duty by her as a brother-in-law, and provide offspring for your brother." But Onan, knowing that the seed would not count as his, let it go to waste whenever he joined with his brother's wife, so as not to provide offspring for his brother. What he did was displeasing to the Lord, and He took his life also. Then Judah said to his daughter-in-law Tamar, "Stay as a widow in your father's house until my son Shelah grows up." (Gen. 38.1–11)

Afterward, Shua's daughter, the wife of Judah, died. When his period of mourning was over, Judah went up to Timnah to his sheepshearers, together with his friend Hirah the Adullamite. And Tamar was told, "Your father-in-law is coming up to Timnah for the sheepshearing." So she took off her widow's garb, covered her face with a veil, and, wrapping herself up, sat down at the entrance to Enaim, which is on the road to Timnah; for she saw that Shelah was grown up, yet she had not been given to him as wife. When Judah saw her, he took her for a harlot; for she had covered her face. So he turned aside to her by the road and said, "Here, let me sleep with you"—for he did not know that she was his daughter-in-law. "What," she asked, "will you pay for sleeping with me?" He replied, "I will send a kid from my flock." But she said, "You must leave a pledge until you have sent it." And he said, "What pledge shall I give you?" She replied, "Your seal and cord, and the staff which you carry." So he gave them to her and slept with her, and she conceived by him. Then she went on her way. She took off her veil and again put on her widow's garb. (Gen. 38.12–19)

About three months later, Judah was told, "Your daughter-in-law Tamar has played the harlot; in fact, she is with child by harlotry." "Bring her out," said Judah, "and let her be burned." As she was being brought out, she sent this message to her father-in-law, "I am with child by the man to whom these belong." And she added, "Examine these: whose seal and cord and staff are these?" Judah recognized them, and said, "She is more in the right than I, inasmuch as I did not give her to my son Shelah. And he was not intimate with her again. (Gen. 38.24–26)

BERESHIT

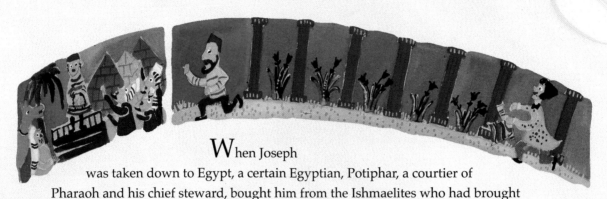

When Joseph was taken down to Egypt, a certain Egyptian, Potiphar, a courtier of Pharaoh and his chief steward, bought him from the Ishmaelites who had brought him there. The Lord was with Joseph, and he was a successful man; and he stayed in the house of his Egyptian master ... And from the time that the Egyptian put him in charge of his household and of all that he owned, the Lord blessed his house for Joseph's sake, so that the blessing of the Lord was upon everything that he owned, in the house and outside ... After a time, his master's wife cast her eyes upon Joseph and said, "Lie with me." But he refused. He said to his master's wife, "Look, with me here, my master gives no thought to anything in this house, and all that he owns he has placed in my hands. He wields no more authority in this house than I, and he has withheld nothing from me except yourself, since you are his wife. How then could I do this most wicked thing, and sin before God?" And much as she coaxed Joseph day after day, he did not yield to her request to lie beside her, to be with her. One such day ... She caught hold of him by his garment and said, "Lie with me!" But he left his garment in her hand and got away and fled outside... She called out to her servants and said to them, "Look, he had to bring us a Hebrew to dally with us! This one came to lie with me; but I screamed loud. And when he heard me screaming at the top of my voice, he left his garment with me and got away and fled outside." ... When his master heard the story that his wife told him, namely, "Thus and so your slave did to me," he was furious. So Joseph's master had him put in prison, where the king's prisoners were confined. But even while he was there in prison, the Lord was with Joseph: He extended kindness to him and disposed the chief jailer favorably toward him. (Gen. 39.1–21)

Some time later, the cupbearer and the baker of the king of Egypt gave offense to their lord the king of Egypt. Pharaoh was angry with his two courtiers, the chief cupbearer and the chief baker, and put them in custody, in the house of the chief steward, in the same prison house where Joseph was confined ... The cupbearer and the baker ... Dreamed in the same night, each his own dream and each dream with its own meaning. When Joseph came to them in the morning, he saw that they were distraught. He asked Pharaoh's courtiers, who were with him in custody in his master's house, saying, "Why do you appear downcast today?" And they said to him, "We had dreams, and there is no one to interpret them." So Joseph said to them, "Surely God can interpret! Tell me your dreams." Then the chief cupbearer told his dream to Joseph. He said to him, "In my dream, there was a vine in front of me. On the vine were three

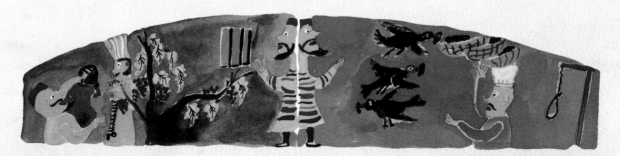

branches. It had barely budded, when out came its blossoms and its clusters ripened into grapes. Pharaoh's cup was in my hand, and I took the grapes, pressed them into Pharaoh's cup, and placed the cup in Pharaoh's hand." Joseph said to him, "This is its interpretation: The three branches are three days. In three days Pharaoh will pardon you and restore you to your post; you will place Pharaoh's cup in his hand, as was your custom formerly when you were his cupbearer. But think of me when all is well with you again, and do me the kindness of mentioning me to Pharaoh, so as to free me from this place ... When the chief baker saw how favorably he had interpreted, he said to Joseph, "In my dream, similarly, there were three openwork baskets on my head. In the uppermost basket were all kinds of food for Pharaoh that a baker prepares; and the birds were eating it out of the basket above my head." Joseph answered, "This is its interpretation: The three baskets are three days. In three days Pharaoh will lift off your head and impale you upon a pole; and the birds will pick off your flesh." On the third day—his birthday— Pharaoh made a banquet for all his officials, and he singled out his chief cupbearer and his chief baker from among his officials. He restored the chief cupbearer to his cupbearing, and he placed the cup in Pharaoh's hand; but the chief baker he impaled—just as Joseph had interpreted to them. (Gen. 40.1–22)

Haftarat Vayeshev

(Amos 2.6–3.8)

Thus said the Lord: for three transgressions of Israel, for four, I will not revoke it: because they have sold for silver those whose cause was just, and the needy for a pair of sandals. [Ah], you who trample the heads of the poor into the dust of the ground, and make the humble walk a twisted course! Father and son go to the same girl, and thereby profane My holy name. They recline by every altar on garments taken in pledge, and drink in the House of their God wine bought with fines they imposed. (Amos 2.6–8)

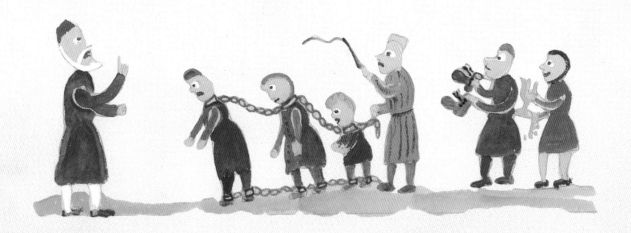

BERESHIT

*P*haraoh had two disturbing dreams: in the first, seven healthy cows swallowed up seven sickly cows. In the second dream, seven sickly ears of corn swallowed up seven healthy ones. No one in Pharaoh's court could interpret his dreams. At his cupbearer's urging, Pharaoh then summoned Joseph from prison. Joseph told Pharaoh that the seven healthy cows and ears were seven years of plenty; the seven sickly cows and ears, seven years of famine. He advised him to store up seven years of harvests against the coming famine. Pharaoh put Joseph in charge of this plan, making him viceroy of Egypt. In Canaan, the famine forced Jacob to send his ten older sons to Egypt for food, but he refused to send his youngest son, Benjamin. Joseph recognized his brothers, but they did not recognize him. To test them, he demanded that they bring Benjamin to him. Joseph then had Benjamin falsely accused as a thief.

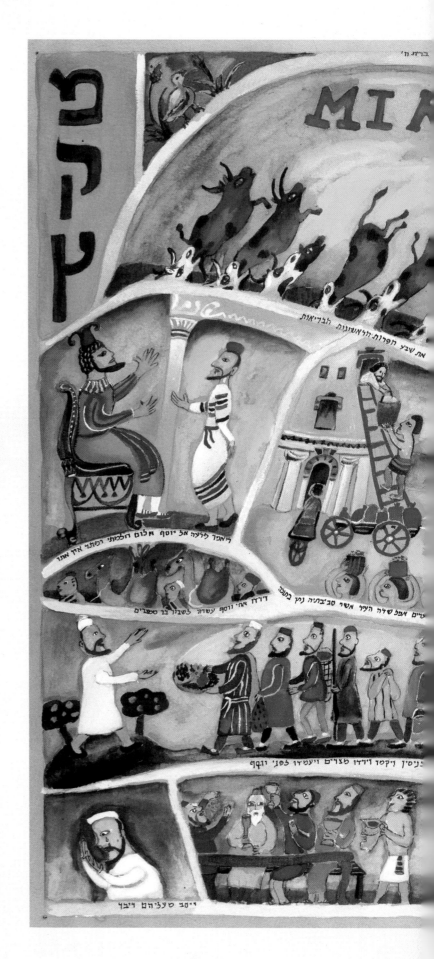

ויהי מקץ שנתים ימים ופרעה חלם
והנה עמד על היאר: והנה מן היאר
עלת שבע פרות יפות מראה ובריאת
בשר ותרעינה באחו:

*A*fter two years' time, Pharaoh dreamed that he was standing by the Nile, when out of the Nile there came up seven cows, handsome and sturdy, and they grazed in the reed grass. (Gen. 41.1–2)

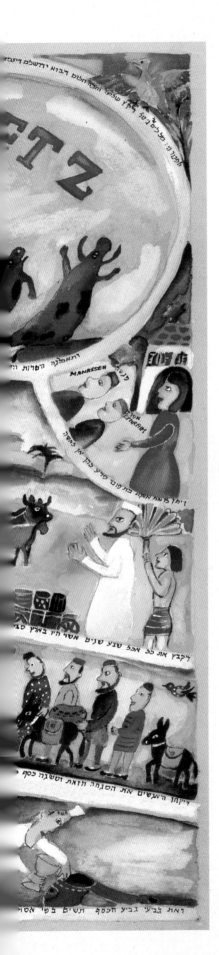

But presently, seven other cows came up from the Nile close behind them, ugly and gaunt, and stood beside the cows on the bank of the Nile; and the ugly gaunt cows ate up the seven handsome sturdy cows. And Pharaoh awoke. He fell asleep and dreamed a second time: Seven ears of grain, solid and healthy, grew on a single stalk. But close behind them sprouted seven ears, thin and scorched by the east wind. And the thin ears swallowed up the seven solid and full ears. Then Pharaoh awoke: it was a dream! Next morning, his spirit was agitated, and he sent for all the magicians of Egypt, and all its wise men; and Pharaoh told them his dreams, but none could interpret them for Pharaoh. The chief cupbearer then spoke up and said to Pharaoh, "I must make mention today of my offenses. Once Pharaoh was angry with his servants, and placed me in custody in the house of the chief steward, together with the chief baker. We had dreams the same night, he and I, each of us a dream with a meaning of its own. A Hebrew youth was there with us, a servant of the chief steward; and when we told him our dreams, he interpreted them for us, telling each of the meaning of his dream. And as he interpreted for us, so it came to pass: I was restored to my post, and the other was impaled." ... And Pharaoh said to Joseph, "I have had a dream, but no one can interpret it. Now I have heard it said of you that for you to hear a dream is to tell its meaning." Joseph answered Pharaoh, saying, "Not I! God will see to Pharaoh's welfare." ... And Joseph said to Pharaoh, "Pharaoh's dreams are one and the same: God has told Pharaoh what He is about to do. The seven healthy cows are seven years, and the seven healthy ears are seven years; it is the same dream. The seven lean and ugly cows that followed are seven years, as are also the seven empty ears scorched by the east wind; they are seven years of famine. It is just as I have told Pharaoh: God has revealed to Pharaoh what He is about to do. Immediately ahead are seven years of great abundance in all the land of Egypt. After them will come seven years of famine, and all the abundance in the land of Egypt will be forgotten. As the land is ravaged by famine, no trace of the abundance will be left in the land because of the famine thereafter, for it will be very severe. As for Pharaoh having had the same dream twice, it means that the matter has been determined by God, and that God will soon carry it out ... Let all the food of these good years that are coming be gathered, and let the grain be collected under Pharaoh's authority as food to be stored in the cities. Let that food be a reserve for the land for the seven years of famine which will come upon the land of Egypt, so that the land may not perish in the famine." The plan pleased Pharaoh and all his courtiers. And Pharaoh said to his courtiers, "Could we find another like him, a man in whom is the spirit of God?" So Pharaoh said to Joseph, "Since God has made all this known to you, there is none so discerning and wise as you. You shall be in charge of my court, and by your command shall all my people be directed; only with respect to the throne shall I be superior to you." ... Pharaoh then gave Joseph the name Zaphenath-paneah; and he gave him for a wife Asenath daughter of Poti-phera, priest of On ... And he gathered all the grain of the seven years that the land of Egypt was enjoying, and stored the grain in the cities ... Before the years of famine came, Joseph became the father of two sons, whom Asenath daughter of Poti-phera, priest of On, bore to him. Joseph named the first-born Manasseh, meaning, "God has made me forget completely my hardship and my parental home." And the

second he named Ephraim, meaning, "God has made me fertile in the land of my affliction." The seven years of abundance that the land of Egypt enjoyed came to an end, and the seven years of famine set in, just as Joseph had foretold. There was famine in all lands, but throughout the land of Egypt there was bread ... Accordingly, when the famine became severe in the land of Egypt, Joseph laid open all that was within, and rationed out grain to the Egyptians. The famine, however, spread over the whole world ... So ten of Joseph's brothers went down to get grain rations in Egypt. (Gen. 41.3–42.3)

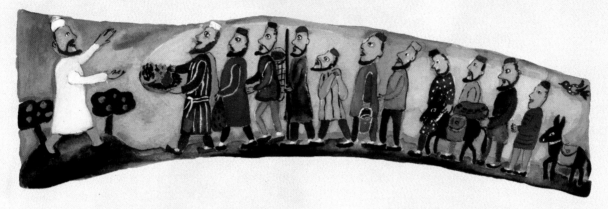

Now Joseph was the vizier of the land ... And Joseph's brothers came and bowed low to him, with their faces to the ground. When Joseph saw his brothers, he recognized them; but he acted like a stranger toward them and spoke harshly to them. He asked them, "Where do you come from?" And they said, "From the land of Canaan, to procure food." For though Joseph recognized his brothers, they did not recognize him ... And he said to them, "No, you have come to see the land in its nakedness!" And they replied, "We your servants were twelve brothers, sons of a certain man in the land of Canaan; the youngest, however, is now with our father, and one is no more." ... On the third day Joseph said to them, "Do this and you shall live, for I am a God-fearing man. If you are honest men, let one of you brothers be held in your place of detention, while the rest of you go and take home rations for your starving households; but you must bring me your youngest brother, that your words may be verified and that you may not die." And they did accordingly ... So they loaded their asses with the rations and departed from there. As one of them was opening his sack to give feed to his ass at the night encampment, he saw his money right there at the mouth of his bag. And he said to his brothers, "My money has been returned! It is here in my bag!" Their hearts sank; and, trembling, they turned to one another, saying, "What is this that God has done to us?" When they came to their father Jacob in the land of Canaan, they told him all that had befallen them, saying, "The man who is lord of the land spoke harshly to us and accused us of spying on the land ..." Their father Jacob said to them, "It is always me that you bereave: Joseph is no more and Simeon is no more, and now you would take away Benjamin. These things always happen to me! ..." But the famine in the land was severe. And when they had eaten up the rations which they had brought from Egypt ... Then their father Israel said to them, "If it must be so, do this: take some of the choice products of the land in your baggage, and carry them down as a gift for the man—some balm and some honey, gum, ladanum, pistachio nuts, and almonds ..." So the men took that gift, and they took with them double the money, as well as Benjamin. They made their way down to Egypt, where they presented themselves to Joseph. (Gen. 42.6–43.15)

Looking about, he saw his brother Benjamin, his mother's son, and asked, "Is this your youngest brother of whom you spoke to me?" And he went on, "May God be gracious to you, my boy." With that, Joseph hurried out, for he was overcome with feeling toward his brother and was on the verge of tears;

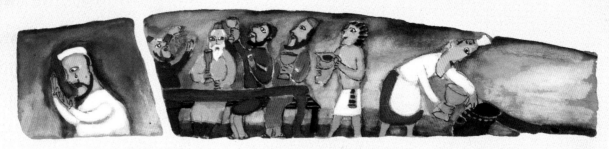

he went into a room and wept there ... Then he instructed his house steward as follows ... "Put my silver goblet in the mouth of the bag of the youngest one, together with his money for the rations." ... They had just left the city and had not gone far, when Joseph said to his steward, "Up, go after the men! And when you overtake them, say to them, 'Why did you repay good with evil? It is the very one from which my master drinks and which he uses for divination. It was a wicked thing for you to do!'" ... And they said to him, "Here we brought back to you from the land of Canaan the money that we found in the mouths of our bags. How then could we have stolen any silver or gold from your master's house! Whichever of your servants it is found with shall die; the rest of us, moreover, shall become slaves to my lord." He replied, "Although what you are proposing is right, only the one with whom it is found shall be my slave; but the rest of you shall go free." ... And the goblet turned up in Benjamin's bag. (Gen. 43.29–44.12)

Haftarat Miketz

(1 Kings 3.15–4.1)

Then Solomon awoke: it was a dream! He went to Jerusalem, stood before the Ark of the Covenant of the Lord, and sacrificed burnt offerings and presented offerings of well-being; and he made a banquet for all his courtiers. Later two prostitutes came to the king and stood before him. The first woman said, "Please, my lord! This woman and I live in the same house; and I gave birth to a child while she was in the house. On the third day after I was delivered, this woman also gave birth to a child. We were alone; there was no one else with us in the house, just the two of us in the house. During the night this woman's child died, because she lay on it. She arose in the night and took my son from my side while your maidservant was asleep, and laid him in her bosom; and she laid her dead son in my bosom. When I arose in the morning to nurse my son, there he was, dead; but when I looked at him closely in the morning, it was not the son I had borne." The other woman spoke up, "No, the live one is my son, and the dead one is yours!" But the first insisted, "No, the dead boy is yours; mine is the live one!" And they went on arguing before the king. The king said, "One says, 'This is my son, the live one, and the dead one is yours'; and the other says, 'No, the dead boy is yours, mine is the live one.' So the king gave the order, "Fetch me a sword." A sword was brought before the king, and the king said, "Cut the live child in two, and give half to one and half to the other." But the woman whose son was the live one pleaded with the king, for she was overcome with compassion for her son. "Please, my lord," she cried, "give her the live child; only don't kill it!" The other insisted, "It shall be neither yours nor mine; cut it in two!" Then the king spoke up. "Give the live child to her," he said, "and do not put it to death; she is its mother." When all Israel heard the decision that the king had rendered, they stood in awe of the king; for they saw that he possessed divine wisdom to execute justice. King Solomon was now king over all Israel. (1 Kings 3.15–28)

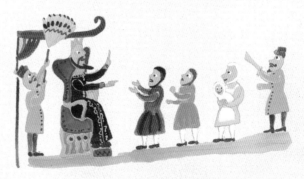

BERESHIT

Vayigash 44.18–47.27

Judah, unwilling to deprive his old father of yet another son, offered to take Benjamin's place in prison. Joseph, no longer able to restrain himself, revealed his true identity to his brothers. They embraced and reconciled. Joseph then sent for his father, and Jacob's whole household, seventy in number, came down to Egypt and settled in the land of Goshen.

ויגש אליו יהודה ויאמר בי אדני ידבר נא עבדך דבר
באזני אדני ואל יחר אפך בעבדך כי כמוך כפרעה:

Then Judah went up to him and said, "Please, my lord, let your servant appeal to my lord, and do not be impatient with your servant, you who are the equal of Pharaoh." (Gen. 44.18)

"My lord asked his servants, 'Have you a father or another brother?' We told my lord, 'We have an old father, and there is a child of his old age, the youngest; his full brother is dead, so that he alone is left of his mother, and his father dotes on him.' Then you said to your servants, 'Bring him down to me, that I may set eyes on him.' We said to my lord, 'The boy cannot leave his father; if he were to leave him, his father would die.' But you said to your servants, 'Unless your youngest brother comes down with you, do not let me see your faces ... Later our father said, 'Go back and procure some food for us.' We answered, 'We cannot go down; only if our youngest brother is with us can we go down, for we may not show our faces to the man unless our youngest brother is with us.' ... Now, if I come to your servant my father and the boy is not with us—since his own life is so bound up with his—when he sees that the boy is not with us, he will die, and your servants will send the white head of your servant our father down to Sheol in grief ... Therefore, please let your servant remain as a slave to my lord instead of the boy, and let the boy go back with his brothers." (Gen. 44.19–33)

Joseph could no longer control himself before all his attendants, and he cried out, "Have everyone withdraw from me!" So there was no one else about when Joseph made himself known to his brothers ... "I am Joseph. Is my father still well?" But his brothers could not answer him, so dumfounded were they on account of him. (Gen. 45.1–3)

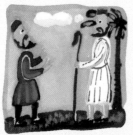 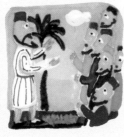 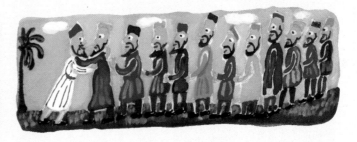

"And you are bidden [to add], 'Do as follows: take from the land of Egypt wagons for your children and your wives, and bring your father here. And never mind your belongings, for the best of all the land of Egypt shall be yours.'" The sons of Israel did so; Joseph gave them wagons as Pharaoh had commanded, and he supplied them with provisions for the journey. To each of them, moreover, he gave a change of clothing; but to Benjamin he gave three hundred pieces of silver and several changes of clothing. And to his father he sent the following: ten he-asses laden with the best things of Egypt, and ten she-asses laden with grain, bread, and provisions for his father on the journey. As he sent his brothers off on their way, he told them, "Do not be quarrelsome on the way." They went up from Egypt and came to their father Jacob in the land of Canaan. And they told him, "Joseph is still alive; yes, he is ruler over the whole land of Egypt." His heart went numb, for he did not believe them. But when they recounted all that Joseph had said to them, and when he saw the wagons that Joseph had sent to transport him, the spirit of their father Jacob revived. "Enough!" said Israel. "My son Joseph is still alive! I must go and see him before I die." (Gen. 45.19–28)

He had sent Judah ahead of him to Joseph, to point the way before him to Goshen. So when they came to the region of Goshen, Joseph ordered his chariot and went to Goshen to meet his father Israel; he presented himself to him and, embracing him around the neck, he wept on his neck a good while. Then Israel said to Joseph, "Now I can die, having seen for myself that you are still alive." ... Then Joseph said to his brothers and to his father's household, "I will go up and tell the news to Pharaoh, and say to him, 'My brothers and my father's household, who were in the land of Canaan, have come to me. The men are shepherds; they have always been breeders of livestock, and they have brought with them their flocks and herds and all that is theirs.' So when Pharaoh summons you and asks, 'What is your occupation?' you shall answer, 'Your servants have been breeders of livestock from the start until now, both we and our fathers'—so that you may stay in the region of Goshen. For all shepherds are abhorrent to Egyptians." (Gen. 46.28–34)

"The land of Egypt is open before you: settle your father and your brothers in the best part of the land; let them stay in the region of Goshen. And if you know any capable men among them, put them in charge of my livestock." … So Joseph settled his father and his brothers, giving them holdings in the choicest part of the land of Egypt, in the region of Rameses, as Pharaoh had commanded. (Gen. 47.6–11)

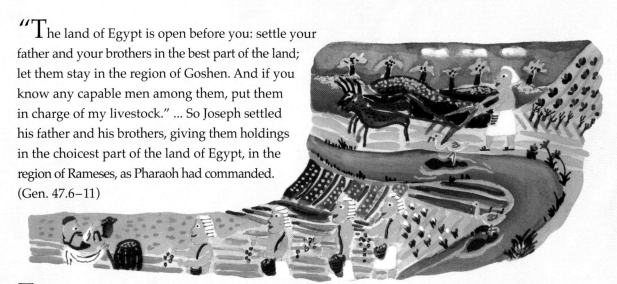

Then Joseph said to the people, "Whereas I have this day acquired you and your land for Pharaoh, here is seed for you to sow the land. And when harvest comes, you shall give one-fifth to Pharaoh, and four-fifths shall be yours as seed for the fields and as food for you and those in your households, and as nourishment for your children." (Gen 47.23–24)

Haftarat Vayigash

(Ezekiel 37.15–28)

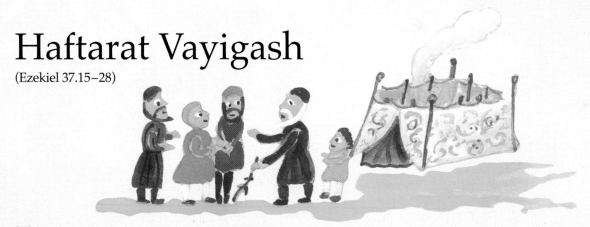

The word of the Lord came to me: And you, O mortal, take a stick and write on it, "Of Judah and the Israelites associated with him"; and take another stick and write on it, "Of Joseph—the stick of Ephraim—and all the House of Israel associated with him." Bring them close to each other, so that they become one stick, joined together in your hand. And when any of your people ask you, "Won't you tell us what these actions of yours mean?" answer them, "Thus said the Lord God: I am going to take the stick of Joseph—which is in the hand of Ephraim—and of the tribes of Israel associated with him, and I will place the stick of Judah upon it and make them into one stick; they shall be joined in My hand." You shall hold up before their eyes the sticks which you have inscribed, and you shall declare to them: Thus said the Lord God: I am going to take the Israelite people from among the nations they have gone to, and gather them from every quarter, and bring them to their own land. I will make them a single nation in the land, on the hills of Israel, and one king shall be king of them all. Never again shall they be two nations, and never again shall they be divided into two kingdoms. Nor shall they ever again defile themselves by their fetishes and their abhorrent things, and by their other transgressions. I will save them in all their settlements where they sinned, and I will cleanse them. Then they shall be My people, and I will be their God. (Ezek. 37.15–23)

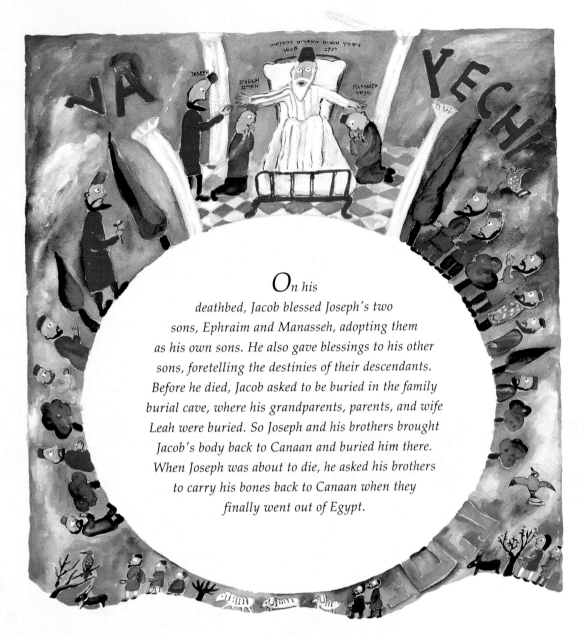

On his
deathbed, Jacob blessed Joseph's two
sons, Ephraim and Manasseh, adopting them
as his own sons. He also gave blessings to his other
sons, foretelling the destinies of their descendants.
Before he died, Jacob asked to be buried in the family
burial cave, where his grandparents, parents, and wife
Leah were buried. So Joseph and his brothers brought
Jacob's body back to Canaan and buried him there.
When Joseph was about to die, he asked his brothers
to carry his bones back to Canaan when they
finally went out of Egypt.

ויחי יעקב בארץ מצרים שבע עשרה שנה ויהי ימי יעקב
שני חייו שבע שנים וארבעים ומאת שנה:

Jacob lived seventeen years in the land of Egypt, so that the span of Jacob's life came to one hundred and forty-seven years. (Gen. 47.28)

Noticing Joseph's sons, Israel asked, "Who are these?" And Joseph said to his father, "They are my sons, whom God has given me here." "Bring them up to me," he said, "that I may bless them."... So he blessed them that day, saying, "By you shall Israel invoke blessings, saying: God make you like Ephraim and Manasseh." Thus he put Ephraim before Manasseh. (Gen. 48.8–20)

BERESHIT

Vayechi

Reuben, you are my first-born, my might and first fruit of my vigor, exceeding in rank and exceeding in honor. Unstable as water, you shall excel no longer; for when you mounted your father's bed, you brought disgrace—my couch he mounted! (Gen. 49.3–4)

Simeon and Levi are a pair; their weapons are tools of lawlessness. Let not my person be included in their council, let not my being be counted in their assembly. For when angry they slay men, and when pleased they maim oxen. Cursed be their anger so fierce, and their wrath so relentless. I will divide them in Jacob, scatter them in Israel. (Gen. 49.5–7)

You, O Judah, your brothers shall praise; your hand shall be on the nape of your foes; your father's sons shall bow low to you. Judah is a lion's whelp; on prey, my son, have you grown. He crouches, lies down like a lion, like the king of beasts—who dare rouse him? The scepter shall not depart from Judah, nor the ruler's staff from between his feet; so that tribute shall come to him and the homage of peoples be his. He tethers his ass to a vine, his ass's foal to a choice vine; he washes his garment in wine, his robe in blood of grapes. His eyes are darker than wine; his teeth are whiter than milk. (Gen. 49.8–12)

Zebulun shall dwell by the seashore; he shall be a haven for ships, and his flank shall rest on Sidon. (Gen. 49.13)

Issachar is a strong-boned ass, crouching among the sheepfolds. When he saw how good was security, and how pleasant was the country, he bent his shoulder to the burden, and became a toiling serf. (Gen. 49.14–15)

Dan shall govern his people, as one of the tribes of Israel. Dan shall be a serpent by the road, a viper by the path, that bites the horse's heels so that his rider is thrown backward. (Gen. 49.16–17)

Gad shall be raided by raiders, but he shall raid at their heels. (Gen. 49.19)

Asher's bread shall be rich, and he shall yield royal dainties. (Gen. 49.20)

Naphtali is a hind let loose, which yields lovely fawns. (Gen. 49.21)

Joseph is a wild ass, a wild ass by a spring—wild colts on a hillside. Archers bitterly assailed him; they shot at him and harried him. Yet his bow stayed taut, and his arms were made firm by the hands of the Mighty One of Jacob—there, the Shepherd, the Rock of Israel—the God of your father who helps you, and Shaddai who blesses you with blessings of heaven above, blessings of the deep that couches below, blessings of the breast and womb. The blessings of your father surpass the blessings of my ancestors, to the utmost bounds of the eternal hills. May they rest on the head of Joseph, on the brow of the elect of his brothers. (Gen. 49.22–26)

Benjamin is a ravenous wolf; in the morning he consumes the foe, and in the evening he divides the spoil." (Gen. 49.27)

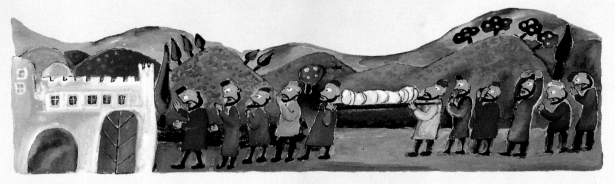

His sons carried him to the land of Canaan, and buried him in the cave of the field of Machpelah, the field near Mamre, which Abraham had bought for a burial site from Ephron the Hittite. After burying his father, Joseph returned to Egypt, he and his brothers and all who had gone up with him to bury his father. (Gen. 50.13–14)

Haftarat Vayechi

(1 Kings 2.1–12)

When David's life was drawing to a close, he instructed his son Solomon as follows: "I am going the way of all the earth; be strong and show yourself a man. Keep the charge of the Lord your God, walking in His ways and following His laws, His commandments, His rules, and His admonitions as recorded in the Teaching of Moses, in order that you may succeed in whatever you undertake and wherever you turn. Then the Lord will fulfill the promise that He made concerning me: 'If your descendants are scrupulous in their conduct, and walk before Me faithfully, with all their heart and soul, your line on the throne of Israel shall never end!' Further, you know what Joab son of Zeruiah did to me, what he did to the two commanders of Israel's forces, Abner son of Ner and Amasa son of Jether: he killed them, shedding blood of war in peacetime, staining the girdle of his loins and the sandals on his feet with blood of war. So act in accordance with your wisdom, and see that his white hair does not go down to Sheol in peace. But deal graciously with the sons of Barzillai the Gileadite, for they befriended me when I fled from your brother Absalom; let them be among those that eat at your table. You must also deal with Shimei son of Gera, the Benjaminite from Bahurim. He insulted me outrageously when I was on my way to Mahanaim; but he came down to meet me at the Jordan, and I swore to him by the Lord: 'I will not put you to the sword.' So do not let him go unpunished; for you are a wise man and you will know how to deal with him and send his gray hair down to Sheol in blood." So David slept with his fathers, and he was buried in the City of David. (1 Kings 2.1–10)

SHEMOT

Shemot 1.1–6.1

Jacob's descendants remained in Egypt for many years and multiplied greatly. Then the Egyptians enslaved them, and treated them harshly. Fearful of their numbers, Pharaoh ordered the Hebrew midwives to kill every son born to an Israelite, but they disobeyed. A son was born to a Levite woman, Yokheved, and she hid him for three months. Then she set him adrift on the Nile, where he was found and adopted by Pharaoh's daughter, who named him Moses. When he grew up, he killed an Egyptian taskmaster who was beating a Hebrew slave, and fled to Midian. There he married Zipporah, daughter of a Midianite priest, and had two sons. He encountered God in a burning bush, who commanded him to appear before Pharaoh. Together with his brother Aaron, Moses confronted Pharaoh, demanding that he let the Israelites go, but Pharaoh only increased their labors.

ואלה שמות בני ישראל הבאים מצרימה....

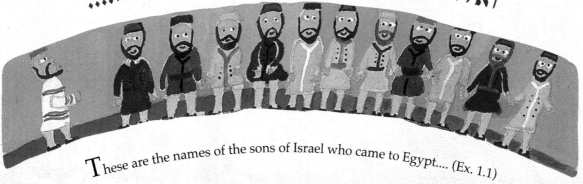

These are the names of the sons of Israel who came to Egypt.... (Ex. 1.1)

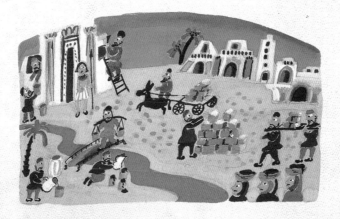

The Egyptians ruthlessly imposed upon the Israelites the various labors that they made them perform. Ruthlessly they made life bitter for them with harsh labor at mortar and bricks and with all sorts of tasks in the field. The king of Egypt spoke to the Hebrew midwives, one of whom was named Shiphrah and

61

SHEMOT

Shemot

the other Puah, saying, "When you deliver the Hebrew women, look at the birthstool: if it is a boy, kill him; if it is a girl, let her live." The midwives, fearing God, did not do as the king of Egypt had told them; they let the boys live ... Then Pharaoh charged all his people, saying, "Every boy that is born you shall throw into the Nile, but let every girl live." (Ex. 1.13–22)

A certain man of the house of Levi went and married a Levite woman. The woman conceived and bore a son; and when she saw how beautiful he was, she hid him for three months. When she could hide him no longer, she got a wicker basket for him and caulked it with bitumen and pitch. She put the child into it and placed it among the reeds by the bank of the Nile. And his sister stationed herself at a distance, to learn what would befall him. (Ex. 2.1–4)

The daughter of Pharaoh came down to bathe in the Nile, while her maidens walked along the Nile. She spied the basket among the reeds and sent her slave girl to fetch it. When she opened it, she saw that it was a child, a boy crying. She took pity on it and said, "This must be a Hebrew child." Then his sister said to Pharaoh's daughter, "Shall I go and get you a Hebrew nurse to suckle the child for you?" And Pharaoh's daughter answered, "Yes." So the girl went and called the child's mother ... When the child grew up, she brought him to Pharaoh's daughter, who made him her son. She named him Moses, explaining, "I drew him out of the water." (Ex. 2.5–10)

Some time after that, when Moses had grown up, he went out to his kinsfolk and witnessed their labors. He saw an Egyptian beating a Hebrew, one of his kinsmen. He turned this way and that and, seeing no one about, he struck down the Egyptian and hid him in the sand ... When Pharaoh learned of the matter, he sought to kill Moses; but Moses fled from Pharaoh. He arrived in the land of Midian, and sat down beside a well. (Ex. 2.11–15)

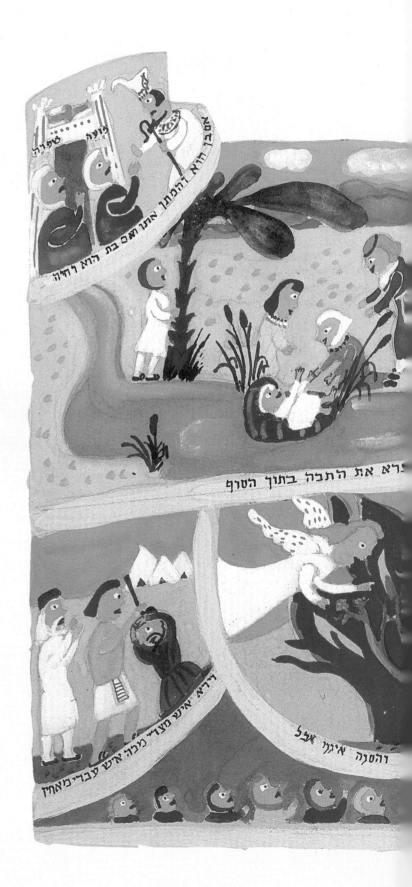

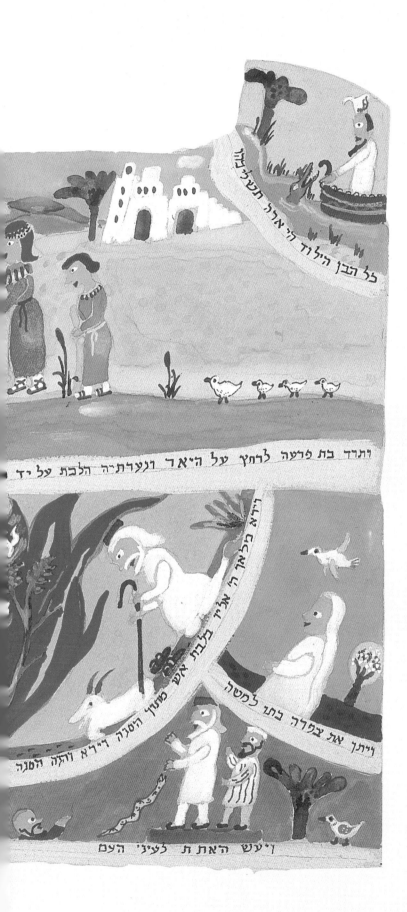

Now the priest of Midian had seven daughters. They came to draw water, and filled the troughs to water their father's flock; but shepherds came and drove them off. Moses rose to their defense, and he watered their flock. When they returned to their father Reuel ... Moses consented to stay with the man, and he gave Moses his daughter Zipporah as wife. She bore a son whom he named Gershom, for he said, "I have been a stranger in a foreign land." (Ex. 2.16–22)

An angel of the Lord appeared to him in a blazing fire out of a bush. He gazed, and there was a bush all aflame, yet the bush was not consumed ... "Moses! Moses!" He answered, "Here I am." And He said, "Do not come closer. Remove your sandals from your feet, for the place on which you stand is holy ground. I am," He said, "the God of your father, the God of Abraham, the God of Isaac, and the God of Jacob." And Moses hid his face, for he was afraid to look at God ... "Come, therefore, I will send you to Pharaoh, and you shall free My people, the Israelites, from Egypt." (Ex. 3.2–10)

The Lord said to Aaron, "Go to meet Moses in the wilderness." ... Moses told Aaron about all the things that the Lord had committed to him and all the signs about which He had instructed him. Then Moses and Aaron went and assembled all the elders of the Israelites. Aaron repeated all the words that the Lord had spoken to Moses, and he performed the signs in the sight of the people, and the people were convinced. When they heard that the Lord had taken note of the Israelites and that He had seen their plight, they bowed low in homage. (Ex. 4.27–31)

Afterward Moses and Aaron went and said to Pharaoh, "Thus says the Lord, the God of Israel: Let My people go that they may celebrate a festival for Me in the wilderness." But Pharaoh said, "Who is the Lord that I should heed Him and let Israel go? I do not know the Lord, nor will I let Israel go." (Ex. 5.1–2)

Haftarat Shemot

(Ashkenazim read Isaiah 27.6–28.13; 29.22–23)

[In days] To come Jacob shall strike root, Israel shall sprout and blossom, and the face of the world shall be covered with fruit. Was he beaten as his beater has been? Did he suffer such slaughter as his slayers? Assailing them with fury unchained, His pitiless blast bore them off on a day of gale. Assuredly, by this alone shall Jacob's sin be purged away; this is the only price for removing his guilt: That he make all the altar-stones like shattered blocks of chalk—With no sacred post left standing, nor any incense altar. Thus fortified cities lie desolate, homesteads deserted, forsaken like a wilderness; there calves graze, there they lie down and consume its boughs. When its crown is withered, they break; women come and make fires with them. For they are a people without understanding; that is why their Maker will show them no mercy, their Creator will deny them grace. (Isa. 27.6–11)

(Sephardim read Jeremiah 1.1–2.3)

The words of Jeremiah son of Hilkiah, one of the priests at Anathoth in the territory of Benjamin. The word of the Lord came to him in the days of King Josiah son of Amon of Judah, in the thirteenth year of his reign, and throughout the days of King Jehoiakim son of Josiah of Judah, and until the end of the eleventh year of King Zedekiah son of Josiah of Judah, when Jerusalem went into exile in the fifth month. The word of the Lord came to me: Before I created you in the womb, I selected you; before you were born, I consecrated you; I appointed you a prophet concerning the nations. I replied: Ah, Lord God! I don't know how to speak, for I am still a boy. And the Lord said to me: Do not say, "I am still a boy," but go wherever I send you And speak whatever I command you. Have no fear of them, For I am with you to deliver you—declares the Lord. The Lord put out His hand and touched my mouth, and the Lord said to me: Herewith I put My words into your mouth. See, I appoint you this day over nations and kingdoms: To uproot and to pull down, to destroy and to overthrow, to build and to plant. The word of the Lord came to me: What do you see, Jeremiah? I replied: I see a branch of an almond tree. The Lord said to me: You have seen right, for I am watchful to bring My word to pass. (Jer. 1.1–12)

When Pharaoh refused to let the people go, God brought devastating plagues upon Egypt. First, the Nile was turned to blood as was all the water in Egypt—except in Goshen where the Israelites lived. Then frogs overran the land, followed by lice, and then swarms of wild beasts. With each plague, Pharaoh promised Moses that he would let the people go but he reneged once the plague had ceased. Then Egypt's herds and flocks were devastated by a terrible pestilence, and after that, the Egyptians together with their beasts were afflicted with boils. When Pharaoh still refused to yield, God sent down fiery hail, which laid waste to the fields and trees. Still Pharaoh would not let the Israelites go.

God spoke to Moses and said to him, "I am the Lord. I appeared to Abraham, Isaac, and Jacob as El Shaddai, but I did not make Myself known to them by My name.... (Ex. 6.2–3)

וידבר אלקים אל משה ויאמר אליו אני
ה': וארא אל אברהם אל יצחק ואל יעקב
באל שדי ושמי ה' לא נודעתי להם:

Say, therefore, to the Israelite people: I am the Lord. I will free you from the labors of the Egyptians and deliver you from their bondage. I will redeem you with an outstretched arm and through extraordinary chastisements. And I will take you to be My people, and I will be your God. And you shall know that I, the Lord, am your God who freed you from the labors of the Egyptians. I will bring you into the land which I swore to give to Abraham, Isaac, and Jacob, and I will give it to you for a possession, I the Lord." ... The Lord spoke to Moses, saying, "Go and tell Pharaoh king of Egypt to let the Israelites depart from his land." (Ex. 6.6–11)

The Lord replied to Moses, "See, I place you in the role of God to Pharaoh, with your brother Aaron as your prophet. You shall repeat all that I command you, and your brother Aaron shall speak to Pharaoh to let the Israelites depart from his land. But I will harden Pharaoh's heart, that I may multiply My signs and marvels in the land of Egypt. When Pharaoh does not heed you, I will lay My hand upon Egypt and deliver My ranks, My people the Israelites, from the land of Egypt with extraordinary chastisements. And the Egyptians shall know that I am the Lord, when I stretch out My hand over Egypt and bring out the Israelites from their midst. (Ex. 7.1–5)

The Lord said to Moses and Aaron, "When Pharaoh speaks to you and says, 'Produce your marvel,' you shall say to Aaron, 'Take your rod and cast it down before Pharaoh.' It shall turn into a serpent." So Moses and Aaron came before Pharaoh ... Aaron cast down his rod in the presence of Pharaoh and his courtiers, and it turned into a serpent. (Ex. 7.8–10)

SHEMOT

Va'era

And the Lord said to Moses, "Say to Aaron: Take your rod and hold out your arm over the waters of Egypt—its rivers, its canals, its ponds, all its bodies of water—that they may turn to blood; there shall be blood throughout the land of Egypt, even in vessels of wood and stone." Moses and Aaron did just as the Lord commanded: he lifted up the rod and struck the water in the Nile in the sight of Pharaoh and his courtiers, and all the water in the Nile was turned into blood and the fish in the Nile died. (Ex. 7.19–21)

And the Lord said to Moses, "Say to Aaron: Hold out your arm with the rod over the rivers, the canals, and the ponds, and bring up the frogs on the land of Egypt." ... Then Pharaoh summoned Moses and Aaron and said, "Plead with the Lord to remove the frogs from me and my people, and I will let the people go to sacrifice to the Lord." ... But when Pharaoh saw that there was relief, he became stubborn and would not heed them, as the Lord had spoken. (Ex. 8.1–11)

Then the Lord said to Moses, "Say to Aaron: Hold out your rod and strike the dust of the earth, and it shall turn to lice throughout the land of Egypt." ... But Pharaoh's heart stiffened and he would not heed them, as the Lord had spoken. (Ex. 8.12–15)

Thus says the Lord: Let My people go that they may worship Me. For if you do not let My people go, I will let loose swarms of insects against you and your courtiers and your people and your houses; the houses of the Egyptians ... And the Lord did so. Heavy swarms of insects 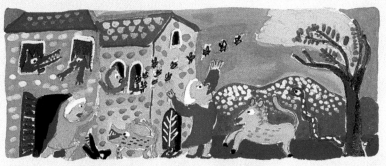 invaded Pharaoh's palace and the houses of his courtiers; throughout the country of Egypt the land was ruined because of the swarms of insects. (Ex. 8.16–20)

Then Pharaoh summoned Moses and Aaron and said, "Go and sacrifice to your God within the land."
But Moses replied, "It would not be right to do this, for what we sacrifice to the Lord our God is untouchable
to the Egyptians. If we sacrifice that which is untouchable to the Egyptians before their very eyes, will
they not stone us! So we must go a distance of three days into the wilderness and sacrifice to the Lord
our God as He may command us." Pharaoh said, "I will let you go to sacrifice to the Lord your God in
the wilderness; but do not go very far. Plead, then, for me." And Moses said, "When I leave your presence,
I will plead with the Lord that the swarms of insects depart tomorrow from Pharaoh and his courtiers
and his people; but let not Pharaoh again act deceitfully, not letting the people go to sacrifice to the Lord."
So Moses left Pharaoh's presence and pleaded with the Lord. And the Lord did as Moses asked ... But
Pharaoh became stubborn this time also, and would not let the people go. (Ex. 8.21–28)

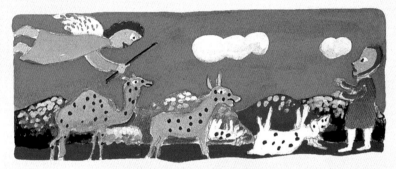

Then the hand of the Lord will
strike your livestock in the fields—
the horses, the asses, the camels, the
cattle, and the sheep—with a very
severe pestilence. But the Lord will
make a distinction between the
livestock of Israel and the livestock
of the Egyptians, so that nothing shall die of all that belongs to the Israelites. (Ex. 9.3–4)

Then the Lord said to Moses and
Aaron, "Each of you take handfuls
of soot from the kiln, and let Moses
throw it toward the sky in the sight
of Pharaoh. It shall become a fine
dust all over the land of Egypt, and
cause an inflammation breaking

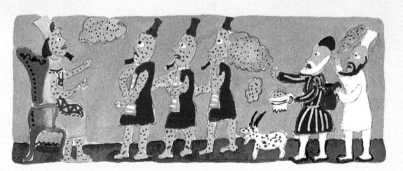

out in boils on man and beast throughout the land of Egypt." (Ex. 9.8–9)

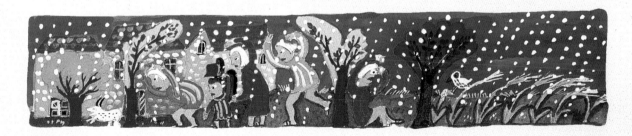

The Lord said to Moses, "Hold out your arm toward the sky that hail may fall on all the land of Egypt,
upon man and beast and all the grasses of the field in the land of Egypt." (Ex. 9.22)

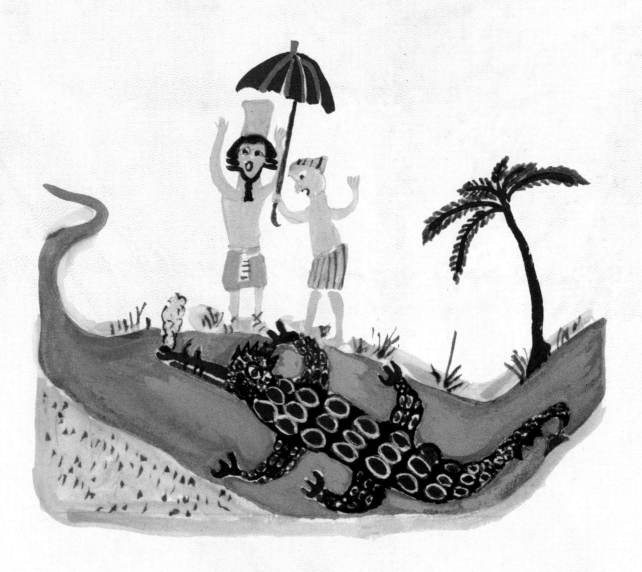

Haftarat Va'era

(Ezekiel 28.25–29.21)

Thus said the Lord God: When I have gathered the House of Israel from the peoples among which they have been dispersed, and have shown Myself holy through them in the sight of the nations, they shall settle on their own soil, which I gave to My servant Jacob, and they shall dwell on it in security. They shall build houses and plant vineyards, and shall dwell on it in security, when I have meted out punishment to all those about them who despise them. And they shall know that I the Lord am their God. In the tenth year, on the twelfth day of the tenth month, the word of the Lord came to me: O mortal, turn your face against Pharaoh king of Egypt, and prophesy against him and against all Egypt. Speak these words: Thus said the Lord God: I am going to deal with you, O Pharaoh king of Egypt, mighty monster, sprawling in your channels, who said, my Nile is my own; I made it for myself. I will put hooks in your jaws, and make the fish of your channels cling to your scales; I will haul you up from your channels, with all the fish of your channels clinging to your scales. (Ezek. 28.25–29.4)

God sent two more plagues: swarms of locusts, followed by three days of darkness. At God's command, the Israelites celebrated the first Passover, and smeared blood on their doorposts to protect them from the Angel of Death. Then God struck down all the first-born of Egypt, but passed over the homes of the Israelites. Pharaoh ordered the Hebrew slaves to leave Egypt, and they departed in haste.

ויאמר ה׳ אל משה בא אל פרעה כי אני הכבדתי את לבו
ואת לב עבדיו למען שתי אתתי אלה בקרבו:

Then the Lord said to Moses, "Go to Pharaoh. For I have hardened his heart and the hearts of his courtiers, in order that I may display these My signs among them.... (Ex. 10.1)

So Moses and Aaron went to Pharaoh and said to him, "Thus says the Lord, the God of the Hebrews, 'How long will you refuse to humble yourself before Me? Let My people go that they may worship Me. For if you refuse to let My people go, tomorrow I will bring locusts on your territory. They shall cover the surface of the land, so that no one will be able to see the land. They shall devour the surviving remnant that was left to you after the hail; and they shall eat away all your trees that grow in the field. (Ex. 10.3–5)

Then the Lord said to Moses, "Hold out your arm toward the sky that there may be darkness upon the land of Egypt, a darkness that can be touched." Moses held out his arm toward the sky and thick darkness descended upon all the land of Egypt for three days. People could not see one another, and for three days no one could get up from where he was; but all the Israelites enjoyed light in their dwellings. (Ex. 10.21–23)

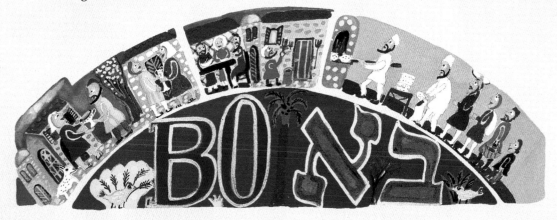

And the Lord said to Moses, "I will bring but one more plague upon Pharaoh and upon Egypt; after that he shall let you go from here ... Tell the people to borrow, each man from his neighbor and each woman from hers, objects of silver and gold. " The Lord disposed the Egyptians favorably toward the

SHEMOT

Bo

people ... Moses said, "Thus says the Lord: Toward midnight I will go forth among the Egyptians, and every first-born in the land of Egypt shall die, from the first-born of Pharaoh who sits on his throne to the first-born of the slave girl who is behind the millstones; and all the first-born of the cattle. And there shall be a loud cry in all the land of Egypt, such as has never been or will ever be again; but not a dog shall snarl at any of the Israelites, at man or beast—in order that you may know that the Lord makes a distinction between Egypt and Israel ..." Now the Lord had said to Moses, "Pharaoh will not heed you, in order that My marvels may be multiplied in the land of Egypt." Moses and Aaron had performed all these marvels before Pharaoh, but the Lord had stiffened the heart of Pharaoh so that he would not let the Israelites go from his land. (Ex. 11.1–10)

The Lord said to Moses and Aaron in the land of Egypt: "This month shall mark for you the beginning of the months; it shall be the first of the months of the year for you. Speak to the whole community of Israel and say that on the tenth of this month each of them shall take a lamb to a family, a lamb to a household. But if the household is too small for a lamb, let him share one with a neighbor who dwells nearby, in proportion to the number of persons: you shall contribute for the lamb according to what each household will eat. Your lamb shall be without blemish, a yearling male; you may take it from the sheep or from the goats. You shall keep watch over it until the fourteenth day of this month; and all the assembled congregation of the Israelites shall slaughter it at twilight. They shall take some of the blood and put it on the two doorposts and the lintel of the houses in which they are to eat it. They shall eat the flesh that same night; they shall eat it roasted over the fire, with unleavened bread and with bitter herbs. Do not eat any of it raw, or cooked in any way with water, but roasted—head, legs, and entrails—over the fire. You shall not leave any of it over until morning; if any of it is left until morning, you shall burn it. This is how you shall eat it: your loins girded, your sandals on your feet, and your staff in your hand; and you shall eat it hurriedly: it is a passover offering to the Lord. For that night I will go through the land of Egypt and strike down every first-born in the land of Egypt, both man and beast; and I will mete out

punishments to all the gods of Egypt, I the Lord. And the blood on the houses where you are staying shall be a sign for you: when I see the blood I will pass over you, so that no plague will destroy you when I strike the land of Egypt. This day shall be to you one of remembrance: you shall celebrate it as a festival to the Lord throughout the ages; you shall celebrate it as an institution for all time. Seven days you shall eat unleavened bread; on the very first day you shall remove leaven from your houses, for whoever eats leavened bread from the first day to the seventh day, that person shall be cut off from Israel. You shall celebrate a sacred occasion on the first day, and a sacred occasion on the seventh day; no work at all shall be done on them; only what every person is to eat, that alone may be prepared for you. You shall observe the Feast of Unleavened Bread, for on this very day I brought your ranks out of the land of Egypt; you shall observe this day throughout the ages as an institution for all time. In the first month, from the fourteenth day of the month at evening, you shall eat unleavened bread until the

twenty-first day of the month at evening. No leaven shall be found in your houses for seven days. For whoever eats what is leavened, that person shall be cut off from the community of Israel, whether he is a stranger or a citizen of the country. You shall eat nothing leavened; in all your settlements you shall eat unleavened bread." Moses then summoned all the elders of Israel and said to them, "Go, pick out lambs for your families, and slaughter the passover offering. Take a bunch of hyssop, dip it in the blood that is in the basin,

and apply some of the blood that is in the basin to the lintel and to the two doorposts. None of you shall go outside the door of his house until morning. For when the Lord goes through to smite the Egyptians, He will see the blood on the lintel and the two doorposts, and the Lord will pass over the door and not let the Destroyer enter and smite your home. You shall observe this as an institution for all time, for you and for your descendants. And when you enter the land that the Lord will give you, as He has promised, you shall observe this rite. And when your children ask you, 'What do you mean by this rite?' you shall say, 'It is the passover sacrifice to the Lord, because He passed over the houses of the Israelites in Egypt when He smote the Egyptians, but saved our houses.'" The people then bowed low in homage. And the Israelites went and did so; just as the Lord had commanded Moses and Aaron, so they did. (Ex. 12.1–28)

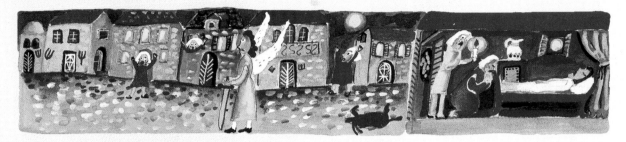

In the middle of the night the Lord struck down all the first-born in the land of Egypt, from the first-born of Pharaoh who sat on the throne to the first-born of the captive who was in the dungeon, and all the first-born of the cattle ... That very day the Lord freed the Israelites from the land of Egypt, troop by troop. The Lord spoke further to Moses, saying, "Consecrate to Me every first-born; man and beast, the first issue of every womb among the Israelites is Mine." And Moses said to the people, "Remember this day, on which you went free from Egypt, the house of bondage, how the Lord freed you from it with a mighty hand: no leavened bread shall be eaten. You go free on this day, in the month of Abib. So, when the Lord has brought you into the land of the Canaanites, the Hittites, the Amorites, the Hivites, and the Jebusites, which He swore to your fathers to give you, a land flowing with milk and honey, you shall observe in this month the following practice: Seven days you shall eat unleavened bread, and on the seventh day there shall be a festival of the Lord. Throughout the seven days unleavened bread shall be eaten; no leavened bread shall be found with you, and no leaven shall be found in all your territory. And you shall explain to your son on that day, 'It is because of what the Lord did for me when I went free from Egypt.'" (Ex. 12.29–13.8)

Haftarat Bo

(Jeremiah 46.13–28)

The word which the Lord spoke to the prophet Jeremiah about the coming of King Nebuchadrezzar of Babylon to attack the land of Egypt: Declare in Egypt, proclaim in Migdol, proclaim in Noph and Tahpanhes! Say: Take your posts and stand ready, for the sword has devoured all around you! Why are your stalwarts swept away? They did not stand firm, for the Lord thrust them down; He made many stumble, they fell over one another. They said: "Up! let us return to our people, to the land of our birth, because of the deadly sword." There they called Pharaoh king of Egypt: "Braggart who let the hour go by." As I live—declares the King, whose name is Lord of Hosts—as surely as Tabor is among the mountains and Carmel is by the sea, so shall this come to pass. Equip yourself for exile, fair Egypt, you who dwell secure! For Noph shall become a waste, desolate, without inhabitants. Egypt is a handsome heifer—a gadfly from the north is coming, coming! The mercenaries, too, in her midst are like stall-fed calves; They too shall turn tail, flee as one, and make no stand. (Jer. 46.13–21)

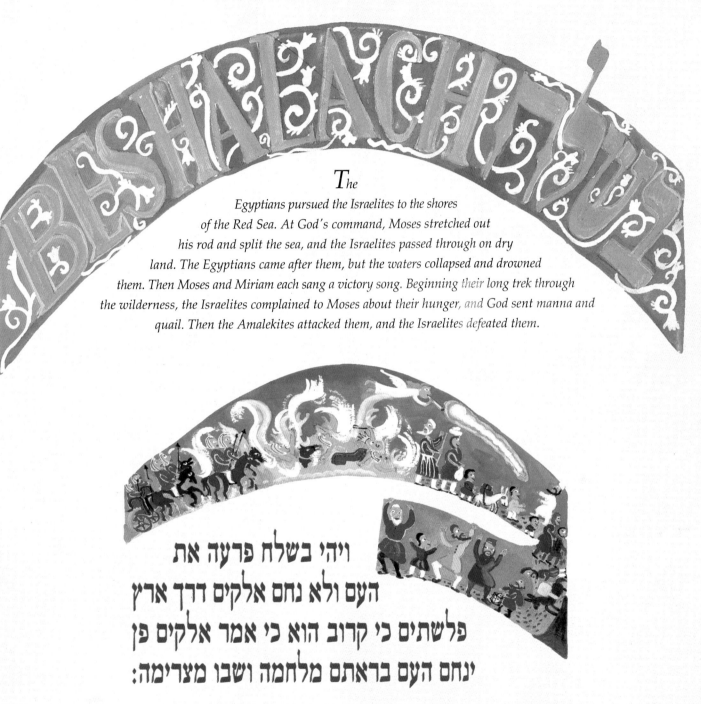

The
Egyptians pursued the Israelites to the shores
of the Red Sea. At God's command, Moses stretched out
his rod and split the sea, and the Israelites passed through on dry
land. The Egyptians came after them, but the waters collapsed and drowned
them. Then Moses and Miriam each sang a victory song. Beginning their long trek through
the wilderness, the Israelites complained to Moses about their hunger, and God sent manna and
quail. Then the Amalekites attacked them, and the Israelites defeated them.

ויהי בשלח פרעה את
העם ולא נחם אלקים דרך ארץ
פלשתים כי קרוב הוא כי אמר אלקים פן
ינחם העם בראתם מלחמה ושבו מצרימה:

Now when Pharaoh let the people go, God did not lead them by way of the
land of the Philistines, although it was nearer; for God said, "The people may
have a change of heart when they see war, and return to Egypt." (Ex. 13.17)

And Moses took with him the bones of Joseph, who had exacted an oath from the children of Israel,
saying, "God will be sure to take notice of you: then you shall carry up my bones from here with you."
They set out from Succoth, and encamped at Etham, at the edge of the wilderness. The Lord went before
them in a pillar of cloud by day, to guide them along the way, and in a pillar of fire by night, to give them
light, that they might travel day and night. The pillar of cloud by day and the pillar of fire by night did

not depart from before the people. The Lord said to Moses ... "I will stiffen Pharaoh's heart and he will pursue them, that I may gain glory through Pharaoh and all his host; and the Egyptians shall know that I am the Lord." And they did so ... The Lord stiffened the heart of Pharaoh king of Egypt, and he gave chase to the Israelites. As the Israelites were departing defiantly ... Then Moses held out his arm over the sea and the Lord drove back the sea with a strong east wind all that night, and turned the sea into dry ground. The waters were split, and the Israelites went into the sea on dry ground, the waters forming a wall for them on their right and on their left. The Egyptians came in pursuit after them into the sea, all of Pharaoh's horses, chariots, and horsemen ... Then the Lord said to Moses, "Hold out your arm over the sea, that the waters may come back upon the Egyptians and upon their chariots and upon their horsemen." Moses held out his arm over the sea, and at daybreak the sea returned to its normal state, and the Egyptians fled at its approach. But the Lord hurled the Egyptians into the sea ... Then Moses and the Israelites sang this song to the Lord. They said: I will sing to the Lord, for He has triumphed gloriously; horse and driver He has hurled into the sea. The Lord is my strength and might; He is become my deliverance. This is my God and I will enshrine Him; the God of my father, and I will exalt Him. (Ex. 13.19–15.2)

For the horses of Pharaoh, with his chariots and horsemen, went into the sea; and the Lord turned back on them the waters of the sea; but the Israelites marched on dry ground in the midst of the sea. Then Miriam the prophetess, Aaron's sister, took a timbrel in her hand, and all the women went out after her in dance with timbrels. And Miriam chanted for them: Sing to the Lord, for He has triumphed gloriously; horse and driver He has hurled into the sea. (Ex. 15.19–21)

Setting out from Elim, the whole Israelite community came to the wilderness of Sin, which is between Elim and Sinai, on the fifteenth day of the second month after their departure from the land of Egypt. In the wilderness, the whole Israelite community grumbled against Moses and Aaron. The Israelites said to them, "If only we had died by the hand of the Lord in the land of Egypt, when we sat by the fleshpots, when we ate our fill of bread! For you have brought us out into this wilderness to starve this whole congregation to death." ... The Lord spoke to Moses: "I have heard the grumbling of the Israelites. Speak to them and say: By evening you shall eat flesh, and in the morning you shall have your fill of bread; and you shall know that I the Lord am your God." In the evening quail appeared and covered the camp; in the morning there was a fall of

dew about the camp. When the fall of dew lifted, there, over the surface of the wilderness, lay a fine and flaky substance, as fine as frost on the ground. When the Israelites saw it, they said to one another, "What is it?"—for they did not know what it was. And Moses said to them, "That is the bread which the Lord has given you to eat." ... But the people thirsted there for water; and the people grumbled against Moses and said, "Why did you bring us up from Egypt, to kill us and our children and livestock with thirst?" ... Then the Lord said to Moses ... "Strike the rock and water will issue from it, and the people will drink." And Moses did so in the sight of the elders of Israel. (Ex. 16.1–17.6)

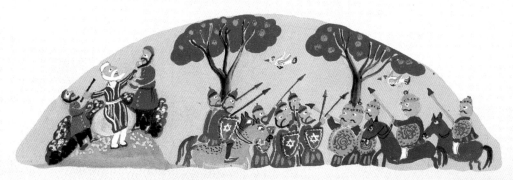

Amalek came and fought with Israel at Rephidim. Moses said to Joshua, "Pick some men for us, and go out and do battle with Amalek. Tomorrow I will station myself on the top of the hill, with the rod of God in my hand." Joshua did as Moses told him and fought with Amalek, while Moses, Aaron, and Hur went up to the top of the hill. Then, whenever Moses held up his hand, Israel prevailed; but whenever he let down his hand, Amalek prevailed. But Moses' hands grew heavy; so they took a stone and put it under him and he sat on it, while Aaron and Hur, one on each side, supported his hands; thus his hands remained steady until the sun set. And Joshua overwhelmed the people of Amalek with the sword. Then the Lord said to Moses, "Inscribe this in a document as a reminder, and read it aloud to Joshua: I will utterly blot out the memory of Amalek from under heaven!" (Ex. 17.8–14)

Haftarat Beshalach

(Ashkenazim read Judges 4.4–5.31)

(Sephardim read Judges 5.1–31)

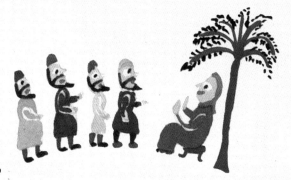

Deborah, wife of Lappidoth, was a prophetess; she led Israel at that time. She used to sit under the Palm of Deborah, between Ramah and Bethel in the hill country of Ephraim, and the Israelites would come to her for decisions. She summoned Barak son of Abinoam, of Kedesh in Naphtali, and said to him, "The Lord, the God of Israel, has commanded: Go, march up to Mount Tabor, and take with you ten thousand men of Naphtali and Zebulun. And I will draw Sisera, Jabin's army commander, with his chariots and his troops, toward you up to the Wadi Kishon; and I will deliver him into your hands." But Barak said to her, "If you will go with me, I will go; if not, I will not go." "Very well, I will go with you," she answered. "However, there will be no glory for you in the course you are taking, for then the Lord will deliver Sisera into the hands of a woman." (Judg. 4.4–9)

Jethro traveled to join the Israelites in the wilderness with his daughter Zipporah, the wife of Moses, and their two sons. Jethro advised Moses to delegate his authority before he wore himself out. Arriving at Mount Sinai, the people prepared themselves to receive the Law. God then pronounced the Ten Commandments from the thundering, cloud-covered mountaintop.

<div dir="rtl">

וישמע יתרו כהן מדין חתן משה את כל אשר עשה אלקים
למשה ולישראל עמו כי הוציא ה׳ את ישראל ממצרים:

</div>

Jethro priest of Midian, Moses' father-in-law, heard all that God had done for Moses and for Israel His people, how the Lord had brought Israel out from Egypt. (Ex. 18.1)

Jethro, Moses' father-in-law, brought Moses' sons and wife to him in the wilderness, where he was encamped at the mountain of God. He sent word to Moses, "I, your father-in-law Jethro, am coming to you, with your wife and her two sons." Moses went out to meet his father-in-law; he bowed low and kissed him ... Moses then recounted to his father-in-law everything that the Lord had done to Pharaoh and to the Egyptians for Israel's sake, all the hardships that had befallen them on the way, and how the Lord had delivered them. And Jethro rejoiced over all the kindness that the Lord had shown Israel ... "Blessed be the Lord," Jethro said, "who delivered you from the Egyptians and from Pharaoh, and who delivered the people from under the hand of the Egyptians ... Next day, Moses sat as magistrate among the people ... But when Moses' father-in-law saw how much he had to do for the people, he said ... "Why do you act alone ... While all the people stand about you from morning until evening?" Moses replied ... "When they have a dispute, it comes before me, and I decide between one person and another, and I make known the laws and teachings of God." But Moses' father-in-law said to him ... "Now listen to me. I will give you counsel, and God be with you! ... You shall ... seek out from among all the people capable men who fear God, trustworthy men who spurn ill-gotten gain. Set these over them as chiefs of thousands, hundreds, fifties, and tens, and let them judge the people at all times. Have them bring every major dispute to you, but let them decide every minor dispute themselves ..." Moses heeded his father-in-law and did just as he had said. (Ex. 18.5–24)

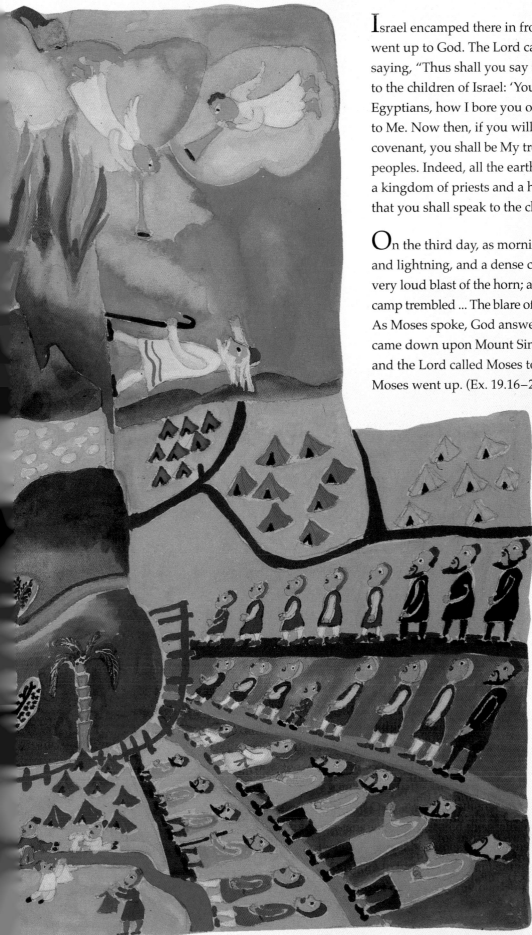

Israel encamped there in front of the mountain, and Moses went up to God. The Lord called to him from the mountain, saying, "Thus shall you say to the house of Jacob and declare to the children of Israel: 'You have seen what I did to the Egyptians, how I bore you on eagles' wings and brought you to Me. Now then, if you will obey Me faithfully and keep My covenant, you shall be My treasured possession among all the peoples. Indeed, all the earth is Mine, but you shall be to Me a kingdom of priests and a holy nation.' These are the words that you shall speak to the children of Israel." (Ex. 19.2–6)

On the third day, as morning dawned, there was thunder, and lightning, and a dense cloud upon the mountain, and a very loud blast of the horn; and all the people who were in the camp trembled ... The blare of the horn grew louder and louder. As Moses spoke, God answered him in thunder. The Lord came down upon Mount Sinai, on the top of the mountain, and the Lord called Moses to the top of the mountain and Moses went up. (Ex. 19.16–20)

God spoke all these words, saying:

I the Lord am your God who brought you out of the land of Egypt, the house of bondage: You shall have no other gods besides Me.

You shall not make for yourself a sculptured image, or any likeness of what is in the heavens above, or on the earth below, or in the waters under the earth. You shall not bow down to them or serve them. For I the Lord your God am an impassioned God, visiting the guilt of the parents upon the children, upon the third and upon the fourth generations of those who reject Me, but showing kindness to the thousandth generation of those who love Me and keep My commandments.

You shall not swear falsely by the name of the Lord your God; for the Lord will not clear one who swears falsely by His name.

Remember the sabbath day and keep it holy. Six days you shall labor and do all your work, but

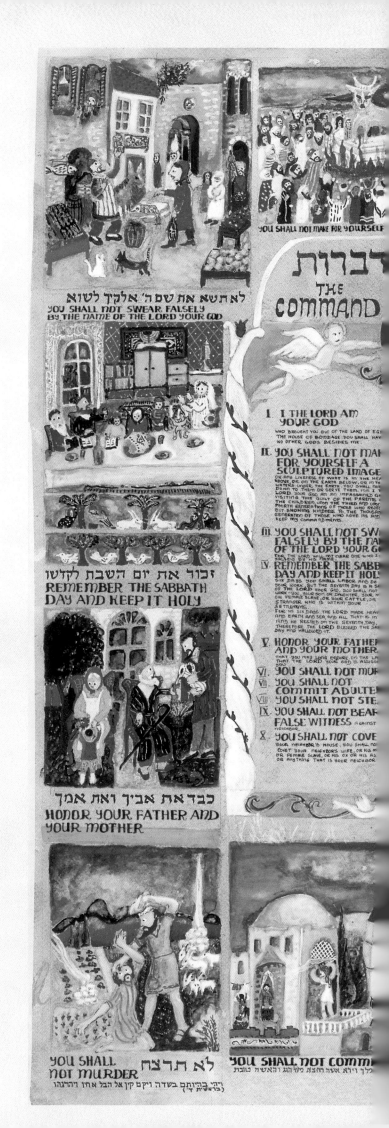

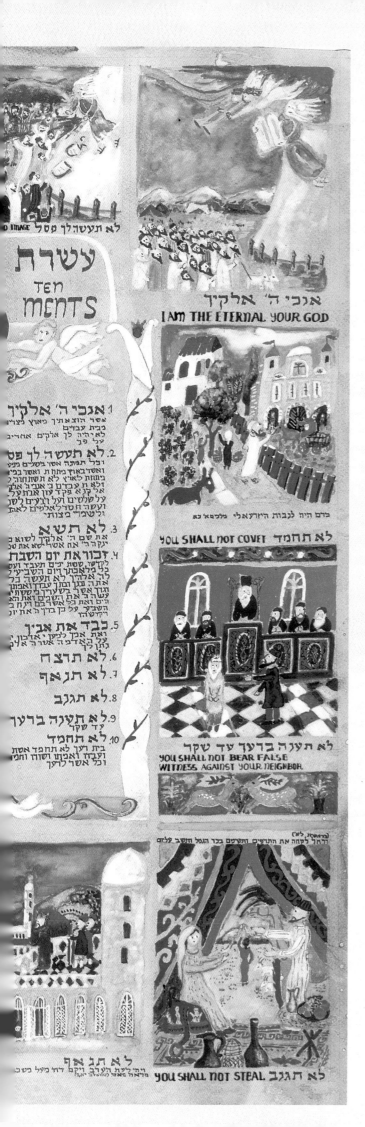

the seventh day is a sabbath of the Lord your God: you shall not do any work—you, your son or daughter, your male or female slave, or your cattle, or the stranger who is within your settlements. For in six days the Lord made heaven and earth and sea, and all that is in them, and He rested on the seventh day; therefore the Lord blessed the sabbath day and hallowed it.

Honor your father and your mother, that you may long endure on the land that the Lord your God is assigning to you.

You shall not murder.

You shall not commit adultery.

You shall not steal.

You shall not bear false witness against your neighbor.

You shall not covet your neighbor's house: you shall not covet your neighbor's wife, or his male or female slave, or his ox or his ass, or anything that is your neighbor's. (Ex. 20.1–14)

Haftarat Yitro

(Ashkenazim read Isaiah 6.1–7.6, 9.5–6) (Sephardim read 6.1–13)

In the year that King Uzziah died, I beheld my Lord seated on a high and lofty throne; and the skirts of His robe filled the Temple. Seraphs stood in attendance on Him. Each of them had six wings: with two he covered his face, with two he covered his legs, and with two he would fly. And one would call to the other, "Holy, holy, holy! The Lord of Hosts! His presence fills all the earth!" The doorposts would shake at the sound of the one who called, and the House kept filling with smoke. I cried, "Woe is me; I am lost! For I am a man of unclean lips and I live among a people of unclean lips; yet my own eyes have beheld the King Lord of Hosts." Then one of the seraphs flew over to me with a live coal, which he had taken from the altar with a pair of tongs. He touched it to my lips and declared, "Now that this has touched your lips, Your guilt shall depart and your sin be purged away." Then I heard the voice of my Lord saying, "Whom shall I send? Who will go for us?" And I said, "Here am I; send me." And He said, "Go, say to that people: 'Hear, indeed, but do not understand; see, indeed, but do not grasp.' Dull that people's mind, stop its ears, and seal its eyes—lest, seeing with its eyes and hearing with its ears, it also grasp with its mind, and repent and save itself." I asked, "How long, my Lord?" And He replied: "till towns lie waste without inhabitants and houses without people, and the ground lies waste and desolate—for the Lord will banish the population—and deserted sites are many in the midst of the land. "But while a tenth part yet remains in it, it shall repent. It shall be ravaged like the terebinth and the oak, of which stumps are left even when they are felled: its stump shall be a holy seed." (Isa. 6.1–13)

Mishpatim 21.1–24.18

*After proclaiming the Ten Commandments, God ordained a set of ethical and ritual laws, and promised victory
to the Israelites when they entered Canaan—if the people remained loyal to God. The people pledged to do so. Moses
then reascended the mountain with seventy elders, and there they beheld a vision of God. When they went back
down to the camp, Moses remained alone on the mountain for forty days.*

ואלה המשפטים אשר תשים לפניהם:

These are the rules that you shall set before them: (Ex. 21.1)

When you acquire a Hebrew slave, he shall serve six years; in the seventh year he shall go free,
without payment. If he came single, he shall leave single; if he had a wife, his wife shall leave with him.
If his master gave him a wife, and she has borne him children, the wife and her children shall belong
to the master, and he shall leave alone. But if the slave declares, "I love my master, and my wife and
children: I do not wish to go free," his master shall take him before God. He shall be brought to the door
or the doorpost, and his master shall pierce his ear with an awl; and he shall then remain his slave for
life. (Ex. 21.2–6)

He who fatally strikes a man shall be put to death. If he did not do it by design, but it came about by
an act of God, I will assign you a place to which he can flee. When a man schemes against another and
kills him treacherously, you shall take him from My very altar to be put to death. He who strikes his
father or his mother shall be put to death. He who kidnaps a man—whether he has sold him or is still
holding him—shall be put to death. He who insults his father or his mother shall be put to death. When
men quarrel and one strikes the other with stone or fist, and he does not die but has to take to his bed—
if he then gets up and walks outdoors upon his staff, the assailant shall go unpunished, except that he
must pay for his idleness and his cure ... When men fight, and one of them pushes a pregnant woman
and a miscarriage results, but no other damage ensues, the one responsible shall be fined according as
the woman's husband may exact from him, the payment to be based on reckoning. But if other damage
ensues, the penalty shall be life for life, eye for eye, tooth for tooth, hand for hand, foot for foot, burn
for burn, wound for wound, bruise for bruise ... When an ox gores a man or a woman to death, the ox
shall be stoned and its flesh shall not be eaten, but the owner of the ox is not to be punished. If, however,
that ox has been in the habit of goring, and its owner, though warned, has failed to guard it, and it kills
a man or a woman—the ox shall be stoned and its owner, too, shall be put to death ... When a man

SHEMOT

Mishpatim

opens a pit, or digs a pit and does not cover it, and an ox or an ass falls into it, the one responsible for the pit must make restitution; he shall pay the price to the owner, but shall keep the dead animal ... When a man steals an ox or a sheep, and slaughters it or sells it, he shall pay five oxen for the ox, and four sheep for the sheep ... When a man lets his livestock loose to graze in another's land, and so allows a field or a vineyard to be grazed bare, he must make restitution for the impairment of that field or vineyard. When a fire is started and spreads to thorns, so that stacked, standing, or growing grain is consumed, he who started the fire must make restitution. (Ex. 21.12–22.5)

If a man seduces a virgin for whom the bride-price has not been paid, and lies with her, he must make her his wife by payment of a bride-price. If her father refuses to give her to him, he must still weigh out silver in accordance with the bride-price for virgins. (Ex. 22.15–16)

You shall not tolerate a sorceress. Whoever lies with a beast shall be put to death. Whoever sacrifices to a god other than the Lord alone shall be proscribed. You shall not wrong a stranger or oppress him, for you were strangers in the land of Egypt. You shall not ill-treat any widow or orphan. If you do mistreat them, I will heed their outcry as soon as they cry out to Me, and My anger shall blaze forth and I will put you to the sword, and your own wives shall become widows and your children orphans. If you lend money to My people, to the poor among you, do not act toward them as a creditor; exact no interest from them. If you take your neighbor's garment in pledge, you must return it to him before the sun sets; it is his only clothing, the sole covering for his skin. In what else shall he sleep? Therefore, if he cries out to Me, I will pay heed, for I am compassionate ... You shall be holy people to Me: you must not eat flesh torn by beasts in the field; you shall cast it to the dogs. (Ex. 22.17–30)

You must not carry false rumors; you shall not join hands with the guilty to act as a malicious witness: You shall neither side with the mighty to do wrong—you shall not give perverse testimony in a dispute so as to

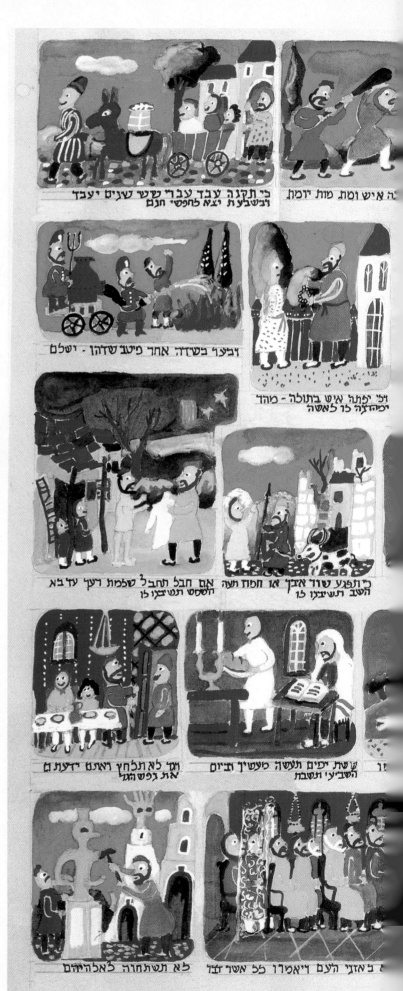

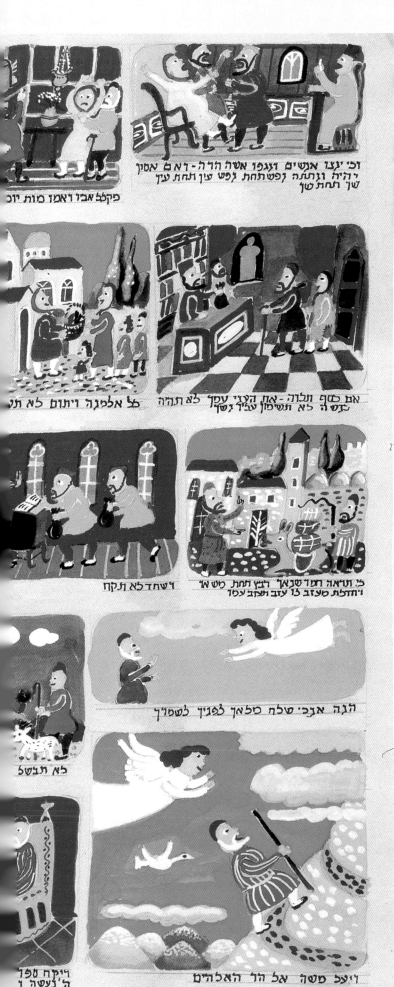

pervert it in favor of the mighty—nor shall you show deference to a poor man in his dispute. When you encounter your enemy's ox or ass wandering, you must take it back to him ... Do not take bribes, for bribes blind the clear-sighted and upset the pleas of those who are in the right. You shall not oppress a stranger, for you know the feelings of the stranger, having yourselves been strangers in the land of Egypt. Six years you shall sow your land and gather in its yield; but in the seventh you shall let it rest and lie fallow ... Six days you shall do your work, but on the seventh day you shall cease from labor, in order that your ox and your ass may rest, and that your bondman and the stranger may be refreshed. (Ex. 23.1–12)

Three times a year you shall hold a festival for Me: You shall observe the Feast of Unleavened Bread— eating unleavened bread for seven days as I have commanded you ... And the Feast of the Harvest, of the first fruits of your work, of what you sow in the field; and the Feast of Ingathering at the end of the year, when you gather in the results of your work from the field. Three times a year all your males shall appear before the Sovereign, the Lord ... You shall not boil a kid in its mother's milk. (Ex. 23.14–19)

I am sending an angel before you to guard you on the way and to bring you to the place that I have made ready. Pay heed to him and obey him. Do not defy him, for he will not pardon your offenses, since My Name is in him; but if you obey him and do all that I say, I will be an enemy to your enemies and a foe to your foes. When My angel goes before you and brings you to the Amorites, the Hittites, the Perizzites, the Canaanites, the Hivites, and the Jebusites, and I annihilate them, you shall not bow down to their gods in worship or follow their practices, but shall tear them down and smash their pillars to bits ... Then he took the record of the covenant and read it aloud to the people ... So Moses and his attendant Joshua arose, and Moses ascended the mountain of God. To the elders he had said, "Wait here for us until we return to you. You have Aaron and Hur with you; let anyone who has a legal matter approach them." (Ex. 23.20–24.14)

Haftarat Mishpatim

(Jeremiah 33.25–26; 34.8–22)

The word which came to Jeremiah from the Lord after King Zedekiah had made a covenant with all the people in Jerusalem to proclaim a release among them—that everyone should set free his Hebrew slaves, both male and female, and that no one should keep his fellow Judean enslaved. Everyone, officials and people, who had entered into the covenant agreed to set their male and female slaves free and not keep them enslaved any longer; they complied and let them go. But afterward they turned about and brought back the men and women they had set free, and forced them into slavery again. Then it was that the word of the Lord came to Jeremiah from the Lord: Thus said the Lord, the God of Israel: I made a covenant with your fathers when I brought them out of the land of Egypt, the house of bondage, saying: "In the seventh year each of you must let go any fellow Hebrew who may be sold to you; when he has served you six years, you must set him free." But your fathers would not obey Me or give ear. Lately you turned about and did what is proper in My sight, and each of you proclaimed a release to his countrymen; and you made a covenant accordingly before Me in the House which bears My name. But now you have turned back and have profaned My name; each of you has brought back the men and women whom you had given their freedom, and forced them to be your slaves again. Assuredly, thus said the Lord: You would not obey Me and proclaim a release, each to his kinsman and countryman. Lo! I proclaim your release—declares the Lord—to the sword, to pestilence, and to famine; and I will make you a horror to all the kingdoms of the earth. I will make the men who violated My covenant, who did not fulfill the terms of the covenant which they made before Me, [like] the calf which they cut in two so as to pass between the halves: The officers of Judah and Jerusalem, the officials, the priests, and all the people of the land who passed between the halves of the calf shall be handed over to their enemies, to those who seek to kill them. Their carcasses shall become food for the birds of the sky and the beasts of the earth. I will hand over King Zedekiah of Judah and his officers to their enemies, who seek to kill them—to the army of the king of Babylon which has withdrawn from you. I hereby give the command—declares the Lord—by which I will bring them back against this city. They shall attack it and capture it, and burn it down. I will make the towns of Judah a desolation, without inhabitant. (Jer. 34.8–22)

During his forty-day vigil on the mountain, God provided Moses with detailed instructions about how to build the Tabernacle, the Mishkan, *and its furnishings, including the Ark of the Covenant, the seven-branched menorah, and the altar.*

וידבר ה' אל משה לאמר: דבר אל בני ישראל ויקחו לי תרומה מאת כל איש אשר ידבנו לבו תקחו את תרומתי:

The Lord spoke to Moses, saying: Tell the Israelite people to bring Me gifts; you shall accept gifts for Me from every person whose heart so moves him. (Ex. 25.1–2)

And let them make Me a sanctuary that I may dwell among them. Exactly as I show you—the pattern of the Tabernacle and the pattern of all its furnishings—so shall you make it. They shall make an ark of acacia wood, two and a half cubits long, a cubit and a half wide, and a cubit and a half high. Overlay it with pure gold—overlay it inside and out—and make upon it a gold molding round about ... You shall make a cover of pure gold, two and a half cubits long and a cubit and a half wide. Make two cherubim of gold—make them of hammered work—at the two ends of the cover. Make one cherub at one end and the other cherub at the other end; of one piece with the cover shall you make the cherubim at its two ends. The cherubim shall have their wings spread out above, shielding the cover with their wings. They shall confront each other, the faces of the cherubim being turned toward the cover. Place the cover on top of the Ark, after depositing inside the Ark the Pact that I will give you. There I will meet with you, and I will impart to you—from above the cover, from between the two cherubim that are on top of the Ark of the Pact—all that I will command you concerning the Israelite

people. You shall make a table of acacia wood, two cubits long, one cubit wide, and a cubit and a half high. Overlay it with pure gold, and make a gold molding around it. Make a rim of a hand's breadth around it, and make a gold molding for its rim round about. Make four gold rings for it, and attach the rings to the four corners at its four legs. The rings shall be next to the rim, as holders for poles to carry the table. Make the poles of acacia wood, and overlay them with gold; by these the table shall be carried ... And on the table you shall set the bread of display, to be before Me always. You shall make a lampstand of pure gold; the lampstand shall be made of hammered work; its base and its shaft, its cups, calyxes, and petals shall be of one piece. Six branches shall issue from its sides; three branches from one side of the lampstand and three branches from the other side of the lampstand ... Make its seven lamps—the

lamps shall be so mounted as to give the light on its front side—and its tongs and fire pans of pure gold. It shall be made, with all these furnishings, out of a talent of pure gold. Note well, and follow the patterns for them that are being shown you on the mountain. As for the Tabernacle, make it of ten strips of cloth; make these of fine twisted linen, of blue, purple, and crimson yarns ... Make fifty copper clasps, and fit the clasps into the loops, and couple the tent together so that it becomes one whole ... You shall make the planks for the Tabernacle of acacia wood, upright. The length of each plank shall be ten cubits and the width of each plank a cubit and a half. (Ex. 25.8–26.16)

You shall make a curtain of blue, purple, and crimson yarns, and fine twisted linen; it shall have a design of cherubim worked into it. Hang it upon four posts of acacia wood overlaid with gold and having hooks of gold, [set] in four sockets of silver. Hang the curtain under the clasps, and carry the Ark of the Pact there, behind the curtain, so that the curtain shall serve you as a partition between the Holy and the Holy of Holies. Place the cover upon the Ark of the Pact in the Holy of Holies ... You shall make a screen for the entrance of the Tent, of blue, purple, and crimson yarns, and fine twisted linen, done in embroidery. Make five posts of acacia wood for the screen and overlay them with gold—their hooks being of gold— and cast for them five sockets of copper. You shall make the altar of acacia wood, five cubits long and five cubits wide—the altar is to be square—and three cubits high. Make its horns on the four corners, the horns to be of one piece with it; and overlay it with copper ... You shall make the enclosure of the Tabernacle: On the south side, a hundred cubits of hangings of fine twisted linen for the length of the enclosure on that side—with its twenty posts and their twenty sockets of copper, the hooks and bands of the posts to be of silver. (Ex. 26.31–27.10)

Haftarat Terumah

(1 Kings 5.26–6.13)

The Lord had given Solomon wisdom, as He had promised him. There was friendship between Hiram and Solomon, and the two of them made a treaty. King Solomon imposed forced labor on all Israel; the levy came to 30,000 men. He sent them to the Lebanon in shifts of 10,000 a month: they would spend one month in the Lebanon and two months at home. Adoniram was in charge of the forced labor. Solomon also had 70,000 porters and 80,000 quarriers in the hills, apart from Solomon's 3,300 officials who were in charge of the work and supervised the gangs doing the work. The king ordered huge blocks of choice stone to be quarried, so that the foundations of the house might be laid with hewn stones. Solomon's masons, Hiram's masons, and the men of Gebal shaped them. Thus the timber and the stones for building the house were made ready. In the four hundred and eightieth year after the Israelites left the land of Egypt, in the month of Ziv—that is, the second month—in the fourth year of his reign over Israel, Solomon began to build the House of the Lord. (1 Kings 5.26–6.1)

God also revealed to Moses how to make the priestly garments and described the seven day ritual to invest Aaron and his sons as priests.

You shall further instruct the Israelites to bring you clear oil of beaten olives for lighting, for kindling lamps regularly. (Ex. 27.20)

ואתה תצוה את בני ישראל ויקחו אליך
שמן זית זך כתית למאור להעלת נר תמיד:

Aaron and his sons shall set them up in the Tent of Meeting, outside the curtain which is over [the Ark of] the Pact, [to burn] from evening to morning before the Lord. It shall be a due from the Israelites for all time, throughout the ages. You shall bring forward your brother Aaron, with his sons, from among the Israelites, to serve Me as priests ... Make sacral vestments for your brother Aaron, for dignity and adornment ... These are the vestments they are to make: a breastpiece, an ephod, a robe, a fringed tunic, a headdress, and a sash. They shall make those sacral vestments for your brother Aaron and his sons,

for priestly service to Me; they, therefore, shall receive the gold, the blue, purple, and crimson yarns, and the fine linen. They shall make the ephod of gold, of blue, purple, and crimson yarns, and of fine twisted linen, worked into designs. It shall have two shoulder-pieces attached; they shall be attached at its two ends. And the decorated band that is upon it shall be made like it, of one piece with it: of gold, of blue, purple, and crimson yarns, and of fine twisted linen. Then take two lazuli stones and engrave on them the names of the sons of Israel: six of their names on the one stone, and the names of the remaining six on the other stone, in the order of their birth ... You shall make a breastpiece of decision ... Set in it mounted stones, in four rows of stones. The first row shall be a row of carnelian, chrysolite, and emerald; the second row: a turquoise, a sapphire, and an amethyst; the third row: a jacinth, an agate, and a crystal; and the fourth row: a beryl, a lapis lazuli, and a jasper. They shall be framed with gold in their mountings. The stones shall correspond [in number] to the names of the sons of Israel: twelve, corresponding to their names. They shall be engraved like seals, each with its name, for the twelve tribes. On the breastpiece make braided chains of corded work in pure gold. Make two rings of gold on the breastpiece, and fasten the two rings at the two ends of the breastpiece, attaching the two golden cords to the two rings at the ends of the breastpiece ... Inside the breastpiece of decision you shall place the Urim and Thummim, so that they are over Aaron's heart when he comes before the Lord ... You shall make the robe of the ephod of pure blue ... You shall make a frontlet of pure gold and engrave on it the seal inscription: "Holy to the Lord." ... You shall make the fringed tunic of fine linen. You shall make the headdress of fine linen. You shall make the sash of embroidered work. And for Aaron's sons also you shall make tunics, and make sashes for them, and make turbans for them, for dignity and adornment. (Ex. 27.21–28.40)

This is what you shall do to them in consecrating them to serve Me as priests: Take a young bull of the herd and two rams without blemish; also unleavened bread, unleavened cakes with oil mixed in, and unleavened wafers spread with oil—make these of choice wheat flour. Place these in one basket and present them in the basket, along with the bull and the two rams ... Then take the other ram, and let Aaron and his sons lay their hands upon the ram's head. Slaughter the ram, and take some of its blood and put it on the ridge of Aaron's right ear and on the ridges of his sons' right ears, and on the thumbs of their right hands, and on the big toes of their right feet; and dash the rest of the blood against every side of the altar round about. Take some of the blood that is on the altar and some of the anointing oil and sprinkle upon Aaron and his vestments, and also upon his sons and his sons' vestments. Thus shall he and his vestments be holy, as well as his sons and his sons' vestments. You shall take from the ram the fat parts—the broad tail, the fat that covers the entrails, the protuberance on the liver, the two kidneys with the fat on them—and the right thigh; for this is a ram of ordination. Add one flat loaf of bread, one cake of oil bread, and one wafer, from the basket of unleavened bread that is before the Lord. Place all these on the palms of Aaron and his sons, and offer

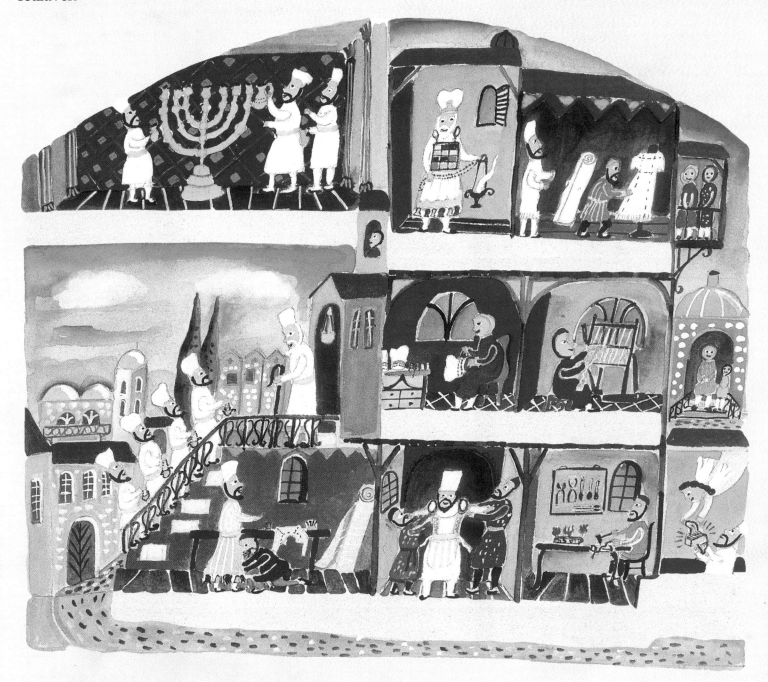

them as an elevation offering before the Lord. Take them from their hands and turn them into smoke upon the altar with the burnt offering, as a pleasing odor before the Lord; it is an offering by fire to the Lord. Then take the breast of Aaron's ram of ordination and offer it as an elevation offering before the Lord; it shall be your portion. You shall consecrate the breast that was offered as an elevation offering and the thigh that was offered as a gift offering from the ram of ordination—from that which was Aaron's and from that which was his sons'—and those parts shall be a due for all time from the Israelites to Aaron and his descendants. For they are a gift; and so shall they be a gift from the Israelites, their gift to the Lord out of their sacrifices of well-being. The sacral vestments of Aaron shall pass on to his sons after him, for them to be anointed and ordained in. He among his sons who becomes priest in his stead, who enters the Tent of Meeting to officiate within the sanctuary, shall wear them seven days ... Now this is what you shall offer upon the altar: two yearling lambs each day, regularly. You shall offer the

one lamb in the morning, and you shall offer the other lamb at twilight. There shall be a tenth of a measure of choice flour with a quarter of a *hin* of beaten oil mixed in, and a libation of a quarter *hin* of wine for one lamb; and you shall offer the other lamb at twilight, repeating with it the meal offering of the morning with its libation—an offering by fire for a pleasing odor to the Lord, a regular burnt offering throughout the generations, at the entrance of the Tent of Meeting before the Lord ... You shall make an altar for burning incense; make it of acacia wood. It shall be a cubit long and a cubit wide—it shall be square—and two cubits high, its horns of one piece with it. Overlay it with pure gold: its top, its sides round about, and its horns; and make a gold molding for it round about. And make two gold rings for it under its molding; make them on its two side walls, on opposite sides. They shall serve as holders for poles with which to carry it. Make the poles of acacia wood, and overlay them with gold. (Ex. 29.1–30.5)

Haftarat Tetzaveh

(Ezekiel 43.10–27)

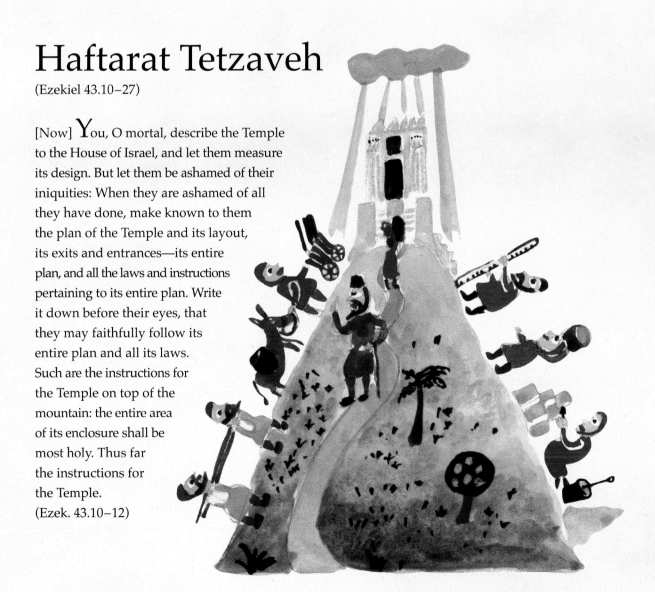

[Now] You, O mortal, describe the Temple to the House of Israel, and let them measure its design. But let them be ashamed of their iniquities: When they are ashamed of all they have done, make known to them the plan of the Temple and its layout, its exits and entrances—its entire plan, and all the laws and instructions pertaining to its entire plan. Write it down before their eyes, that they may faithfully follow its entire plan and all its laws. Such are the instructions for the Temple on top of the mountain: the entire area of its enclosure shall be most holy. Thus far the instructions for the Temple.
(Ezek. 43.10–12)

God gave Moses additional instructions about the Tabernacle, including how to prepare the special oil and incense. To maintain the Tabernacle, God commanded that every Israelite pay a half shekel to the priests. When Moses had been gone for forty days, the people despaired of seeing him alive, and asked Aaron to fashion a Golden Calf for them to worship. Incensed at their betrayal, God doomed the Israelites to destruction, but Moses successfully appealed the sentence. Moses then descended the mountain and shattered the tablets of the Ten Commandments upon the Golden Calf. The Levites killed three thousand idolaters. Then Moses again appealed to God for mercy. A deadly plague struck the camp, killing many more of the sinners.

כי תשא את ראש בני ישראל לפקדיהם ונתנו איש כפר
נפשו לה' בפקד אתם ולא יהיה בהם נגף בפקד אתם:

The Lord spoke to Moses, saying: When you take a census of the Israelite people according to their enrollment, each shall pay the Lord a ransom for himself on being enrolled, that no plague may come upon them through their being enrolled. (Ex. 30.11–12)

This is what everyone who is entered in the records shall pay: a half-shekel by the sanctuary weight—twenty *gerah*s to the shekel—a half-shekel as an offering to the Lord. Everyone who is entered in the records, from the age of twenty years up, shall give the Lord's offering ... Make a laver of copper and a stand of copper for it, for washing; and place it between the Tent of Meeting and the altar. Put water in it, and let Aaron and his sons wash their hands and feet [in water drawn] from it ... Make of this a sacred anointing oil, a compound of ingredients expertly blended, to serve as sacred anointing oil ... Take the herbs stacte, onycha, and galbanum—these herbs together with pure frankincense; let there be an equal part of each. Make them into incense, a compound expertly blended, refined, pure, sacred. Beat some of it into powder, and put some before the Pact in the Tent of Meeting, where I will meet with you; it shall be most holy to you. (Ex. 30.12–36)

The Lord spoke to Moses: See, I have singled out by name Bezalel son of Uri son of Hur, of the tribe of Judah. I have endowed him with a divine spirit of skill, ability, and knowledge in every kind of craft; to make designs for work in gold, silver, and copper, to cut stones for setting and to carve wood—to work in every kind of craft. Moreover, I have assigned to him Oholiab son of Ahisamach, of the tribe of Dan; and I have also granted skill to all who are skillful, that they may make everything that I have commanded you: the Tent of Meeting, the Ark for the Pact and the cover upon it, and all the furnishings of the Tent; the table and its utensils, the pure lampstand and all its fittings, and the altar of incense; the altar of burnt offering and all its utensils, and the laver and its stand; the service vestments, the sacral vestments of Aaron the priest and the vestments of his sons, for their service as priests ... Speak to the Israelite people and say: Nevertheless, you must keep My sabbaths, for this is a sign between Me and you throughout the ages, that you may know that I the Lord have consecrated you. You shall keep the sabbath, for it is holy for you. He who profanes it shall be put to death: whoever does work on it, that person shall be cut off from among his kin. Six days may work be done, but on the seventh day there shall be a sabbath of complete rest, holy to the Lord; whoever does work on the sabbath day shall be put to death. The Israelite people shall keep the sabbath, observing the sabbath throughout the ages as a covenant for all time: it shall be a sign for all time between Me and the people of Israel. For in six days the Lord made heaven and earth, and on the seventh day He ceased from work and was refreshed. (Ex. 31.1–17)

When He finished speaking with him on Mount Sinai, He gave Moses the two tablets of the Pact, stone tablets inscribed with the finger of God. When the people saw that Moses was so long in coming down from the mountain, the people gathered against Aaron and said to him, "Come, make us a god who shall go before us, for that man Moses, who brought us from the land of Egypt—we do not know what has happened to him." Aaron said to them, "Take off the gold rings that are on the ears of your wives, your sons, and your daughters, and bring them to me." And all the people took off the gold rings that were in their ears and brought them to Aaron. This he took from them and cast in a mold, and made

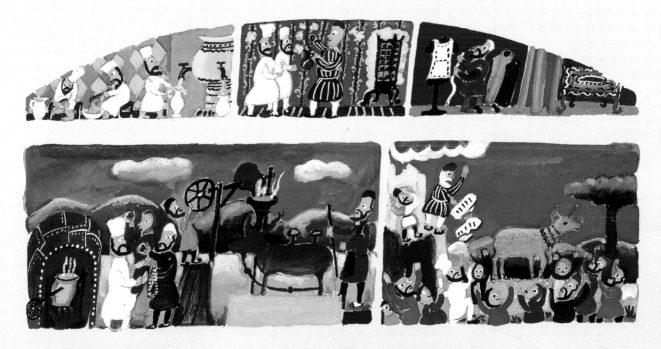

it into a molten calf. And they exclaimed, "This is your god, O Israel, who brought you out of the land of Egypt!" When Aaron saw this, he built an altar before it; and Aaron announced: "Tomorrow shall be a festival of the Lord!" Early next day, the people offered up burnt offerings and brought sacrifices of well-being; they sat down to eat and drink, and then rose to dance. The Lord spoke to Moses, "Hurry down, for your people, whom you brought out of the land of Egypt, have acted basely. They have been quick to turn aside from the way that I enjoined upon them. They have made themselves a molten calf and bowed low to it and sacrificed to it, saying: 'This is your god, O Israel, who brought you out of the land of Egypt!'" The Lord further said to Moses, "I see that this is a stiffnecked people. Now, let Me be, that My anger may blaze forth against them and that I may destroy them, and make of you a great nation." But Moses implored the Lord his God, saying, "Let not Your anger, O Lord, blaze forth against Your people, whom You delivered from the land of Egypt with great power and with a mighty hand. Let not the Egyptians say, 'It was with evil intent that He delivered them, only to kill them off in the mountains and annihilate them from the face of the earth.' Turn from Your blazing anger, and renounce the plan to punish Your people. Remember Your servants, Abraham, Isaac, and Israel, how You swore to them by Your Self and said to them: I will make your offspring as numerous as the stars of heaven, and I will give to your offspring this whole land of which I spoke, to possess forever." And the Lord renounced the punishment He had planned to bring upon His people. (Ex. 31.18–32.14)

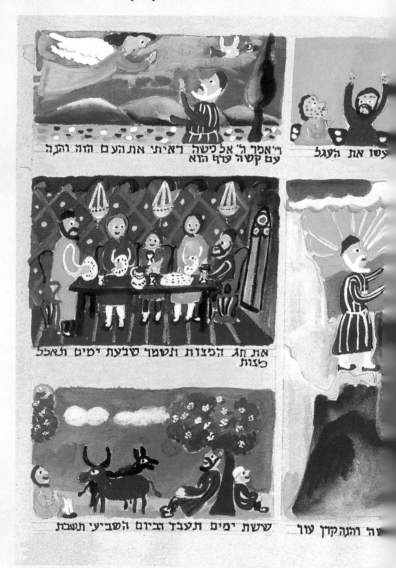

As soon as Moses came near the camp and saw the calf and the dancing, he became enraged; and he hurled the tablets from his hands and shattered them at the foot of the mountain. He took the calf that they had made and burned it; he ground it to powder and strewed it upon the water and so made the Israelites drink it ... Moses saw that the people were out of control—since Aaron had let them get out of control—so that they were a menace to any who might oppose them. Moses stood up in the gate of the camp and said, "Whoever is for the Lord, come here!" And all the Levites rallied to him. He said to them, "Thus says the Lord, the God of Israel: Each of you put sword on thigh, go back and forth from gate to gate throughout the camp, and slay brother, neighbor, and kin." The Levites did as Moses had bidden; and some three thousand of the people fell that day. And Moses said, "Dedicate yourselves to the Lord this day—for each of you has been against son and brother—that He may bestow a blessing upon you today." ... Then the Lord sent a plague upon the people, for what they did with the calf that Aaron made. Then the Lord said to Moses, "Set out from here, you and the people that you have brought up from the land of Egypt, to the land of which I swore to Abraham,

Isaac, and Jacob, saying, 'To your offspring will I give it'—I will send an angel before you, and I will drive out the Canaanites, the Amorites, the Hittites, the Perizzites, the Hivites, and the Jebusites—a land flowing with milk and honey. But I will not go in your midst, since you are a stiffnecked people, lest I destroy you on the way." ... And when Moses entered the Tent, the pillar of cloud would descend and stand at the entrance of the Tent, while He spoke with Moses. When all the people saw the pillar of cloud poised at the entrance of the Tent, all the people would rise and bow low, each at the entrance of his tent. (Ex. 32.19–33.10)

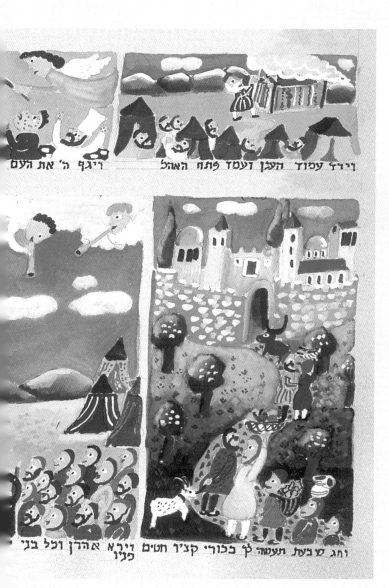

He [Moses] said, "Oh, let me behold Your Presence!" And He answered, "I will make all My goodness pass before you, and I will proclaim before you the name Lord, and the grace that I grant and the compassion that I show. But," He said, "you cannot see My face, for man may not see Me and live." And the Lord said, "See, there is a place near Me. Station yourself on the rock and, as My Presence passes by, I will put you in a cleft of the rock and shield you with My hand until I have passed by. Then I will take My hand away and you will see My back; but My face must not be seen." The Lord said to Moses: "Carve two tablets of stone like the first, and I will inscribe upon the tablets the words that were on the first tablets, which you shattered ... So Moses carved two tablets of stone, like the first, and early in the morning he went up on Mount Sinai, as the Lord had commanded him, taking the two stone tablets with him. The Lord came down in a cloud; He stood with him there, and proclaimed the name Lord. The Lord passed before him and proclaimed: "The Lord! the Lord! a God compassionate and gracious, slow to anger, abounding in kindness and faithfulness, extending kindness to the thousandth generation, forgiving iniquity, transgression, and sin; yet He does not remit all punishment, but visits the iniquity of parents upon children and children's children, upon the third and fourth generations." Moses hastened to bow low to the ground in homage, and said, "If I have gained Your favor, O Lord, pray, let the Lord go in our midst, even though this is a stiffnecked people. Pardon our iniquity and our sin, and take us for Your own!" (Ex. 33.18–34.9)

He said: I hereby make a covenant. Before all your people I will work such wonders as have not been wrought on all the earth or in any nation; and all the people who are with you shall see how awesome are the Lord's deeds which I will perform for you. Mark well what I command you this day. I will drive out before you the Amorites, the Canaanites, the Hittites, the Perizzites, the Hivites, and the Jebusites.

Beware of making a covenant with the inhabitants of the land against which you are advancing, lest they be a snare in your midst. No, you must tear down their altars, smash their pillars, and cut down their sacred posts; for you must not worship any other god, because the Lord, whose name is Impassioned, is an impassioned God. You must not make a covenant with the inhabitants of the land, for they will lust after their gods and sacrifice to their gods and invite you, and you will eat of their sacrifices ... And the Lord said to Moses: Write down these commandments, for in accordance with these commandments I make a covenant with you and with Israel. And he was there with the Lord forty days and forty nights; he ate no bread and drank no water; and he wrote down on the tablets the terms of the covenant, the Ten Commandments. So Moses came down from Mount Sinai. And as Moses came down from the mountain bearing the two tablets of the Pact, Moses was not aware that the skin of his face was radiant, since he had spoken with Him. Aaron and all the Israelites saw that the skin of Moses' face was radiant; and they shrank from coming near him. (Ex. 34.10–30)

Haftarat Ki Tisa

(Ashkenazim read 1 Kings 18.1–39) (Sephardim read 18.20–39)

Ahab sent orders to all the Israelites and gathered the prophets at Mount Carmel. Elijah approached all the people and said, "How long will you keep hopping between two opinions? If the Lord is God, follow Him; and if Baal, follow him!" But the people answered him not a word. Then Elijah said to the people, "I am the only prophet of the Lord left, while the prophets of Baal are four hundred and fifty men. Let two young bulls be given to us. Let them choose one bull, cut it up, and lay it on the wood, but let them not apply fire; I will prepare the other bull, and lay it on the wood, and will not apply fire. You will then invoke your god by name, and I will invoke the Lord by name; and let us agree: the god who responds with fire, that one is God." And all the people answered, "Very good!" Elijah said to the prophets of Baal, "Choose one bull and prepare it first, for you are the majority; invoke your god by name, but apply no fire." They took the bull that was given them; they prepared it, and invoked Baal by name from morning until noon, shouting, "O Baal, answer us!" But there was no sound, and none who responded; so they performed a hopping dance about the altar that had been set up. When noon came, Elijah mocked them, saying, "Shout louder! After all, he is a god. But he may be in conversation, he may be detained, or he may be on a journey, or perhaps he is asleep and will wake up." So they shouted louder, and gashed themselves with knives and spears, according to their practice, until the blood streamed over them. When noon passed, they kept raving until the hour of presenting the meal offering. Still there was no sound, and none who responded or heeded. (1 Kings 18.20–29)

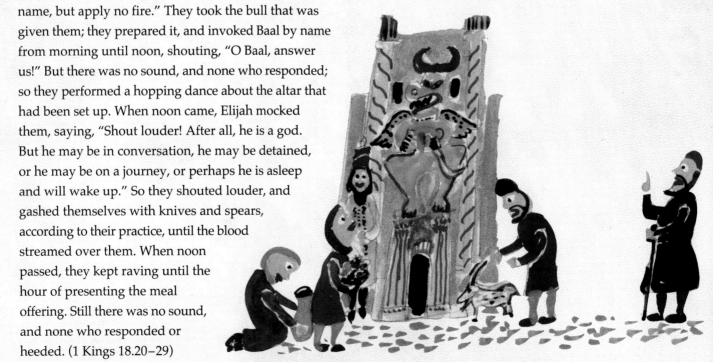

Moses asked the people to donate precious metals, wood, yarn, skins, and cloth to build and furnish the Tabernacle. The people brought so many gifts that Moses had to ask them to stop. Following God's instructions, Bezalel and his artisans then built the Tabernacle and its furnishings, including the Ark of the Covenant, the seven-branched menorah, and the altar.

ויקהל משה את כל עדת בני ישראל ויאמר אלהם
אלה הדברים אשר צוה ה' לעשת אתם:

Moses then convoked the whole Israelite community and said to them: These are the things that the Lord has commanded you to do: (Ex. 35.1)

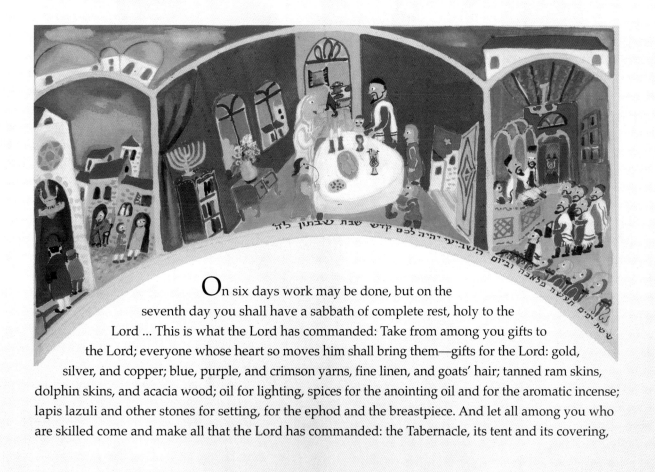

On six days work may be done, but on the seventh day you shall have a sabbath of complete rest, holy to the Lord ... This is what the Lord has commanded: Take from among you gifts to the Lord; everyone whose heart so moves him shall bring them—gifts for the Lord: gold, silver, and copper; blue, purple, and crimson yarns, fine linen, and goats' hair; tanned ram skins, dolphin skins, and acacia wood; oil for lighting, spices for the anointing oil and for the aromatic incense; lapis lazuli and other stones for setting, for the ephod and the breastpiece. And let all among you who are skilled come and make all that the Lord has commanded: the Tabernacle, its tent and its covering,

its clasps and its planks, its bars, its posts, and its sockets; the ark and its poles, the cover, and the curtain for the screen; the table, and its poles and all its utensils; and the bread of display; the lampstand for lighting, its furnishings and its lamps, and the oil for lighting; the altar of incense and its poles; the anointing oil and the aromatic incense; and the entrance screen for the entrance of the Tabernacle; the altar of burnt offering, its copper grating, its poles, and all its furnishings; the laver and its stand; the hangings of the enclosure, its posts and its sockets, and the screen for the gate of the court; the pegs for the Tabernacle, the pegs for the enclosure, and their cords; the service vestments for officiating in the sanctuary, the sacral vestments of Aaron the priest and the vestments of his sons for priestly service. (Ex. 35.2–19)

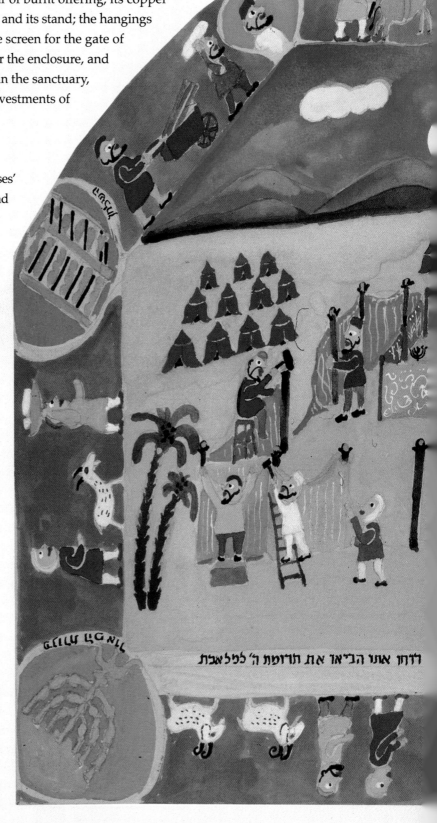

So the whole community of the Israelites left Moses' presence. And everyone who excelled in ability and everyone whose spirit moved him came, bringing to the Lord his offering for the work of the Tent of Meeting and for all its service and for the sacral vestments. Men and women, all whose hearts moved them, all who would make an elevation offering of gold to the Lord, came bringing brooches, earrings, rings, and pendants—gold objects of all kinds. And everyone who had in his possession blue, purple, and crimson yarns, fine linen, goats' hair, tanned ram skins, and dolphin skins, brought them; everyone who would make gifts of silver or copper brought them as gifts for the Lord; and everyone who had in his possession acacia wood for any work of the service brought that. And all the skilled women spun with their own hands, and brought what they had spun, in blue, purple, and crimson yarns, and in fine linen. And all the women who excelled in that skill spun the goats' hair. And the chieftains brought lapis lazuli and other stones for setting, for the ephod and for the breastpiece; and spices and oil for lighting, for the anointing oil, and for the aromatic incense. Thus the Israelites, all the men and women whose hearts moved them to bring anything for the work that the Lord, through Moses, had commanded to be done, brought it as a freewill offering to the Lord. And Moses said to the Israelites: See, the Lord has singled out by name Bezalel, son of Uri son

of Hur, of the tribe of Judah. He has endowed him with a divine spirit of skill, ability, and knowledge in every kind of craft and has inspired him to make designs for work in gold, silver, and copper, to cut stones for setting and to carve wood—to work in every kind of designer's craft— and to give directions. He and Oholiab son of Ahisamach of the tribe of Dan have been endowed with the skill to do any work—of the carver, the designer, the embroiderer in blue, purple, crimson yarns, and in fine linen, and of the weaver—as workers in all crafts and as makers of designs. Let, then, Bezalel and Oholiab and all the skilled persons whom the Lord has endowed with skill and ability to perform expertly all the tasks connected with the service of the sanctuary carry out all that the Lord has commanded. (Ex. 35.20–36.1)

They made cloths of goats' hair for a tent over the Tabernacle; they made the cloths eleven in number ... They made fifty loops on the edge of the outermost cloth of the one set, and they made fifty loops on the edge of the end cloth of the other set. They made fifty copper clasps to couple the Tent together so that it might become one whole. And they made a covering of tanned ram skins for the tent, and a covering of dolphin skins above. They made the planks for the Tabernacle of acacia wood, upright ... They made bars of acacia wood, five for the planks of the one side wall of the Tabernacle ... They made the curtain of blue, purple, and crimson yarns, and fine twisted linen, working into it a design of cherubim. They made for it four posts of acacia wood and overlaid them with gold, with their hooks of gold; and they cast for them four silver sockets. They made the screen for the entrance of the Tent, of blue, purple, and crimson yarns, and fine twisted linen, done in embroidery; and five posts for it with their hooks. They overlaid their tops and their bands with gold; but the five sockets were of copper. Bezalel made ... The lampstand of pure gold. He made the lampstand— its base and its shaft—of hammered work; its cups, calyxes, and petals were of one piece with it. Six branches issued from its sides: three branches from one side of the lampstand, and three branches from the other side of the lampstand. (Ex. 36.14–18)

99

Haftarat Vayakhel

(Ashkenazim read 1 Kings 7.40–50)

Hiram also made the lavers, the scrapers, and the sprinkling bowls. So Hiram finished all the work that he had been doing for King Solomon on the House of the Lord: the two columns, the two globes of the capitals upon the columns; and the two pieces of network to cover the two globes of the capitals upon the columns; the four hundred

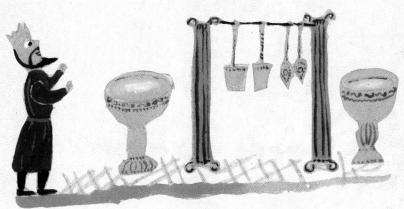

pomegranates for the two pieces of network, two rows of pomegranates for each network, to cover the two globes of the capitals upon the columns; the ten stands and the ten lavers upon the stands; the one tank with the twelve oxen underneath the tank; the pails, the scrapers, and the sprinkling bowls. All those vessels in the House of the Lord that Hiram made for King Solomon were of burnished bronze. (1 Kings 7.40–45)

(Sephardim read 1 Kings 7.13–26)

King Solomon sent for Hiram and brought him down from Tyre. He was the son of a widow of the tribe of Naphtali, and his father had been a Tyrian, a coppersmith. He was endowed with skill, ability, and talent for executing all work in bronze. He came to King Solomon and executed all his work. He cast two columns of bronze; one column was 18 cubits high and measured 12 cubits in circumference, [and similarly] the other column. He made two capitals, cast in bronze, to be set upon the two columns, the height of each of the two capitals being 5 cubits; also nets of meshwork with festoons of chainwork for the capitals that were on the top of the columns, seven for each of the two capitals. He made the columns so that there were two rows [of pomegranates] encircling the top of the one network, to cover the capitals that were on the top of the pomegranates; and he did the same for [the network on] the second capital. (1 Kings 7.13–18)

Skilled workers made the priestly garments according to God's instructions. When the work was finally finished, Moses blessed people. On the first day of the first month of their first year of wandering in the desert, Moses dedicated the Tabernacle as God had commanded. Then the Cloud of Divine Presence, the Shekhinah, *filled the Tabernacle.*

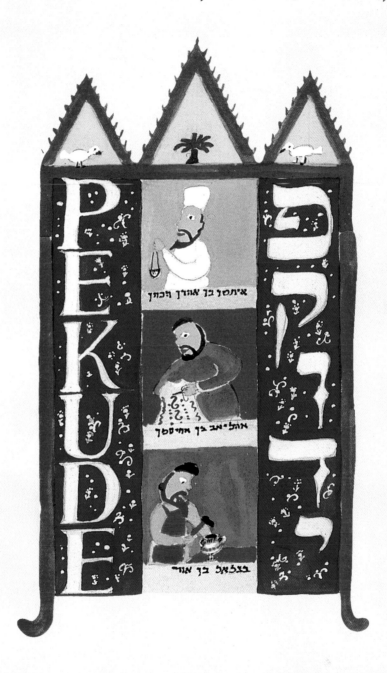

אלה פקודי המשכן משכן העדת אשר פקד על פי משה
עבדת הלוים ביד איתמר בן אהרן הכהן:

These are the records of the Tabernacle, the Tabernacle of the Pact, which were drawn up at Moses' bidding—the work of the Levites under the direction of Ithamar son of Aaron the priest. (Ex. 38.21)

SHEMOT

Pekude

All the gold that was used for the work, in all the work of the sanctuary—the elevation offering of gold—came to 29 talents and 730 shekels by the sanctuary weight. The silver of those of the community who were recorded came to 100 talents and 1,775 shekels by the sanctuary weight: a half-shekel a head, half a shekel by the sanctuary weight, for each one who was entered in the records, from the age of twenty years up, 603,550 men. The 100 talents of silver were for casting the sockets of the sanctuary and the sockets for the curtain, 100 sockets to the 100 talents, a talent a socket. And of the 1,775 shekels he made hooks for the posts, overlay for their tops, and bands around them.

The copper from the elevation offering came to 70 talents and 2,400 shekels. (Ex. 38.24–29)

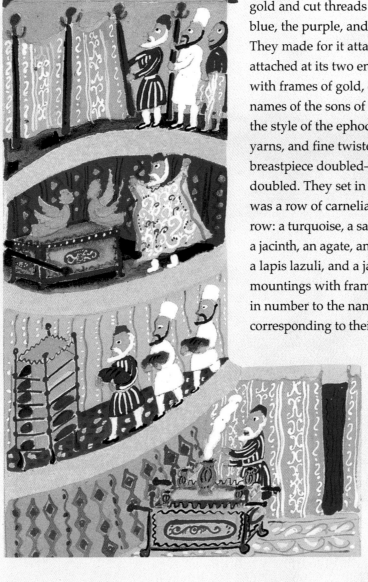

The ephod was made of gold, blue, purple, and crimson yarns, and fine twisted linen. They hammered out sheets of gold and cut threads to be worked into designs among the blue, the purple, and the crimson yarns, and the fine linen. They made for it attaching shoulder-pieces; they were attached at its two ends ... They bordered the lazuli stones with frames of gold, engraved with seal engravings of the names of the sons of Israel ... The breastpiece was made in the style of the ephod: of gold, blue, purple, and crimson yarns, and fine twisted linen. It was square; they made the breastpiece doubled—a span in length and a span in width, doubled. They set in it four rows of stones. The first row was a row of carnelian, chrysolite, and emerald; the second row: a turquoise, a sapphire, and an amethyst; the third row: a jacinth, an agate, and a crystal; and the fourth row: a beryl, a lapis lazuli, and a jasper. They were encircled in their mountings with frames of gold. The stones corresponded in number to the names of the sons of Israel: twelve, corresponding to their names; engraved like seals, each with its name, for the twelve tribes. On the breastpiece they made braided chains of corded work in pure gold. They made two frames of gold and two rings of gold, and fastened the two rings at the two ends of the breastpiece, attaching the two golden cords to the two rings at the ends of the breastpiece. (Ex. 39.2–16)

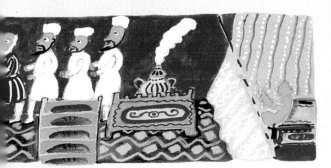

They made the tunics of fine linen, of woven work, for
Aaron and his sons ... They made the frontlet for the holy diadem
of pure gold, and incised upon it the seal inscription: "Holy to the
Lord." ... Thus was completed all the work of the Tabernacle of
the Tent of Meeting. The Israelites did so; just as the Lord had
commanded Moses, so they did. Then they brought the Tabernacle
to Moses, with the Tent and all its
furnishings: its clasps, its planks, its
bars, its posts, and its sockets ... Just as the Lord had commanded
Moses, so the Israelites had done all the work. And when Moses
saw that they had performed all the tasks—as the Lord had
commanded, so they had done—Moses blessed them.
(Ex. 39.27–43)

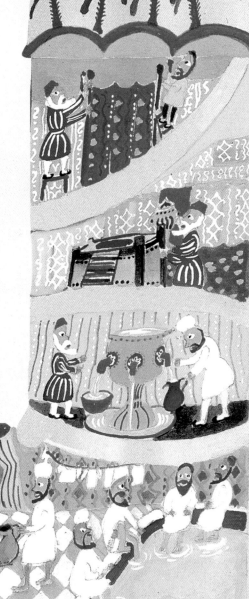

And the Lord spoke to Moses, saying: On the first day of
the first month you shall set up the Tabernacle of the Tent of
Meeting. Place there the Ark of the Pact, and screen off the
ark with the curtain. Bring in the table and lay out its due
setting; bring in the lampstand and light its lamps ... Moses
set up the Tabernacle, placing its sockets, setting up its planks,
inserting its bars, and erecting its posts ... He took the Pact
and placed it in the ark; he fixed the poles to the ark, placed
the cover on top of the ark ... He placed the table in the Tent
of Meeting, outside the curtain, on the north side of the
Tabernacle. Upon it he laid out the setting of bread before the
Lord—as the Lord had commanded Moses. He placed the
lampstand in the Tent of Meeting opposite the table, on the
south side of the Tabernacle. And he lit the lamps before the
Lord—as the Lord had commanded Moses. He placed the
altar of gold in the Tent of Meeting, before the curtain ...
Then he put up the screen for the entrance of the Tabernacle.
At the entrance of the Tabernacle of the Tent of Meeting he
placed the altar of burnt offering ... He
placed the laver between the Tent of
Meeting and the altar, and put water
in it for washing. From it Moses and
Aaron and his sons would wash their
hands and feet ... When Moses had
finished the work, the cloud covered
the Tent of Meeting, and the Presence
of the Lord filled the Tabernacle.
(Ex. 40.1–35)

Haftarat Pekude

(Ashkenazim read 1 Kings 7.51–8.21)

When all the work that King Solomon had done in the House of the Lord was completed, Solomon brought in the sacred donations of his father David—the silver, the gold, and the vessels—and deposited them in the treasury of the House of the Lord. Then Solomon convoked the elders of Israel—all the heads of the tribes and the ancestral chieftains of the Israelites—before King Solomon in Jerusalem, to bring up the Ark of the Covenant of the Lord from the City of David, that is, Zion. All the men of Israel gathered before King Solomon at the Feast, in the month of Ethanim—that is, the seventh month. When all the elders of Israel had come, the priests lifted the Ark and carried up the Ark of the Lord. Then the priests and the Levites brought the Tent of Meeting and all the holy vessels that were in the Tent. (1 Kings 7.51–8.4)

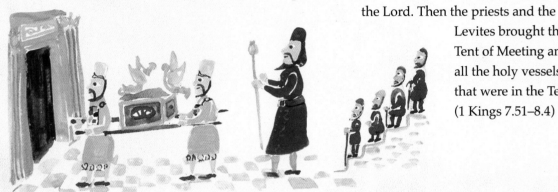

(Sephardim read 1 Kings 7.40–50)

Hiram also made the lavers, the scrapers, and the sprinkling bowls. So Hiram finished all the work that he had been doing for King Solomon on the House of the Lord: the two columns, the two globes of the capitals upon the columns; and the two pieces of network to cover the two globes of the capitals upon the columns; the four hundred pomegranates for the two pieces of network, two rows of pomegranates for each network, to cover the two globes of the capitals upon the columns; the ten stands and the ten lavers upon the stands; the one tank with the twelve oxen underneath the tank; the pails, the scrapers, and the sprinkling bowls. All those vessels in the House of the Lord that Hiram made for King Solomon were of burnished bronze. The king had them cast in earthen molds, in the plain of the Jordan between Succoth and Zarethan. Solomon left all the vessels unweighed because of their very great quantity; the weight of the bronze was not reckoned. And Solomon made all the furnishings that were in the House of the Lord: the altar, of gold; the table for the bread of display, of gold; the lampstands— five on the right side and five on the left—in front of the Shrine, of solid gold; and the petals, lamps, and tongs, of gold; the basins, snuffers, sprinkling bowls, ladles, and fire pans, of solid gold; and the hinge sockets for the doors of the innermost part of the House, the Holy of Holies, and for the doors of the Great Hall of the House, of gold. (1 Kings 7.40–50)

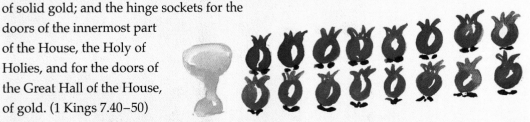

God summoned Moses to the Tent of Meeting and told him how the people should prepare their offerings. They were to bring to the priests choice animals from their flocks—or if they were unable to afford these, turtledoves or fine flour—and the priests would burn these offerings upon the altar. These sacrifices were to be made as offerings of well-being, purification and atonement. The people would make their sacrifices and the fragrant smoke would ascend to God.

ויקרא אל משה וידבר ה׳ אליו מאהל מועד....

The Lord called to Moses and spoke to him from the Tent of Meeting.... (Lev. 1.1)

If his offering is a burnt offering from the herd, he shall make his offering a male without blemish. He shall bring it to the entrance of the Tent of Meeting, for acceptance in his behalf before the Lord ... The sons of Aaron the priest shall put fire on the altar and lay out wood upon the fire; and Aaron's sons, the priests, shall lay out the sections, with the

VAYIKRAH

Vayikrah

head and the suet, on the wood that is on the fire upon the altar. Its entrails and legs shall be washed with water, and the priest shall turn the whole into smoke on the altar as a burnt offering, an offering by fire of pleasing odor to the Lord ... If his offering to the Lord is a burnt offering of birds, he shall choose his offering from turtledoves or pigeons. The priest shall bring it to the altar ... and turn it into smoke on the altar ... It is a burnt offering, an offering by fire, of pleasing odor to the Lord. When a person presents an offering of meal to the Lord, his offering shall be of choice flour; he shall pour oil upon it, lay frankincense on it, and present it to Aaron's sons, the priests. The priest shall scoop out of it a handful of its choice flour and oil, as well as all of its frankincense; and this token portion he shall turn into smoke on the altar, as an offering by fire, of pleasing odor to the Lord ... When you present an offering of meal baked in the oven, it shall be of choice flour: unleavened cakes with oil mixed in, or unleavened wafers spread with oil ... When you present to the Lord a meal offering that is made in any of these ways, it shall be brought to the priest who shall take it up to the altar. The priest shall remove the token portion from the meal offering and turn it into smoke on the altar as an offering by fire, of pleasing odor to the Lord. And the remainder of the meal offering shall be for Aaron and his sons, a most holy portion from the Lord's offerings by fire ... If you bring a meal offering of first fruits to the Lord, you shall bring new ears parched with fire, grits of the fresh grain, as your meal offering of first fruits. You shall add oil to it and lay frankincense on it; it is a meal offering. And the priest shall turn a token portion of it into smoke: some of the grits and oil, with all of the frankincense, as an offering by fire to the Lord. (Lev. 1.3–2.16)

If it is the whole community of Israel that has erred and the matter escapes the notice of the congregation, so that they do any of the things which by the Lord's commandments ought not to be done, and they realize their guilt—when the sin through which they incurred guilt becomes known, the congregation shall offer a bull of the herd as a sin offering, and bring it before the Tent of Meeting ... If any person from among the populace unwittingly incurs guilt by doing any of the things which by the Lord's commandments ought not to be done, and he realizes his guilt—or the sin of which he is guilty is brought to his knowledge—he shall bring a female goat without blemish as his offering for the sin of which he is guilty ... Thus the priest shall make expiation on his behalf for the sin of which he is guilty, and he shall be forgiven. If a person incurs guilt—when he has heard a public imprecation and—although able to testify as one who has either seen or learned of the matter—he does not give information, so that he is subject to punishment; Or When a person touches any unclean thing—be it the carcass of an

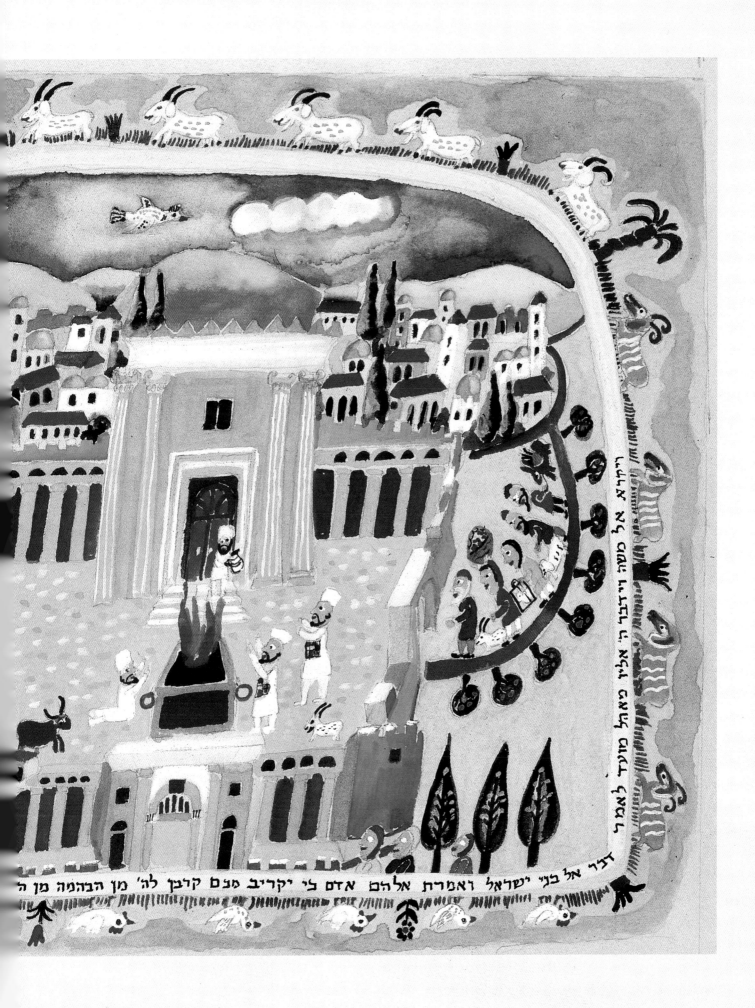

unclean beast or the carcass of unclean cattle or the carcass of an unclean creeping thing—and the fact has escaped him, and then, being unclean, he realizes his guilt; Or when he touches human uncleanness—any such uncleanness whereby one becomes unclean—and, though he has known it, the fact has escaped him, but later he realizes his guilt; Or when a person utters an oath to bad or good purpose—whatever a man may utter in an oath—and, though he has known it, the fact has escaped him, but later he realizes his guilt in any of these matters—when he realizes his guilt in any of these matters, he shall confess that wherein he has sinned. And he shall bring as his penalty to the Lord, for the sin of which he is guilty, a female from the flock, sheep or goat, as a sin offering; and the priest shall make expiation on his behalf for his sin. But if his means do not suffice for a sheep, he shall bring to the Lord, as his penalty for that of which he is guilty, two turtledoves or two pigeons ... And if his means do not suffice for two turtledoves or two pigeons, he shall bring as his offering for that of which he is guilty a tenth of an *ephah* of choice flour for a sin offering; he shall not add oil to it or lay frankincense on it, for it is a sin offering. He shall bring it to the priest, and the priest shall scoop out of it a handful as a token portion of it and turn it into smoke on the altar, with the Lord's offerings by fire; it is a sin offering. Thus the priest shall make expiation on his behalf for whichever of these sins he is guilty, and he shall be forgiven. It shall belong to the priest, like the meal offering. (Lev. 4.13–5.13)

Haftarat Vayikrah

(Isaiah 43.21–44.23)

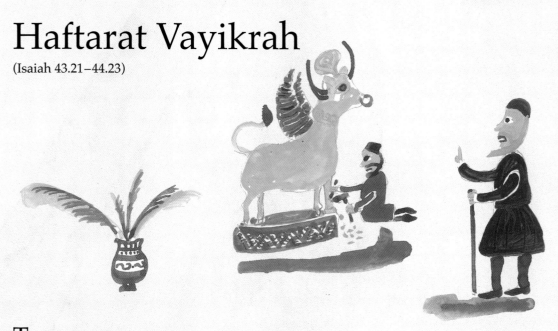

The people I formed for Myself that they might declare My praise. But you have not worshiped Me, O Jacob, that you should be weary of Me, O Israel. You have not brought Me your sheep for burnt offerings, nor honored Me with your sacrifices. I have not burdened you with meal offerings, nor wearied you about frankincense. You have not bought Me fragrant reed with money, nor sated Me with the fat of your sacrifices. Instead, you have burdened Me with your sins, you have wearied Me with your iniquities. It is I, I who—for My own sake—wipe your transgressions away and remember your sins no more. Help me remember! Let us join in argument, tell your version, that you may be vindicated. Your earliest ancestor sinned, and your spokesmen transgressed against Me. So I profaned the holy princes; I abandoned Jacob to proscription and Israel to mockery. (Isa. 43.21–28)

God continued to instruct Moses, calling him to gather Aaron and his sons so that they could be taught the rituals of sacrifice. At God's command, Moses called the people to the Tent of Meeting where he consecrated the Tabernacle and anointed Aaron and his sons as priests.

וידבר ה' אל משה לאמר: צו את אהרן ואת בניו לאמר זאת תורת העלה היא העלה על מוקדה על המזבח כל הלילה עד הבקר ואש המזבח תוקד בו:

The Lord spoke to Moses, saying: Command Aaron and his sons thus: This is the ritual of the burnt offering: The burnt offering itself shall remain where it is burned upon the altar all night until morning, while the fire on the altar is kept going on it. (Lev. 6.1–2)

The priest shall dress in linen raiment, with linen breeches next to his body; and he shall take up the ashes to which the fire has reduced the burnt offering on the altar and place them beside the altar. He shall then take off his

vestments and put on other vestments, and carry the ashes outside the camp to a clean place. The fire on the altar shall be kept burning, not to go out: every morning the priest shall feed wood to it, lay out the burnt offering on it, and turn into smoke the fat parts of the offerings of well-being. A perpetual

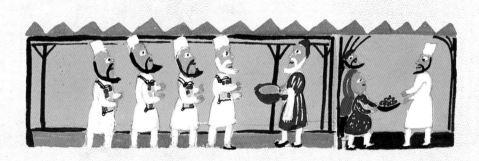

VAYIKRAH

Tzav

fire shall be kept burning on the altar, not to go out. And this is the ritual of the meal offering: Aaron's sons shall present it before the Lord, in front of the altar. A handful of the choice flour and oil of the meal offering shall be taken from it, with all the frankincense that is on the meal offering, and this token portion shall be turned into smoke on the altar as a pleasing odor to the Lord ... The Lord spoke to Moses, saying: This is the offering that Aaron and his sons shall offer to the Lord on the occasion of his anointment: a tenth of an *ephah* of choice flour as a regular meal offering, half of it in the morning and half of it in the evening, shall be prepared with oil on a griddle. You shall bring it well soaked, and offer it as a meal offering of baked slices, of pleasing odor to the Lord. (Lev. 6.3–14)

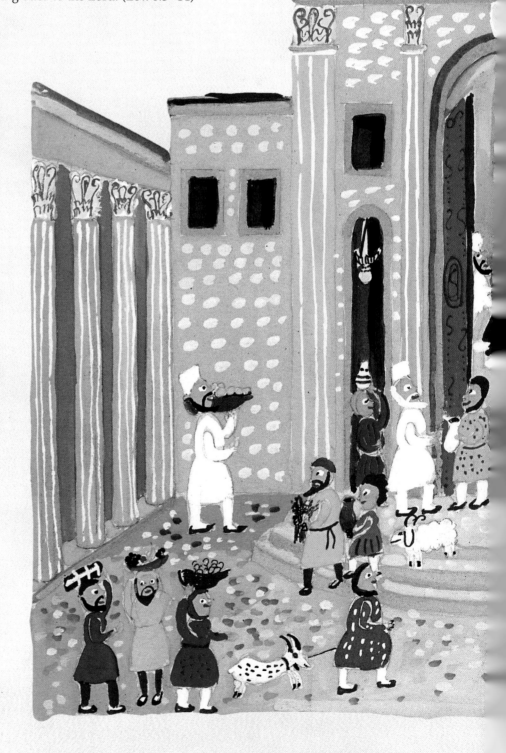

This is the ritual of the guilt offering: it is most holy. The guilt offering shall be slaughtered at the spot where the burnt offering is slaughtered ... The priest shall turn them into smoke on the altar as an offering by fire to the Lord; it is a guilt offering. Only the males in the priestly line may eat of it; it shall be eaten in the sacred precinct: it is most holy. The guilt offering is like the sin offering. The same rule applies to both: it shall belong to the priest who makes expiation thereby ... This is the ritual of the sacrifice of well-being that one may offer to the Lord: If he offers it for thanksgiving, he shall offer together with the sacrifice of thanksgiving unleavened cakes with oil mixed in, unleavened wafers spread with oil, and cakes of choice flour with oil mixed in, well soaked. This offering, with cakes of leavened bread added, he shall offer along with his thanksgiving sacrifice of well-being. Out of this he shall offer one of each kind as a gift to the Lord ... If, however, the sacrifice he offers is a votive or a freewill offering, it shall be eaten on the day that he offers his sacrifice, and what is left of it shall

be eaten on the morrow. What is then left of the flesh of the sacrifice shall be consumed in fire on the third day. If any of the flesh of his sacrifice of well-being is eaten on the third day, it shall not be acceptable; it shall not count for him who offered it. It is an offensive thing, and the person who eats of it shall bear his guilt ... And the Lord spoke to Moses, saying: Speak to the Israelite people thus: ... Such are the rituals of the burnt offering, the meal offering, the sin offering, the guilt offering, the offering of ordination, and the sacrifice of well-being, with which the Lord charged Moses on Mount Sinai, when He commanded that the Israelites present their offerings to the Lord, in the wilderness of Sinai. (Lev. 7.1–38)

Then Moses brought Aaron and his sons forward and washed them with water. He put the tunic on him, girded him with the sash, clothed him with the robe, and put the ephod on him, girding him with the decorated band with which he tied it to him. He put the breastpiece on him, and put into the breastpiece the Urim and Thummim. And he set the headdress on his head; and on the headdress, in front, he put the gold frontlet, the holy diadem—as the Lord had commanded Moses. Moses took the anointing oil and anointed the Tabernacle and all that was in it, thus consecrating them. He sprinkled some of it on the altar seven times, anointing the altar, all its utensils, and the laver with its stand, to consecrate them. He poured some of the anointing oil upon Aaron's head and anointed him, to consecrate him. Moses then brought Aaron's sons forward, clothed them in tunics, girded them with sashes, and wound turbans upon them, as the Lord had commanded Moses ... Everything done today, the Lord has commanded to be done seven days, to make expiation for you. You shall remain at the entrance of the Tent of Meeting day and night for seven days, keeping the Lord's charge—that you may not die—for so I have been commanded. And Aaron and his sons did all the things that the Lord had commanded through Moses. (Lev. 8.6–36)

Haftarat Tzav

(Ordinary years Malachi 3.4–24)

For lo! That day is at hand, burning like an oven. All the arrogant and all the doers of evil shall be straw, and the day that is coming— said the Lord of Hosts—shall burn them to ashes and leave of them neither stock nor boughs. But for you who revere My name a sun of victory shall rise to bring healing. You shall go forth and stamp like stall-fed calves, and you shall trample the wicked to a pulp, for they shall be dust beneath your feet on the day that I am preparing—said the Lord of Hosts. (Mal. 3.19–21)

(Leap years Jeremiah 7.21–8.3; 9.22–23)

Thus said the Lord of Hosts, the God of Israel: Add your burnt offerings to your other sacrifices and eat the meat! For when I freed your fathers from the land of Egypt, I did not speak with them or command them concerning burnt offerings or sacrifice. But this is what I commanded them: Do My bidding, that I may be your God and you may be My people; walk only in the way that I enjoin upon you, that it may go well with you. Yet they did not listen or give ear; they followed their own counsels, the willfulness of their evil hearts. They have gone backward, not forward, from the day your fathers left the land of Egypt until today. And though I kept sending all My servants, the prophets, to them daily and persistently, they would not listen to Me or give ear.... (Jer.7.21–26)

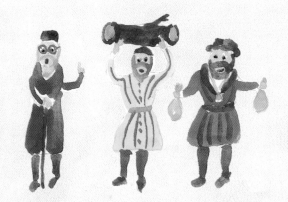

Thus said the Lord: Let not the wise man glory in his wisdom; let not the strong man glory in his strength; let not the rich man glory in his riches. But only in this should one glory: In his earnest devotion to Me. For I the Lord act with kindness, justice, and equity in the world; for in these I delight—declares the Lord. (Jer. 9.22–23)

Then Aaron's sons Nadav and Avihu offered strange fire before God and were struck dead. The people and the priests saw the glory of God and were silent. God spoke to Moses and Aaron, telling them that the people must learn to distinguish between the sacred and the profane, the pure and the impure, permitted and forbidden foods. God instructed Moses to warn the priests to abstain from strong drink.

ויהי ביום השמיני קרא משה לאהרן ולבניו ולזקני ישראל:

On the eighth day Moses called Aaron and his sons, and the elders of Israel. (Lev. 9.1)

Aaron lifted his hands toward the people and blessed them; and he stepped down after offering the sin offering, the burnt offering, and the offering of well-being. Moses and Aaron then went inside the Tent of Meeting. When they came out, they blessed the people; and the Presence of the Lord appeared to all the people. Fire came forth from before the Lord and consumed the burnt offering and the fat parts on the altar. And all the people saw, and shouted, and fell on their faces. Now Aaron's sons Nadab and Abihu each took his fire pan, put fire in it, and laid incense on it; and they offered before the Lord alien fire, which He had not enjoined upon them. And fire came forth from the Lord and consumed them; thus they died ... Moses called Mishael and Elzaphan, sons of Uzziel the uncle of Aaron, and said to them, "Come forward and carry your kinsmen away from the front of the sanctuary to a place outside the camp." ... And Moses said to Aaron and to his sons Eleazar and Ithamar, "Do not bare your heads and do not rend your clothes, lest you die and anger strike the whole community. But your kinsmen, all the house of Israel, shall bewail the burning that the Lord has wrought. And so do not go outside the entrance of the Tent of Meeting, lest you die, for the Lord's anointing oil is upon you." And they did as Moses had bidden. And the Lord spoke to Aaron, saying: Drink no wine or other intoxicant, you or your sons, when you enter the Tent of Meeting, that you may not die. This is a law for all time throughout the ages, for you must distinguish between the sacred and the profane, and between the unclean and the clean; and you must teach the Israelites all the laws which the Lord has imparted to them through Moses. Moses spoke to Aaron and to his remaining sons, Eleazar and Ithamar: Take the meal offering that is left over from the Lord's offerings ... You shall eat it in the sacred precinct, inasmuch as it is your due, and that of your children, from the Lord's offerings by fire; for so I have been commanded ... Together with the fat of fire offering, they must present the thigh of gift offering and the breast of elevation offering, which are to be elevated as an elevation offering before the Lord, and which are to be your due and that of your children with you for all time—as the Lord has commanded. (Lev. 9.22–10.15)

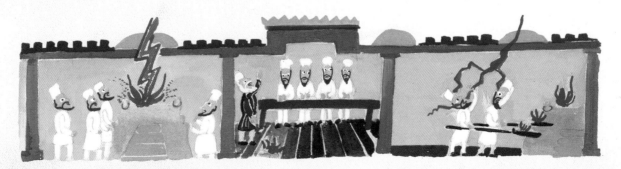

VAYIKRAH

Shemini

The Lord spoke to Moses and Aaron, saying to them: Speak to the Israelite people thus: These are the creatures that you may eat from among all the land animals: any animal that has true hoofs, with clefts through the hoofs, and that chews the cud—such you may eat. The following, however, of those that either chew the cud or have true hoofs, you shall not eat: the camel—although it chews the cud, it has no true hoofs: it is unclean for you; the daman—although it chews the cud, it has no true hoofs: it is unclean for you; the hare—although it chews the cud, it has no true hoofs: it is unclean for you; and the swine—although it has true hoofs, with the hoofs cleft through, it does not chew the cud: it is unclean for you. You shall not eat of their flesh or touch their carcasses; they are unclean for you. These you may eat of all that live in water: anything in water, whether in the seas or in the streams, that has fins and scales—these you may eat. But anything in the seas or in the streams that has no fins and scales, among all the swarming things of the water and among all the other living creatures that are in the water—they are an abomination for you and an abomination for you they shall remain: you shall not eat of their flesh and you shall abominate their carcasses. Everything in water that has no fins and scales shall be an abomination for you. (Lev. 11.1–12)

The following you shall abominate among the birds—they shall not be eaten, they are an abomination: the eagle, the vulture, and the black vulture; the kite, falcons of every variety; all varieties of raven; the ostrich, the nighthawk, the sea gull; hawks of every variety; the little owl, the cormorant, and the great owl; the white owl, the pelican, and the bustard; the stork; herons of every variety; the hoopoe, and the bat. All winged swarming things that walk on fours shall be an abomination for you. But these you may eat among all the winged swarming things that walk on fours: all that have, above their feet, jointed legs to leap with on the ground—of these you may eat the following: locusts of every variety; all varieties of bald locust; crickets of every variety; and all varieties of grasshopper. But all other winged swarming

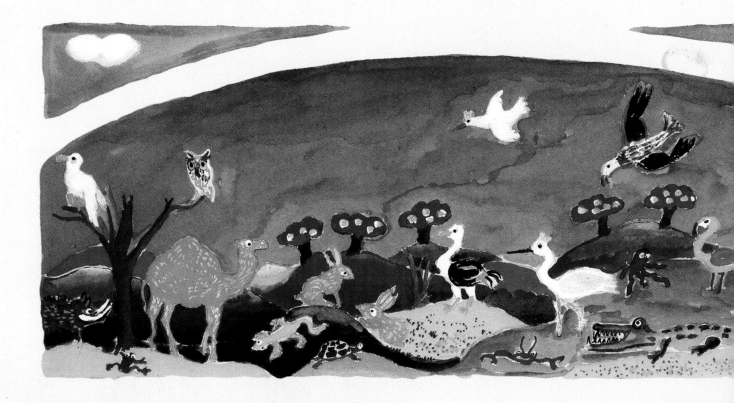

things that have four legs shall be an abomination for you. And the following shall make you unclean—whoever touches their carcasses shall be unclean until evening, and whoever carries the carcasses of any of them shall wash his clothes and be unclean until evening—every animal that has true hoofs but without clefts through the hoofs, or that does not chew the cud. They are unclean for you; whoever touches them shall be unclean. Also all animals that walk on paws, among those that walk on fours, are unclean for you; whoever touches their carcasses shall be unclean until evening. And anyone who carries their carcasses shall wash his clothes and remain unclean until evening. They are unclean for you. The following shall be unclean for you from among the things that swarm on the earth: the mole, the mouse, and great lizards of every variety; the gecko, the land crocodile, the lizard, the sand lizard, and the chameleon. Those are for you the unclean among all the swarming things; whoever touches them when they are dead shall be unclean until evening. And anything on which one of them falls when dead shall be unclean: be it any article of wood, or a cloth, or a skin, or a sack—any such article that can be put to use shall be dipped in water, and it shall remain unclean until evening; then it shall be clean. And if any of those falls into an earthen vessel, everything inside it shall be unclean and the vessel itself you shall break. As to any food that may be eaten, it shall become unclean if it came in contact with water; as to any liquid that may be drunk, it shall become unclean if it was inside any vessel. Everything on which the carcass of any of them falls shall be unclean: an oven or stove shall be smashed. They are unclean and unclean they shall remain for you. However, a spring or cistern in which water is collected shall be clean, but whoever touches such a carcass in it shall be unclean. If such a carcass falls upon seed grain that is to be sown, it is clean; but if water is put on the seed and any part of a carcass falls upon it, it shall be unclean for you. If an animal that you may eat has died, anyone who touches its carcass shall be unclean until evening; anyone who eats of its carcass shall wash his clothes and remain unclean until evening; and anyone who carries its carcass shall wash his clothes and remain unclean until evening. All the things that swarm upon the earth are an abomination; they shall not be eaten. You shall not eat, among all things that swarm

upon the earth, anything that crawls on its belly, or anything that walks on fours, or anything that has many legs; for they are an abomination. You shall not draw abomination upon yourselves through anything that swarms; you shall not make yourselves unclean therewith and thus become unclean. For I the Lord am your God: you shall sanctify yourselves and be holy, for I am holy. You shall not make yourselves unclean through any swarming thing that moves upon the earth. For I the Lord am He who brought you up from the land of Egypt to be your God: you shall be holy, for I am holy. These are the instructions concerning animals, birds, all living creatures that move in water, and all creatures that swarm on earth, for distinguishing between the unclean and the clean, between the living things that may be eaten and the living things that may not be eaten. (Lev. 11.13–47)

Haftarat Shemini

(Ashkenazim read 2 Samuel 6.1–7.17) (Sephardim read 6.1–19)

David again assembled all the picked men of Israel, thirty thousand strong. Then David and all the troops that were with him set out from Baalim of Judah to bring up from there the Ark of God to which the Name was attached, the name Lord of Hosts Enthroned on the Cherubim ... They conveyed it from Abinadab's house on the hill ... But when they came to the threshing floor of Nacon, Uzzah reached out for the Ark of God and grasped it, for the oxen had stumbled. The Lord was incensed at Uzzah. And God struck him down on the spot for his indiscretion, and he died there beside the Ark of God. David was distressed because the Lord had inflicted a breach upon Uzzah ... David was afraid of the Lord that day ... So David would not bring the Ark of the Lord to his place in the City of David; instead, David diverted it to the house of Obed-edom the Gittite ... and the Lord blessed Obed-edom and his whole household ... Thereupon David went and brought up the Ark of God from the house of Obed-edom to the City of David, amid rejoicing ... David whirled with all his might before the Lord ... Michal daughter of Saul looked out of the window and saw King David leaping and whirling before the Lord; and she despised him for it ... David went home to greet his household. And Michal daughter of Saul came out to meet David and said, "Didn't the king of Israel do himself honor today—exposing himself today in the sight of the slavegirls of his subjects, as one of the riffraff might expose himself!" David answered Michal, "It was before the Lord who chose me instead of your father and all his family and appointed me ruler over the Lord's people Israel! I will dance before the Lord and dishonor myself even more, and be low in my own esteem; but among the slavegirls that you speak of I will be honored." So to her dying day Michal daughter of Saul had no children. (2 Samuel 6.1–23)

God told Moses to explain to the people that women who had given birth were to be regarded as ritually impure for a certain period of time. Those who suffered from certain skin diseases were similarly to be considered impure. God instructed Moses in the laws concerning diagnosing and purifying such individuals.

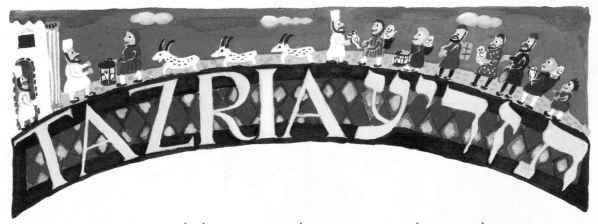

וידבר ה' אל משה לאמר: דבר אל בני ישראל לאמר אשה כי תזריע וילדה זכר וטמאה שבעת ימים כימי נידת דותא תטמא:

The Lord spoke to Moses, saying: Speak to the Israelite people thus: When a woman at childbirth bears a male, she shall be unclean seven days.... (Lev. 12.1–2)

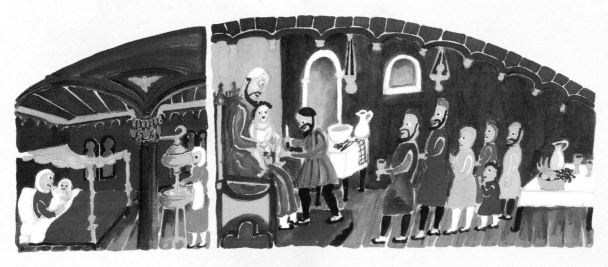

She shall be unclean as at the time of her menstrual infirmity.—On the eighth day the flesh of his foreskin shall be circumcised.—She shall remain in a state of blood purification for thirty-three days: she shall not touch any consecrated thing, nor enter the sanctuary until her period of purification is completed. If she bears a female, she shall be unclean two weeks as during her menstruation, and she shall remain in a state of blood purification for sixty-six days ... When a person has on the skin of his body a swelling, a rash, or a discoloration, and it develops into a scaly affection on the skin of his body, it shall be reported

Tazria

to Aaron the priest or to one of his sons, the priests. The priest shall examine the affection on the skin of his body: if hair in the affected patch has turned white and the affection appears to be deeper than the skin of his body, it is a leprous affection; when the priest sees it, he shall pronounce him unclean. But if it is a white discoloration on the skin of his body which does not appear to be deeper than the skin and the hair in it has not turned white, the priest shall isolate the affected person for seven days. On the seventh day the priest shall examine him, and if the affection has remained unchanged in color and the disease has not spread on the skin, the priest shall isolate him for another seven days. On the seventh day the priest shall examine him again: if the affection has faded and has not spread on the skin, the priest shall pronounce him clean. It is a rash; he shall wash his clothes, and he shall be clean. But if the rash should spread on the skin after he has presented himself to the priest and been pronounced clean, he shall present himself again to the priest. And if the priest sees that the rash has spread on the skin, the priest shall pronounce him unclean; it is leprosy. When a person has a scaly affection, it shall be reported to the priest. If the priest finds on the skin a white swelling which has turned some hair white, with a patch of undiscolored flesh in the swelling, it is chronic leprosy on the skin of his body, and the priest shall pronounce him unclean; he need not isolate him, for he is unclean. If the eruption spreads out over the skin so that it covers all

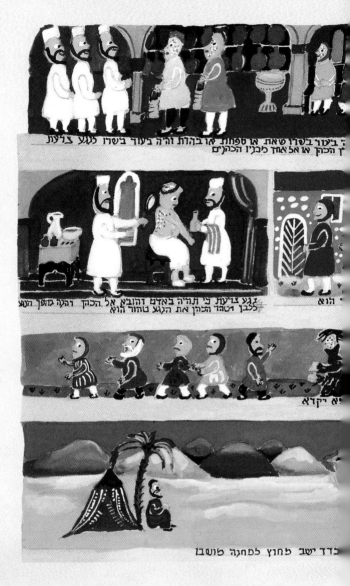

the skin of the affected person from head to foot, wherever the priest can see—if the priest sees that the eruption has covered the whole body—he shall pronounce the affected person clean; he is clean, for he has turned all white. But as soon as undiscolored flesh appears in it, he shall be unclean; when the priest sees the undiscolored flesh, he shall pronounce him unclean. The undiscolored flesh is unclean; it is leprosy. But if the undiscolored flesh again turns white, he shall come to the priest, and the priest shall examine him: if the affection has turned white, the priest shall pronounce the affected person clean; he is clean. (Lev. 12.2–13.17)

When an inflammation appears on the skin of one's body and it heals, and a white swelling or a white discoloration streaked with red develops where the inflammation was, he shall present himself to the priest. If the priest finds that it appears lower than the rest of the skin and that the hair in it has turned white, the priest shall pronounce him unclean; it is a leprous affection that has broken out in the inflammation. But if the priest finds that there is no white hair in it and it is not lower than the rest of the skin, and it is faded, the priest shall isolate him for seven days. If it should spread in the skin, the priest shall pronounce him unclean; it is an affection. But if the discoloration remains stationary, not having spread, it is the scar of the inflammation; the priest shall pronounce him clean. When the skin of one's body sustains a burn by fire, and the patch from the burn is a discoloration, either white streaked with red, or white, the priest shall examine it. If some hair has turned white in the discoloration, which itself appears to go deeper than the skin, it is leprosy that has broken out in the burn. The priest shall pronounce him unclean; it is a leprous

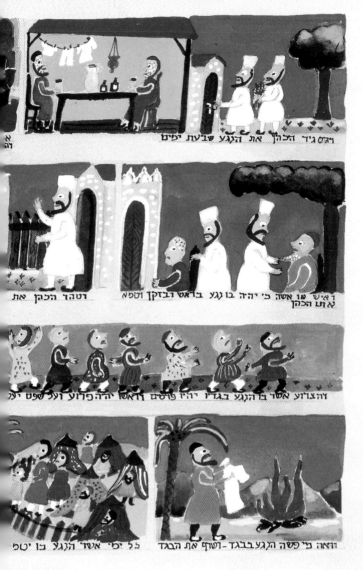

affection. But if the priest finds that there is no white hair in the discoloration, and that it is not lower than the rest of the skin, and it is faded, the priest shall isolate him for seven days. On the seventh day the priest shall examine him: if it has spread in the skin, the priest shall pronounce him unclean; it is a leprous affection. But if the discoloration has remained stationary, not having spread on the skin, and it is faded, it is the swelling from the burn. The priest shall pronounce him clean, for it is the scar of the burn. If a man or a woman has an affection on the head or in the beard, the priest shall examine the affection. If it appears to go deeper than the skin and there is thin yellow hair in it, the priest shall pronounce him unclean ... As for the person with a leprous affection, his clothes shall be rent, his head shall be left bare, and he shall cover over his upper lip; and he shall call out, "Unclean! Unclean!" He shall be unclean as long as the disease is on him. Being unclean, he shall dwell apart; his dwelling shall be outside the camp ... On the seventh day he shall examine the affection: if the affection has spread in the cloth—whether in the warp or the woof, or in the skin, for whatever purpose the skin may be used—the affection is a malignant eruption; it is unclean. The cloth—whether warp or woof in wool or linen, or any article of skin—in which the affection is found, shall be burned, for it is a malignant eruption; it shall be consumed in fire. (Lev. 13.18–52)

Haftarat Tazria

(2 Kings 4.42–5.19)

A man came from Baal-shalishah and he brought the man of God some bread of the first reaping—twenty loaves of barley bread, and some fresh grain in his sack. And Elisha said, "Give it to the people and let them eat." His attendant replied, "How can I set this before a hundred men?" But he said, "Give it to the people and let them eat. For thus said the Lord: They shall eat and have some left over." So he set it before them; and when they had eaten, they had some left over, as the Lord had said. Naaman, commander of the army of the king of Aram, was important to his lord and high in his favor, for through him the Lord had granted victory to Aram. But the man, though a great warrior, was a leper. Once, when the Arameans were out raiding, they carried off a young girl from the land of Israel, and she became an attendant to Naaman's wife. She said to her mistress, "I wish Master could come before the prophet in Samaria; he would cure him of his leprosy." (2 Kings 4.42–5.3)

God gave Moses additional instructions about treating skin afflictions, and further explained to him how to cleanse buildings that had been tainted by impurities. God then prescribed rituals of sacrifice to purify the body from discharges, particularly menstrual flow and nocturnal emissions.

וידבר ה' אל משה לאמר: זאת
תהיה תורת המצרע ביום טהרתו
והובא אל הכהן: ויצא הכהן אל
מחוץ למחנה....

The Lord spoke to Moses, saying: This shall be the ritual for a leper at the time that he is to be cleansed. When it has been reported to the priest, the priest shall go outside the camp.... (Lev. 14.1–3)

The priest shall order two live clean birds, cedar wood, crimson stuff, and hyssop to be brought for him who is to be cleansed. The priest shall order one of the birds slaughtered over fresh water in an earthen vessel; and he shall take the live bird, along with the cedar wood, the crimson stuff, and the hyssop, and dip them together with the live bird in the blood of the bird that was slaughtered over the

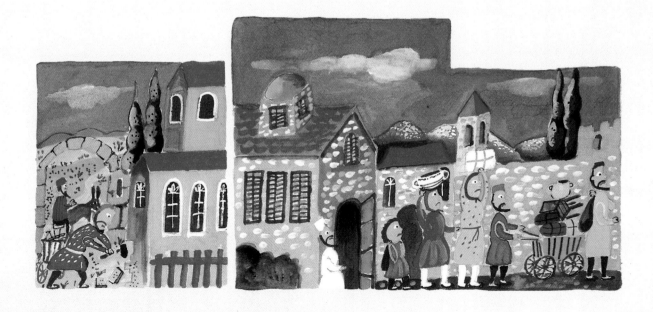

fresh water. He shall then sprinkle it seven times on him who is to be cleansed of the eruption and

cleanse him; and he shall set the live bird free in the open country. The one to be cleansed shall wash his clothes, shave off all his hair, and bathe in water; then he shall be clean ... The Lord spoke to Moses and Aaron, saying: When you enter the land of Canaan that I give you as a possession, and I inflict an eruptive plague upon a house in the land you possess, the owner of the house shall come and tell the priest, saying, "Something like a plague has appeared upon my house." The priest shall order the house cleared before the priest enters to examine the plague, so that nothing in the house may become unclean; after that the priest shall enter to examine the house. If, when he examines the plague, the plague in the walls of the house is found to consist of greenish or reddish streaks that appear to go deep into the wall, the priest shall come out of the house to the entrance of the house, and close up

the house for seven days. On the seventh day the priest shall return. If he sees that the plague has spread on the walls of the house, the priest shall order the stones with the plague in them to be pulled out and cast outside the city into an unclean place. The house shall be scraped inside all around, and the coating that is scraped off shall be dumped outside the city in an unclean place. They shall take other stones and replace those stones with them, and take other coating and plaster the house. If the plague again breaks out in the house, after the stones have been pulled out and after the house has been scraped and replastered, the priest shall come to examine: if the plague has spread in the house, it is a malignant eruption in the house; it is unclean. The house shall be torn down—its stones and timber and all the coating on the house—and taken to an unclean place outside the city ... You shall put the Israelites on guard against their uncleanness, lest they die through their uncleanness by defiling My Tabernacle which is among them. (Lev. 14.4–15.31)

Haftarat Metzora

(Ordinary years 2 Kings 7.3–20)

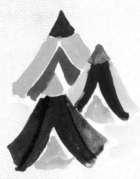
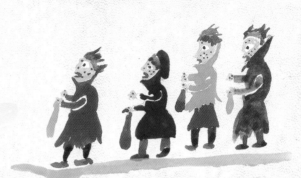

There were four men, lepers, outside the gate. They said to one another, "Why should we sit here waiting for death? If we decide to go into the town, what with the famine in the town, we shall die there; and if we just sit here, still we die. Come, let us desert to the Aramean camp. If they let us live, we shall live; and if they put us to death, we shall but die." They set out at twilight for the Aramean camp; but when they came to the edge of the Aramean camp, there was no one there. For the Lord had caused the Aramean camp to hear a sound of chariots, a sound of horses—the din of a huge army. They said to one another, "The king of Israel must have hired the kings of the Hittites and the kings of Mizraim to attack us!" And they fled headlong in the twilight, abandoning their tents and horses and asses—the entire camp just as it was—as they fled for their lives. (2 Kings 7.3–7)

(Leap years Malachi 3.4–24)

Then the offerings of Judah and Jerusalem shall be pleasing to the Lord as in the days of yore and in the years of old. But first I will step forward to contend against you, and I will act as a relentless accuser against those who have no fear of Me: Who practice sorcery, who commit adultery, who swear falsely, who cheat laborers of their hire, and who subvert the cause of the widow, orphan, and stranger, said the Lord of Hosts. For I am the Lord—I have not changed; and you are the children of Jacob—you have not ceased to be. From the very days of your fathers you have turned away from My laws and have not observed them. Turn back to Me, and I will turn back to you—said the Lord of Hosts. But you ask, "How shall we turn back?" Ought man to defraud God? Yet you are defrauding Me. And you ask, "How have we been defrauding You?" In tithe and contribution. You are suffering under a curse, yet you go on defrauding Me—the whole nation of you. Bring the full tithe into the storehouse, and let there be food in My House, and thus put Me to the test—said the Lord of Hosts. I will surely open the floodgates of the sky for you and pour down blessings on you; and I will banish the locusts from you, so that they will not destroy the yield of your soil; and your vines in the field shall no longer miscarry—said the Lord of Hosts. And all the nations shall account you happy, for you shall be the most desired of lands—said the Lord of Hosts. (Mal. 3.4–12)

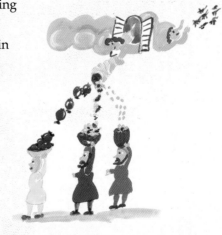

Achare Mot 16.1–18.30

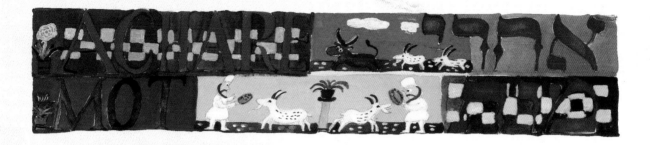

After the death of Aaron's two sons, God directed Moses to instruct the Levites and priests in the rituals of purification and atonement, including the special practices performed by the High Priest on Yom Kippur. The ritual of the scapegoat enabled the priest to atone for the sins of all of Israel. Through Moses, God commanded the people to abstain from forbidden sexual relations, lest they defile themselves and their land as did the people of Egypt and Canaan.

The Lord spoke to Moses after the death of the two sons of Aaron who died when they drew too close to the presence of the Lord. (Lev. 16.1)

וידבר ה׳ אל משה אחרי מות שני בני
אהרן בקרבתם לפני ה׳ וימתו:

The Lord said to Moses: Tell your brother Aaron that he is not to come at will into the Shrine behind the curtain, in front of the cover that is upon the ark, lest he die; for I appear in the cloud over the cover. Thus only shall Aaron enter the Shrine: with a bull of the herd for a sin offering and a ram for a burnt offering.—He shall be dressed in a sacral linen tunic, with linen breeches next to his flesh, and be girt with a linen sash, and he shall wear a linen turban. They are sacral vestments; he shall bathe his body in water and then put them on.—And from the Israelite community he shall take two he-goats for a sin offering and a ram for a burnt offering ... and he shall place lots upon the two goats, one marked for the Lord and the other marked for Azazel ... while the goat designated by lot for Azazel shall be left standing alive before the Lord, to make expiation with it and to send it off to the wilderness for Azazel. Aaron shall then offer his bull of sin offering, to make expiation for himself and his household. He shall slaughter his bull of sin offering, and he shall take a panful of glowing coals scooped from the altar before the Lord, and two handfuls of finely ground aromatic incense, and bring this behind the curtain. He shall put the incense on the fire before the Lord, so that the cloud from the incense screens the cover that is over the Ark of the Pact, lest he die ... Thus he shall purge the Shrine of the uncleanness and transgression

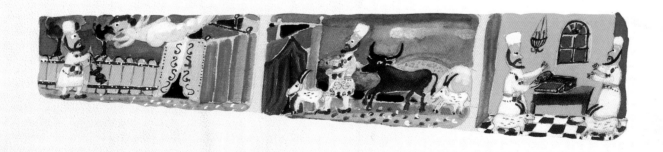

VAYIKRAH

Achare Mot

And this shall be to you a law for all time: In the seventh month, on the tenth day of the month, you shall practice self-denial; and you shall do no manner of work, neither the citizen nor the alien who resides among you. For on this day atonement shall be made for you to cleanse you of all your sins; you shall be clean before the Lord.
(Lev. 16.29–30)

VAYIKRAH

Achare Mot

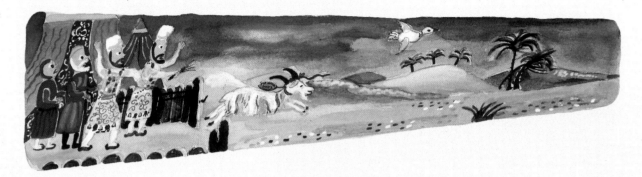

of the Israelites, whatever their sins; and he shall do the same for the Tent of Meeting, which abides with them in the midst of their uncleanness. When he goes in to make expiation in the Shrine, nobody else shall be in the Tent of Meeting until he comes out ... When he has finished purging the Shrine, the Tent of Meeting, and the altar, the live goat shall be brought forward. Aaron shall lay both his hands upon the head of the live goat and confess over it all the iniquities and transgressions of the Israelites, whatever their sins, putting them on the head of the goat; and it shall be sent off to the wilderness through a designated man. Thus the goat shall carry on it all their iniquities ... He who set the Azazel-goat free shall wash his clothes and bathe his body in water; after that he may reenter the camp ... And this shall be to you a law for all time: In the seventh month, on the tenth day of the month, you shall practice self-denial; and you shall do no manner of work, neither the citizen nor the alien who resides among you. For on this day atonement shall be made for you to cleanse you of all your sins; you shall be clean before the Lord. It shall be a sabbath of complete rest for you, and you shall practice self-denial; it is a law for all time. The priest who has been anointed and ordained to serve as priest in place of his father shall make expiation. He shall put on the linen vestments, the sacral vestments. He shall purge the innermost Shrine; he shall purge the Tent of Meeting and the altar; and he shall make expiation for the priests and for all the people of the congregation. This shall be to you a law for all time: to make atonement for the Israelites for all their sins once a year. And Moses did as the Lord had commanded him. (Lev. 16.2–34)

And if anyone of the house of Israel or of the strangers who reside among them partakes of any blood, I will set My face against the person who partakes of the blood, and I will cut him off from among his kin. For the life of the flesh is in the blood, and I have assigned it to you for making expiation for your lives upon the altar; it is the blood, as life, that effects expiation. Therefore I say to the Israelite people: No person among you shall partake of blood, nor shall the stranger who resides among you partake of blood. And if any Israelite or any stranger who resides among them hunts down an animal or a bird that may be eaten, he shall pour out its blood and cover it with earth. For the life of all flesh—its blood is its life. Therefore I say to the Israelite people: You shall not partake of the blood of any flesh, for the life of all flesh is its blood. Anyone who partakes of it shall be cut off. Any person, whether citizen or stranger, who eats what has died or has been torn by beasts shall wash his clothes, bathe in water, and remain unclean until evening; then he shall be clean. But if he does not wash his clothes and bathe his body, he shall bear his guilt. The Lord spoke to Moses, saying: Speak to the Israelite people and say to them: I the

Lord am your God. You shall not copy the practices of the land of Egypt where you dwelt, or of the land of Canaan to which I am taking you; nor shall you follow their laws. My rules alone shall you observe, and faithfully follow My laws: I the Lord am your God. You shall keep My laws and My rules, by the pursuit of which man shall live: I am the Lord ... Do not defile yourselves in any of those ways, for it is by such that the nations that I am casting out before you defiled themselves. Thus the land became defiled; and I called it to account for its iniquity, and the land spewed out its inhabitants. But you must keep My laws and My rules, and you must not do any of those abhorrent things, neither the citizen nor the stranger who resides among you; for all those abhorrent things were done by the people who were in the land before you, and the land became defiled. So let not the land spew you out for defiling it, as it spewed out the nation that came before you. All who do any of those abhorrent things—such persons shall be cut off from their people. (Lev. 17.10–18.29)

Haftarat Achare Mot

(Ashkenazim read Ezekiel 22.1–19) (Sephardim read 22.1–16)

The word of the Lord came to me: Further, O mortal, arraign, arraign the city of bloodshed; declare to her all her abhorrent deeds! Say: Thus said the Lord God: O city in whose midst blood is shed, so that your hour is approaching ... You have taken advance and accrued interest; you have defrauded your countrymen to your profit. You have forgotten Me —declares the Lord God. Lo, I will strike My hands over the ill-gotten gains that you have amassed, and over the bloodshed that has been committed in your midst. Will your courage endure, will your hands remain firm in the days when I deal with you? I the Lord have spoken and I will act. I will scatter you among the nations and disperse you through the lands; I will consume the uncleanness out of you. You shall be dishonored in the sight of nations, and you shall know that I am the Lord. The word of the Lord came to me: O mortal, the House of Israel has become dross to Me; they are all copper, tin, iron, and lead. But in a crucible, the dross shall turn into silver. Assuredly, thus said the Lord God: Because you have all become dross, I will gather you into Jerusalem. (Ezek. 22.1–19)

VAYIKRAH

Kedoshim 19.1–20.27

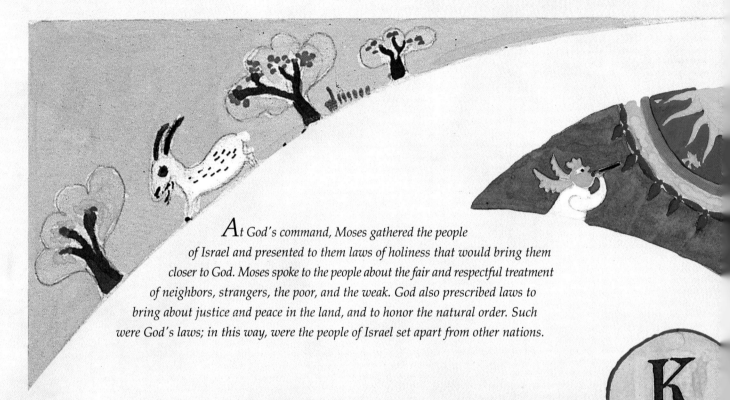

At God's command, Moses gathered the people of Israel and presented to them laws of holiness that would bring them closer to God. Moses spoke to the people about the fair and respectful treatment of neighbors, strangers, the poor, and the weak. God also prescribed laws to bring about justice and peace in the land, and to honor the natural order. Such were God's laws; in this way, were the people of Israel set apart from other nations.

The Lord spoke to Moses, saying: Speak to the whole Israelite community and say to them: You shall be holy, for I, the Lord your God, am holy. (Lev. 19.1–2)

You shall each revere his mother and his father, and keep My sabbaths: I the Lord am your God. Do not turn to idols or make molten gods for yourselves: I the Lord am your God ... When you reap the harvest of your land, you shall not reap all the way to the edges of your field, or gather the gleanings of your harvest. You shall not pick your vineyard bare, or gather the fallen fruit of your vineyard; you shall leave them for the poor and the stranger: I the Lord am your God. You shall not steal; you shall not deal deceitfully or falsely with one another. You shall not swear falsely by My name, profaning the name of your God: I am the Lord. You shall not defraud your fellow. You shall not commit robbery. The wages of a laborer shall not remain with you until morning. You shall not insult the deaf, or place a stumbling block before the blind. You shall fear your God: I am the Lord. You shall not render an unfair decision: do not favor the poor or show deference to the rich; judge your kinsman fairly. Do not deal basely with your countrymen. Do not profit by the blood of your fellow: I am the Lord. You shall not hate your kinsfolk in your heart. Reprove your kinsman but incur no guilt because of him. You shall not take vengeance or bear a grudge against your countrymen. Love your fellow as yourself: I am the Lord. You shall observe My laws ... When you enter the land and plant any tree for food, you shall regard its fruit as forbidden. Three years it shall be forbidden for you, not to be eaten. In the fourth year all its fruit shall be set aside for

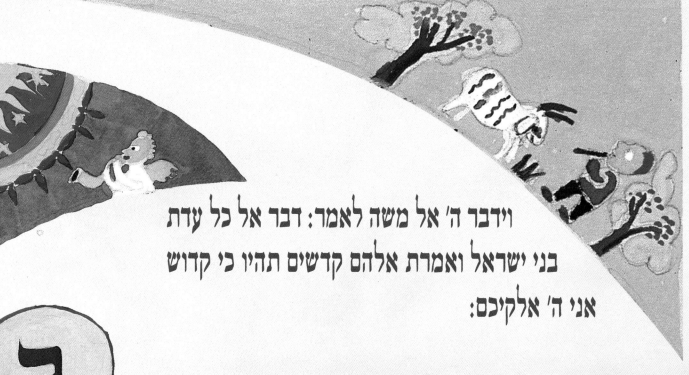

וידבר ה׳ אל משה לאמר: דבר אל כל עדת
בני ישראל ואמרת אלהם קדשים תהיו כי קדוש
אני ה׳ אלקיכם:

jubilation before the Lord ... You shall not practice divination or soothsaying. You shall not round off the side-growth on your head, or destroy the side-growth of your beard. You shall not make gashes in your flesh for the dead, or incise any marks on yourselves: I am the Lord. Do not degrade your daughter and make her a harlot, lest the land fall into harlotry and the land be filled with depravity. You shall keep My sabbaths and venerate My sanctuary: I am the Lord. Do not turn to ghosts and do not inquire of familiar spirits, to be defiled by them: I the Lord am your God. You shall rise before the aged and show deference to the old; you shall fear your God: I am the Lord. When a stranger resides with you in your land, you shall not wrong him. The stranger who resides with you shall be to you as one of your citizens; you shall love him as yourself, for you were strangers in the land of Egypt: I the Lord am your God. You shall not falsify measures of length, weight, or capacity. You shall have an honest balance, honest weights, an honest *ephah*, and an honest *hin*. I the Lord am your God who freed you from the land of Egypt. You shall faithfully observe all My laws and all My rules: I am the Lord ... You shall faithfully observe all My laws and all My regulations, lest the land to which I bring you to settle in spew you out. You shall not follow the practices of the nation that I am driving out before you. For it is because they did all these things that I abhorred them and said to you: You shall possess their land, for I will give it to you to possess, a land flowing with milk and honey. I the Lord am your God who has set you apart from other peoples. So you shall set apart the clean beast from the unclean, the unclean bird from the clean. You shall not draw abomination upon yourselves through beast or bird or anything with which the ground is alive, which I have set apart for you to treat as unclean. You shall be holy to Me, for I the Lord am holy, and I have set you apart from other peoples to be Mine. (Lev. 19.3–20.26)

Haftarat Kedoshim

(Ashkenazim read Amos 9.7–15)

To Me, O Israelites, you are just like the Ethiopians—declares the Lord. True, I brought Israel up from the land of Egypt, but also the Philistines from Caphtor and the Arameans from Kir. Behold, the Lord God has His eye upon the sinful kingdom: I will wipe it off the face of the earth! But, I will not wholly wipe out the House of Jacob—declares the Lord. For I will give the order and shake the House of Israel—through all the nations—as one shakes sand in a sieve, and not a pebble falls to the ground. All the sinners of My people shall perish by the sword, who boast, "Never shall the evil overtake us or come near us." In that day, I will set up again the fallen booth of David: I will mend its breaches and set up its ruins anew. I will build it firm as in the days of old, so that they shall possess the rest of Edom and all the nations once attached to My name—declares the Lord who will bring this to pass. (Amos 9.7–12)

(Sephardim read Ezekiel 20.2–20)

And the word of the Lord came to me: O mortal, speak to the elders of Israel and say to them: Thus said the Lord God: Have you come to inquire of Me? As I live, I will not respond to your inquiry—declares the Lord God. Arraign, arraign them, O mortal! Declare to them the abhorrent deeds of their fathers. Say to them: Thus said the Lord God: On the day that I chose Israel, I gave My oath to the stock of the House of Jacob; when I made Myself known to them in the land of Egypt, I gave my oath to them. When I said, "I the Lord am your God," that same day I swore to them to take them out of the land of Egypt into a land flowing with milk and honey, a land which I had sought out for them, the fairest of all lands. I also said to them: Cast away, every one of you, the detestable things that you are drawn to, and do not defile yourselves with the fetishes of Egypt—I the Lord am your God. But they defied Me and refused to listen to Me. They did not cast away the detestable things they were drawn to, nor did

they give up the fetishes of Egypt. Then I resolved to pour out My fury upon them, to vent all My anger upon them there, in the land of Egypt. But I acted for the sake of My name, that it might not be profaned in the sight of the nations among whom they were. For it was before their eyes that I had made Myself known to Israel to bring them out of the land of Egypt. (Ezek. 20.2–9)

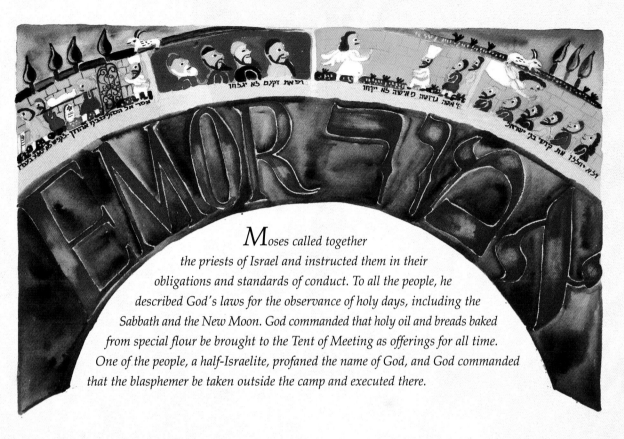

*M*oses called together
the priests of Israel and instructed them in their
obligations and standards of conduct. To all the people, he
described God's laws for the observance of holy days, including the
Sabbath and the New Moon. God commanded that holy oil and breads baked
from special flour be brought to the Tent of Meeting as offerings for all time.
One of the people, a half-Israelite, profaned the name of God, and God commanded
that the blasphemer be taken outside the camp and executed there.

*T*he Lord said to Moses: Speak to the priests, the sons of Aaron, and say to them: None shall defile himself for any dead person among his kin.... (Lev. 21.1)

ויאמר ה' אל משה אמר אל הכהנים
בני אהרן ואמרת אלהם לנפש לא
יטמא בעמיו:

*E*xcept for the relatives that are closest to him: his mother, his father, his son, his daughter, and his brother; also for a virgin sister, close to him because she has not married, for her he may defile himself. But he shall not defile himself as a kinsman by marriage, and so profane himself. They shall not shave smooth any part of their heads, or cut the side-growth of their beards, or make gashes in their flesh ... They shall not marry a woman defiled by harlotry, nor shall they marry one divorced from her husband. For they are holy to their God and you must treat them as holy, since they offer the food of your God; they shall be holy to you, for I the Lord who sanctify you am holy. When the daughter of a

VAYIKRAH

Emor

priest defiles herself through harlotry, it is her father whom she
defiles; she shall be put to the fire ... Only a virgin of his
own kin may he take to wife—that he may not
profane his offspring among his kin, for I
the Lord have sanctified him ... The Lord
spoke to Moses, saying: Instruct Aaron
and his sons to be scrupulous about the
sacred donations that the Israelite people
consecrate to Me, lest they profane My
holy name, Mine the Lord's. Say to
them ... When any man of the house of
Israel or of the strangers in Israel presents
a burnt offering as his offering for any of
the votive or any of the freewill offerings
that they offer to the Lord, it must ... be a
male without blemish, from cattle or
sheep or goats ... You shall faithfully
observe My commandments: I am the
Lord ... These are My fixed times, the fixed
times of the Lord, which you shall
proclaim as sacred occasions. On six days
work may be done, but on the seventh day
there shall be a sabbath of complete rest, a
sacred occasion. You shall do no work; it
shall be a sabbath of the Lord throughout
your settlements ... In the first month, on
the fourteenth day of the month, at
twilight, there shall be a passover offering
to the Lord, and on the fifteenth day of that
month the Lord's Feast of Unleavened
Bread. You shall eat unleavened bread for
seven days. On the first day you shall
celebrate a sacred occasion: you shall not
work at your occupations. Seven days you
shall make offerings by fire to the Lord. The
seventh day shall be a sacred occasion: you

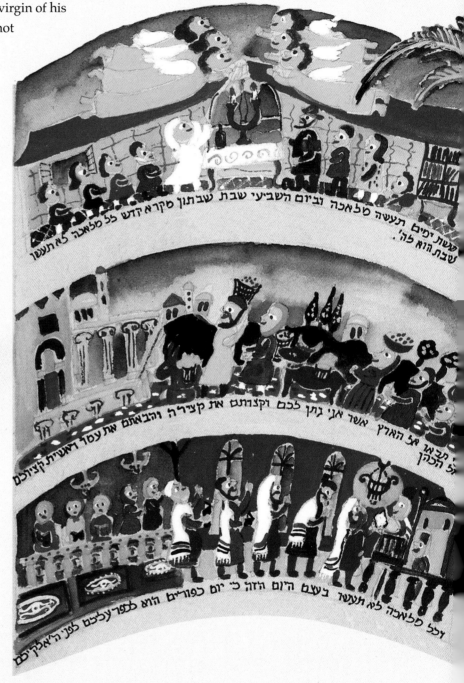

shall not work at your occupations ... When you enter the land that I am giving to you and you reap its
harvest, you shall bring the first sheaf of your harvest to the priest. He shall elevate the sheaf before the
Lord for acceptance in your behalf; the priest shall elevate it on the day after the sabbath ... And from
the day on which you bring the sheaf of elevation offering—the day after the sabbath—you shall count
off seven weeks. They must be complete: you must count until the day after the seventh week—fifty
days; then you shall bring an offering of new grain to the Lord. You shall bring from your settlements
two loaves of bread as an elevation offering; each shall be made of two-tenths of a measure of choice
flour, baked after leavening, as first fruits to the Lord. (Lev. 21.2–23.17)

Hebrew text on illustration bands:
אשר עשר יום לחדש הזה חג המצות לה' שבעת ימים מצות תאכלו
וב חמשה

בחדש השביעי באחד לחדש יהיה לכם שבתון זכרון תרועה מקרא קדש

בסכת תשבו שבעת ימים כל האזרח בישראל ישבו בסכת

And when you reap the harvest of your land, you shall not reap all the way to the edges of your field, or gather the gleanings of your harvest; you shall leave them for the poor and the stranger: I the Lord am your God ... In the seventh month, on the first day of the month, you shall observe complete rest, a sacred occasion commemorated with loud blasts. You shall not work at your occupations; and you shall bring an offering by fire to the Lord ... Mark, the tenth day of this seventh month is the Day of Atonement. It shall be a sacred occasion for you: you shall practice self-denial, and you shall bring an offering by fire to the Lord; you shall do no work throughout that day. For it is a Day of Atonement, on which expiation is made on your behalf before the Lord your God. Indeed, any person who does not practice self-denial throughout that day shall be cut off from his kin; and whoever does any work throughout that day, I will cause that person to perish from among his people. Do no work whatever; it is a law for all time, throughout the ages in all your settlements. It shall be a sabbath of complete rest for you, and you shall practice self-denial; on the ninth day of the month at evening, from evening to evening, you shall observe this your sabbath ... On the fifteenth day of this seventh month there shall be the Feast of Booths to the Lord, to last seven days. The first day shall be a sacred occasion: you shall not work at your occupations; seven days you shall bring offerings by fire to the Lord. On the eighth day you shall observe a sacred occasion and bring an offering by fire to the Lord; it is a solemn gathering: you shall not work at your occupations ... Mark, on the fifteenth day of the seventh month, when you have gathered in the yield of your land, you shall observe the festival of the Lord to last seven days: a complete rest on the first day, and a complete rest on the eighth day. On the first day you shall take the product of *hadar* trees, branches of palm trees, boughs of leafy trees, and willows of the brook, and you shall rejoice before the Lord your God seven days. You shall observe it as a festival of the Lord for seven days in the year; you shall observe it in the seventh month as a law for all time, throughout the ages. You shall live in booths seven days; all citizens in Israel shall live in booths, in order that future generations may know that I made the Israelite people live in booths when I brought them out of the land of Egypt, I the Lord your God. (Lev. 23.22-43)

The Lord spoke to Moses, saying: Command the Israelite people to bring you clear oil of beaten olives for lighting, for kindling lamps regularly. Aaron shall set them up in the Tent of Meeting outside the curtain of the Pact to burn from evening to morning before the Lord regularly; it is a law for all time throughout the ages. He shall set up the lamps on the pure lampstand before the Lord to burn regularly ... Anyone who blasphemes his God shall bear his guilt ... if he has thus pronounced the Name, he shall be put to death. If anyone kills any human being, he shall be put to death. One who kills a beast shall make restitution for it: life for life. If anyone maims his fellow, as he has done so shall it be done to him: fracture for fracture, eye for eye, tooth for tooth ... You shall have one standard for stranger and citizen alike: for I the Lord am your God. (Lev. 24.1–22)

Haftarat Emor

(Ezekiel 44.15–31)

But the levitical priests descended from Zadok, who maintained the service of My Sanctuary when the people of Israel went astray from Me—they shall approach Me to minister to Me ... They shall declare to My people what is sacred and what is profane, and inform them what is clean and what is unclean ... This shall be their portion, for I am their portion; and no holding shall be given them in Israel, for I am their holding. The meal offerings, sin offerings, and guilt offerings shall be consumed by them. Everything proscribed in Israel shall be theirs. All the choice first fruits of every kind, and all the gifts of every kind— of all your contributions—shall go to the priests. You shall further give the first of the yield of your baking to the priest, that a blessing may rest upon your home. (Ezek. 44.15–30)

On Mount Sinai God presented to Moses the laws governing the use and ownership of the land. After six years of sowing and reaping, the fields were to rest—a sabbath year for the land. After seven such sabbatical cycles, the fiftieth year was to be a jubilee year, when the land, debts, and slaves were to be redeemed.

וידבר ה' אל משה בהר סיני לאמר: דבר אל בני ישראל ואמרת אלהם כי תבאו אל הארץ אשר אני נתן לכם ושבתה הארץ שבת לה':

The Lord spoke to Moses on Mount Sinai: Speak to the Israelite people and say to them: When you enter the land that I assign to you, the land shall observe a sabbath of the Lord. (Lev. 25.1–2)

Six years you may sow your field and six years you may prune your vineyard and gather in the yield. But in the seventh year the land shall have a sabbath of complete rest, a sabbath of the Lord: you shall not sow your field or prune your vineyard. You shall not reap the aftergrowth of your harvest or gather the grapes of your untrimmed vines; it shall be a year of complete rest for the land ... You shall count off seven weeks of years—seven times seven years—so that the period of seven weeks of years gives you a total of forty-nine years. Then you shall sound the horn loud; in the seventh month, on the tenth

day of the month—the Day of Atonement—you shall have the horn sounded throughout your land and you shall hallow the fiftieth year. You shall proclaim release throughout the land for all its inhabitants. It shall be a jubilee for you: each of you shall return to his holding and each of you shall return to his family. That fiftieth year shall be a jubilee for you: you shall not sow, neither shall you reap the aftergrowth or harvest the untrimmed vines, for it is a jubilee. It shall be holy to you: you may only eat the growth direct from the field. (Lev. 25.3–12)

In this year of jubilee, each of you shall return to his holding. When you sell property to your neighbor, or buy any from your neighbor, you shall not wrong one another. In buying from your neighbor, you shall deduct only for the number of years since the jubilee; and in selling to you, he shall charge you only for the remaining crop years: the more such years, the higher the price you pay; the fewer such years, the lower the price; for what he is selling you is a number of harvests. Do not wrong one another, but fear your God; for I the Lord am your God ... If your kinsman is in straits and has to sell part of his holding, his nearest redeemer shall come and redeem what his kinsman has sold. If a man has no one to redeem for him, but prospers and acquires enough to redeem with, he shall compute the years since its sale, refund the difference to the man to whom he sold it, and return to his holding. If he lacks sufficient means to recover it, what he sold shall remain with the purchaser until the jubilee; in the jubilee year it shall be released, and he shall return to his holding ... If your kinsman, being in straits, comes under your authority, and you hold him as though a resident alien, let him live by your side: do not exact from him advance or accrued interest, but fear your God. Let him live by your side as your kinsman. Do not lend him your money at advance interest, or give him your food at accrued interest. I the Lord am your God, who brought you out of the land of Egypt, to give you the land of Canaan, to be your God. (Lev. 25.13–38)

If your kinsman under you continues in straits and must give himself over to you, do not subject him to the treatment of a slave. He shall remain with you as a hired or bound laborer; he shall serve with you only until the jubilee year. Then he and his children with him shall be free of your authority; he shall go back to his family and return to his ancestral holding.—For they are My servants, whom I freed from the land of Egypt; they may not give themselves over into servitude ... If a resident alien among you has prospered, and your kinsman being in straits, comes under his authority and gives himself over to the resident alien among you, or to an offshoot of an alien's family, he shall have the right of redemption even after he has given himself over. One of his kinsmen shall redeem him, or his uncle or his uncle's son shall redeem him, or anyone of his family who is of his own flesh shall redeem him; or, if he prospers, he may redeem himself. He shall compute with his purchaser the total from the year he gave himself over to him until the jubilee year; the price of his sale shall be applied to the number of years, as though it were for a term as a hired laborer under the other's authority. If many years remain, he shall pay back for his redemption in proportion to his purchase price; and if few years remain until the jubilee year, he shall so compute: he shall make payment for his redemption according to the years involved. He shall be under his authority as a laborer hired by the year; he shall not rule ruthlessly over him in your sight. If he has not been redeemed in any of those ways, he and his children with him shall go free in the jubilee year. For it is to Me that the Israelites are servants: they are My servants, whom I freed from the land of Egypt, I the Lord your God. You shall not make idols for yourselves, or set up for yourselves carved images or pillars, or place figured stones in your land to worship upon, for I the Lord am your God. You shall keep My sabbaths and venerate My sanctuary, Mine, the Lord's. (Lev. 25.39–26.2)

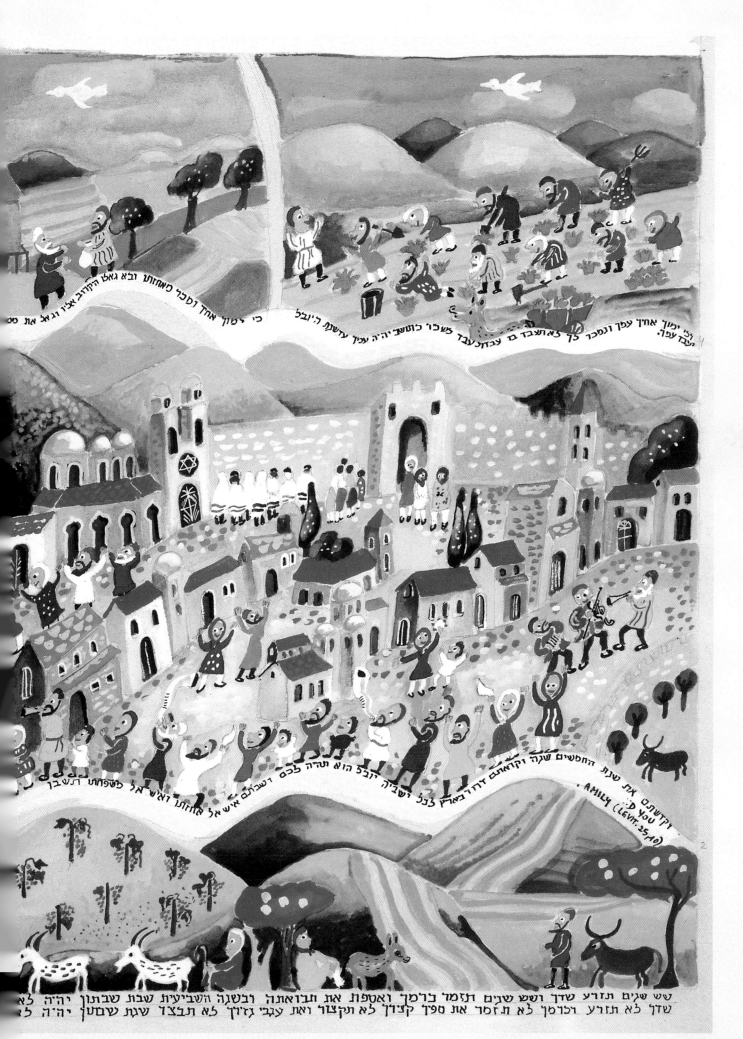

ולפני אחיך עפר ונמכר לך לעבד ... משלו כותשהיה עיר עשתך ליובל . עבד עברי ... כי יפון אחיך ... ובא גאל הקרוב אליו וגאל את ... פאחזתו ודפכר אחד ...

את שנת החמשים שנה וקראתם ... ויקראתם דרור בארץ לכל ישביה יובל הוא תהיה לכם ושבתם איש אל אחזתו ואיש אל משפחתו תשבו ...

Haftarat Behar

(Jeremiah 32.6–27)

Jeremiah said: The word of the Lord came to me: Hanamel, the son of your uncle Shallum, will come to you and say, "Buy my land in Anathoth, for you are next in succession to redeem it by purchase." And just as the Lord had said, my cousin Hanamel came to me in the prison compound and said to me, "Please buy my land in Anathoth, in the territory of Benjamin; for the right of succession is yours, and you have the duty of redemption. Buy it." Then I knew that it was indeed the word of the Lord ... I took the deed of purchase, the sealed text and the open one according to rule and law, and gave the deed to Baruch son of Neriah son of Mahseiah in the presence of my kinsman Hanamel, of the witnesses who were named in the deed, and all the Judeans who were sitting in the prison compound ... But after I had given the deed to Baruch son of Neriah, I prayed to the Lord: "Ah, Lord God! You made heaven and earth with Your great might and outstretched arm. Nothing is too wondrous for You! You show kindness to the thousandth generation, but visit the guilt of the fathers upon their children after them. O great and mighty God whose name is Lord of Hosts, wondrous in purpose and mighty in deed, whose eyes observe all the ways of men, so as to repay every man according to his ways, and with the proper fruit of his deeds! You displayed signs and marvels in the land of Egypt with lasting effect, and won renown in Israel and among mankind to this very day. You freed Your people Israel from the land of Egypt with signs and marvels, with a strong hand and an outstretched arm, and with great terror. You gave them this land that You had sworn to their fathers to give them, a land flowing with milk and honey, and they came and took possession of it." (Jer. 32.6–23)

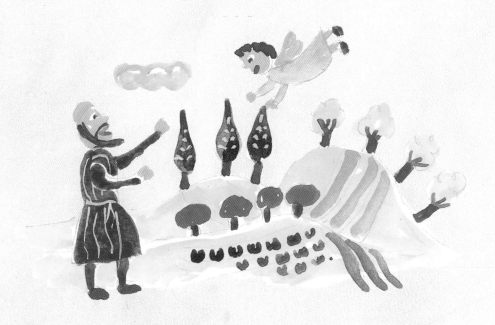

God spoke to the people and promised them prosperity and bounty if they followed God's commandments. But if they ignored these commandments, they would surely face punishment—death, destruction, ruin, and exile. God also instructed Moses in the laws concerning vows.

אם בחקתי תלכו ואת מצותי תשמרו ועשיתם אתם: ונתתי גשמיכם בעתם ונתנה הארץ יבולה ועץ השדה יתן פריו:

If you follow My laws and faithfully observe My commandments, I will grant your rains in their season, so that the earth shall yield its produce and the trees of the field their fruit. (Lev. 26.3–4)

Your threshing shall overtake the vintage, and your vintage shall overtake the sowing; you shall eat your fill of bread and dwell securely in your land. I will grant peace in the land, and you shall lie down untroubled by anyone; I will give the land respite from vicious beasts, and no sword shall cross your land. You shall give chase to your enemies, and they shall fall before you by the sword. Five of you shall give chase to a hundred, and a hundred of you shall give chase to ten thousand; your enemies shall fall before you by the sword. I will look with favor upon you, and make you fertile and multiply you; and I will maintain My covenant with you. You shall eat old grain

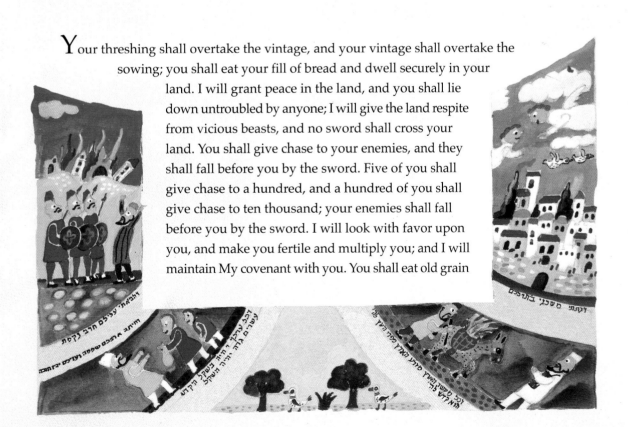

long stored, and you shall have to clear out the old to
make room for the new. I will establish My abode in
your midst, and I will not spurn you. I will be ever
present in your midst: I will be your God, and you shall
be My people. I the Lord am your God who brought
you out from the land of the Egyptians to be their slaves
no more, who broke the bars of your yoke and made
you walk erect. (Lev. 26.5–13)

But if you do not obey Me and do not observe all
these commandments, if you reject My laws and spurn
My rules, so that you do not observe all My
commandments and you break My covenant, I in turn
will do this to you: I will wreak misery upon you—
consumption and fever, which cause the eyes to pine
and the body to languish; you shall sow your seed to
no purpose, for your enemies shall eat it. I will set My
face against you: you shall be routed by your enemies,
and your foes shall dominate you. You shall flee though
none pursues. And if, for all that, you do not obey Me,
I will go on to discipline you sevenfold for your sins,
and I will break your proud glory. I will make your
skies like iron and your earth like copper, so that your
strength shall be spent to no purpose. Your land shall
not yield its produce, nor shall the trees of the land
yield their fruit. And if you remain hostile toward Me
and refuse to obey Me, I will go on smiting you sevenfold
for your sins. I will loose wild beasts against you, and
they shall bereave you of your children and wipe out
your cattle. They shall decimate you, and your roads
shall be deserted. (Lev. 26.14–22)

And if these things fail to discipline you for Me,
and you remain hostile to Me, I too will remain hostile
to you: I in turn will smite you sevenfold for your sins.
I will bring a sword against you to wreak vengeance
for the covenant; and if you withdraw into your cities,
I will send pestilence among you, and you shall be delivered
into enemy hands. When I break your staff of bread, ten women shall bake
your bread in a single oven; they shall dole out your bread by weight, and though you eat,
you shall not be satisfied. But if, despite this, you disobey Me and remain hostile to Me, I will act against
you in wrathful hostility; I, for My part, will discipline you sevenfold for your sins. You shall eat the flesh
of your sons and the flesh of your daughters. I will destroy your cult places and cut down your incense
stands, and I will heap your carcasses upon your lifeless fetishes. I will spurn you. I will lay your cities in

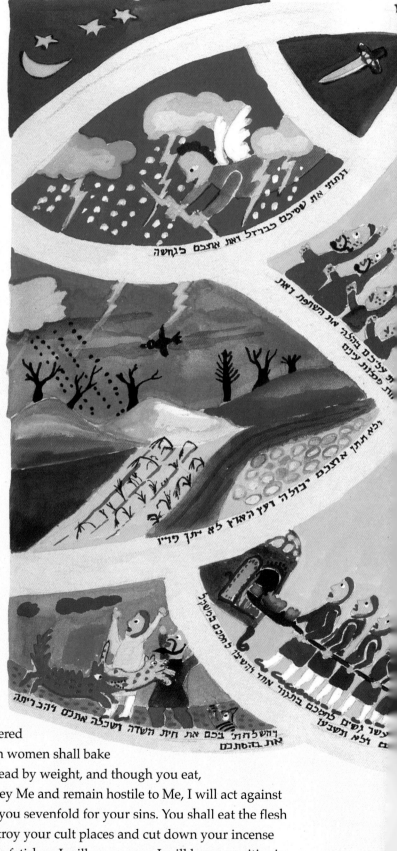

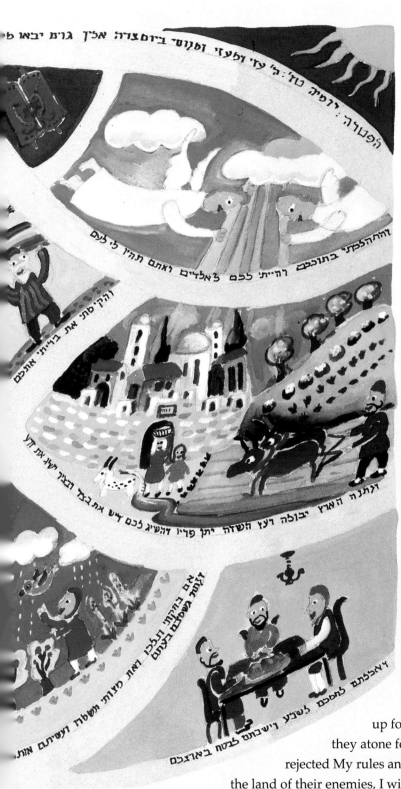

ruin and make your sanctuaries desolate, and I will not savor your pleasing odors. I will make the land desolate, so that your enemies who settle in it shall be appalled by it. And you I will scatter among the nations, and I will unsheath the sword against you. Your land shall become a desolation and your cities a ruin. Then shall the land make up for its sabbath years throughout the time that it is desolate and you are in the land of your enemies; then shall the land rest and make up for its sabbath years. Throughout the time that it is desolate, it shall observe the rest that it did not observe in your sabbath years while you were dwelling upon it. As for those of you who survive, I will cast a faintness into their hearts in the land of their enemies. The sound of a driven leaf shall put them to flight. Fleeing as though from the sword, they shall fall though none pursues. With no one pursuing, they shall stumble over one another as before the sword. You shall not be able to stand your ground before your enemies, but shall perish among the nations; and the land of your enemies shall consume you. (Lev. 26.23–38)

Those of you who survive shall be heartsick over their iniquity in the land of your enemies; more, they shall be heartsick over the iniquities of their fathers; and they shall confess their iniquity and the iniquity of their fathers, in that they trespassed against Me, yea, were hostile to Me. When I, in turn, have been hostile to them and have removed them into the land of their enemies, then at last shall their obdurate heart humble itself, and they shall atone for their iniquity. Then will I remember My covenant with Jacob; I will remember also My covenant with Isaac, and also My covenant with Abraham; and I will remember the land. For the land shall be forsaken of them, making up for its sabbath years by being desolate of them, while they atone for their iniquity; for the abundant reason that they rejected My rules and spurned My laws. Yet, even then, when they are in the land of their enemies, I will not reject them or spurn them so as to destroy them, annulling My covenant with them: for I the Lord am their God. I will remember in their favor the covenant with the ancients, whom I freed from the land of Egypt in the sight of the nations to be their God: I, the Lord ... All assessments shall be by the sanctuary weight, the shekel being twenty *gerahs* ... All tithes from the land, whether seed from the ground or fruit from the tree, are the Lord's; they are holy to the Lord. (Lev. 26.39–27.30)

Haftarat Bechukotai

(Jeremiah 16.19–17.14)

O Lord, my strength and my stronghold, my refuge in a day of trouble, to You nations shall come
from the ends of the earth and say: Our fathers inherited utter delusions, things that are futile and
worthless. Can a man make gods for himself? No-gods are they! Assuredly, I will teach them, once and
for all I will teach them My power and My might. And they shall learn that My name is Lord. The guilt
of Judah is inscribed with a stylus of iron, engraved with an adamant point on the tablet of their hearts,
and on the horns of their altars, while their children remember their altars and sacred posts, by verdant
trees, upon lofty hills. Because of the sin of your shrines throughout your borders, I will make your
rampart a heap in the field, and all your treasures a spoil. You will forfeit, by your own act, the inheritance
I have given you; I will make you a slave to your enemies in a land you have never known. For you have
kindled the flame of My wrath which shall burn for all time. Thus said the Lord: Cursed is he who trusts
in man, who makes mere flesh his strength ... Blessed is he who trusts in the Lord, whose trust is the
Lord alone. He shall be like a tree planted by waters, sending forth its roots by a stream: It does not sense
the coming of heat, its leaves are ever fresh; it has no care in a year of drought, it does not cease to yield
fruit. (Jer. 16.19–17.8)

וידבר ה' אל משה
במדבר סיני באהל מועד באחד לחדש
השני בשנה השנית לצאתם מארץ מצרים לאמר:

On the first day of the second month, in the second year following the exodus from the land of Egypt, the Lord spoke to Moses in the wilderness of Sinai, in the Tent of Meeting.... (Num. 1.1)

In the wilderness of Sinai, God commanded Moses to take the first census. Among them, the Israelites numbered 600,000 fighting men. God then instructed Moses and Aaron to arrange the twelve tribes around the Tent of Meeting when they set up camp and when they marched. The Levites were not included in the census. God described their duties and those assigned to Aaron's family in tending and preserving the Tabernacle.

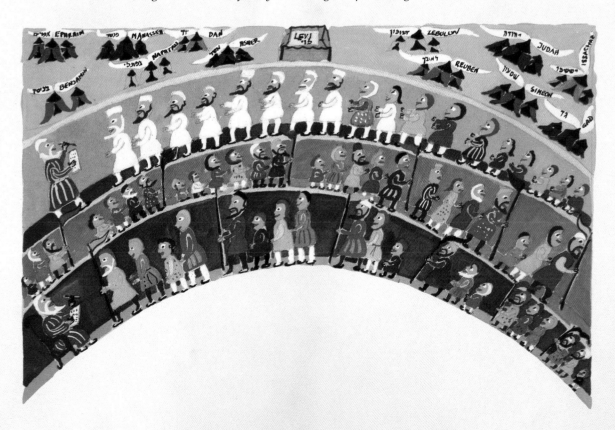

BEMIDBAR

Bemidbar

Take a census of the whole Israelite community by the clans of its ancestral houses, listing the names, every male, head by head ... Associated with you shall be a man from each tribe, each one the head of his ancestral house ... The Levites, however, were not recorded among them by their ancestral tribe. For the Lord had spoken to Moses, saying: Do not on any account enroll the tribe of Levi or take a census of them with the Israelites. You shall put the Levites in charge of the Tabernacle of the Pact, all its furnishings, and everything that pertains to it: they shall carry the Tabernacle and all its furnishings, and they shall tend it; and they shall camp around the Tabernacle. When the Tabernacle is to set out, the Levites shall take it down, and when the Tabernacle is to be pitched, the Levites shall set it up; any outsider who encroaches shall be put to death. The Israelites shall encamp troop by troop, each man with his division and each under his standard. The Levites, however, shall camp around the Tabernacle of the Pact, that wrath may not strike the Israelite community; the Levites shall stand guard around the Tabernacle of the Pact. The Israelites did accordingly; just as the Lord had commanded Moses, so they did. The Lord spoke to Moses and Aaron, saying: The Israelites shall camp each with his standard, under the banners of their ancestral house; they shall camp around the Tent of Meeting at a distance. Camped on the front, or east side: the standard of the division of Judah, troop by troop. Chieftain of the Judites: Nahshon son of Amminadab ... Camping next to it: The tribe of Issachar. Chieftain of the Issacharites: Nethanel son of Zuar ... The tribe of Zebulun. Chieftain of the Zebulunites: Eliab son of Helon ... These shall march first. On the south: the standard of the division of Reuben ... Chieftain of the Reubenites: Elizur son of Shedeur ... Camping next to it: The tribe of Simeon. Chieftain of the Simeonites: Shelumiel son of Zurishaddai ... And the tribe of Gad. Chieftain of the Gadites: Eliasaph son of Reuel ... These shall march second. Then, midway between the divisions, the Tent of Meeting, the division of the Levites, shall move. As they camp, so they shall march, each in position, by their standards. On the west: the standard of the division of Ephraim ... Chieftain of the Ephraimites: Elishama son of Ammihud ... Next to it: The tribe of Manasseh. Chieftain of the Manassites: Gamaliel son of Pedahzur ... And the tribe of Benjamin. Chieftain of the

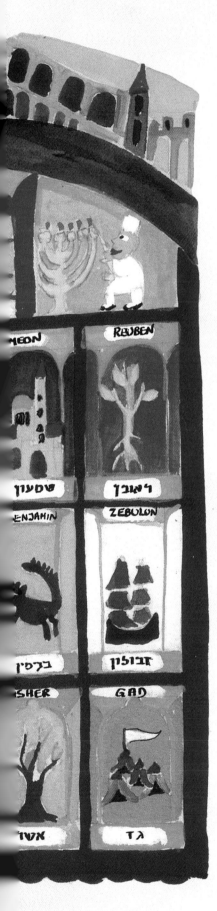

Benjaminites: Abidan son of Gideoni ... These shall march third. On the north: the standard of the division of Dan ... Chieftain of the Danites: Ahiezer son of Ammishaddai. Camping next to it: The tribe of Asher. Chieftain of the Asherites: Pagiel son of Ochran ... And the tribe of Naphtali. Chieftain of the Naphtalites: Ahira son of Enan ... These shall march last, by their standards. Those are the enrollments of the Israelites by ancestral houses. The total enrolled in the divisions, for all troops: 603,550. The Levites, however, were not recorded among the Israelites, as the Lord had commanded Moses. (Num. 1.2–2.33)

The Lord spoke to Moses, saying: Advance the tribe of Levi and place them in attendance upon Aaron the priest to serve him. They shall perform duties for him and for the whole community before the Tent of Meeting, doing the work of the Tabernacle. They shall take charge of all the furnishings of the Tent of Meeting—a duty on behalf of the Israelites—doing the work of the Tabernacle. You shall assign the Levites to Aaron and to his sons: they are formally assigned to him from among the Israelites. You shall make Aaron and his sons responsible for observing their priestly duties; and any outsider who encroaches shall be put to death. The Lord spoke to Moses, saying: I hereby take the Levites from among the Israelites in place of all the first-born, the first issue of the womb among the Israelites: the Levites shall be Mine. For every first-born is Mine: at the time that I smote every first-born in the land of Egypt, I consecrated every first-born in Israel, man and beast, to Myself, to be Mine, the Lord's ... These were the clans of the Levites within their ancestral houses: To Gershon belonged the clan of the Libnites and the clan of the Shimeites; those were the clans of the Gershonites ... To Kohath belonged the clan of the Amramites, the clan of the Izharites, the clan of the Hebronites, and the clan of the Uzzielites; those were the clans of the Kohathites ... To Merari belonged the clan of the Mahlites and the clan of the Mushites; those were the clans of Merari ... The Lord said to Moses: Record every first-born male of the Israelite people from the age of one month up, and make a list of their names; and take the Levites for Me, the Lord, in place of every first-born among the Israelite people, and the cattle of the Levites in place of every first-born among the cattle of the Israelites. (Num. 3.5–41)

Bemidbar

At the breaking of camp, Aaron and his sons shall go in and take down the screening curtain and cover the Ark of the Pact with it ... Then they shall take a blue cloth and cover the lampstand for lighting, with its lamps, its tongs, and its fire pans, as well as all the oil vessels that are used in its service ... Next they shall spread a blue cloth over the altar of gold and cover it with a covering of dolphin skin; and they shall put its poles in place ... Upon [the copper altar] they shall place all the vessels that are used in its service: the fire pans, the flesh hooks, the scrapers, and the basins—all the vessels of the altar—and over it they shall spread a covering of dolphin skin; and they shall put its poles in place. When Aaron and his sons have finished covering the sacred objects and all the furnishings of the sacred objects at the breaking of camp, only then shall the Kohathites come and lift them, so that they do not come in contact with the sacred objects and die. These things in the Tent of Meeting shall be the porterage of the Kohathites. (Num. 4.5–15)

Haftarat Bemidbar

(Hosea 2.1–22)

The number of the people of Israel shall be like that of the sands of the sea, which cannot be measured or counted; and instead of being told, "You are Not-My-People," they shall be called Children-of-the-Living-God. The people of Judah and the people of Israel shall assemble together and appoint one head over them; and they shall rise from the ground—for marvelous shall be the day of Jezreel! Oh, call your brothers "My People," and your sisters "Lovingly Accepted!" ... Assuredly, I will speak coaxingly to her and lead her through the wilderness and speak to her tenderly. I will give her her vineyards from there, and the Valley of Achor as a plowland of hope. There she shall respond as in the days of her youth, when she came up from the land of Egypt. And in that day—declares the Lord— You will call Me Ishi, and no more will you call Me Baali. For I will remove the names of the Baalim from her mouth, and they shall nevermore be mentioned by name. In that day, I will make a covenant for them with the beasts of the field, the birds of the air, and the creeping things of the ground; I will also banish bow, sword, and war from the land. Thus I will let them lie down in safety. And I will espouse you forever: I will espouse you with righteousness and justice, and with goodness and mercy, and I will espouse you with faithfulness; then you shall be devoted to the Lord. (Hos. 2.1–22)

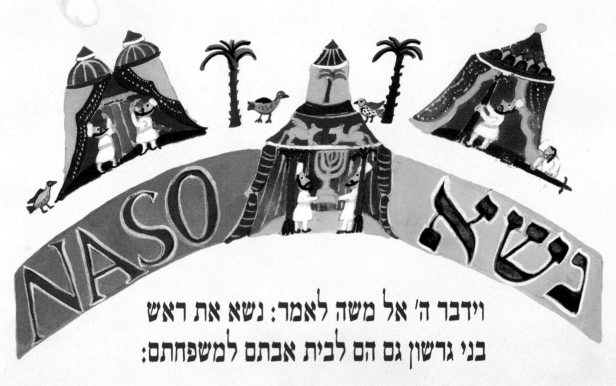

וידבר ה' אל משה לאמר: נשא את ראש
בני גרשון גם הם לבית אבתם למשפחתם:

The Lord spoke to Moses: Take a census of the Gershonites also, by their ancestral house and by their clans. (Num. 4.21)

God told Moses to instruct the people about the special case of the sotah, the woman suspected of adultery by a jealous husband. God then described the laws of the Nazirite, an individual who took upon himself or herself a special vow of renunciation. God then pronounced the Blessing of the Priests, birkat kohanim, henceforth to be recited by the priests for the people. In a twelve-day ceremony, the Israelites brought forth offerings, consecrating the Tabernacle.

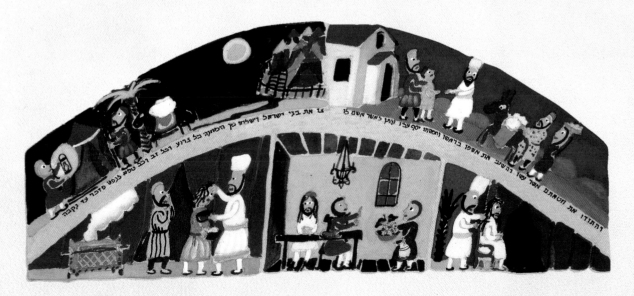

BEMIDBAR

Naso

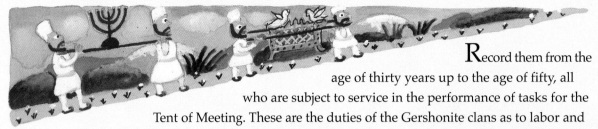

Record them from the age of thirty years up to the age of fifty, all who are subject to service in the performance of tasks for the Tent of Meeting. These are the duties of the Gershonite clans as to labor and porterage: they shall carry the cloths of the Tabernacle, the Tent of Meeting with its covering, the covering of dolphin skin that is on top of it, and the screen for the entrance of the Tent of Meeting; the hangings of the enclosure, the screen at the entrance of the gate of the enclosure that surrounds the Tabernacle, the cords thereof, and the altar, and all their service equipment and all their accessories; and they shall perform the service ... As for the Merarites, you shall record them by the clans of their ancestral house; you shall record them from the age of thirty years up to the age of fifty, all who are subject to service in the performance of the duties for the Tent of Meeting. These are their porterage tasks in connection with their various duties for the Tent of Meeting: the planks, the bars, the posts, and the sockets of the Tabernacle; the posts around the enclosure and their sockets, pegs, and cords— all these furnishings and their service: you shall list by name the objects that are their porterage tasks. Those are the duties of the Merarite clans, pertaining to their various duties in the Tent of Meeting under the direction of Ithamar son of Aaron the priest. So Moses, Aaron, and the chieftains of the community recorded the Kohathites by the clans of their ancestral house ... The Gershonites who

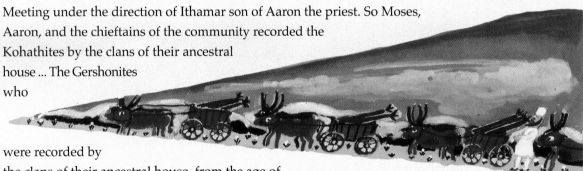

were recorded by the clans of their ancestral house, from the age of thirty years up to the age of fifty, all who were subject to service for work relating to the Tent of Meeting—those recorded by the clans of their ancestral house came to 2,630. That was the enrollment of the Gershonite clans, all those performing duties relating to the Tent of Meeting whom Moses and Aaron recorded at the command of the Lord. The enrollment of the Merarite clans by the clans of their ancestral house, from the age of thirty years up to the age of fifty, all who were subject to service for work relating to the Tent of Meeting—those recorded by their clans came to 3,200. That was the enrollment of the Merarite clans which Moses and Aaron recorded at the command of the Lord through Moses. All the Levites whom Moses, Aaron, and the chieftains of Israel recorded by the clans of their ancestral houses, from the age of thirty years up to the age of fifty, all who were subject to duties of service and porterage relating to the Tent of Meeting—those recorded came to 8,580. Each one was given responsibility for his service and porterage at the command of the Lord through Moses, and each was recorded as the Lord had commanded Moses. (Num. 4.23–49)

The Lord spoke to Moses, saying: Instruct the Israelites to remove from camp anyone with an eruption or a discharge and anyone defiled by a corpse. Remove male and female alike; put them outside the camp so that they do not defile the camp of those in whose midst I dwell ... The Lord spoke to Moses, saying: Speak to the Israelites: When a man or woman commits any wrong toward a fellow man, thus breaking faith with the Lord, and that person realizes his guilt, he shall confess the wrong

that he has done. He shall make restitution in the principal amount and add one-fifth to it, giving it to him whom he has wronged. If the man has no kinsman to whom restitution can be made, the amount repaid shall go to the Lord for the priest—in addition to the ram of expiation with which expiation is made on his behalf. (Num. 5.1–8)

The Lord spoke to Moses, saying: Speak to the Israelites and say to them: If anyone, man or woman, explicitly utters a nazirite's vow, to set himself apart for the Lord ... Throughout the term of his vow as nazirite, no razor shall touch his head; it shall remain consecrated until the completion of his term as nazirite of the Lord, the hair of his head being left to grow untrimmed ... This is the ritual for the nazirite: On the day that his term as nazirite is completed, he shall be brought to the entrance of the Tent of Meeting. As his offering to the Lord he shall present: one male lamb in its first year, without blemish, for a burnt offering; one ewe lamb in its first year, without blemish, for a sin offering; one ram without blemish for an offering of well-being; a basket of unleavened cakes of choice flour with oil mixed in, and unleavened wafers spread with oil; and the proper meal offerings and libations ... The nazirite shall then shave his consecrated hair, at the entrance of the Tent of Meeting, and take the locks of his consecrated hair and put them on the fire that is under the sacrifice of well-being. The priest shall take the shoulder of the ram when it has been boiled, one unleavened cake from the basket, and one unleavened wafer, and place them on the hands of the nazirite after he has shaved his consecrated hair. The priest shall elevate them as an elevation offering before the Lord; and this shall be a sacred donation for the priest, in addition to the breast of the elevation offering and the thigh of gift offering. After that the nazirite may drink wine. Such is the obligation of a nazirite; except that he who vows an offering to the Lord of what he can afford, beyond his nazirite requirements, must do exactly according to the vow that he has made beyond his obligation as a nazirite. (Num. 6.1–21)

The Lord spoke to Moses: Speak to Aaron and his sons: Thus shall you bless the people of Israel. Say to them: The Lord bless you and protect you! The Lord deal kindly and graciously with you! The Lord bestow His favor upon you and grant you peace! Thus they shall link My name with the people of Israel, and I will bless them. On the day that Moses finished setting up the Tabernacle, he anointed and consecrated it and all its furnishings, as well as the altar and its utensils. When he had anointed and consecrated them, the chieftains of Israel, the heads of ancestral houses, namely, the chieftains of the tribes, those who were in charge of enrollment, drew near and brought their offering before the Lord: six draught carts and twelve oxen, a cart for every two chieftains and an ox for each one. When they had brought them before the Tabernacle, the Lord said to Moses: Accept these from them for use in the service of the Tent of Meeting, and give them to the Levites according to their respective services. Moses took the carts and the oxen

and gave them to the Levites. Two carts and four oxen he gave to the Gershonites, as required for their service, and four carts and eight oxen he gave to the Merarites, as required for their service—under the direction of Ithamar son of Aaron the priest. But to the Kohathites he did not give any; since theirs was the service of the most sacred objects, their porterage was by shoulder ... When Moses went into the Tent of Meeting to speak with Him, he would hear the Voice addressing him from above the cover that was on top of the Ark of the Pact between the two cherubim; thus He spoke to him. (Num. 6.22–7.89)

Haftarat Naso

(Judges 13.2–25)

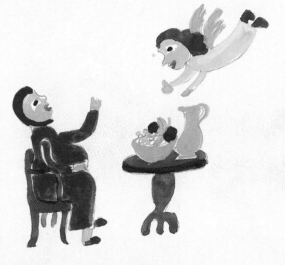

There was a certain man from Zorah, of the stock of Dan, whose name was Manoah. His wife was barren and had borne no children. An angel of the Lord appeared to the woman and said to her, "You are barren and have borne no children; but you shall conceive and bear a son. Now be careful not to drink wine or other intoxicant, or to eat anything unclean. For you are going to conceive and bear a son; let no razor touch his head, for the boy is to be a nazirite to God from the womb on. He shall be the first to deliver Israel from the Philistines." The woman went and told her husband, "A man of God came to me; he looked like an angel of God, very frightening. I did not ask him where he was from, nor did he tell me his name. He said to me, 'You are going to conceive and bear a son. Drink no wine or other intoxicant, and eat nothing unclean, for the boy is to be a nazirite to God from the womb to the day of his death!'"... Manoah took the kid and the meal offering and offered them up on the rock to the Lord; and a marvelous thing happened while Manoah and his wife looked on. As the flames leaped up from the altar toward the sky, the angel of the Lord ascended in the flames of the altar, while Manoah and his wife looked on; and they flung themselves on their faces to the ground. —The angel of the Lord never appeared again

to Manoah and his wife. —Manoah then realized that it had been an angel of the Lord. And Manoah said to his wife, "We shall surely die, for we have seen a divine being." But his wife said to him, "Had the Lord meant to take our lives, He would not have accepted a burnt offering and meal offering from us, nor let us see all these things; and He would not have made such an announcement to us." The woman bore a son, and she named him Samson. The boy grew up, and the Lord blessed him. The spirit of the Lord first moved him in the encampment of Dan, between Zorah and Eshtaol. (Judg. 13.2–25)

In the midst of the desert, God defined for Moses the laws for the Levites, for the observance of Passover, and for waging war. Tired of the rigors of their long journey, the Israelites once again complained to Moses, who despaired of leading this rebellious people. God ordered him to share leadership with seventy elders, who were then possessed by the divine spirit. To satisfy the people's hunger, God sent a glut of quail, followed by a severe plague. Miriam and Aaron spoke out against Moses, challenging his authority. Miriam was stricken with leprosy, and Moses prayed for her healing. The people waited for her to re-enter the camp before traveling on. The Israelites resumed their journey through the desert, camping and resting in accordance with God's command.

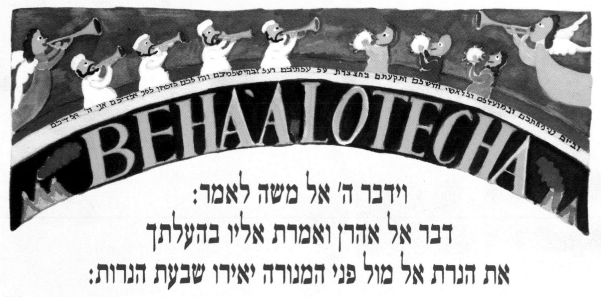

וידבר ה' אל משה לאמר:

דבר אל אהרן ואמרת אליו בהעלתך

את הנרת אל מול פני המנורה יאירו שבעת הנרות:

The Lord spoke to Moses, saying: Speak to Aaron and say to him, "When you mount the lamps, let the seven lamps give light at the front of the lampstand." (Num. 8.1–2)

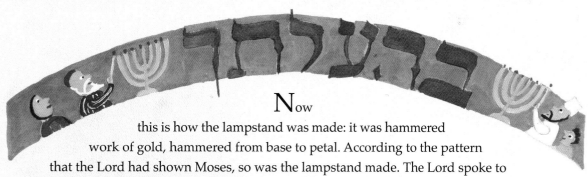

Now this is how the lampstand was made: it was hammered work of gold, hammered from base to petal. According to the pattern that the Lord had shown Moses, so was the lampstand made. The Lord spoke to Moses, saying: Take the Levites from among the Israelites and cleanse them. This is what you shall do to them to cleanse them: sprinkle on them water of purification, and let them go over their whole body with a razor, and wash their clothes; thus they shall be cleansed ... You shall place the Levites in attendance upon Aaron and his sons, and designate them as an elevation offering to the Lord ... The Lord spoke to Moses, saying: This is the rule for the Levites. From twenty-five years of age up they shall participate in the work force in the service of the Tent of Meeting; but at the age of fifty they shall retire from the work force and shall serve no more ... The Lord spoke to Moses in the wilderness of Sinai, on the first new moon of the second year following the exodus from the land of Egypt, saying: Let the Israelite people offer the passover sacrifice at its set time: you shall offer it on the fourteenth day of this month, at twilight, at its set time; you shall offer it in accordance with all

BEMIDBAR

Beha'alotecha

its rules and rites. Moses instructed the Israelites to offer the passover sacrifice; and they offered the passover sacrifice in the first month, on the fourteenth day of the month, at twilight, in the wilderness of Sinai. Just as the Lord had commanded Moses, so the Israelites did ... And when a stranger who resides with you would offer a passover sacrifice to the Lord, he must offer it in accordance with the rules and rites of the passover sacrifice. There shall be one law for you, whether stranger or citizen of the country. On the day that the Tabernacle was set up, the cloud covered the Tabernacle, the Tent of the Pact; and in the evening it rested over the Tabernacle in the likeness of fire until morning ... Whether it was two days or a month or a year—however long the cloud lingered over the Tabernacle—the Israelites remained encamped and did not set out; only when it lifted did they break camp. On a sign from the Lord they made camp and on a sign from the Lord they broke camp; they observed the Lord's mandate at the Lord's bidding through Moses. The Lord spoke to Moses, saying: Have two silver trumpets made; make them of hammered work. They shall serve you to summon the community and to set the divisions in motion. When both are blown in long blasts, the whole community shall assemble before you at the entrance of the Tent of Meeting; and if only one is blown, the chieftains, heads of Israel's contingents, shall assemble before you. But when you sound short blasts, the divisions encamped on the east shall move forward; and when you sound short blasts a second time, those encamped on the south shall move forward. Thus short blasts shall be blown for setting them in motion, while to convoke the congregation you shall blow long blasts, not short ones. The trumpets shall be blown by Aaron's sons, the priests; they shall be for you an institution for all time throughout the ages ... And on your joyous occasions—your fixed festivals and new moon days—you shall sound the trumpets over your burnt offerings and your sacrifices of well-being. They shall be a reminder of you before your God: I, the Lord, am your God. (Num 8.4–10.10)

Moses said to Hobab son of Reuel the Midianite, Moses' father-in-law, "We are setting out for the place of which the Lord has said, 'I will give it to you.' Come with us and we will be generous with you; for the Lord has promised to be generous to Israel." "I will not go," he replied to him, "but will return to my native land." He said, "Please do not leave us, inasmuch as you know

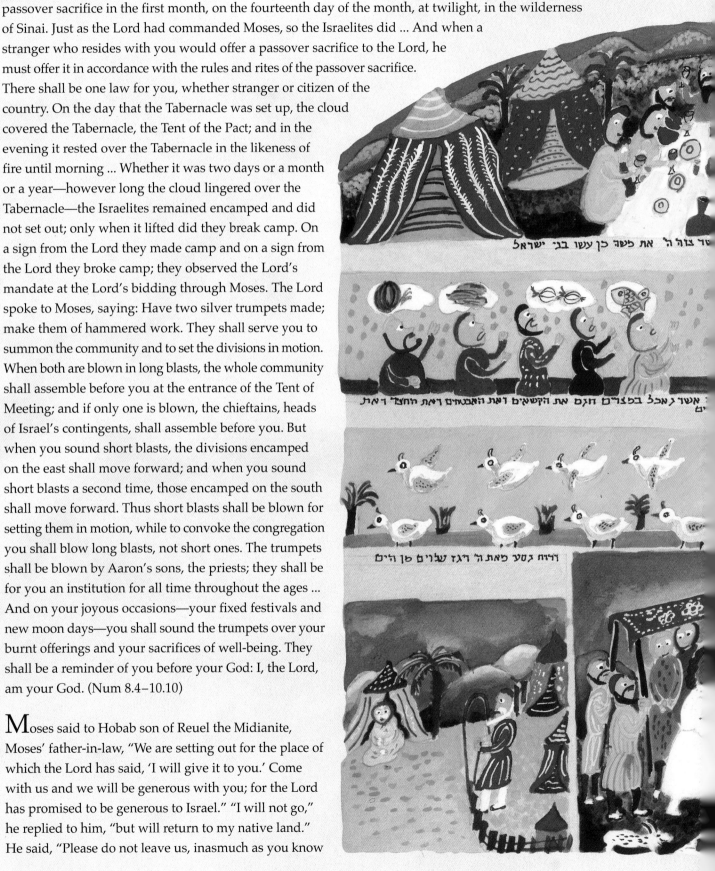

אשר צוה ה' את פסח כן עשו בני ישראל

אשר נאכל במצרים חנם את הקשאים ואת האבטחים ואת החציר ואת ...ים

ורוח נסע מאת ה' ויגז שלוים מן הים

where we should camp in the wilderness and can be our guide. So if you come with us, we will extend to you the same bounty that the Lord grants us." They marched from the mountain of the Lord a distance of three days. The Ark of the Covenant of the Lord traveled in front of them on that three days' journey to seek out a resting place for them ... The people took to complaining bitterly before the Lord. The Lord heard and was incensed: a fire of the Lord broke out against them, ravaging the outskirts of the camp. The people cried out to Moses. Moses prayed to the Lord, and the fire died down.

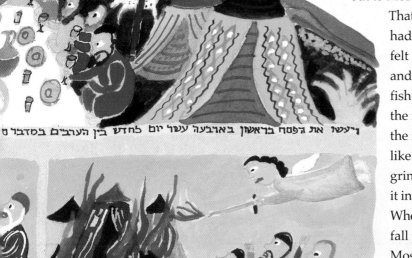

ויעשו את הפסח בראשון בארבעה עשר יום לחדש בין הערבים במדבר ס

That place was named Taberah, because a fire of the Lord had broken out against them. The riffraff in their midst felt a gluttonous craving; and then the Israelites wept and said, "If only we had meat to eat! We remember the fish that we used to eat free in Egypt, the cucumbers, the melons, the leeks, the onions, and the garlic ... Now the manna was like coriander seed, and in color it was like bdellium. The people would go about and gather it, grind it between millstones or pound it in a mortar, boil it in a pot, and make it into cakes. It tasted like rich cream. When the dew fell on the camp at night, the manna would fall upon it. Moses heard the people weeping ... And Moses said to the Lord, "Why have You dealt ill with Your servant, and why have I not enjoyed Your favor, that You have laid the burden of all this people upon me? ... Then the Lord said to Moses, "Gather for Me seventy of Israel's elders of whom you have experience as elders and officers of the people, and bring them to the Tent of Meeting and let them take their place there with you. I will come down and speak with you there ...

ויהי העם כמתאננים רע באזני ה' וישמע ה' ויחר אפו ותבער בם אש ה' ותאכל בקצה המחנה

And say to the people: Purify yourselves for tomorrow and you shall eat meat, for you have kept whining before the Lord ... 'Oh, why did we ever leave Egypt!'" ... Two men, one named Eldad and the other Medad, had remained in camp; yet the spirit rested upon them ... And they spoke in ecstasy in the camp ... And Joshua son of Nun, Moses' attendant from his youth, spoke up and said, "My lord Moses, restrain them!" But Moses said to him, "Are you wrought up on my account? Would that all the Lord's people were prophets, that the Lord put His spirit upon them!" ... A wind from the Lord started up, swept quail from the sea and strewed them over the camp, about a day's journey on this side and about a day's journey on that side, all around the camp, and some two cubits deep on the ground. The people set to gathering quail all that day and night and all the next day ... The meat was still between their teeth, nor

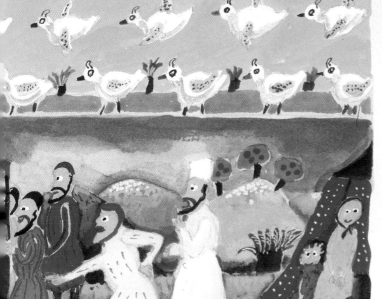

yet chewed, when the anger of the Lord blazed forth against the people and the Lord struck the people with a very severe plague. That place was named Kibroth-hattaavah, because the people who had the craving were buried there. Then the people set out from Kibroth-hattaavah for Hazeroth. (Num 10.29–11.35)

Miriam and Aaron spoke against Moses because of the Cushite woman he had married: "He married a Cushite woman!" They said, "Has the Lord spoken only through Moses? Has He not spoken through us as well?" The Lord heard it. Now Moses was a very humble man, more so than any other man on earth. Suddenly the Lord called to Moses, Aaron, and Miriam, "Come out, you three, to the Tent of Meeting." So the three of them went out. The Lord came down in a pillar of cloud, stopped at the entrance of the Tent, and called out, "Aaron and Miriam!" The two of them came forward; and He said, "Hear these My words: When a prophet of the Lord arises among you, I make Myself known to him in a vision, I speak with him in a dream. Not so with My servant Moses; he is trusted throughout My household. With him I speak mouth to mouth, plainly and not in riddles, and he beholds the likeness of the Lord. How then did you not shrink from speaking against My servant Moses!" Still incensed with them, the Lord departed. As the cloud withdrew from the Tent, there was Miriam stricken with snow-white scales! When Aaron turned toward Miriam, he saw that she was stricken with scales. And Aaron said to Moses, "O my lord, account not to us the sin which we committed in our folly. Let her not be as one dead, who emerges from his mother's womb with half his flesh eaten away." So Moses cried out to the Lord, saying, "O God, pray heal her!" But the Lord said to Moses, "If her father spat in her face, would she not bear her shame for seven days? Let her be shut out of camp for seven days, and then let her be readmitted." So Miriam was shut out of camp seven days; and the people did not march on until Miriam was readmitted. After that the people set out from Hazeroth and encamped in the wilderness of Paran. (Num. 12.1–16)

Haftarat Beha'alotecha

(Zechariah 2.14–4.7)

Shout for joy, Fair Zion! For lo, I come; and I will dwell in your midst—declares the Lord. In that day many nations will attach themselves to the Lord and become His people, and He will dwell in your midst. Then you will know that I was sent to you by the Lord of Hosts ... The angel who talked with me came back and woke me as a man is wakened from sleep. He said to me, "What do you see?" And I answered, "I see a lampstand all of gold, with a bowl above it. The lamps on it are seven in number, and the lamps above it have seven pipes; and by it are two olive trees, one on the right of the bowl and one on its left." I, in turn, asked the angel who talked with me, "What do those things mean, my lord?" "Do you not know what those things mean?" asked the angel who talked with me; and I said, "No, my lord." Then he explained to me as follows: "This is the word of the Lord to Zerubbabel: Not by might, nor by power, but by My spirit—said the Lord of Hosts. Whoever you are, O great mountain in the path of Zerubbabel, turn into level ground! For he shall produce that excellent stone; it shall be greeted with shouts of 'Beautiful! Beautiful!'" (Zech. 2.14–4.7)

When the Israelites reached the borders of Canaan, Moses dispatched twelve scouts to spy out the land. When they returned forty days later, ten of the spies reported that the Canaanites were too powerful to conquer. But Joshua and Caleb disagreed, urging the people to enter and take possession of the land. Hearing the spies' report, the people mutinied, demanding to return to Egypt. In response, God sentenced the entire slave generation to wander for forty years and die in the desert, except for Joshua and Caleb. Too late, the people marched out to fight the Canaanites but they were crushed in battle. God commanded that when the Israelites settled in their new land, they were to make special sacrifices and wear tzitzit, *fringes, on the corner of their garments as a reminder of God's presence.*

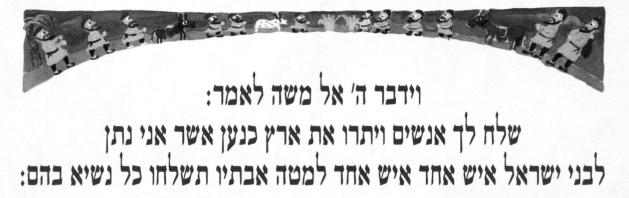

וידבר ה' אל משה לאמר:
שלח לך אנשים ויתרו את ארץ כנען אשר אני נתן
לבני ישראל איש אחד איש אחד למטה אבתיו תשלחו כל נשיא בהם:

The Lord spoke to Moses, saying, "Send men to scout the land of Canaan, which I am giving to the Israelite people; send one man from each of their ancestral tribes, each one a chieftain among them." (Num. 13.1–2)

So Moses, by the Lord's command, sent them out from the wilderness of Paran, all the men being leaders of the Israelites ... When Moses sent them to scout the land of Canaan, he said to them, "Go up there into the Negeb and on into the hill country, and see what kind of country it is. Are the people who dwell in it strong or weak, few or many? Is the country in which they dwell good or bad? Are the towns they live in open or fortified? Is the soil rich or poor? Is it wooded or not? And take pains to bring back some of the fruit of the land."—Now it happened to be the season of the first ripe grapes. They went up and scouted the land, from the wilderness of Zin to Rehob, at Lebo-hamath. They went up into the Negeb and came to Hebron, where lived Ahiman, Sheshai, and Talmai, the Anakites.—Now Hebron was founded seven years before Zoan of Egypt.—They reached the wadi Eshcol, and there they cut down a branch with a single cluster of grapes—it had to be borne on a carrying frame by two of them—and some pomegranates and figs. That place was named the wadi Eshcol because of the cluster that the Israelites cut down there. At the end of forty days they returned from scouting the land. They went straight to Moses and Aaron and the whole Israelite community at Kadesh in the wilderness of Paran, and they made their report to them and to the whole community, as they showed them the fruit of the

land. This is what they told him: "We came to the land you sent us to; it does indeed flow with milk and honey, and this is its fruit. However, the people who inhabit the country are powerful, and the cities are fortified and very large; moreover, we saw the Anakites there. Amalekites dwell in the Negeb region; Hittites, Jebusites, and Amorites inhabit the hill country; and Canaanites dwell by the Sea and along the Jordan." Caleb hushed the people before Moses and said, "Let us by all means go up, and we shall gain possession of it, for we shall surely overcome it." But the men who had gone up with him said, "We cannot attack that people, for it is stronger than we." Thus they spread calumnies among the Israelites about the land they had scouted, saying, "The country that we traversed and scouted is one that devours its settlers. All the people that we saw in it are men of great size; we saw the Nephilim there—the Anakites are part of the Nephilim—and we looked like grasshoppers to ourselves, and so we must have looked to them." (Num 13.3–33)

The whole community broke into loud cries, and the people wept that night. All the Israelites railed against Moses and Aaron. "If only we had died in the land of Egypt," the whole community shouted at them, "or if only we might die in this wilderness! Why is the Lord taking us to that land to fall by the sword? Our wives and children will be carried off! It would be better for us to go back to Egypt!" And they said to one another, "Let us head back for Egypt." Then Moses and Aaron fell on their faces before all the assembled congregation of the Israelites. And Joshua son of Nun and Caleb son of Jephunneh, of those who had scouted the land, rent their clothes and exhorted the whole Israelite community: "The land that we traversed and scouted is an exceedingly good land. If the Lord is pleased with us, He will bring us into that land, a land that flows with milk and honey, and give it to us; only you must not rebel against the Lord. Have no fear then of the people of the country, for they are our prey: their protection has departed from them, but the Lord is with us. Have no fear of them!" As the whole community threatened to pelt them with stones, the Presence of the Lord appeared in the Tent of Meeting to all the Israelites. And the Lord said to Moses, "How long will this people spurn Me, and how long will they have no faith in Me despite all the signs that I have performed in their midst? I will strike them with pestilence and disown them, and I will make of you a nation far more numerous than they!" But Moses said to the Lord, "When the Egyptians, from whose midst You brought up this people in Your might, hear the news, they will tell it to the inhabitants of that land. Now they have heard that You, O Lord, are in the midst of this people; that You, O Lord, appear in plain sight when Your cloud rests over them and when You go before them in a pillar of cloud by day and in a pillar of fire by night. If then You slay this people to a man, the nations who have heard Your fame will say, 'It must be because the Lord was powerless to bring that people into the land He had promised them on oath that He slaughtered them in the wilderness.' Therefore, I pray, let my Lord's forbearance be great, as You have declared, saying, 'The Lord! slow to anger and abounding in kindness; forgiving iniquity and transgression; yet not remitting all punishment, but visiting the iniquity of fathers upon children, upon the third and fourth generations.' Pardon, I pray, the iniquity of this people according to Your great kindness, as You have forgiven this people ever since Egypt." And the Lord said, "I pardon, as you have asked. Nevertheless, as I live and as the Lord's Presence fills the whole world, none of the men who have seen My Presence and the signs that I have performed in Egypt and in the wilderness, and who have tried Me these many times and have disobeyed Me, shall see the land that I promised on oath to their fathers; none of those who spurn Me shall see it. But My servant Caleb, because he was imbued with a different spirit and remained loyal to Me—him will I bring into the land that he entered, and his offspring shall hold it as a possession. (Num. 14.1–24)

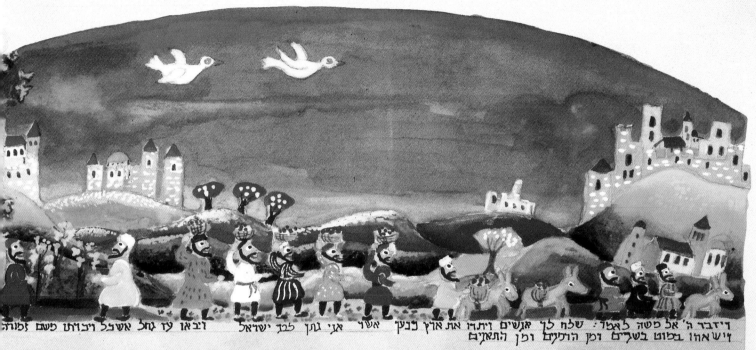

וידבר ה' אל משה לאמר: שלח לך אנשים ויתרו את ארץ כנען אשר אני נתן לבני ישראל

וישאו במוט בשנים ומן הרמם ומן התאנים · ויבאו עד נחל אשכל ויכרתו משם זמרה

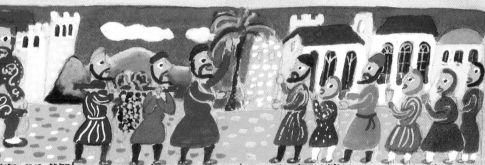

וישבו מתור הארץ מקץ ארבעים יום · ויספרו ט ויאמרו באנו אל הארץ אשר שלחתנו וגם זבת
וזה פריה אפס כי עז העם הישב בארץ והערים בצרות גדלת מאד וגם ילדי הענק ראינו

ותשא כל העדה ויתנו את קולם ויבכו העם
בלילה ההוא

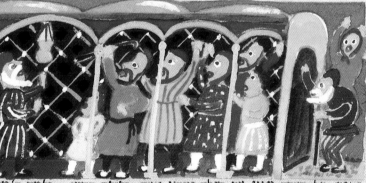

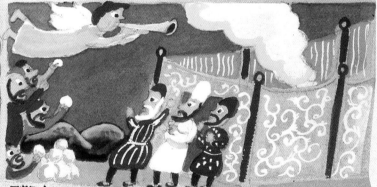

ויאמרו כל העדה לרגם אתם באבנים וכבוד ה' נראה באהל מועד

ותשא כל העדה וישאו את קולם ויצבו העם בלילה ההוא – ולמה ה' מ
לנפל בחרב

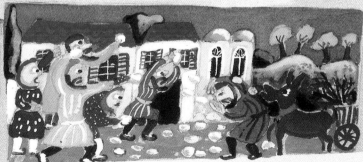

I the Lord have spoken: Thus will I do to all that wicked band that has banded together against Me: in this very wilderness they shall die to the last man.'" As for the men whom Moses sent to scout the land, those who came back and caused the whole community to mutter against him by spreading calumnies about the land—those who spread such calumnies about the land died of plague, by the will of the Lord. Of those men who had gone to scout the land, only Joshua son of Nun and Caleb son of Jephunneh survived ... The Lord spoke to Moses, saying: Speak to the Israelite people and say to them: When you enter the land that I am giving and you eat of the bread of the land, you shall set some aside as a gift to the Lord: as the first yield of your baking, you shall set aside a loaf as a gift; you shall set it aside as a gift like the gift from the threshing floor. (Num 14.35–15.20)

Haftarat Shelach Lecha

(Joshua 2.1–24)

Joshua son of Nun secretly sent two spies from Shittim, saying, "Go, reconnoiter the region of Jericho." So they set out, and they came to the house of a harlot named Rahab and lodged there. The king of

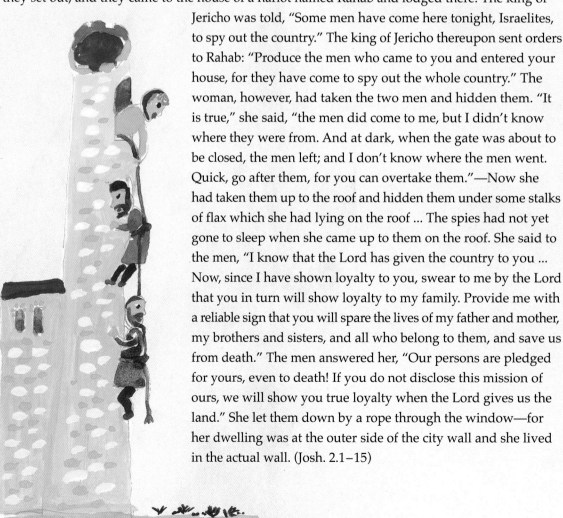

Jericho was told, "Some men have come here tonight, Israelites, to spy out the country." The king of Jericho thereupon sent orders to Rahab: "Produce the men who came to you and entered your house, for they have come to spy out the whole country." The woman, however, had taken the two men and hidden them. "It is true," she said, "the men did come to me, but I didn't know where they were from. And at dark, when the gate was about to be closed, the men left; and I don't know where the men went. Quick, go after them, for you can overtake them."—Now she had taken them up to the roof and hidden them under some stalks of flax which she had lying on the roof ... The spies had not yet gone to sleep when she came up to them on the roof. She said to the men, "I know that the Lord has given the country to you ... Now, since I have shown loyalty to you, swear to me by the Lord that you in turn will show loyalty to my family. Provide me with a reliable sign that you will spare the lives of my father and mother, my brothers and sisters, and all who belong to them, and save us from death." The men answered her, "Our persons are pledged for yours, even to death! If you do not disclose this mission of ours, we will show you true loyalty when the Lord gives us the land." She let them down by a rope through the window—for her dwelling was at the outer side of the city wall and she lived in the actual wall. (Josh. 2.1–15)

Korah 16.1–18.32

Resentful of his cousin Aaron's superior status, the Levite Korah mounted a challenge against his authority. Moses then staged a contest of priestly leadership between Korah and his followers, and Aaron. When Korah and his fellow conspirators brought their fire pans before the Tent of Meeting, the ground suddenly opened up and swallowed them. Angered by these challenges, God caused Aaron's rod to miraculously sprout almond blossoms. God reaffirmed Aaron's role as the High Priest and defined the entitlements accruing to him, his descendants, and to the Levites for their service in the Tent of Meeting.

Now Korah, son of Izhar son of Kohath son of Levi, betook himself, along with Dathan and Abiram sons of Eliab, and On son of Peleth—descendants of Reuben.... (Num. 16.1)

ויקח קרח בן יצהר בן קהת
בן לוי ודתן ואבירם בני אליאב
ואון בן פלת בני ראובן:

To rise up against Moses, together with two hundred and fifty Israelites, chieftains of the community, chosen in the assembly, men of repute. They combined against Moses and Aaron and said to them, "You have gone too far! For all the community are holy, all of them, and the Lord is in their midst. Why then do you raise yourselves above the Lord's congregation?" When Moses heard this, he fell on his face. Then he spoke to Korah and all his company, saying, "Come morning, the Lord will make known who is His and who is holy, and will grant him access to Himself; He will grant access to the one He has chosen. Do this: You, Korah and all your band, take fire pans, and tomorrow put fire in them and lay incense on them before the Lord. Then the man whom the Lord chooses, he shall be the holy one. You have gone too far, sons of Levi!" ... Moses sent for Dathan and Abiram, sons of Eliab; but they said, "We will not come! Is it not enough that you brought us from a land flowing with milk and honey to have us die in the wilderness, that you would also lord it over us? Even if you had brought us to a land flowing with milk and honey, and given us possession of fields and vineyards, should you gouge out those men's

BEMIDBAR

Korah

eyes? We will not come!" ... And Moses said to Korah, "Tomorrow, you and all your company appear before the Lord, you and they and Aaron ... Each of them took his fire pan, put fire in it, laid incense on it, and took his place at the entrance of the Tent of Meeting, as did Moses and Aaron. Korah gathered the whole community against them at the entrance of the Tent of Meeting. Then the Presence of the Lord appeared to the whole community, and the Lord spoke to Moses and Aaron, saying, "Stand back from this community that I may annihilate them in an instant!" But they fell on their faces and said, "O God, Source of the breath of all flesh! When one man sins, will You be wrathful with the whole community?" The Lord spoke to Moses, saying, "Speak to the community and say: Withdraw from about the abodes of Korah, Dathan, and Abiram." Moses rose and went to Dathan and Abiram, the elders of Israel following him. He addressed the community, saying, "Move away from the tents of these wicked men and touch nothing that belongs to them, lest you be wiped out for all their sins." So they withdrew from about the abodes of Korah, Dathan, and Abiram. Now Dathan and Abiram had come out and they stood at the entrance of their tents ... And Moses said, "By this you shall know that it was the Lord who sent me to do all these things; that they are not of my own devising: if these men die as all men do, if their lot be the common fate of all mankind, it was not the Lord who sent me. But if the Lord brings about something unheard-of, so that the ground opens its mouth and swallows them up with all that belongs to them, and they go down alive into Sheol, you shall know that these men have spurned the Lord." Scarcely had he finished speaking all these words when the ground under them burst asunder, and the earth opened its mouth and swallowed them up with their households, all Korah's people and all their possessions. They went down alive into Sheol, with all that belonged to them; the earth closed over them and they vanished from the midst of the congregation. All Israel around them fled at their shrieks, for they said, "The earth might swallow us!" And a fire went forth from the Lord and consumed the two hundred and fifty men offering the incense. (Num. 16.2–35)

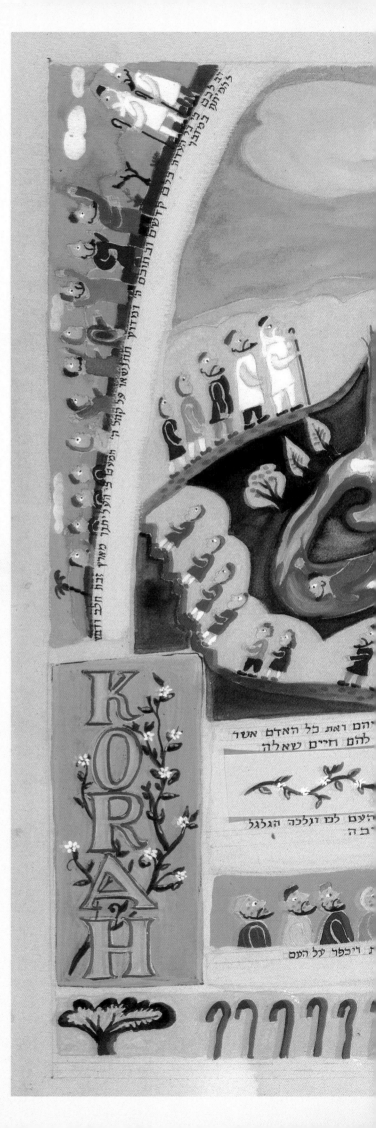

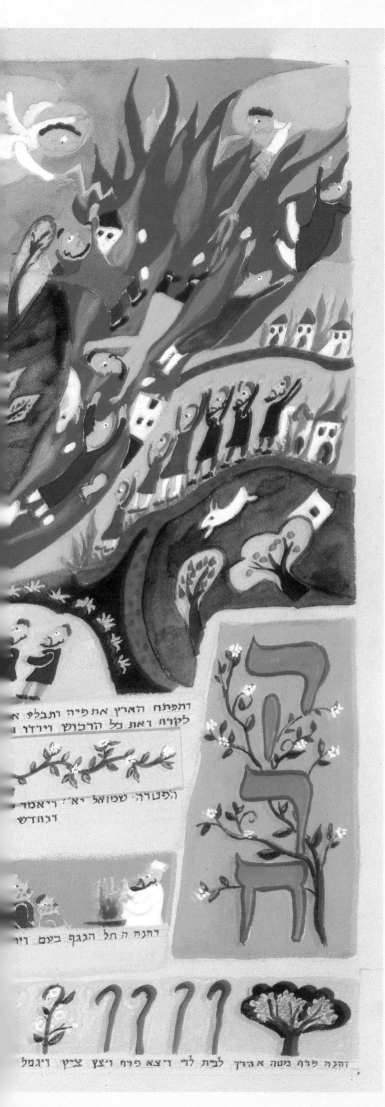

Eleazar the priest took the copper fire pans which had been used for offering by those who died in the fire; and they were hammered into plating for the altar, as the Lord had ordered him through Moses. It was to be a reminder to the Israelites, so that no outsider—one not of Aaron's offspring—should presume to offer incense before the Lord and suffer the fate of Korah and his band. Next day the whole Israelite community railed against Moses and Aaron, saying, "You two have brought death upon the Lord's people!" But as the community gathered against them, Moses and Aaron turned toward the Tent of Meeting; the cloud had covered it and the Presence of the Lord appeared. When Moses and Aaron reached the Tent of Meeting, the Lord spoke to Moses, saying, "Remove yourselves from this community, that I may annihilate them in an instant." They fell on their faces. Then Moses said to Aaron, "Take the fire pan, and put on it fire from the altar. Add incense and take it quickly to the community and make expiation for them. For wrath has gone forth from the Lord: the plague has begun!" Aaron took it, as Moses had ordered, and ran to the midst of the congregation, where the plague had begun among the people. He put on the incense and made expiation for the people ... The Lord spoke to Moses, saying: Speak to the Israelite people and take from them—from the chieftains of their ancestral houses—one staff for each chieftain of an ancestral house: twelve staffs in all. Inscribe each man's name on his staff, there being one staff for each head of an ancestral house; also inscribe Aaron's name on the staff of Levi. Deposit them in the Tent of Meeting before the Pact, where I meet with you. The staff of the man whom I choose shall sprout, and I will rid Myself of the incessant mutterings of the Israelites against you. Moses spoke thus to the Israelites. Their chieftains gave him a staff for each chieftain of an ancestral house, twelve staffs in all; among these staffs was that of Aaron. Moses deposited the staffs before the Lord, in the Tent of the Pact. The next day Moses entered the Tent of the Pact, and there the staff of Aaron of the house of Levi had sprouted: it had brought forth sprouts, produced blossoms, and borne almonds. (Num. 17.4–23)

Haftarat Korah

(1 Samuel 11.14–12.22)

Samuel said to the people, "Come, let us go to Gilgal and there inaugurate the monarchy." So all the people went to Gilgal, and there at Gilgal they declared Saul king before the Lord. They offered sacrifices of well-being there before the Lord; and Saul and all the men of Israel held a great celebration there. Then Samuel said to all Israel, "I have yielded to you in all you have asked of me and have set a king over you. Henceforth the king will be your leader. As for me, I have grown old and gray—but my sons are still with you—and I have been your leader from my youth to this day. Here I am! Testify against me, in the presence of the Lord and in the presence of His anointed one: Whose ox have I taken, or whose ass have I taken? Whom have I defrauded or whom have I robbed? From whom have I taken a bribe to look the other way? I will return it to you." They responded, "You have not defrauded us,

and you have not robbed us, and you have taken nothing from anyone." He said to them, "The Lord then is witness, and His anointed is witness, to your admission this day that you have found nothing in my possession." They responded, "He is!" Samuel said to the people, "The Lord is witness, He who appointed Moses and Aaron and who brought your fathers out of the land of Egypt. Come, stand before the Lord while I cite against you all the kindnesses that the Lord has done to you and your fathers ... If you will revere the Lord, worship Him, and obey Him, and will not flout the Lord's command, if both you and the king who reigns over you will follow the Lord your God, well and good. But if you do not obey the Lord and you flout the Lord's command, the hand of the Lord will strike you as it did your fathers. Now stand by and see the marvelous thing that the Lord will do before your eyes. It is the season of the wheat harvest. I will pray to the Lord and He will send thunder and rain; then you will take thought and realize what a wicked thing you did in the sight of the Lord when you asked for a king." Samuel prayed to the Lord, and the Lord sent thunder and rain that day, and the people stood in awe of the Lord and of Samuel. (1 Sam. 11.14–12.18)

God commanded that an unblemished red heifer be slaughtered by Eleazar the priest, its ashes to be used to purify those who became defiled. In the wilderness of Zin, Miriam died, and the people lacked for water. At God's command, Moses struck a rock with his rod, and water came forth. Soon afterward, Aaron handed on the high priesthood to his son Eleazar and died. The people again complained of thirst, and this time God instructed Moses to command a rock to give forth water. But instead Moses struck the rock, and God sentenced him to die in the wilderness. Not long afterward, the people once more complained of thirst, and they were afflicted with a plague of fiery serpents. Nearing the Promised Land, the Israelites defeated the Amorite kings Sihon and Og.

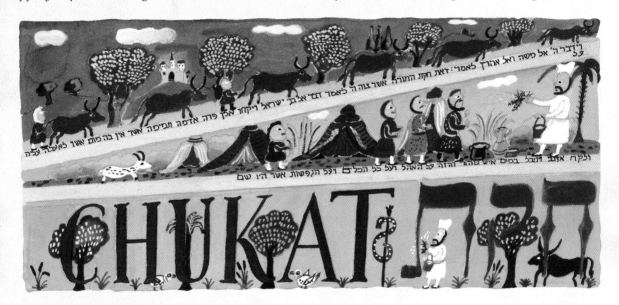

וידבר ה׳ אל משה ואל אהרן לאמר: זאת חקת התורה אשר צוה
ה׳ לאמר דבר אל בני ישראל ויקחו אליך פרה אדומה תמימה
אשר אין בה מום אשר לא עלה עליה על:

The Lord spoke to Moses and Aaron, saying: This is the ritual law that the Lord has commanded: Instruct the Israelite people to bring you a red cow without blemish, in which there is no defect and on which no yoke has been laid. (Num. 19.1–2)

And the priest shall take cedar wood, hyssop, and crimson stuff, and throw them into the fire consuming the cow. The priest shall wash his garments and bathe his body in water; after that the priest may reenter the camp, but he shall be unclean until evening. He who performed the burning shall also wash his garments in water, bathe his body in water, and be unclean until evening. A man who is clean shall gather up the ashes of the cow and deposit them outside the camp in a clean place, to be kept for water of lustration for the Israelite community. It is for cleansing ... The Israelites arrived in a body at the wilderness of Zin on the first new moon, and the people stayed at Kadesh ... The community was without water, and they joined against Moses and Aaron. The people quarreled with Moses, saying, "If only we had perished when our brothers perished at the instance of the Lord! Why have you brought the Lord's congregation into this wilderness for us and our beasts to die there? Why did you make us leave Egypt

BEMIDBAR

Chukat

to bring us to this wretched place, a place with no grain or figs or vines or pomegranates? There is not even water to drink!" Moses and Aaron came away from the congregation to the entrance of the Tent of Meeting, and fell on their faces. The Presence of the Lord appeared to them, and the Lord spoke to Moses, saying, "You and your brother Aaron take the rod and assemble the community, and before their very eyes order the rock to yield its water" ... Moses took the rod from before the Lord, as He had commanded him. Moses and Aaron assembled the congregation in front of the rock ... and Moses raised his hand and struck the rock twice with his rod. Out came copious water, and the community and their beasts drank. But the Lord said to Moses and Aaron, "Because you did not trust Me enough to affirm My sanctity in the sight of the Israelite people, therefore you shall not lead this congregation into the land that I have given them."... From Kadesh, Moses sent messengers to the king of Edom ... "Allow us, then, to cross your country. We will not pass through fields or vineyards, and we will not drink water from wells. We will follow the king's highway, turning off neither to the right nor to the left until we have crossed your territory." But Edom answered him, "You shall not pass through us, else we will go out against you with the sword." "We will keep to the beaten track," the Israelites said to them, "and if we or our cattle drink your water, we will pay for it. We ask only for passage on foot— it is but a small matter." But they replied, "You shall not pass through!" And Edom went out against them in heavy force, strongly armed. So Edom would not let Israel cross their territory, and Israel turned away from them ... The Lord said to Moses and Aaron, "Let Aaron be gathered to his kin: he is not to enter the land that I have assigned to the Israelite people, because you disobeyed my command about the waters of Meribah. Take Aaron

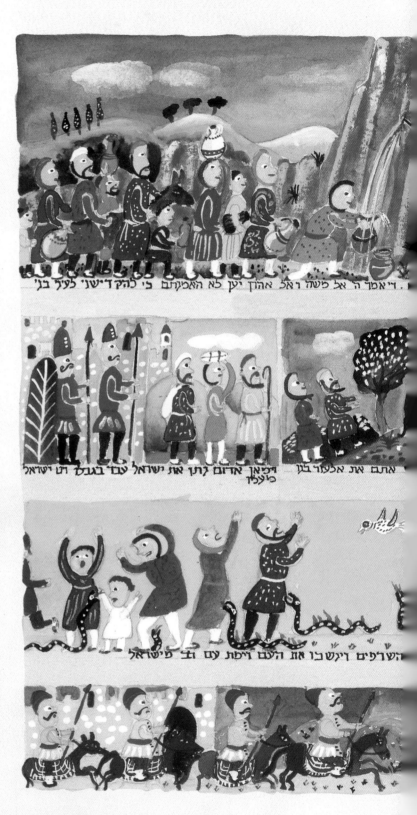

and his son Eleazar and bring them up on Mount Hor. Strip Aaron of his vestments and put them on his son Eleazar. There Aaron shall be gathered unto the dead." Moses did as the Lord had commanded. They ascended Mount Hor in the sight of the whole community. Moses stripped Aaron of his vestments and put them on his son Eleazar, and Aaron died there on the summit of the mountain. When Moses and Eleazar came down from the mountain, the whole community knew that Aaron had breathed his last.

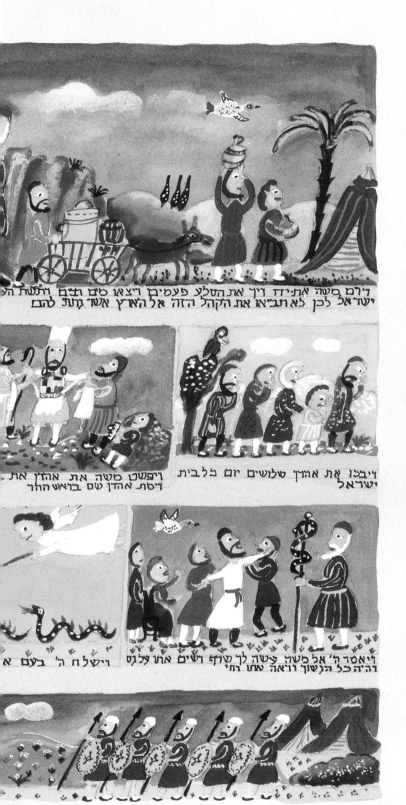

All the house of Israel bewailed Aaron thirty days. When the Canaanite, king of Arad, who dwelt in the Negeb, learned that Israel was coming by the way of Atharim, he engaged Israel in battle and took some of them captive. Then Israel made a vow to the Lord and said, "If You deliver this people into our hand, we will proscribe their towns." The Lord heeded Israel's plea and delivered up the Canaanites; and they and their cities were proscribed. So that place was named Hormah. They set out from Mount Hor by way of the Sea of Reeds to skirt the land of Edom. But the people grew restive on the journey, and the people spoke against God and against Moses, "Why did you make us leave Egypt to die in the wilderness? There is no bread and no water, and we have come to loathe this miserable food." The Lord sent *seraph* serpents against the people. They bit the people and many of the Israelites died ... Then the Lord said to Moses, "Make a *seraph* figure and mount it on a standard. And if anyone who is bitten looks at it, he shall recover." Moses made a copper serpent and mounted it on a standard; and when anyone was bitten by a serpent, he would look at the copper serpent and recover. (Num. 19.6–21.9)

Israel now sent messengers to Sihon king of the Amorites, saying, "Let me pass through your country. We will not turn off into fields or vineyards, and we will not drink water from wells. We will follow the king's highway until we have crossed your territory." But Sihon would not let Israel pass through his territory ... But Israel put them to the sword, and took possession of their land, from the Arnon to the Jabbok, as far as Az of the Ammonites, for Az marked the boundary of the Ammonites. Israel took all those towns. And Israel settled in all the towns of the Amorites, in Heshbon and all its dependencies ... They marched on and went up the road to Bashan, and King Og of Bashan, with all his people, came out to Edrei to engage them in battle. But the Lord said to Moses, "Do not fear him, for I give him and all his people and his land into your hand. You shall do to him as you did to Sihon king of the Amorites who dwelt in Heshbon." They defeated him and his sons and all his people, until no remnant was left him; and they took possession of his country. The Israelites then marched on and encamped in the steppes of Moab, across the Jordan from Jericho. (Num. 21.21–22.1)

Haftarat Chukat

(Judges 11.1–33)

Jephthah the Gileadite was an able warrior, who was the son of a prostitute. Jephthah's father was Gilead; but Gilead also had sons by his wife, and when the wife's sons grew up, they drove Jephthah out. They said to him, "You shall have no share in our father's property, for you are the son of an outsider."

So Jephthah fled from his brothers and settled in the Tob country. Men of low character gathered about Jephthah and went out raiding with him. Some time later, the Ammonites went to war against Israel. And when the Ammonites attacked Israel, the elders of Gilead went to bring Jephthah back from the Tob country. They said to Jephthah, "Come be our chief, so that we can fight the Ammonites." Jephthah replied to the elders of Gilead, "You are the very people who rejected

me and drove me out of my father's house. How can you come to me now when you are in trouble?" The elders of Gilead said to Jephthah, "Honestly, we have now turned back to you. If you come with us and fight the Ammonites, you shall be our commander over all the inhabitants of Gilead" ... Jephthah went with the elders of Gilead, and the people made him their commander and chief ... Jephthah then sent messengers to the king of the Ammonites, saying, "What have you against me that you have come to make war on my country?" The king of the Ammonites replied to Jephthah's messengers, "When Israel came from Egypt, they seized the land which is mine, from the Arnon to the Jabbok as far as the Jordan. Now, then, restore it peaceably." Jephthah again sent messengers to the king of the Ammonites. He said to him, "Thus said Jephthah: Israel did not seize the land of Moab or the land of the Ammonites. When they left Egypt, Israel traveled through the wilderness to the Sea of Reeds and went on to Kadesh. Israel then sent messengers to the king of Edom, saying, 'Allow us to cross your country.' But the king of Edom would not consent. They also sent a mission to the king of Moab, and he refused. So Israel, after staying at Kadesh, traveled on through the wilderness, skirting the land of Edom and the land of Moab ... Then Israel sent messengers to Sihon king of the Amorites, the king of Heshbon. Israel said to him, 'Allow us

to cross through your country to our homeland.' But Sihon would not trust Israel to pass through his territory ... But the Lord, the God of Israel, delivered Sihon and all his troops into Israel's hands, and they defeated them; and Israel took possession of all the land of the Amorites, the inhabitants of that land ... May the Lord, who judges, decide today between the Israelites and the Ammonites!" But the king of the Ammonites paid no heed to the message that Jephthah sent him. (Judg. 11.1–28)

Balak 22.2–25.9

Alarmed by recent Israelite victories over his neighbors, the Moabite king Balak hired the pagan prophet Balaam to curse the invading Israelites. But as Balaam rode out to meet Balak, the ass he was riding swerved aside to avoid a threatening angel, visible only to her. Angry at her disobedience, Balaam beat her, but God opened her mouth and she protested his unfair treatment. Then the angel became visible to Balaam and commanded him to speak only the words that God put in his mouth. Three times Balaam tried to curse the Israelites, but ended up blessing them instead. While encamped in Shittim, the Israelite men were seduced into idolatry by Moabite women, and were then punished by a divine plague.

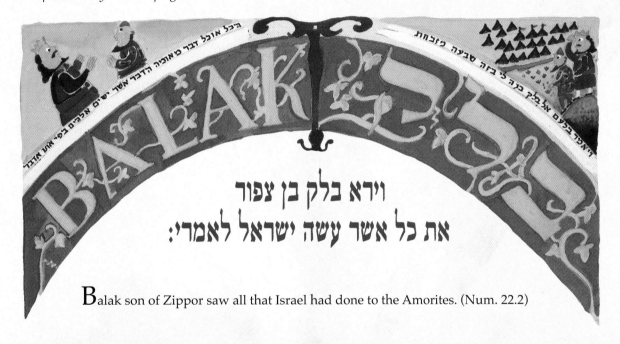

וירא בלק בן צפור
את כל אשר עשה ישראל לאמרי:

Balak son of Zippor saw all that Israel had done to the Amorites. (Num. 22.2)

Moab dreaded the Israelites ... Balak son of Zippor, who was king of Moab at that time, sent messengers to Balaam son of Beor in Pethor ... "Come then, put a curse upon this people for me, since they are too numerous for me ... For I know that he whom you bless is blessed indeed, and he whom you curse is cursed." The elders of Moab and the elders of Midian, versed in divination, set out. They came to Balaam and gave him Balak's message. He said to them, "Spend the night here, and I shall reply to you as the Lord may instruct me." ... God came to Balaam and said "Do not go with them. You must not curse that people, for they are blessed." Balaam arose in the morning and said to Balak's dignitaries, "Go back to

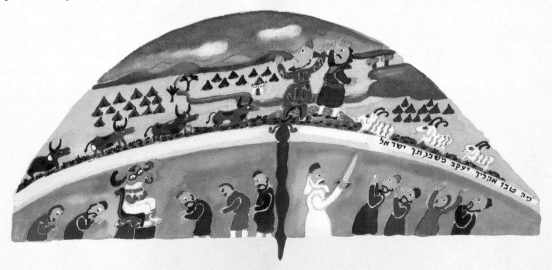

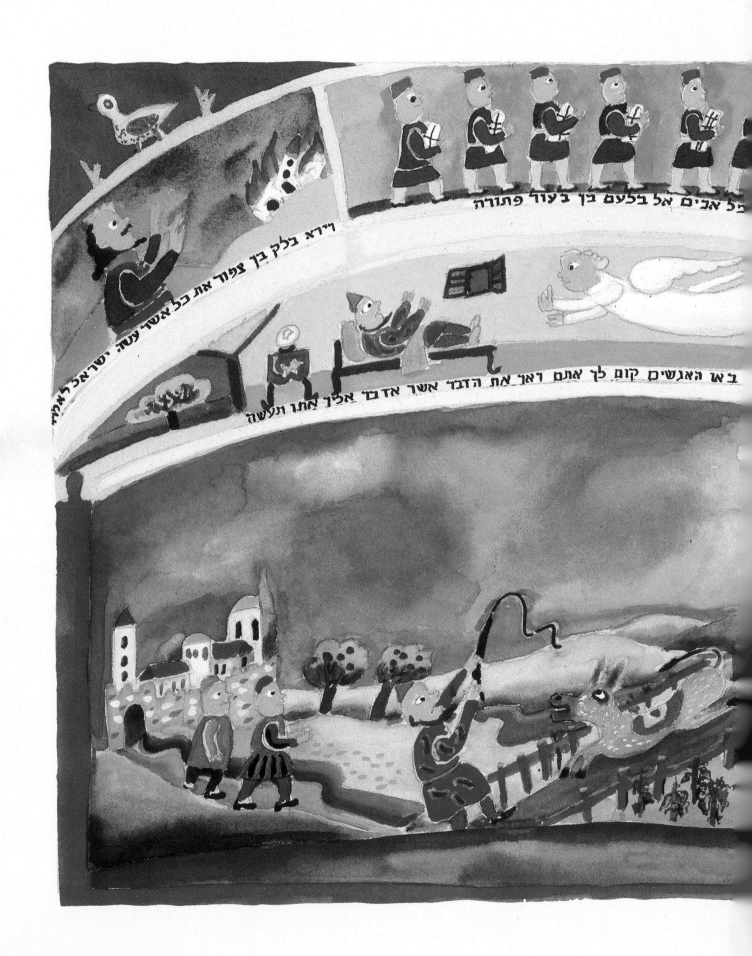

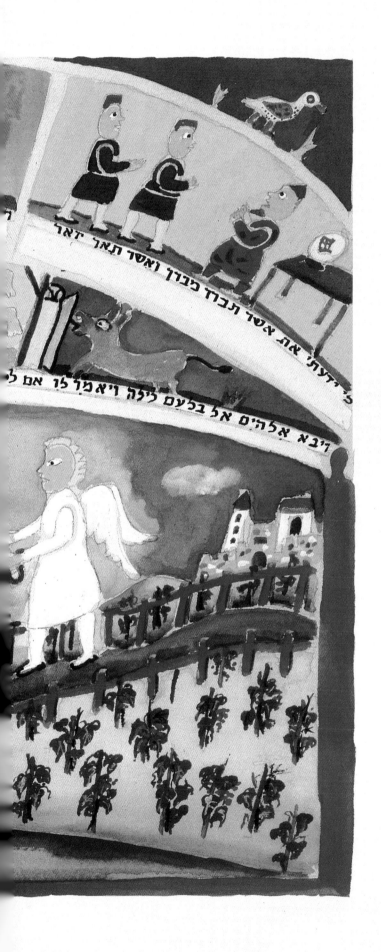

your own country, for the Lord will not let me go with you." ... Then Balak sent other dignitaries, more numerous and distinguished than the first ... "So you, too, stay here overnight, and let me find out what else the Lord may say to me." That night God came to Balaam and said to him, "If these men have come to invite you, you may go with them. But whatever I command you, that you shall do." ... But God was incensed at his going; so an angel of the Lord placed himself in his way as an adversary. He was riding on his she-ass, with his two servants alongside, when the ass caught sight of the angel of the Lord standing in the way, with his drawn sword in his hand. The ass swerved from the road and went into the fields; and Balaam beat the ass to turn her back onto the road ... The ass, seeing the angel of the Lord, pressed herself against the wall and squeezed Balaam's foot against the wall; so he beat her again ... Then the Lord opened the ass's mouth, and she said to Balaam, "What have I done to you" ... Balaam said to the ass, "You have made a mockery of me! If I had a sword with me, I'd kill you." ... Then the Lord uncovered Balaam's eyes, and he saw the angel of the Lord standing in the way ... In the morning Balak took Balaam up to Bamoth-baal. From there he could see a portion of the people ... God manifested Himself to Balaam, who said to Him, "I have set up the seven altars and offered up a bull and a ram on each altar." And the Lord put a word in Balaam's mouth and said, "Return to Balak and speak thus." ... "From Aram has Balak brought me, Moab's king from the hills of the East: Come, curse me Jacob, come, tell Israel's doom! How can I damn whom God has not damned, how doom when the Lord has not doomed?" ... Then Balak said to Balaam, "What have you done to me? Here I brought you to damn my enemies, and instead you have blessed them!" He replied, "I can only repeat faithfully what the Lord puts in my mouth." ... With that, he took him to Sedehzophim, on the summit of Pisgah. He built seven altars and offered a bull and a ram on each altar. And Balaam said to Balak, "Stay here beside your offerings, while I seek a manifestation yonder." The Lord manifested Himself to Balaam and put a word in his mouth, saying, "Return to Balak and speak thus." ... "My message was to bless: when He blesses, I cannot reverse it. No harm is in sight

for Jacob, no woe in view for Israel. The Lord their God is with them" ... Thereupon Balak said to Balaam, "Don't curse them and don't bless them!" In reply, Balaam said to Balak, "But I told you: Whatever the Lord says, that I must do." Balak took Balaam to the peak of Peor, which overlooks the wasteland ... As Balaam looked up and saw Israel encamped tribe by tribe, the spirit of God came upon him. Taking up his theme, he said ... "How fair are your tents, O Jacob, your dwellings, O Israel! like palm-groves that stretch out, like gardens beside a river ... Blessed are they who bless you, accursed they who curse you!" Enraged at Balaam, Balak struck his hands together. "I called you," Balak said to Balaam, "to damn my enemies, and instead you have blessed them these three times! ... Back with you at once to your own place!" ... While Israel was staying at Shittim, the people profaned themselves by whoring with the Moabite women, who invited the people to the sacrifices for their god. The people partook of them and worshiped that god. Thus Israel attached itself to Baal-peor, and the Lord was incensed with Israel ... Just then one of the Israelites came and brought a Midianite woman over to his companions, in the sight of Moses and of the whole Israelite community who were weeping at the entrance of the Tent of Meeting. When Phinehas, son of Eleazar son of Aaron the priest, saw this, he left the assembly and, taking a spear in his hand, he followed the Israelite into the chamber and stabbed both of them, the Israelite and the woman, through the belly. Then the plague against the Israelites was checked. Those who died of the plague numbered twenty-four thousand. (Num. 22.3–25.9)

Haftarat Balak

(Micah 5.6–6.8)

The remnant of Jacob shall be, in the midst of the many peoples, like dew from the Lord, like droplets on grass—which do not look to any man nor place their hope in mortals. The remnant of Jacob shall be among the nations, in the midst of the many peoples, like a lion among beasts of the wild, like a fierce lion among flocks of sheep, which tramples wherever it goes and rends, with none to deliver. Your hand shall prevail over your foes, and all your enemies shall be cut down! In that day—declares the Lord ... Hear what the Lord is saying ... "My people! What wrong have I done you? What hardship have I caused you? Testify against Me. In fact, I brought you up from the land of Egypt, I redeemed you from the house of bondage, and I sent before you Moses, Aaron, and Miriam" ... With what shall I ... do homage to God on high? ... Would the Lord be pleased with thousands of rams, with myriads of streams of oil? ... "Only to do justice and to love goodness, and to walk modestly with your God." (Micah 5.6–6.8)

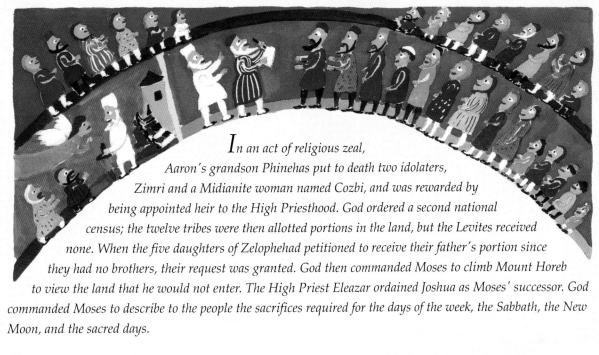

In an act of religious zeal,
Aaron's grandson Phinehas put to death two idolaters,
Zimri and a Midianite woman named Cozbi, and was rewarded by
being appointed heir to the High Priesthood. God ordered a second national
census; the twelve tribes were then allotted portions in the land, but the Levites received
none. When the five daughters of Zelophehad petitioned to receive their father's portion since
they had no brothers, their request was granted. God then commanded Moses to climb Mount Horeb
to view the land that he would not enter. The High Priest Eleazar ordained Joshua as Moses' successor. God
commanded Moses to describe to the people the sacrifices required for the days of the week, the Sabbath, the New
Moon, and the sacred days.

וידבר ה' אל משה לאמר: פינחס בן
אלעזר בן אהרן הכהן השיב את חמתי
מעל בני ישראל בקנאו את קנאתי בתוכם
ולא כליתי את בני ישראל בקנאתי:

The Lord spoke to Moses, saying, "Phinehas, son of
Eleazar son of Aaron the priest, has turned back My
wrath from the Israelites by displaying among them his
passion for Me, so that I did not wipe out the Israelite
people in My passion." (Num. 25.10-11)

"Say, therefore, 'I grant him My pact of friendship. It shall be for him and his descendants after him
a pact of priesthood for all time, because he took impassioned action for his God, thus making expiation
for the Israelites.'" ... The Lord spoke to Moses, saying, "Assail the Midianites and defeat them—for they
assailed you by the trickery they practiced against you—because of the affair of Peor and because of the
affair of their kinswoman Cozbi, daughter of the Midianite chieftain, who was killed at the time of the
plague on account of Peor." When the plague was over, the Lord said to Moses and to Eleazar son of
Aaron the priest, "Take a census of the whole Israelite community from the age of twenty years up, by

their ancestral houses, all Israelites able to bear arms." So Moses and Eleazar the priest, on the steppes of Moab, at the Jordan near Jericho, gave instructions about them, namely, those from twenty years up, as the Lord had commanded Moses ... The descendants of the Israelites who came out of the land of Egypt were ... 601,730. The Lord spoke to Moses, saying: "Among these shall the land be apportioned as shares, according to the listed names: with larger groups increase the share, with smaller groups reduce the share. Each is to be assigned its share according to its enrollment. The land, moreover, is to be apportioned by lot; and the allotment shall be made according to the listings of their ancestral tribes. Each portion shall be assigned by lot, whether for larger or smaller groups." ... These are the persons enrolled by Moses and Eleazar the priest who registered the Israelites on the steppes of Moab, at the Jordan near Jericho. Among these there was not one of those enrolled by Moses and Aaron the priest when they recorded the Israelites in the wilderness of Sinai. For the Lord had said of them, "They shall die in the wilderness." Not one of them survived, except Caleb son of Jephunneh and Joshua son of Nun. (Num. 25.12–26.65)

The daughters of Zelophehad, of Manassite family—son of Hepher son of Gilead son of Machir son of Manasseh son of Joseph—came forward. The names of the daughters were Mahlah, Noah, Hoglah, Milcah, and Tirzah. They stood before Moses, Eleazar the priest, the chieftains, and the whole assembly, at the entrance of the Tent of Meeting, and they said, "Our father died in the wilderness. He was not one of the faction, Korah's faction, which banded together against the Lord, but died for his own sin; and he has left no sons. Let not our father's name be lost to his clan just because he had no son! Give us a holding among our father's kinsmen!" Moses brought their case before the Lord. And the Lord said to Moses, "The plea of Zelophehad's daughters is just: you should give them a hereditary holding among their father's kinsmen; transfer their father's share to them. Further, speak to the Israelite people as follows: 'If a man dies without leaving a son, you shall transfer his property to his daughter. If he has no daughter, you shall assign his property to his brothers. If he has no brothers, you shall assign his property to his father's brothers. If his father had no brothers, you shall assign his property to his nearest relative in his own clan, and he shall inherit it.' This shall be the law of procedure for the Israelites, in accordance with the Lord's command to Moses." (Num. 27.1–11)

The Lord said to Moses, "Ascend these heights of Abarim and view the land that I have given to the Israelite people ... Moses spoke to the Lord, saying, "Let the Lord, Source of the breath of all flesh, appoint someone over the community who shall go out before them and come in before them, and who shall take them out and bring them in, so that the Lord's community may not be like sheep that have no shepherd." And the Lord answered Moses, "Single out Joshua son of Nun, an inspired man, and lay your hand upon him. Have him stand before Eleazar the priest and before the whole community, and commission him in their sight. Invest him with some of your authority, so that the whole Israelite community may obey.

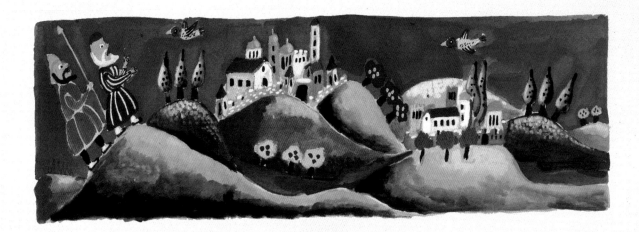

But he shall present himself to Eleazar the priest, who shall on his behalf seek the decision of the Urim before the Lord. By such instruction they shall go out and by such instruction they shall come in, he and all the Israelites, the whole community." (Num. 27.12–21)

The Lord spoke to Moses, saying: Command the Israelite people and say to them: Be punctilious in presenting to Me at stated times the offerings of food due Me, as offerings by fire of pleasing odor to Me ... On the sabbath day: two yearling lambs without blemish, together with two-tenths of a measure of choice flour with oil mixed in as a meal offering, and with the proper libation ... On your new moons you shall present a burnt offering to the Lord: two bulls of the herd, one ram, and seven yearling lambs, without blemish ... That shall be the monthly burnt offering for each new moon of the year ... In the first month, on the fourteenth day of the month, there shall be a passover sacrifice to the Lord, and on the fifteenth day of that month a festival ... On the day of the first fruits, your Feast of Weeks, when you bring an offering of new grain to the Lord, you shall observe a sacred occasion: you shall not work at your occupations ... In the seventh month, on the first day of the month, you shall observe a sacred occasion: you shall not work at your occupations. You shall observe it as a day when the horn is sounded. On the tenth day of the same seventh month you shall observe a sacred occasion when you shall practice self-denial. You shall do no work ... On the fifteenth day of the seventh month, you shall observe a sacred occasion: you shall not work at your occupations.—Seven days you shall observe a festival of the Lord. All these you shall offer to the Lord at the stated times, in addition to your votive and freewill offerings, be they burnt offerings, meal offerings, libations, or offerings of well-being. So Moses spoke to the Israelites just as the Lord had commanded Moses. (Num. 28.1–30.1)

Haftarat Pinchas

(1 Kings 18.46–19.21)

The hand of the Lord had come upon Elijah. He tied up his skirts and ran in front of Ahab all the way to Jezreel. When Ahab told Jezebel all that Elijah had done and how he had put all the prophets to the sword, Jezebel sent a messenger to Elijah, saying, "Thus and more may the gods do if by this time tomorrow I have not made you like one of them." Frightened, he fled at once for his life. He came to Beer-sheba, which is in Judah, and left his servant there; he himself went a day's journey into the wilderness. He came to a broom bush and sat down under it, and prayed that he might die. "Enough!" he cried. "Now, O Lord, take my life, for I am no better than my fathers." ... Then the word of the Lord came to him. He said to him, "Why are you here, Elijah?" He replied, "I am moved by zeal for the Lord, the God of Hosts, for the Israelites have forsaken Your covenant, torn down Your altars, and put Your prophets to the sword. I alone am left, and they are out to take my life." "Come out," He called, "and stand on the mountain before the Lord." And lo, the Lord passed by. There was a great and mighty wind, splitting mountains and shattering rocks by the power of the Lord; but the Lord was not in the wind. After the wind—an earthquake; but the Lord was not in the earthquake. After the earthquake—fire; but the Lord was not in the fire. And after the fire—a soft murmuring sound. When Elijah heard it, he wrapped his mantle about his face and went out and stood at the entrance of the cave. Then a voice addressed him: "Why are you here, Elijah?" He answered, "I am moved by zeal for the Lord, the God of Hosts; for the Israelites have forsaken Your

covenant, torn down Your altars, and have put Your prophets to the sword. I alone am left, and they are out to take my life." The Lord said to him, "Go back by the way you came, and on to the wilderness of Damascus. When you get there, anoint Hazael as king of Aram. Also anoint Jehu son of Nimshi as king of Israel, and anoint Elisha son of Shaphat of Abel-meholah to succeed you as prophet. Whoever escapes the sword of Hazael shall be slain by Jehu, and whoever escapes the sword of Jehu shall be slain by Elisha. I will leave in Israel only seven thousand—every knee that has not knelt to Baal and every mouth that has not kissed him." He set out from there and came upon Elisha son of Shaphat as he was plowing. There were twelve yoke of oxen ahead of him, and he was with the twelfth. Elijah came over to him and threw his mantle over him. He left the oxen and ran after Elijah, saying: "Let me kiss my father and mother good-by, and I will follow you." And he answered him, "Go back. What have I done to you?" He turned back from him and took the yoke of oxen and slaughtered them; he boiled their meat with the gear of the oxen and gave it to the people, and they ate. Then he arose and followed Elijah and became his attendant. (1 King 18.46–19.21)

Moses explained to the heads of the Israelite tribes God's rules regarding vows and sworn obligations. God then spoke to Moses and commanded the Israelites to attack Midian to avenge the Israelites' seduction into idolatry. When Moses learned that the Israelite soldiers had spared the Midianite women and children, he commanded them to kill all the male children as well as females who were not virgins. The spoils were then shared among the soldiers, the people, and the Levites. Wishing to settle in the fertile lands east of Canaan, the tribes of Gad, Reuben, and half the tribe of Manasseh asked permission to remain on the east side of the Jordan. Moses granted them permission as long as they agreed to join in the conquest of Canaan before returning home to their families. They agreed to do so.

וידבר משה אל ראשי המטות לבני ישראל לאמר זה הדבר
אשר צוה ה': איש כי ידר נדר לה' או השבע שבעה לאסר
אסר על נפשו לא יחל דברו ככל היוצא מפיו יעשה:

Moses spoke to the heads of the Israelite tribes, saying: This is what the Lord has commanded: If a man makes a vow to the Lord or takes an oath imposing an obligation on himself, he shall not break his pledge; he must carry out all that has crossed his lips. (Num. 30.2–3)

The Lord spoke to Moses, saying, "Avenge the Israelite people on the Midianites; then you shall be gathered to your kin." Moses spoke to the people, saying, "Let men be picked out from among you for a campaign, and let them fall upon Midian to wreak the Lord's vengeance on Midian. You shall dispatch on the campaign a thousand from every one of the tribes of Israel." So a thousand from each tribe were furnished from the divisions of Israel, twelve thousand picked for the campaign. Moses dispatched them on the campaign, a thousand from each tribe, with Phinehas son of Eleazar serving as a priest on the

campaign, equipped with the sacred utensils and the trumpets for sounding the blasts. They took the field against Midian, as the Lord had commanded Moses, and slew every male. Along with their other victims, they slew the kings of Midian: Evi, Rekem, Zur, Hur, and Reba, the five kings of Midian. They also put Balaam son of Beor to the sword ... They gathered all the spoil and all the booty, man and beast, and they brought the captives, the booty, and the spoil to Moses, Eleazar the priest, and the whole Israelite community, at the camp in the steppes of Moab, at the Jordan near Jericho. Moses, Eleazar the priest, and all the chieftains of the community came out to meet them outside the camp. Moses became angry with the commanders of the army, the officers of thousands and the officers of hundreds, who had come back from the military campaign. Moses said to them, "You have spared every female! Yet they are the very ones who, at the bidding of Balaam, induced the Israelites to trespass against the Lord in the matter of Peor, so that the Lord's community was struck by the plague. Now, therefore, slay every male among the children, and slay also every woman who has known a man carnally; but spare every young woman who has not had carnal relations with a man. You shall then stay outside the camp seven days; every one among you or among your captives who has slain a person or touched a corpse shall cleanse himself on the third and seventh days. You shall also cleanse every cloth, every article of skin, everything made of goats' hair, and every object of wood." (Num. 31.1–20)

The Reubenites and the Gadites owned cattle in very great numbers. Noting that the lands of Jazer and Gilead were a region suitable for cattle, the Gadites and the Reubenites came to Moses, Eleazar the priest, and the chieftains of the community, and said, "Ataroth, Dibon, Jazer, Nimrah, Heshbon, Elealeh, Sebam, Nebo, and Beon—the land that the Lord has conquered for the community of Israel is cattle country, and your servants have cattle. It would be a favor to us," they continued, "if this land were given to your servants as a holding; do not move us across the Jordan." Moses replied to the Gadites and the Reubenites, "Are your brothers to go to war while you stay here? Why will you turn the minds of the Israelites from crossing into the land that the Lord has given them? ... The Lord was incensed at Israel ... And now you, a breed of sinful men, have replaced your fathers, to add still further to the Lord's wrath against Israel. If you turn away from Him and He abandons them once more in the wilderness, you will bring calamity upon all this people." Then they stepped up to him and said, "We will build here sheepfolds for our flocks and towns for our children. And we will hasten as shock-troops in the van of the Israelites until we have established them in their home, while our children stay in the fortified towns because of the inhabitants of the land. We will not return to our homes until every one of the Israelites is in possession of his portion. But we will not have a share with them in the territory beyond the Jordan, for we have received our share on the east side of the Jordan." Moses said to them, "If you do this, if you go to battle as shock-troops, at the instance of the Lord, and every shock-fighter among you crosses the Jordan, at the instance of the Lord, until He has dispossessed His enemies before Him, and the land has been subdued, at the instance of the Lord, and then you return—you shall be clear before the Lord and before Israel; and this land shall be your holding under the Lord. But if you do not do so, you will have sinned against the Lord; and know that your sin will overtake you. Build towns for your children and sheepfolds for your flocks, but do what you have promised." The Gadites and the Reubenites answered Moses, "Your servants will do as my lord commands. Our children, our wives, our flocks, and all our other livestock will stay behind in the towns of Gilead; while your servants, all those recruited for war, cross over, at the instance of the Lord, to engage in battle—as my lord orders." (Num. 32.1–27)

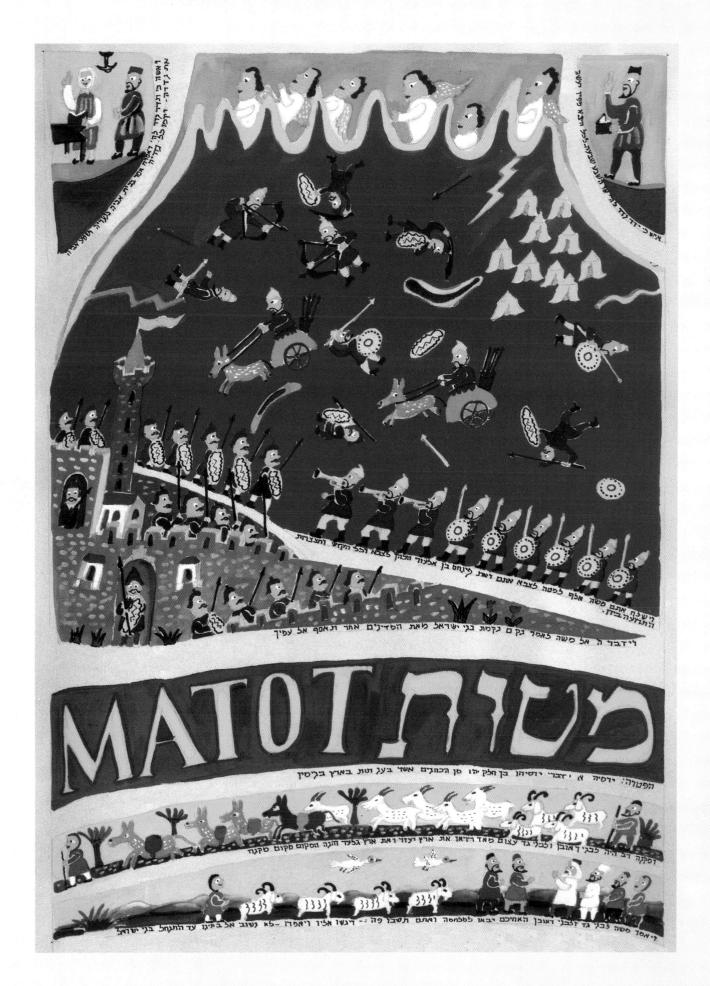

Haftarat Matot

(Jeremiah 1.1–2.3)

The words of Jeremiah son of Hilkiah, one of the priests at Anathoth in the territory of Benjamin. The word of the Lord came to him in the days of King Josiah son of Amon of Judah, in the thirteenth year of his reign, and throughout the days of King Jehoiakim son of Josiah of Judah, and until the end of the eleventh year of King Zedekiah son of Josiah of Judah, when Jerusalem went into exile in the fifth month. The word of the Lord came to me: Before I created you in the womb, I selected you; before you were born, I consecrated you; I appointed you a prophet concerning the nations ... And the word of the Lord came to me a second time: What do you see? I replied: I see a steaming pot, tipped away from the north. And the Lord said to me: From the north shall disaster break loose upon all the inhabitants of the land! ... Declares the Lord. They shall come, and shall each set up a throne before the gates of Jerusalem, against its walls roundabout, and against all the towns of Judah. And I will argue My case against them for all their wickedness: They have forsaken Me and sacrificed to other gods and worshiped the works of their hands. (Jer. 1.1–16)

The Israelites journeyed for forty years from Egypt to the east bank of the Jordan where they now stand. As they stood before the river, Moses followed God's instructions and apportioned the land to the tribes, assigned tribal leaders, and commanded that forty-eight towns be set aside for the Levites, including six cities of refuge for anyone guilty of involuntary manslaughter. God spoke further to Moses and described the laws concerning homicide. When the descendants of Gilead protested that they would lose their share of the land if the daughters of their kinsman Zelophehad married men outside their clan, Moses assured them that the daughters would be required to marry within their father's clan.

אלה מסעי בני ישראל אשר יצאו מארץ מצרים
לצבאתם ביד משה ואהרן:

These were the marches of the Israelites who started out from the land of Egypt, troop by troop, in the charge of Moses and Aaron. (Num. 33.1)

Moses recorded the starting points of their various marches as directed by the Lord. Their marches, by starting points, were as follows: They set out from Rameses in the first month, on the fifteenth day of the first month. It was on the morrow of the passover offering that the Israelites started out defiantly, in plain view of all the Egyptians. The Egyptians meanwhile were burying those among them whom the Lord had struck down, every first-born—whereby the Lord executed judgment on their gods. The Israelites set out from Rameses and encamped at Succoth. They set out from Succoth and encamped at Etham, which is on the edge of the wilderness. They set out from Etham and turned about toward Pi-hahiroth, which faces Baal-zephon, and they encamped before Migdol. They set out from Penehahiroth and passed through the sea into the wilderness; and they made a three-days' journey in the wilderness of Etham and encamped at Marah. They set out from Marah and came to Elim. There were twelve springs in Elim and seventy palm trees, so they encamped there. They set out from Elim and encamped by the Sea of Reeds. They set out from the Sea of Reeds and encamped in the wilderness of Sin. They set out from the wilderness of Sin and encamped at Dophkah. They set out from Dophkah and encamped at Alush. They set out from Alush and encamped at Rephidim; it was there that the people had no water to drink. They set out from Rephidim and encamped in the wilderness of Sinai. They set out from the wilderness of Sinai and encamped at Kibroth-hattaavah. They set out from Kibroth-hattaavah and encamped at Hazeroth. They

set out from Hazeroth and encamped at Rithmah. They set out from Rithmah and encamped at Rimmon-perez. They set out from Rimmon-perez and encamped at Libnah. They set out from Libnah and encamped at Rissah. They set out from Rissah and encamped at Kehelath. They set out from Kehelath and encamped at Mount Shepher. They set out from Mount Shepher and encamped at Haradah. They set out from Haradah and encamped at Makheloth. They set out from Makheloth and encamped at Tahath. They set out from Tahath and encamped at Terah. They set out from Terah and encamped at Mithkah. They set out from Mithkah and encamped at Hashmonah. They set out from Hashmonah and encamped at Moseroth. They set out from Moseroth and encamped at Bene-jaakan. They set out from Bene-jaakan and encamped at Hor-haggidgad. They set out from Hor-haggidgad and encamped at Jotbath. They set out from Jotbath and encamped at Abronah. They set out from Abronah and encamped at Ezion-geber. They set out from Ezion-geber and encamped in the wilderness of Zin, that is, Kadesh. They set out from Kadesh and encamped at Mount Hor, on the edge of the land of Edom ... Aaron was a hundred and twenty-three years old when he died on Mount Hor. (Num. 33.2–39)

The Lord spoke to Moses, saying: Speak to the Israelite people and say to them: When you cross the Jordan into the land of Canaan, you shall dispossess all the inhabitants of the land; you shall destroy all their figured objects; you shall destroy all their molten images, and you shall demolish all their cult places. And you shall take possession of the land and settle in it, for I have assigned the land to you to possess. You shall apportion the land among yourselves by lot, clan by clan: with larger groups increase the share, with smaller groups reduce the share. Wherever the lot falls for anyone, that shall be his. You shall have your portions according to your ancestral tribes. But if you do not dispossess the inhabitants of the land, those whom you allow to remain shall be stings in your eyes and thorns in your sides, and they shall harass you in the land in which you live; so that I will do to you what I planned to do to them. The Lord spoke to Moses, saying: Instruct the Israelite people and say to them: When you enter the land of Canaan, this is the land that shall fall to you as your portion, the land of Canaan with its various boundaries: Your southern sector shall extend from the wilderness of Zin alongside Edom. Your southern boundary shall start on the east from the tip of the Dead Sea. Your boundary shall then turn to pass south of the ascent of Akrabbim and continue to Zin, and its limits shall be south of

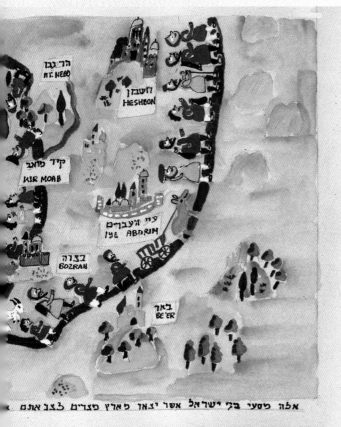

הר נבו MT. NEBO

חשבון HESHBON

קיר מואב KIR MOAB

עיי העברים IYE ABARIM

בצרה BOZRAH

באר BE'ER

אלה מסעי בני ישראל אשר יצאו מארץ מצרים לצבאתם

Kadesh-barnea, reaching Hazar-addar and continuing to Azmon. From Azmon the boundary shall turn toward the Wadi of Egypt and terminate at the Sea. For the western boundary you shall have the coast of the Great Sea; that shall serve as your western boundary. This shall be your northern boundary: Draw a line from the Great Sea to Mount Hor; from Mount Hor draw a line to Lebo-hamath, and let the boundary reach Zedad. The boundary shall then run to Ziphron and terminate at Hazar-enan. That shall be your northern boundary. For your eastern boundary you shall draw a line from Hazar-enan to Shepham. From Shepham the boundary shall descend to Riblah on the east side of Ain; from there the boundary shall continue downward and abut on the eastern slopes of the Sea of Chinnereth. The boundary shall then descend along the Jordan and terminate at the Dead Sea. That shall be your land as defined by its boundaries on all sides. (Num. 33.50–34.12)

צו את בני ישראל ונתנו ללוים מנחלת אחזתם ערים לשבת ומגרש סביבתיהם ונתנו ללוים

Moses instructed the Israelites, saying: This is the land you are to receive by lot as your hereditary portion, which the Lord has commanded to be given to the nine and a half tribes. For the Reubenite tribe by its ancestral houses, the Gadite tribe by its ancestral houses, and the half-tribe of Manasseh have already received their portions: those two and a half tribes have received their portions across the Jordan, opposite Jericho, on the east, the orient side ... The Lord spoke to Moses in the steppes of Moab at the Jordan near Jericho, saying: Instruct the Israelite people to assign, out of the holdings apportioned to them, towns for the Levites to dwell in; you shall also assign to the Levites pasture land around their towns. The towns shall be theirs to dwell in, and the pasture shall be for the cattle they own and all their other beasts ... The towns that you assign to the Levites shall comprise the six cities of refuge that you are to designate for a manslayer to flee to, to which you shall add forty-two towns ... The Lord spoke further to Moses: Speak to the Israelite people and say to them: When you cross the Jordan into the land of Canaan, you shall provide yourselves with places to serve you as cities of refuge to which a manslayer who has killed a person unintentionally may flee. The cities shall serve you as a refuge from the avenger, so that the manslayer may not

ואת הערים אשר ותנו ללוים את שש ערי המקלט אשר תתנו

ותהיינה מחלה תרצה וחגלה ומלכה ונעה בנות צלפחד 5

die unless he has stood trial before the assembly ... The daughters of Zelophehad did as the Lord had commanded Moses: Mahlah, Tirzah, Hoglah, Milcah, and Noah, Zelophehad's daughters, were married to sons of their uncles, marrying into clans of descendants of Manasseh son of Joseph; and so their share remained in the tribe of their father's clan. (Num. 34.13–36.12)

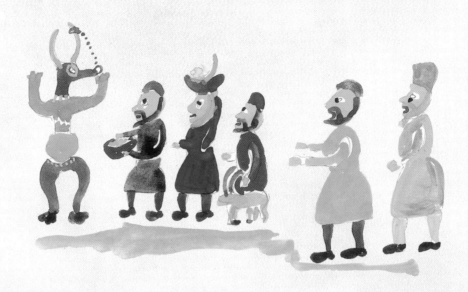

Haftarat Mas'ey

(Ashkenazim read Jeremiah 2.4–28, 3.4) (Sephardim read 2.4–28, 4.1–2)

Hear the word of the Lord, O House of Jacob, every clan of the House of Israel! Thus said the Lord: What wrong did your fathers find in Me that they abandoned Me and went after delusion and were deluded? ... I brought you to this country of farm land to enjoy its fruit and its bounty; but you came and defiled My land, you made My possession abhorrent. The priests never asked themselves, "Where is the Lord?" The guardians of the Teaching ignored Me; the rulers rebelled against Me, and the prophets prophesied by Baal and followed what can do no good. Oh, I will go on accusing you—declares the Lord ... For My people have done a twofold wrong: They have forsaken Me, the Fount of living waters, And hewed them out cisterns, broken cisterns, which cannot even hold water. (Jer. 2.4–13)

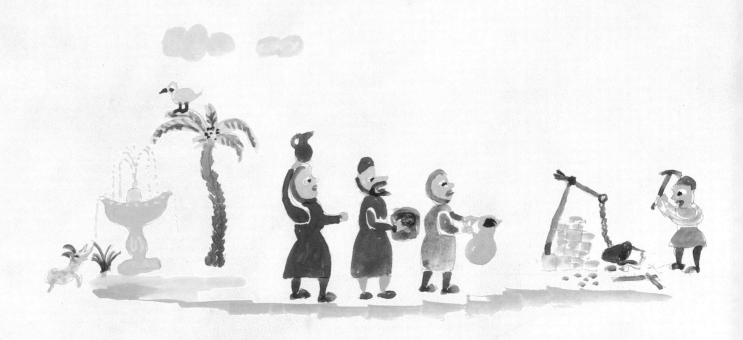

DEVARIM

Devarim 1.1–3.22

Before the people crossed the Jordan, Moses addressed all of the people, reviewing their long journey through the wilderness. He highlighted the Israelites' military defeats, including the fatal incident of the spies, as well as their triumphs, including their recent conquest of the Amorite kings Sihon and Og.

<div dir="rtl">

אלה הדברים אשר דבר משה אל כל ישראל בעבר הירדן במדבר בערבה
מול סוף בין פארן ובית תפל ולבן וחצרת ודי זהב:

</div>

These are the words that Moses addressed to all Israel on the other side of the Jordan.—
Through the wilderness, in the Arabah near Suph, between Paran and Tophel, Laban,
Hazeroth, and Di-zahab (Deut. 1.1)

The Lord our God spoke to us at Horeb, saying: You have stayed long enough at this mountain. Start out and make your way to the hill country of the Amorites and to all their neighbors in the Arabah, the hill country, the Shephelah, the Negeb, the seacoast, the land of the Canaanites, and the Lebanon, as far as the Great River, the river Euphrates. See, I place the land at your disposal. Go, take possession of the

DEVARIM

Devarim

land that the Lord swore to your fathers, Abraham, Isaac, and Jacob, to assign to them and to their heirs after them. Thereupon I said to you, "I cannot bear the burden of you by myself. The Lord your God has multiplied you until you are today as numerous as the stars in the sky.—May the Lord, the God of your fathers, increase your numbers a thousandfold, and bless you as He promised you.—How can I bear unaided the trouble of you, and the burden, and the bickering! Pick from each of your tribes men who are wise, discerning, and experienced, and I will appoint them as your heads. ... Hear out your fellow men, and decide justly between any man and a fellow Israelite or a stranger. You shall not be partial in judgment: hear out low and high alike. Fear no man, for judgment is God's. And any matter that is too difficult for you, you shall bring to me and I will hear it." Thus I instructed you, at that time, about the various things that you should do ... "Go up, take possession, as the Lord, the God of your fathers, promised you. Fear not and be not dismayed." Then all of you came to me and said, "Let us send men ahead to

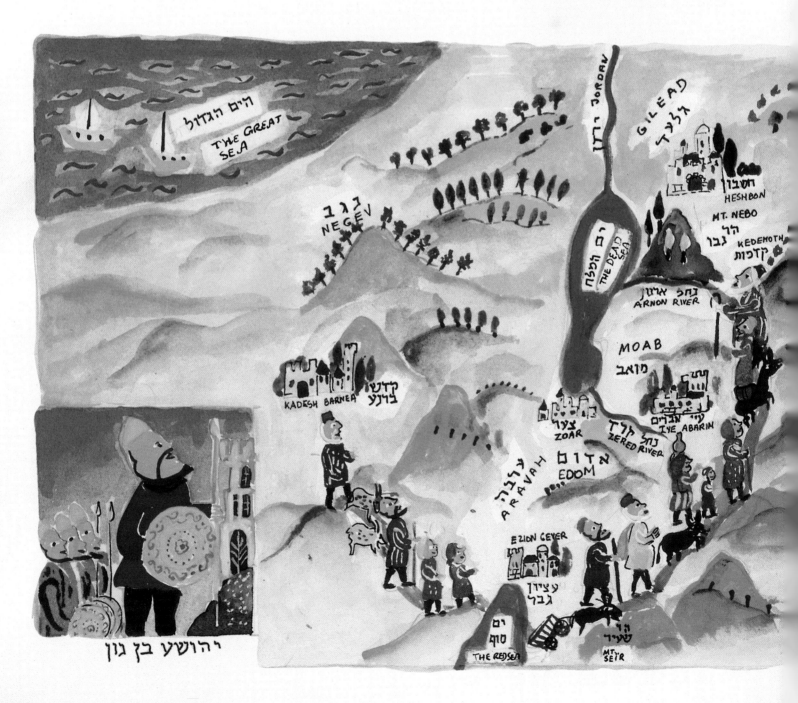

reconnoiter the land for us and bring back word on the route we shall follow and the cities we shall come to." I approved of the plan, and so I selected twelve of your men, one from each tribe. They made for the hill country, came to the wadi Eshcol, and spied it out. They took some of the fruit of the land with them and brought it down to us. And they gave us this report: "It is a good land that the Lord our God is giving to us." Yet you refused to go up, and flouted the command of the Lord your God. You sulked in your tents and said, "It is because the Lord hates us that He brought us out of the land of Egypt, to hand us over to the Amorites to wipe us out. What kind of place are we going to? Our kinsmen have taken the heart out of us, saying, 'We saw there a people stronger and taller than we, large cities with walls sky-high, and even Anakites.'" (Deut. 1.6–28)

When the Lord heard your loud complaint, He was angry. He vowed: Not one of these men, this evil generation, shall see the good land that I swore to give to your fathers—none except Caleb son of Jephunneh; he shall see it, and to him and his descendants will I give the land on which he sets foot, because he remained loyal to the Lord.— Because of you the Lord was incensed with me too, and He said: You shall not enter it either. Joshua son of Nun, who attends you, he shall enter it. Imbue him with strength, for he shall allot it to Israel ... And you all girded yourselves with war gear and recklessly started for the hill country. But the Lord said to me, "Warn them: Do not go up and do not fight, since I am not in your midst; else you will be routed by your enemies." I spoke to you, but you would not listen; you flouted the Lord's command and willfully marched into the hill country. Then the Amorites who lived in those hills came out against you like so many bees and chased you, and they crushed you at Hormah in Seir. Again you wept before the Lord; but the Lord would not heed your cry or give ear to you ... We then moved on, away from our kinsmen, the descendants of Esau, who live in Seir, away from the road of the Arabah, away from Elath and Ezion-geber; and we marched on in the direction of the wilderness of Moab. And the Lord said to me: Do not harass the Moabites or provoke them to war. For I will not give you any of their land as a possession; I have assigned Ar as a possession to the descendants of Lot ... So we crossed the wadi Zered. The time that we spent in travel from Kadesh-barnea until we crossed the wadi Zered was thirty-eight years, until that whole generation of warriors had perished from the camp, as the Lord had sworn concerning them. Indeed, the hand of the Lord struck them, to root them out from the camp to the last man. When all the warriors among the people had died off, the Lord spoke to me, saying: You are now passing through the territory of Moab, through Ar. You will then be close to the Ammonites; do not harass them or start a fight with them. For I will not give any part of the land of the Ammonites to you as a possession; I have assigned it as a possession to the descendants of Lot ... Then I sent messengers from the wilderness of Kedemoth to King Sihon of Heshbon with an offer of peace, as follows, "Let me pass through your country. I will keep strictly to the highway, turning off neither to

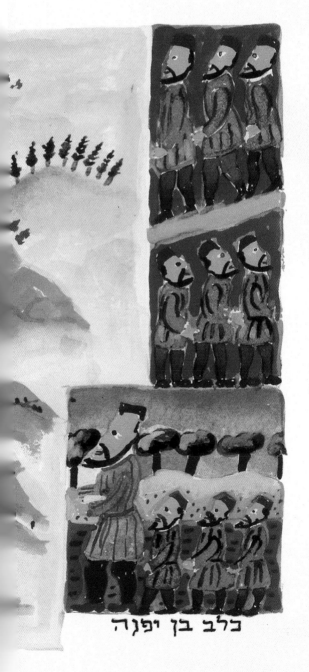

כלב בן יפנה

the right nor to the left." ... But King Sihon of Heshbon refused to let us pass through, because the Lord had stiffened his will and hardened his heart in order to deliver him into your power—as is now the case. And the Lord said to me: See, I begin by placing Sihon and his land at your disposal. Begin the occupation; take possession of his land. Sihon with all his men took the field against us at Jahaz, and the Lord our God delivered him to us and we defeated him and his sons and all his men ... We made our way up the road toward Bashan, and King Og of Bashan with all his men took the field against us at Edrei. But the Lord said to me: Do not fear him, for I am delivering him and all his men and his country into your power, and you will do to him as you did to Sihon king of the Amorites, who lived in Heshbon ... We also seized the Arabah, from the foot of the slopes of Pisgah on the east, to the edge of the Jordan, and from Chinnereth down to the sea of the Arabah, the Dead Sea ... I also charged Joshua at that time, saying, "You have seen with your own eyes all that the Lord your God has done to these two kings; so shall the Lord do to all the kingdoms into which you shall cross over. Do not fear them, for it is the Lord your God who will battle for you." (Deut. 1.34–3.22)

Haftarat Devarim

(Isaiah 1.1–27)

The prophecies of Isaiah son of Amoz, who prophesied concerning Judah and Jerusalem in the reigns of Uzziah, Jotham, Ahaz, and Hezekiah, kings of Judah. Hear, O heavens, and give ear, O earth, for the Lord has spoken: "I reared children and brought them up—and they have rebelled against Me! An ox knows its owner, an ass its master's crib: Israel does not know, My people takes no thought ... Come, let us reach an understanding, —says the Lord. Be your sins like crimson, they can turn snow-white; be they red as dyed wool, they can become like fleece." If, then, you agree and give heed, you will eat the good things of the earth; but if you refuse and disobey, you will be devoured by the sword.—For it was the Lord who spoke. "...I will restore your magistrates as of old, and your counselors as of yore. After that you shall be called City of Righteousness, Faithful City." Zion shall be saved in the judgment; her repentant ones, in the retribution. (Isa. 1.1–27)

*I*n his second farewell address, Moses spoke to the people about their memorable experiences at the foot of Mount Sinai. After reciting the Ten Commandments, he reminded the Israelites of their covenant with God and the dire consequences of disobedience: "Hear, O Israel, the Lord is our God ... Take to heart these instructions ... Bind them ... on your hand ... inscribe them on [your] doorposts."

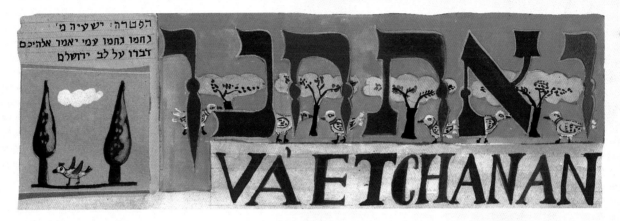

ואתחנן אל ה' בעת ההיא לאמר: ה' אלקים אתה החילות להראות
את עבדך את גדלך ואת ידך החזקה אשר מי אל בשמים ובארץ
אשר יעשה כמעשיך וכגבורתך:

I pleaded with the Lord at that time, saying, "O Lord God, You who let Your servant see the first works of Your greatness and Your mighty hand, You whose powerful deeds no god in heaven or on earth can equal!" (Deut. 3.23–24)

"*L*et me, I pray, cross over and see the good land on the other side of the Jordan, that good hill country, and the Lebanon." But the Lord was wrathful with me on your account and would not listen to me. The Lord said to me, "Enough! Never speak to Me of this matter again! Go up to the summit of Pisgah and gaze about, to the west, the north, the south, and the east. Look at it well, for you shall not go across yonder Jordan. Give Joshua his instructions, and imbue him with strength and courage, for he shall go across at the head of this people, and he shall allot to them the land that you may only see." Meanwhile we stayed on in the valley near Beth-peor. And now, O Israel, give heed to the laws and rules that I am instructing you to observe, so that you may live to enter and occupy the land that the Lord, the God of your fathers, is giving you. You shall not add anything to what I command you or take anything away from it, but keep the commandments of the Lord your God that I enjoin upon you ... The day you stood before the Lord your God at Horeb, when the Lord said to Me, "Gather the people to Me that I may let them hear My words, in order that they may learn to revere Me as long as they live on earth, and may so teach their children." You came forward and stood at the foot of the mountain. The mountain was ablaze with flames to the very skies, dark with densest clouds ... But if you search there for the Lord your God, you will find Him, if only you seek Him with all your heart and soul—when

DEVARIM

Va'etchanan

you are in distress because all these things have befallen you and, in the end, return to the Lord your God and obey Him. For the Lord your God is a compassionate God: He will not fail you nor will He let you perish; He will not forget the covenant which He made on oath with your fathers. (Deut. 3.25–4.31)

Observe His laws and commandments, which I enjoin upon you this day, that it may go well with you and your children after you, and that you may long remain in the land that the Lord your God is assigning to you for all time ... Moses summoned all the Israelites and said to them: Hear, O Israel, the laws and rules that I proclaim to you this day! Study them and observe them faithfully! ... I the Lord am your God who brought you out of the land of Egypt, the house of bondage: You shall have no other gods beside Me. You shall not make for yourself a sculptured image, any likeness of what is in the heavens above, or on the earth below, or in the waters below the earth. You shall not bow down to them or serve them. For I the Lord your God am an impassioned God, visiting the guilt of the parents upon the children, upon the third and upon the fourth generations of those who reject Me, but showing kindness to the thousandth generation of those who love Me and keep My commandments. You shall not swear falsely by the name of the Lord your God; for the Lord will not clear one who swears falsely by His name. Observe the sabbath day and keep it holy, as the Lord your God has commanded you. Six days you shall labor and do all your work, but the seventh day is a

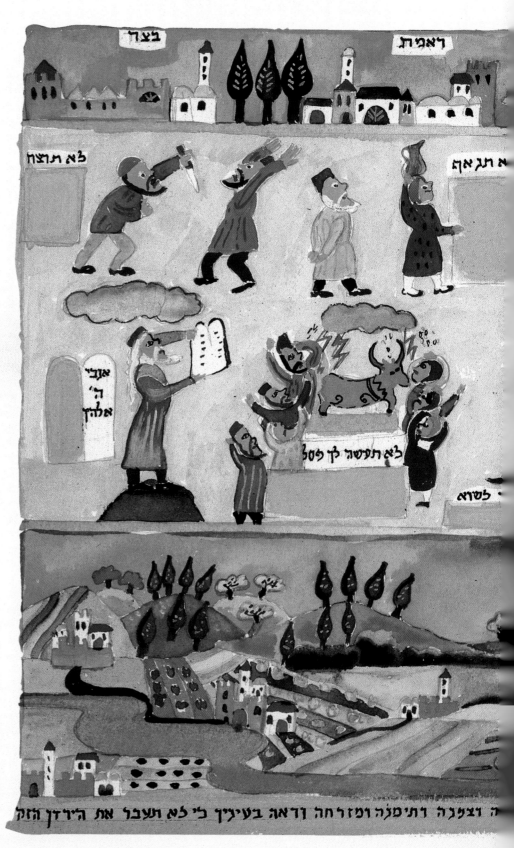

sabbath of the Lord your God; you shall not do any work—you, your son or your daughter, your male or female slave, your ox or your ass, or any of your cattle, or the stranger in your settlements, so that your male and female slave may rest as you do. Remember that you were a slave in the land of Egypt and the Lord your God freed you from there with a mighty hand and an outstretched arm; therefore the Lord your God has commanded you to observe the sabbath day. Honor your father and your mother, as the Lord your God has commanded you, that you may long endure, and that you may fare well, in the land that the Lord your God is assigning to you. You shall not murder. You shall not commit adultery. You shall not steal. You shall not bear false witness against your neighbor. You shall not covet your neighbor's wife. You shall not crave your neighbor's house, or his field, or his male or female slave, or his ox, or his ass, or anything that is your neighbor's ... Be careful, then, to do as the Lord your God has commanded you. Do not turn aside to the right or to the left: follow only the path that the Lord your God has enjoined upon you, so that you may thrive and that it may go well with you, and that you may long endure in the land you are to possess ... Obey, O Israel, willingly and faithfully, that it may go well with you and that you may increase greatly in a land flowing with milk and honey, as the Lord, the God of your fathers, spoke to you. (Deut. 4.40–6.3)

גזלן

לא תחמד

לא תגנב

לא תענה ברעך עד שוא

כבד את אביך ואת אמך

לא תשא את שם

שמור את יום השבת לקדשו

עלה ראש הפסגה ושא

צו את יהושע וחזקהו ואמצהו

Hear, O Israel!

The Lord is our God, the Lord alone.
You shall love the Lord your God with
all your heart and with all your soul
and with all your might. Take to heart
these instructions with which I charge
you this day. Impress them upon your
children. Recite them when you stay
at home and when you are away,
when you lie down and when you get
up. Bind them as a sign on your hand
and let them serve as a symbol on
your forehead; inscribe them on the
doorposts of your house and on your
gates. (Deut. 6.4–9)

Do not try the Lord your God, as you did at Massah. Be sure to keep the commandments, decrees, and laws that the Lord your God has enjoined upon you. Do what is right and good in the sight of the Lord, that it may go well with you and that you may be able to possess the good land that the Lord your God promised on oath to your fathers, and that all your enemies may be driven out before you, as the Lord has spoken ... When the Lord your God brings you to the land that you are about to enter and possess, and He dislodges many nations before you—the Hittites, Girgashites, Amorites, Canaanites, Perizzites, Hivites, and Jebusites, seven nations much larger than you—and the Lord your God delivers them to you and you defeat them, you must doom them to destruction: grant them no terms and give them no quarter. You shall not intermarry with them: do not give your daughters to their sons or take their daughters for your sons. For they will turn your children away from Me to worship other gods, and the Lord's anger will blaze forth against you and He will promptly wipe you out ... For you are a people consecrated to the Lord your God: of all the peoples on earth the Lord your God chose you to be His treasured people. It is not because you are the most numerous of peoples that the Lord set His heart on you and chose you—indeed, you are the smallest of peoples; but it was because the Lord favored you and kept the oath He made to your fathers that the Lord freed you with a mighty hand and rescued you from the house of bondage, from the power of Pharaoh king of Egypt. Know, therefore, that only the Lord your God is God, the steadfast God who keeps His covenant faithfully to the thousandth generation of those who love Him and keep His commandments, but who instantly requites with destruction those who reject Him—never slow with those who reject Him, but requiting them instantly. Therefore, observe faithfully the Instruction—the laws and the rules—with which I charge you today. (Deut. 6.16–7.11)

Haftarat Va'etchanan

(Isaiah 40.1–26)

Comfort, oh comfort My people, says your God. Speak tenderly to Jerusalem, and declare to her that her term of service is over, that her iniquity is expiated; for she has received at the hand of the Lord double for all her sins. A voice rings out: "Clear in the desert a road for the Lord! Level in the wilderness a highway for our God! Let every valley be raised, every hill and mount made low. Let the rugged ground become level and the ridges become a plain. The Presence of the Lord shall appear, and all flesh, as one, shall behold—for the Lord Himself has spoken." ... Indeed, man is but grass: Grass withers, flowers fade—But the word of our God is always fulfilled!" (Isa. 40.1–8)

Moses reminded the people of their duties to God and of their chosenness. He recounted again the tragic incident of the Golden Calf and its consequences. He reminded them of their responsibilities to care for the weak and helpless among them. Finally, he warned them of the curses that would befall them if they disobeyed God's laws, and of the blessings they would reap if they followed them.

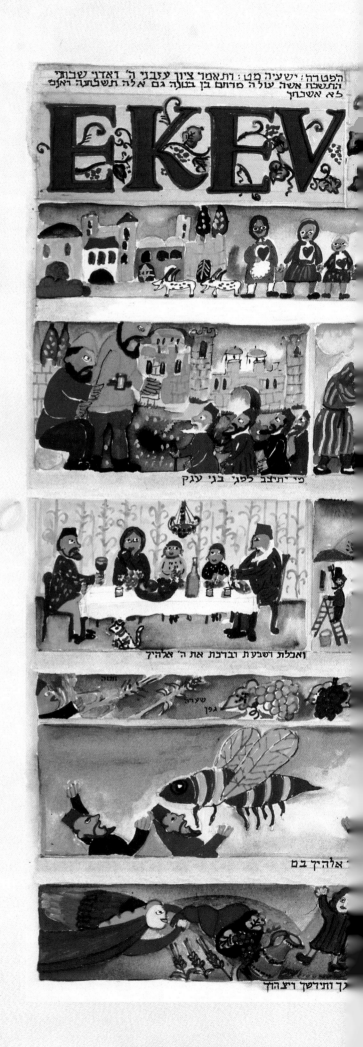

והיה עקב תשמעון את המשפטים
האלה ושמרתם ועשיתם אתם
ושמר ה' אלקיך לך את הברית
ואת החסד אשר נשבע לאבתיך:

And if you do obey these rules and observe them carefully, the Lord your God will maintain faithfully for you the covenant that He made on oath with your fathers: (Deut. 7.12)

He will favor you and bless you and multiply you; He will bless the issue of your womb and the produce of your soil, your new grain and wine and oil, the calving of your herd and the lambing of your flock, in the land that He swore to your fathers to assign to you. You shall be blessed above all other peoples: there shall be no sterile male or female among you or among your livestock. The Lord will ward off from you all sickness; He will not bring upon you any of the dreadful diseases of Egypt, about which you know, but will inflict them upon all your enemies ... Should you say to yourselves, "These nations are more numerous than we; how can we dispossess them?" You need have no fear of them.

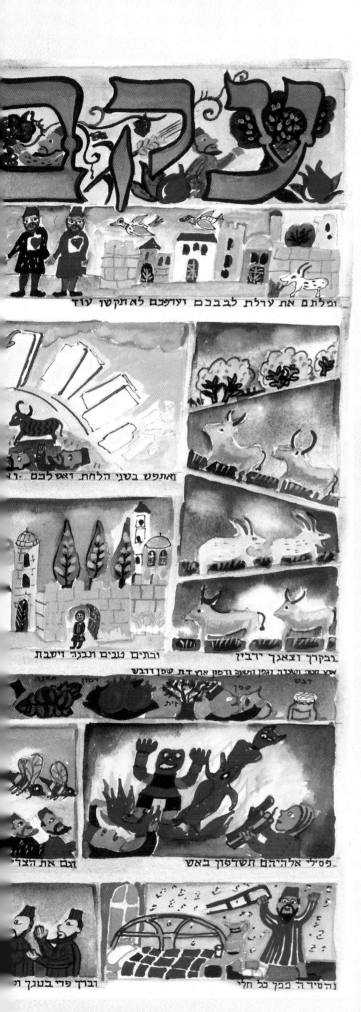

You have but to bear in mind what the Lord your God did to Pharaoh and all the Egyptians: the wondrous acts that you saw with your own eyes, the signs and the portents, the mighty hand, and the outstretched arm by which the Lord your God liberated you. Thus will the Lord your God do to all the peoples you now fear. The Lord your God will also send a plague against them, until those who are left in hiding perish before you. Do not stand in dread of them, for the Lord your God is in your midst, a great and awesome God ... You shall consign the images of their gods to the fire; you shall not covet the silver and gold on them and keep it for yourselves, lest you be ensnared thereby; for that is abhorrent to the Lord your God. You must not bring an abhorrent thing into your house, or you will be proscribed like it; you must reject it as abominable and abhorrent, for it is proscribed. (Deut. 7.13–26)

Remember the long way that the Lord your God has made you travel in the wilderness these past forty years, that He might test you by hardships to learn what was in your hearts: whether you would keep His commandments or not. He subjected you to the hardship of hunger and then gave you manna to eat, which neither you nor your fathers had ever known, in order to teach you that man does not live on bread alone, but that man may live on anything that the Lord decrees ... For the Lord your God is bringing you into a good land, a land with streams and springs and fountains issuing from plain and hill; a land of wheat and barley, of vines, figs, and pomegranates, a land of olive trees and honey; a land where you may eat food without stint, where you will lack nothing; a land whose rocks are iron and from whose hills you can mine copper. When you have eaten your fill, give thanks to the Lord your God for the good land which He has given you. Take care lest you forget the Lord your God and fail to keep His commandments, His rules, and His laws, which I enjoin upon you today ... Know, then, that it is not for any virtue of yours that the Lord your God is giving you this good land to possess; for you are a stiffnecked people. Remember, never forget, how you provoked the Lord your God to anger in the wilderness: from the day that you left the land of Egypt until you reached this place, you have continued defiant

toward the Lord ... Thereupon I gripped the two tablets and flung them away with both my hands, smashing them before your eyes. I threw myself down before the Lord—eating no bread and drinking no water forty days and forty nights, as before—because of the great wrong you had committed, doing what displeased the Lord and vexing Him ... Again you provoked the Lord at Taberah, and at Massah, and at Kibroth-hattaavah ... As long as I have known you, you have been defiant toward the Lord. When I lay prostrate before the Lord those forty days and forty nights, because the Lord was determined to destroy you, I prayed to the Lord and said, "O Lord God, do not annihilate Your very own people, whom You redeemed in Your majesty and whom You freed from Egypt with a mighty hand. Give thought to Your servants, Abraham, Isaac, and Jacob, and pay no heed to the stubbornness of this people, its wickedness, and its sinfulness ... Yet they are Your very own people, whom You freed with Your great might and Your outstretched arm." ... Love, therefore, the Lord your God, and always keep His charge, His laws, His rules, and His commandments ... Therefore impress these My words upon your very heart: bind them as a sign on your hand and let them serve as a symbol on your forehead, and teach them to your children—reciting them when you stay at home and when you are away, when you lie down and when you get up; and inscribe them on the doorposts of your house and on your gates—to the end that you and your children may endure, in the land that the Lord swore to your fathers to assign to them, as long as there is a heaven over the earth. If, then, you faithfully keep all this Instruction that I command you, loving the Lord your God, walking in all His ways, and holding fast to Him, the Lord will dislodge before you all these nations: you will dispossess nations greater and more numerous than you. (Deut. 8.2–11.23)

Haftarat Ekev

(Isaiah 49.14–51.3)

Zion says, "The Lord has forsaken me, my Lord has forgotten me." Can a woman forget her baby, or disown the child of her womb? Though she might forget, I never could forget you. See, I have engraved you on the palms of My hands, your walls are ever before Me. Swiftly your children are coming; those who ravaged and ruined you shall leave you. Look up all around you and see: They are all assembled, are come to you! As I live—declares the Lord—you shall don them all like jewels, deck yourself with them like a bride ... Thus said the Lord God: I will raise My hand to nations and lift up My ensign to peoples; and they shall bring your sons in their bosoms, and carry your daughters on their backs. Kings shall tend your children, their queens shall serve you as nurses. They shall bow to you, face to the ground, and lick the dust of your feet. And you shall know that I am the Lord—those who trust in Me shall not be shamed ... Truly the Lord has comforted Zion, comforted all her ruins; He has made her wilderness like Eden, her desert like the Garden of the Lord. Gladness and joy shall abide there, thanksgiving and the sound of music. (Isa. 49.14–51.3)

Moses instructed the people to perform a ritual drama of blessing and curse when they entered the land. He spoke to them of the laws concerning sacrifice, permitted and forbidden foods, and the dangers of false religious practices. He reminded them of their obligations toward the Levites and the less fortunate, namely, widows, orphans, the poor, and slaves. Moses told the people that they must pay homage to God through the observances of the three pilgrimage festivals of Passover, Shavuot, and Sukkot.

ראה אנכי נתן לפניכם
היום ברכה וקללה:

See, this day I set before you
blessing and curse: (Deut. 11.26)

Blessing, if you obey the commandments of the Lord your God that I enjoin upon you this day; and curse, if you do not obey the commandments of the Lord your God ... When the Lord your God brings you into the land that you are about to enter and possess, you shall pronounce the blessing at Mount Gerizim and the curse at Mount Ebal.—Both are on the other side of the Jordan, beyond the west road that is in the land of the Canaanites who dwell in the Arabah—near Gilgal, by the terebinths of Moreh ... And you shall rejoice before the Lord your God with your sons and daughters and with your male and

female slaves, along with the Levite in your settlements, for he has no territorial allotment among you ... You may not partake in your settlements of the tithes of your new grain or wine or oil, or of the firstlings of your herds and flocks, or of any of the votive offerings that you vow, or of your freewill offerings, or of your contributions. These you must consume before the Lord your God in the place that the Lord your God will choose—you and your sons and your daughters, your male and female slaves, and the Levite in your settlements—happy before the Lord your God in all your undertakings. Be sure not to neglect the Levite as long as you live in your land. (Deut. 11.27–12.19)

Be careful to observe only that which I enjoin upon you: neither add to it nor take away from it. If there appears among you a prophet or a dream-diviner and he gives you a sign or a portent, saying, "Let us follow and worship another god"— whom you have not experienced even if the sign or portent that he named to you

DEVARIM

Re'eh

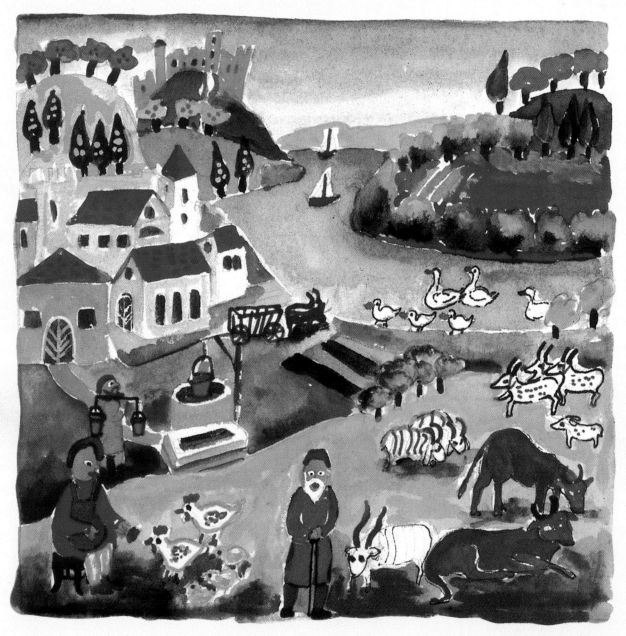

comes true, do not heed the words of that prophet or that dream-diviner. For the Lord your God is testing you to see whether you really love the Lord your God with all your heart and soul. Follow none but the Lord your God, and revere none but Him; observe His commandments alone, and heed only His orders; worship none but Him, and hold fast to Him ... You shall not boil a kid in its mother's milk. You shall set aside every year a tenth part of all the yield of your sowing that is brought from the field. You shall consume the tithes of your new grain and wine and oil, and the firstlings of your herds and flocks, in the presence of the Lord your God, in the place where He will choose to establish His name, so that you may learn to revere the Lord your God forever ... Every seventh year you shall practice remission of debts. This shall be the nature of the remission: every creditor shall remit the due that he claims from his fellow; he shall not dun his fellow or

kinsman, for the remission proclaimed is of the Lord. You may dun the foreigner; but you must remit whatever is due you from your kinsmen. There shall be no needy among you—since the Lord your God will

bless you in the land that the Lord your God is giving you as a hereditary portion—if only you heed the Lord your God and take care to keep all this Instruction that I enjoin upon you this day. For the Lord your God will bless you as He has promised you: you will extend loans to many nations, but require none yourself; you will dominate many nations, but they will not dominate you. If, however, there is a needy person among you, one of your kinsmen in any of your settlements in the land that the Lord your God is giving you, do not harden your heart and shut

your hand against your needy kinsman. Rather, you must open your hand and lend him sufficient for whatever he needs. Beware lest you harbor the base thought, "The seventh year, the year of remission, is approaching," so that you are mean to your needy kinsman and give him nothing. He will cry out to the Lord against you, and you will incur guilt. Give to him readily and have no regrets when you do so, for in return the Lord your God will bless you in all your efforts and in all your undertakings. For there will never cease to be needy ones in your land, which is why I command you: open your hand to the poor and needy kinsman in your land ... Observe the month of Abib and offer a passover

sacrifice to the Lord your God, for it was in the month of Abib, at night, that the Lord your God freed you from Egypt ... You shall count off seven weeks; start to count the seven weeks when the sickle is first put to the standing grain. Then you shall observe the Feast of Weeks for the Lord your God, offering your freewill contribution according as the Lord your God has blessed you. You shall rejoice before the Lord your God with your son and daughter, your male and female slave, the Levite in your communities, and the stranger, the fatherless, and the widow in your midst, at the place where the Lord your God will choose to establish His name. Bear in mind that you were slaves in Egypt, and take care to obey these laws.

After the ingathering from your threshing floor and your vat, you shall hold the Feast of Booths for seven days. You shall rejoice in your festival, with your son and daughter, your male and female slave, the Levite, the stranger, the fatherless, and the widow in your communities. You shall hold a festival for the Lord your God seven days, in the place that the Lord will choose; for the Lord your God will bless all your crops and all your undertakings, and you shall have nothing but joy. (Deut. 13.1–16.15)

Three times a year—on the Feast of Unleavened Bread, on the Feast of Weeks, and on the Feast of Booths—all your males shall appear before the Lord your God in the place that He will choose. They shall not appear before the Lord empty-handed, but each with his own gift, according to the blessing that the Lord your God has bestowed upon you. (Deut. 16.16–17)

Haftarat Re'eh

(Isaiah 54.11–55.5)

Unhappy, storm-tossed one, uncomforted! I will lay carbuncles as your building stones and make your foundations of sapphires. I will make your battlements of rubies, your gates of precious stones, the whole encircling wall of gems. And all your children shall be disciples of the Lord, and great shall be the happiness of your children; you shall be established through righteousness. You shall be safe from oppression, and shall have no fear; from ruin, and it shall not come near you. Surely no harm can be done without My consent: Whoever would harm you shall fall because of you. It is I who created the smith to fan the charcoal fire and produce the tools for his work; so it is I who create the instruments of havoc. No weapon formed against you shall succeed. (Isa. 54.11–17)

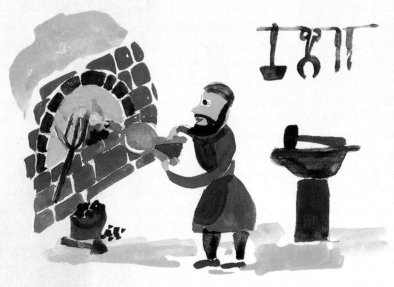

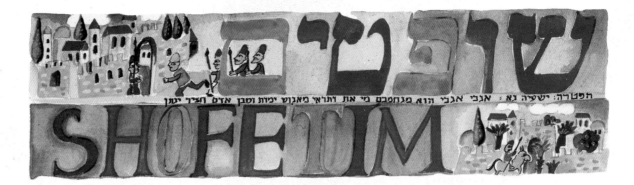

Moses instructed the people to appoint judges and to pursue justice. He warned them of the excesses their kings
would commit in future times. Moses then defined the laws concerning the rights and privileges of priests, taboos
against magic, and the character of legitimate prophecy. He also repeated for them the laws concerning the cities
of refuge, legal testimony, and how to conduct war. Finally he instructed them about what to do when an unidentified
corpse was found between two inhabited towns.

שפטים ושטרים תתן לך בכל שעריך אשר ה' אלקיך
נתן לך לשבטיך ושפטו את העם משפט צדק:

You shall appoint magistrates and officials for your tribes, in all the settlements that the Lord your
God is giving you, and they shall govern the people with due justice. (Deut. 16.18)

You shall not judge unfairly: you shall show no partiality; you shall not take bribes, for bribes blind
the eyes of the discerning and upset the plea of the just. Justice, justice shall you pursue, that you may
thrive and occupy the land that the Lord your God is giving you. You shall not set up a sacred post—
any kind of pole beside the altar of the Lord your God that you may make—or erect a stone pillar; for
such the Lord your God detests ... Thus you will sweep out evil from Israel: all the people will hear and
be afraid and will not act presumptuously again. If, after you have entered the land that the Lord your
God has assigned to you, and taken possession of it and settled in it, you decide, "I will set a king over
me, as do all the nations about me," you shall be free to set a king over yourself, one chosen by the Lord
your God. Be sure to set as king over yourself one of your own people; you must not set a foreigner over
you, one who is not your kinsman. Moreover, he shall not keep many horses or send people back to
Egypt to add to his horses, since the Lord has warned you, "You must not go back that way again." And
he shall not have many wives, lest his heart go astray; nor shall he amass silver and gold to excess. When
he is seated on his royal throne, he shall have a copy of this Teaching written for him on a scroll by the
levitical priests. Let it remain with him and let him read in it all his life, so that he may learn to revere
the Lord his God, to observe faithfully every word of this Teaching as well as these laws. Thus he will
not act haughtily toward his fellows or deviate from the Instruction to the right or to the left, to the end
that he and his descendants may reign long in the midst of Israel. (Deut. 16.19–17.20)

DEVARIM

Shofetim

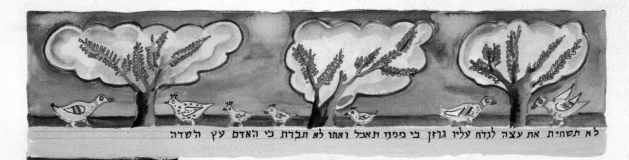

לא תשחית את עצה לנדח עליו גרזן כי ממנו תאכל ואתו לא תכרת כי האדם עץ השדה

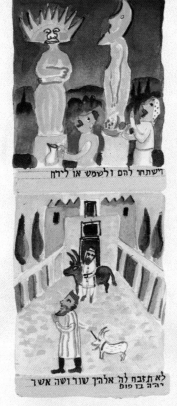

וישתחו להם ולשמש או לירח

לא תזבח לה׳ אלהיך שור ושה אשר יהיה בו מום

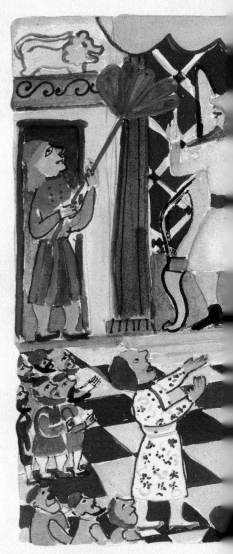

When you enter the land that the Lord your God is giving you, you shall not learn to imitate the abhorrent practices of those nations. Let no one be found among you who consigns his son or daughter to the fire, or who is an augur, a soothsayer, a diviner, a sorcerer, one who casts spells, or one who consults ghosts or familiar spirits, or one who inquires of the dead. For anyone who does such things is abhorrent to the Lord, and it is because of these abhorrent things that the Lord your God is dispossessing them before you. You must be wholehearted with the Lord your God ... The Lord your God will raise up for you a prophet from among your own people, like myself; him you shall heed. This is just what you asked of the Lord your God at Horeb, on the day of the Assembly, saying, "Let me not hear the voice of the Lord my God any longer or see this wondrous fire any more, lest I die." Whereupon the Lord said to me, "They have done well in speaking thus. I will raise up a prophet for them from among their own people, like yourself: I will put My words in his mouth and he will speak to them all that I command him; and if anybody fails to heed the words he speaks in My name, I Myself will call him to account. But any prophet who presumes to speak in My name an oracle that I did not command him to utter, or who speaks in the name of other gods—that prophet shall die." And should you ask yourselves, "How can we know that the oracle was not spoken by the Lord?"—if the prophet speaks in the name of the Lord and the oracle does not come true, that oracle was not spoken by the Lord; the prophet has uttered it presumptuously: do not stand in dread of him ... And when the Lord your God enlarges your territory, as He swore to your fathers, and gives you all the land that He promised to give your fathers—if you faithfully observe all this Instruction that I enjoin upon you this day, to love the Lord your God and to walk in His ways at all times—then you shall add three more towns to those three. Thus blood of the innocent will not be shed, bringing bloodguilt upon you in the land that the Lord your God is allotting to you. If, however, a person who is the enemy of another lies in wait for him and sets upon him and strikes him a fatal blow and then flees to one of these towns, the elders of his town shall have him brought

back from there and shall hand him over to the blood-avenger to be put to death; you must show him no pity. Thus you will purge Israel of the blood of the innocent, and it will go well with you. You shall not move your countryman's landmarks, set up by previous generations, in the property that will be allotted to you in the land that the Lord your God is giving you to possess. A single witness may not validate against a person any guilt or blame for any offense that may be committed; a case can be valid only on the testimony of two witnesses or more. If a man appears against another to testify maliciously and gives false testimony against him, the two parties to the dispute shall appear before the Lord, before the priests or magistrates in authority at the time, and the magistrates shall make a thorough investigation. If the man who testified is a false witness, if he has testified falsely against his fellow, you shall do to

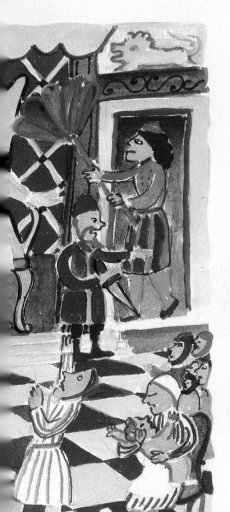

him as he schemed to do to his fellow. Thus you will sweep out evil from your midst; others will hear and be afraid, and such evil things will not again be done in your midst. Nor must you show pity: life for life, eye for eye, tooth for tooth, hand for hand, foot for foot. When you take the field against your enemies, and see horses and chariots—forces larger than yours—have no fear of them, for the Lord your God, who brought you from the land of Egypt, is with you. Before you join battle, the priest shall come forward and address the troops. He shall say to them, "Hear, O Israel! You are about to join battle with your enemy. Let not your courage falter. Do not be in fear, or in panic, or in dread of them. For it is the Lord your God who marches with you to do battle for you against your enemy, to bring you victory." Then the officials shall address the troops, as follows: "Is there anyone who has built a new house but has not dedicated it? Let him go back to his home, lest he die in battle and another dedicate it. Is there anyone who has planted a vineyard but has never harvested it? Let him go back to his home, lest he die in battle and another harvest it. Is there anyone who has paid the bride-price for a wife, but who has not yet married her? Let him go back to his home, lest he die in battle and another marry her." The officials shall go on addressing the troops and say, "Is there anyone afraid and disheartened? Let him go back to his home, lest the courage of his comrades flag like his." When the officials have finished addressing the troops, army commanders shall assume command of the troops. When you approach a town to attack it, you shall

על פי שלשה עדים יקום דבר

שום תשים עליך מלך אשר יבחר ה׳
אלהיך

offer it terms of peace. If it responds peaceably and lets you in, all the people present there shall serve you at forced labor. If it does not surrender to you, but would join battle with you, you shall lay siege to it; and when the Lord your God delivers it into your hand, you shall put all its males to the sword. You may, however, take as your booty the women, the children, the livestock, and everything in the town—all its spoil—and enjoy the use of the spoil of your enemy, which the Lord your God gives you ... When in your war against a city you have to besiege it a long time in order to capture it, you must not destroy its trees, wielding the ax against them. You may eat of them, but you must not cut them down. Are trees of the field human to withdraw before you into the besieged city? Only trees that you know do not yield food may be destroyed; you may cut them down for constructing siegeworks against the city that is waging war on you, until it has been reduced. (Deut. 18.9–20.20)

Haftarat Shofetim

(Isaiah 51.12–52.12)

I, I am He who comforts you! What ails you that you fear man who must die, mortals who fare like grass? You have forgotten the Lord your Maker, who stretched out the skies and made firm the earth! And you live all day in constant dread because of the rage of an oppressor who is aiming to cut you down. Yet of what account is the rage of an oppressor? Quickly the crouching one is freed; he is not cut down and slain, and he shall not want for food. For I the Lord your God—who stir up the sea into roaring waves, whose name is Lord of Hosts—have put My words in your mouth and sheltered you with My hand ... How welcome on the mountain are the footsteps of the herald announcing happiness, heralding good fortune, announcing victory, telling Zion, "Your God is King!" (Isa. 51.12–52.7)

Ki Tetze 21.10–25.19

Continuing his address to the people, Moses recounted the many laws which taken together laid the groundwork for a just society: laws concerning women captured in war, birthrights, punishing a disobedient son, disposing of the corpse of an executed criminal, handling lost property, cross-dressing, robbing a bird's nest, the taboo against mixed species, cases of adultery and rape, cult prostitution, interest, vows, divorce, loans, dealing with vulnerable members of society, excluding certain individuals from Israelite society, levirate marriage, a woman who seizes a man's genitals, honest weights and measures. Moses concluded his speech with the commandment that the Israelites remember Amalek's treachery against them in the desert.

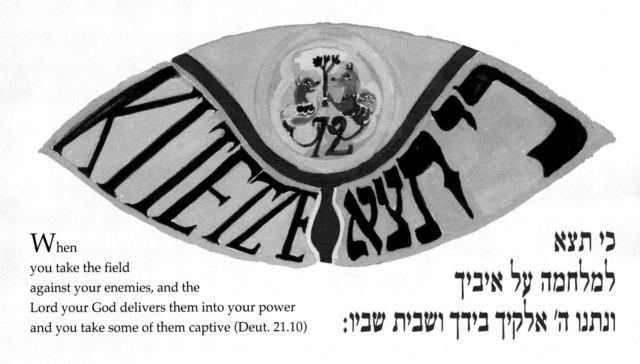

When
you take the field
against your enemies, and the
Lord your God delivers them into your power
and you take some of them captive (Deut. 21.10)

כי תצא
למלחמה על איביך
ונתנו ה' אלקיך בידך ושבית שביו:

And you see among the captives a beautiful woman and you desire her and would take her to wife, you shall bring her into your house, and she shall trim her hair, pare her nails, and discard her captive's garb. She shall spend a month's time in your house lamenting her father and mother; after that you may come to her and possess her, and she shall be your wife. Then, should you no longer want her, you must release her outright. You must not sell her for money: since you had your will of her, you must not enslave her ... If you see your fellow's ox or sheep gone astray, do not ignore it; you must take it back to your fellow. If your fellow does not live near you or you do not know who he is, you shall bring it home and it shall remain with you until your fellow claims it; then you shall give it back to him. You shall do the same with his ass; you shall do the same with his garment; and so too shall you do with anything that your fellow loses and you find: you must not remain indifferent. If you see your fellow's ass or ox fallen on the road, do not ignore it; you must help him raise it. A woman must not put on man's apparel, nor shall a man wear woman's clothing; for whoever does these things is abhorrent to the Lord your God. If, along the road, you chance upon a bird's nest, in any tree or on the ground, with fledglings or eggs and the mother sitting over the fledglings or on the eggs, do not take the mother together with her young. Let the mother go, and take only the young, in order that you may fare well and have a long life. When you build a new house, you shall make a parapet for your roof, so that you do not bring

DEVARIM

Ki Tetze

bloodguilt on your house if anyone should fall from it ... You shall not plow with an ox and an ass together. You shall not wear cloth combining wool and linen. You shall make tassels on the four corners of the garment with which you cover yourself ... No Ammonite or Moabite shall be admitted into the congregation of the Lord; none of their descendants, even in the tenth generation, shall ever be admitted into the congregation of the Lord, because they did not meet you with food and water on your journey after you left Egypt, and because they hired Balaam son of Beor, from Pethor of Aram-naharaim, to curse you.—But the Lord your God refused to heed Balaam; instead, the Lord your God turned the curse into a blessing for you, for the Lord your God loves you.—You shall never concern yourself with their welfare or benefit as long as you live. You shall not abhor an Edomite, for he is your kinsman. You shall not abhor an Egyptian, for you were a stranger in his land. Children born to them may be admitted into the congregation of the Lord in the third generation. (Deut. 21.11–23.9)

When you go out as a troop against your enemies, be on your guard against anything untoward ... Since the Lord your God moves about in your camp to protect you and to deliver your enemies to you, let your camp be holy; let Him not find anything unseemly among you and turn away from you. You shall not turn over to his master a slave who seeks refuge with you from his master. He shall live with you in any place he may choose among the settlements in your midst, wherever he pleases; you must not ill-treat him. No Israelite woman shall be a cult prostitute, nor shall any Israelite man be a cult prostitute. You shall not bring the fee of a whore or the pay of a dog into the house of the Lord your God in fulfillment of any vow, for both are abhorrent to the Lord your God. You shall not deduct interest from loans to your countrymen, whether in money or food or anything else that can be deducted as interest ... When you make a vow to the Lord your God, do

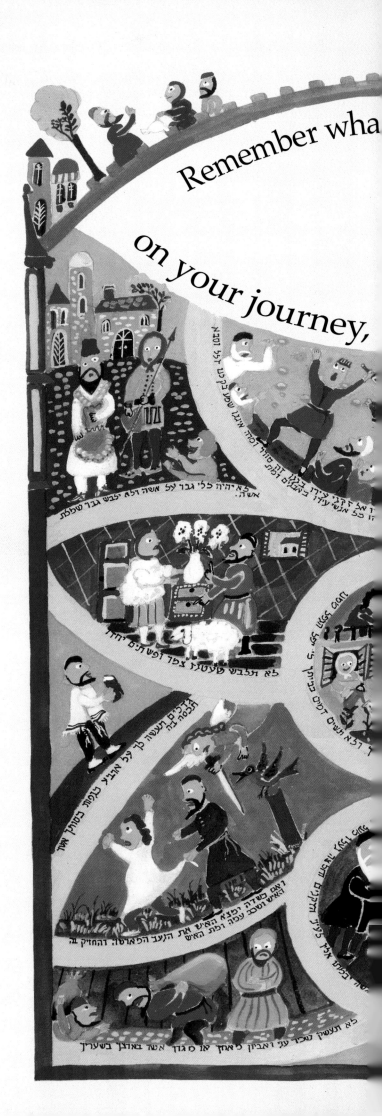

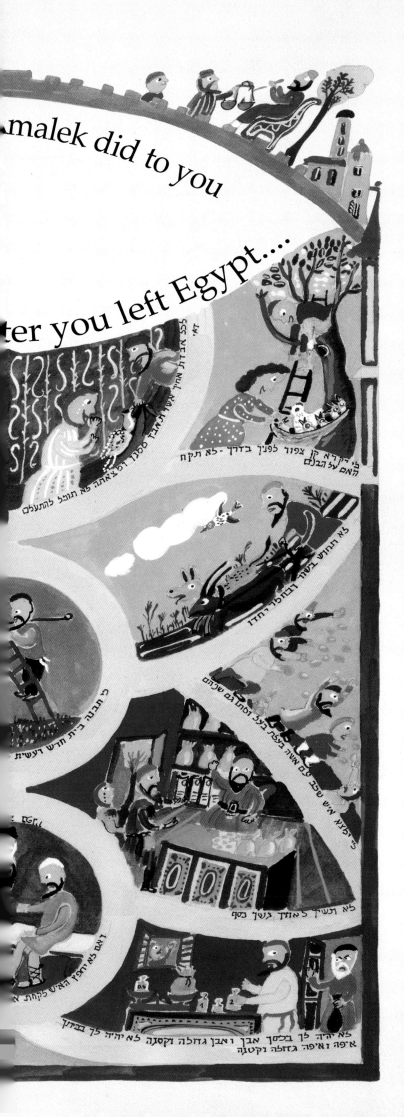

not put off fulfilling it, for the Lord your God will require it of you, and you will have incurred guilt; whereas you incur no guilt if you refrain from vowing. You must fulfill what has crossed your lips and perform what you have voluntarily vowed to the Lord your God, having made the promise with your own mouth. (Deut. 23.10–24)

A handmill or an upper millstone shall not be taken in pawn, for that would be taking someone's life in pawn ... In cases of a skin affection be most careful to do exactly as the levitical priests instruct you. Take care to do as I have commanded them. Remember what the Lord your God did to Miriam on the journey after you left Egypt. When you make a loan of any sort to your countryman, you must not enter his house to seize his pledge. You must remain outside, while the man to whom you made the loan brings the pledge out to you. If he is a needy man, you shall not go to sleep in his pledge; you must return the pledge to him at sundown, that he may sleep in his cloth and bless you; and it will be to your merit before the Lord your God. You shall not abuse a needy and destitute laborer, whether a fellow countryman or a stranger in one of the communities of your land. You must pay him his wages on the same day, before the sun sets, for he is needy and urgently depends on it; else he will cry to the Lord against you and you will incur guilt ... You shall not subvert the rights of the stranger or the fatherless; you shall not take a widow's garment in pawn. Remember that you were a slave in Egypt and that the Lord your God redeemed you from there; therefore do I enjoin you to observe this commandment ... You shall not have in your pouch alternate weights, larger and smaller. You shall not have in your house alternate measures, a larger and a smaller. You must have completely honest weights and completely honest measures, if you are to endure long on the soil that the Lord your God is giving you. For everyone who does those things, everyone who deals dishonestly, is abhorrent to the Lord your God. (Deut. 24.6–25.16)

Remember what Amalek did to you on your journey, after you left Egypt—how, undeterred by fear of God, he surprised you on the march, when you were famished and weary, and cut down all the stragglers in your rear. Therefore, when the Lord your God grants you safety from all your enemies around you, in the land that the Lord your God is giving you as a hereditary portion, you shall blot out the memory of Amalek from under heaven. Do not forget! (Deut. 25.17–19)

Haftarat Ki Tetze

(Isaiah 54.1–10)

Shout, O barren one, you who bore no child! Shout aloud for joy, you who did not travail! For the children of the wife forlorn shall outnumber those of the espoused—said the Lord. Enlarge the site of your tent, extend the size of your dwelling, do not stint! Lengthen the ropes, and drive the pegs firm. For you shall spread out to the right and the left ... I hid My face from you; but with kindness everlasting I will take you back in love—said the Lord your Redeemer. For this to Me is like the waters of Noah: as I swore that the waters of Noah nevermore would flood the earth, so I swear that I will not be angry with you or rebuke you. For the mountains may move and the hills be shaken, but my loyalty shall never move from you, nor My covenant of friendship be shaken—said the Lord, who takes you back in love. (Isa. 54.1–10)

Moses described the ritual drama they were to perform once they crossed the Jordan. Half the people were to stand on one mountain, reciting the blessings that would come to Israel if they obeyed God's laws; the other half were to stand on the opposite mountain, reciting the curses that would befall them if they disobeyed. Moses presented these blessings and curses to the people so they would never forget the choices that lay before them as they entered the land.

וְהָיָה כִּי תָבוֹא אֶל הָאָרֶץ אֲשֶׁר
ה׳ אלקיך נתן לך נחלה וירשתה
וישבת בה:

When you enter the land that the Lord your God is giving you as a heritage, and you possess it and settle in it (Deut. 26.1)

You shall take some of every first fruit of the soil, which you harvest from the land that the Lord your God is giving you, put it in a basket and go to the place where the Lord your God will choose to establish His name ... You shall then recite ... "The Lord freed us from Egypt by a mighty hand, by an outstretched arm and awesome power, and by signs and portents" ... And you shall enjoy, together with the Levite and the stranger in your midst, all the bounty that the Lord your God has bestowed upon you and your household. When you have set aside in full the tenth part of your yield—in the third year, the year of the tithe—and have given it to the Levite, the stranger, the fatherless, and the widow, that they may eat their fill in your settlements ... You shall be, as He promised, a holy people ... Moses and the elders of Israel charged the people, saying: Observe all the Instruction that I enjoin upon you this day. As soon as you have crossed the Jordan into the land that the Lord your God is giving you, you shall set up large stones. Coat them with plaster and inscribe upon them all the words of this Teaching. When you cross over to enter the land that the Lord your God is giving you, a land flowing with milk and honey, as the Lord, the God of your fathers, promised you—upon crossing the Jordan, you shall set up these stones, about which I charge you this day, on Mount Ebal, and coat them with plaster. There, too, you shall build an altar to the Lord your God, an altar of stones. Do not wield an iron tool over

DEVARIM

Ki Tavo

them; you must build the altar of the Lord your God of unhewn stones ... And on those stones you shall inscribe every word of this Teaching most distinctly. Moses and the levitical priests spoke to all Israel, saying: Silence! Hear, O Israel! Today you have become the people of the Lord your God: Heed the Lord your God and observe His commandments and His laws, which I enjoin upon you this day. Thereupon Moses charged the people, saying: After you have crossed the Jordan, the following shall stand on Mount Gerizim when the blessing for the people is spoken: Simeon, Levi, Judah, Issachar, Joseph, and Benjamin. And for the curse, the following shall stand on Mount Ebal: Reuben, Gad, Asher, Zebulun, Dan, and Naphtali. The Levites shall then proclaim in a loud voice to all the people of Israel: Cursed be anyone who makes a sculptured or molten image, abhorred by the Lord, a craftsman's handiwork, and sets it up in secret.—And all the people shall respond, Amen. Cursed be he who insults his father or mother.— And all the people shall say, Amen. Cursed be he who moves his fellow countryman's landmark.—And all the people shall say, Amen. Cursed be he who misdirects a blind person on his way.—And all the people shall say, Amen. Cursed be he who subverts the rights of the stranger, the fatherless, and the widow.—And all the people shall say, Amen. Cursed be he who lies with his father's wife, for he has removed his father's garment.—And all the people shall say, Amen. Cursed be he who lies with any beast.—And all the people shall say, Amen. Cursed be he who lies with his sister, whether daughter of his father or of his mother.—And all the people shall say, Amen. Cursed be he who lies with his mother-in-law.—And all the people shall say, Amen. Cursed be he who strikes down his fellow countryman in secret.—And all the people shall say, Amen. Cursed be he who accepts a bribe in the case of the murder of an innocent person.—And all the people shall say, Amen. Cursed be he who will not uphold the terms of this Teaching and observe them.—And all the people shall say, Amen. (Deut. 26.2–27.26)

Now, if you obey the Lord your God, to observe
faithfully all His commandments
which I enjoin upon
you this day,
the Lord

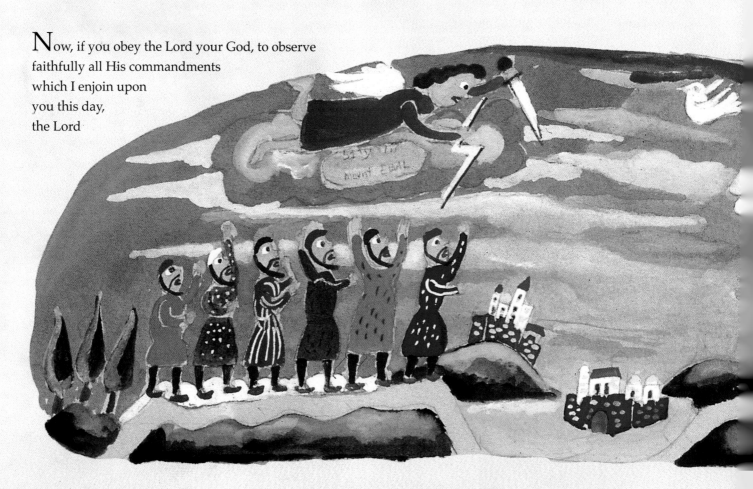

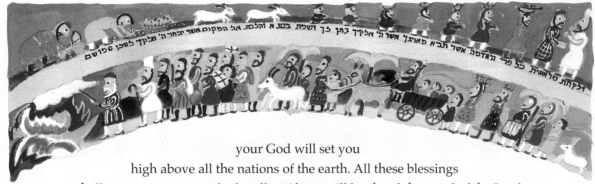

your God will set you
high above all the nations of the earth. All these blessings
shall come upon you and take effect, if you will but heed the word of the Lord
your God: Blessed shall you be in the city and blessed shall you be in the country. Blessed
shall be the issue of your womb, the produce of your soil, and the offspring of your cattle, the calving
of your herd and the lambing of your flock. Blessed shall be your basket and your kneading bowl.
Blessed shall you be in your comings and blessed shall you be in your goings. The Lord will put to rout
before you the enemies who attack you; they will march out against you by a single road, but flee from
you by many roads. The Lord will ordain blessings for you upon your barns and upon all your
undertakings: He will bless you in the land that the Lord your God is giving you. The Lord will establish
you as His holy people, as He swore to you, if you keep the commandments of the Lord your God and
walk in His ways. And all the peoples of the earth shall see that the Lord's name is proclaimed over
you, and they shall stand in fear of you. The Lord will give you abounding prosperity in the issue of
your womb, the offspring of your cattle, and the produce of your soil in the land that the Lord swore to
your fathers to assign to you. The Lord will open for you His bounteous store, the heavens, to provide
rain for your land in season and to bless all your undertakings. You will be creditor to many nations,
but debtor to none. The Lord will make you the head, not the tail; you will always be at the top and
never at the bottom—if only you obey and faithfully observe the commandments of the Lord your God
that I enjoin upon you this day, and do not deviate to the right or to the left from any of the
commandments that I enjoin upon you this day and turn to the worship of
other gods. But if you do not obey the Lord your God to observe
faithfully all His commandments and laws which I enjoin upon
you this day, all these curses shall come upon you and take
effect ... The Lord will scatter you among all the peoples from
one end of the earth to the other, and there you shall serve
other gods, wood and stone, whom neither you nor your
ancestors have experienced. Yet even among those nations
you shall find no peace, nor shall your foot find a place to
rest. The Lord will give you there an anguished heart and
eyes that pine and a despondent spirit. The life you face
shall be precarious; you shall be in terror, night and day,
with no assurance of survival. In the morning you shall
say, "If only it were evening!" and in the evening you shall
say, "If only it were morning!"—because of what your heart
shall dread and your eyes shall see. The Lord will send you
back to Egypt in galleys, by a route which I told you you should
not see again. There you shall offer yourselves for sale to your enemies

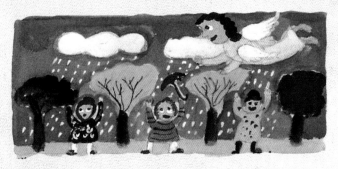

as male and female slaves, but none will buy ... Moses summoned all Israel and said to them: You have seen all that the Lord did before your very eyes in the land of Egypt, to Pharaoh and to all his courtiers and to his whole country: the wondrous feats that you saw with your own eyes, those prodigious signs and marvels. Yet to this day the Lord has not given you a mind to understand or eyes to see or ears to hear. I led you through the wilderness forty years; the clothes on your back did not wear out, nor did the sandals on your feet; you had no bread to eat and no wine or other intoxicant to drink—that you might know that I the Lord am your God. When you reached this place, King Sihon of Heshbon and King Og of Bashan came out to engage us in battle, but we defeated them. We took their land and gave it to the Reubenites, the Gadites, and the half-tribe of Manasseh as their heritage. Therefore observe faithfully all the terms of this covenant, that you may succeed in all that you undertake. (Deut. 28.1–29.8)

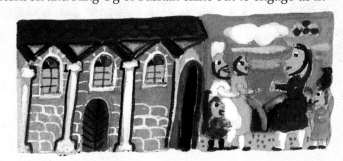

Haftarat Ki Tavo

(Isaiah 60.1–22)

Arise, shine, for your light has dawned; the Presence of the Lord has shone upon you! Behold! Darkness shall cover the earth, and thick clouds the peoples; but upon you the Lord will shine, and His Presence be seen over you. And nations shall walk by your light, kings, by your shining radiance. Raise your eyes and look about: They have all gathered and come to you. Your sons shall be brought from afar, your daughters like babes on shoulders. As you behold, you will glow; your heart will throb and thrill—for the wealth of the sea shall pass on to you, the riches of nations shall flow to you. Dust clouds of camels shall cover you, dromedaries of Midian and Ephah. They all shall come from Sheba; they shall bear gold and frankincense, and shall herald the glories of the Lord. All the flocks of Kedar shall be assembled for you, the rams of Nebaioth shall serve your needs; they shall be welcome offerings on My altar, and I will add glory to My glorious House. Who are these that float like a cloud, like doves to their cotes?

Behold, the coastlands await me, with ships of Tarshish in the lead, to bring your sons from afar, and their silver and gold as well—for the name of the Lord your God, for the Holy One of Israel, who has glorified you. (Isa. 60.1–9)

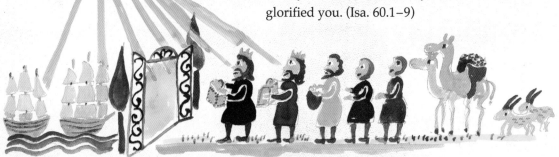

Moses concluded his final address by explaining the mutual obligations owed by and to the Israelites and God. He prophesied future betrayals by Israel and consequent punishments, but assured the people that they would be forgiven and brought back from exile.

You stand this day, all of you, before the Lord your God—your tribal heads, your elders and your officials, all the men of Israel (Deut. 29.9)

אתם נצבים היום כלכם לפני ה' אלקיכם ראשיכם שבטיכם זקניכם ושטריכם כל איש ישראל:

Your children, your wives, even the stranger within your camp, from woodchopper to waterdrawer— to enter into the covenant of the Lord your God, which the Lord your God is concluding with you this day, with its sanctions; to the end that He may establish you this day as His people and be your God, as He promised you and as He swore to your fathers, Abraham, Isaac, and Jacob. I make this covenant, with its sanctions, not with you alone, but both with those who are standing here with us this day before the Lord our God and with those who are not with us here this day. Well you know that we dwelt in the land of Egypt and that we passed through the midst of various other nations through which you passed; and you have seen the detestable things and the fetishes of wood and stone, silver and gold, that they keep. Perchance there is among you some man or woman, or some clan or tribe, whose heart is even now turning away from the Lord our God to go and worship the gods of those nations ... The Lord will never forgive him; rather will the Lord's anger and passion rage against that man, till every sanction recorded in this book comes down upon him, and the Lord blots out his name from under heaven. The Lord will single them out from all the tribes of Israel for misfortune, in accordance with

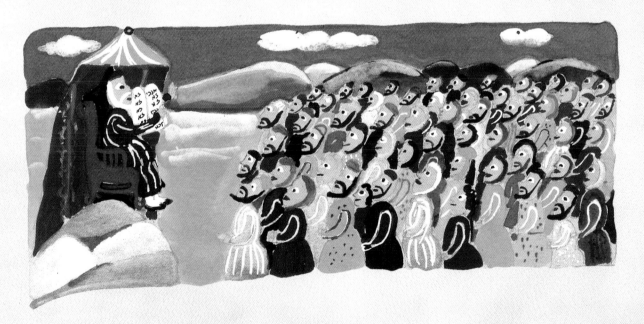

DEVARIM

Nitzavim

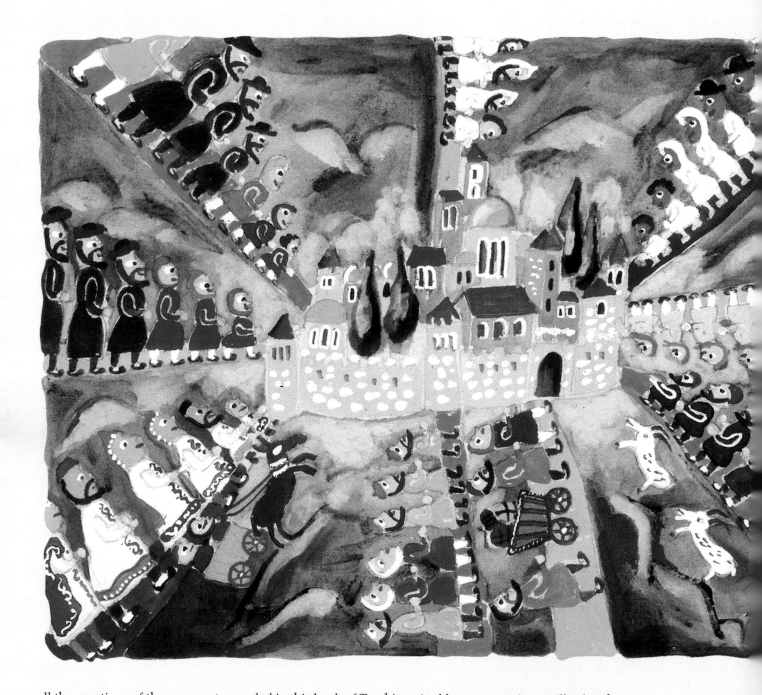

all the sanctions of the covenant recorded in this book of Teaching. And later generations will ask—the children who succeed you, and foreigners who come from distant lands and see the plagues and diseases that the Lord has inflicted upon that land, all its soil devastated by sulfur and salt, beyond sowing and producing, no grass growing in it, just like the upheaval of Sodom and Gomorrah, Admah and Zeboiim, which the Lord overthrew in His fierce anger—all nations will ask, "Why did the Lord do thus to this land? Wherefore that awful wrath?" They will be told, "Because they forsook the covenant that the Lord, God of their fathers, made with them when He freed them from the land of Egypt; they turned to the service of other gods and worshiped them, gods whom they had not experienced and whom He had not allotted to them. So the Lord was incensed at that land and brought upon it all the curses recorded in this book. The Lord uprooted them from their soil in anger, fury, and great wrath, and cast them into another land, as is still the case." Concealed acts concern the Lord our God; but with overt acts, it is for

us and our children ever to apply all the provisions of this Teaching. When all these things befall you ... and you return to the Lord your God, and you and your children heed His command with all your heart and soul, just as I enjoin upon you this day, then the Lord your God will restore your fortunes and take you back in love. He will bring you together again from all the peoples where the Lord your God has scattered you. Even if your outcasts are at the ends of the world, from there the Lord your God will gather you, from there He will fetch you. And the Lord your God will bring you to the land that your fathers possessed, and you shall possess it; and He will make you more prosperous and more numerous than your fathers. Then the Lord your God will open up your heart and the hearts of your offspring to love the Lord your God with all your heart and soul, in order that you may live ... And the Lord your God will grant you abounding prosperity in all your undertakings, in the issue of your womb, the offspring of your cattle, and the produce of your soil. For the Lord will again delight in your well-being, as He did in that of your fathers, since you will be heeding the Lord your God and keeping His commandments and laws that are recorded in this book of the Teaching—once you return to the Lord your God with all your heart and soul. Surely, this Instruction which I enjoin upon you this day is not too baffling for you, nor is it beyond reach. It is not in the heavens, that you should say, "Who among us can go up to the heavens and get it for us and impart it to us, that we may observe it?" Neither is it beyond the sea, that you should say, "Who among us can cross to the other side of the sea and get it for us and impart it to us, that we may observe it?" No, the thing is very close to you, in your mouth and in your heart, to observe it. (Deut. 29.10–30.14)

Haftarat Nitzavim

(Isaiah 61.10–63.9)

For the sake of Zion I will not be silent, for the sake of Jerusalem I will not be still, till her victory emerge resplendent and her triumph like a flaming torch. Nations shall see your victory, and every king your majesty; and you shall be called by a new name which the Lord Himself shall bestow. You shall be a glorious crown in the hand of the Lord, and a royal diadem in the palm of your God. Nevermore shall you be called "Forsaken," nor shall your land be called "Desolate"; but you shall be called "I delight in her," and your land "Espoused." For the Lord takes delight in you, and your land shall be espoused. As a youth espouses a maiden, your sons shall espouse you; and as a bridegroom rejoices over his bride, so will your God rejoice over you. Upon your walls, O Jerusalem, I have set watchmen, who shall never be silent by day or by night. O you, the Lord's remembrancers, take no rest and give no rest to Him, until He establish Jerusalem and make her renowned on earth. (Isa. 62.1–7)

DEVARIM

Vayelech 31.1–30

*Moses assured the people that Joshua would
lead them ably with God's guidance. He then invested Joshua as his successor.
Moses wrote down his Teaching and handed it to the priests. God appeared to Moses and Joshua
at the Tent of Meeting in a pillar of cloud. God prophesied that Israel would soon backslide, and instructed
Moses to recite a poem to forewarn the people of their future betrayal and foretell their ultimate redemption.*

וילך משה וידבר את הדברים האלה אל כל ישראל: ויאמר אלהם
בן מאה ועשרים שנה אנכי היום לא אוכל עוד לצאת ולבוא
וה׳ אמר אלי לא תעבר את הירדן הזה:

Moses went and spoke these things to all Israel. He said to them: I am now one hundred and twenty years old, I can no longer be active. Moreover, the Lord has said to me, "You shall not go across yonder Jordan." (Deut. 31.1–2)

The Lord your God Himself will cross over before you; and He Himself will wipe out those nations from your path and you shall dispossess them.—Joshua is the one who shall cross before you, as the Lord has spoken ... Then Moses called Joshua and said to him in the sight of all Israel: "Be strong and resolute, for it is you who shall go with this people into the land that the Lord swore to their fathers to give them, and it is you who shall apportion it to them ... Moses wrote down this Teaching and gave it to the priests, sons of Levi, who carried the Ark of the Lord's Covenant, and to all the elders of Israel. And Moses instructed them as follows: Every seventh year, the year set for remission, at the Feast of Booths, when all Israel comes to appear before the Lord your God in the place that He will choose, you shall read this Teaching aloud in the presence of all Israel. Gather the people—men, women, children, and the strangers in your communities—that they may hear and so learn to revere the Lord your God and to observe faithfully every word of this Teaching ... The Lord said to Moses: The time is drawing near for you to die. Call Joshua and present yourselves in the Tent of Meeting, that I may instruct him. Moses and Joshua went and presented themselves in the Tent of Meeting. The Lord appeared in the Tent, in a pillar of cloud, the pillar of cloud having come to rest at the entrance of the tent. The Lord said to Moses: You are soon to lie with your fathers. This people will thereupon go astray after the alien gods in their midst, in the land that they are about to enter; they will forsake Me and break My covenant that I made with them. Then My anger will flare up against them, and I will abandon them and hide My countenance from them. They shall be ready prey; and many evils and troubles shall befall them. And

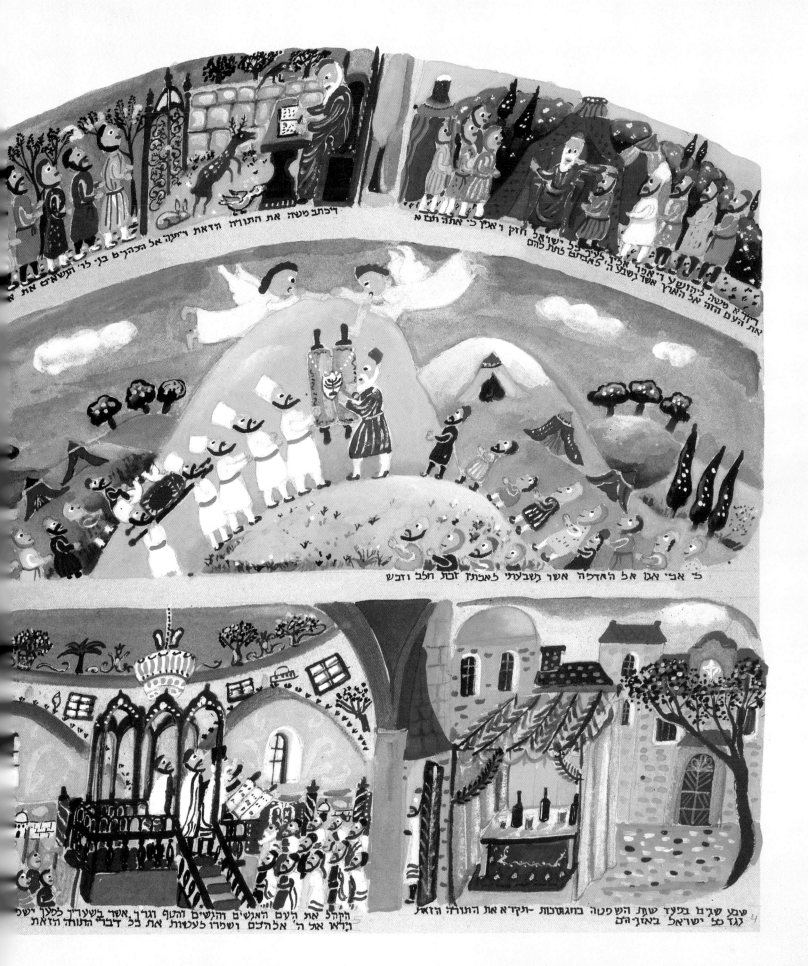

ויכתב משה את התורה הזאת ויתנה אל הכהנים בני לוי הנשאים את

ליהושע ואמר חזק ואמץ כי אתה תבא את העם הזה אל הארץ אשר נשבע ה' לאבתם לתת להם

כי אבי אנו אל הארמה אשר נשבעתי לאבתם זבת חלב ודבש

הקהל את העם האנשים והנשים והטף וגרך אשר בשעריך למען ישמעו ולמען ילמדו ויראו את ה' אלהיכם ושמרו לעשות את כל דברי התורה הזאת

שמע שגם במעד שמת השפטה במגבטות תקרא את התורה הזאת נגד כל ישראל באזניהם

they shall say on that day, "Surely it is because our God is not in our midst that these evils have befallen us." Yet I will keep My countenance hidden on that day, because of all the evil they have done in turning to other gods. Therefore, write down this poem and teach it to the people of Israel; put it in their mouths, in order that this poem may be My witness against the people of Israel. When I bring them into the land flowing with milk and honey that I promised on oath to their fathers, and they eat their fill and grow fat and turn to other gods and serve them, spurning Me and breaking My covenant, and the many evils and troubles befall them—then this poem shall confront them as a witness, since it will never be lost from the mouth of their offspring. For I know what plans they are devising even now, before I bring them into the land that I promised on oath. That day, Moses wrote down this poem and taught it to the Israelites. And He charged Joshua son of Nun: "Be strong and resolute: for you shall bring the Israelites into the land that I promised them on oath, and I will be with you." When Moses had put down in writing the words of this Teaching to the very end, Moses charged the Levites who carried the Ark of the Covenant of the Lord, saying: Take this book of Teaching and place it beside the Ark of the Covenant of the Lord your God, and let it remain there as a witness against you ... Then Moses recited the words of this poem to the very end, in the hearing of the whole congregation of Israel. (Deut. 31.3–30)

Haftarat Vayelech

(Isaiah 55.6–56.8)

Seek the Lord while He can be found, call to Him while He is near. Let the wicked give up his ways, the sinful man his plans; let him turn back to the Lord, and He will pardon him; to our God, for he freely forgives. For My plans are not your plans, nor are My ways your ways—declares the Lord. But as the heavens are high above the earth, so are My ways high above your ways and My plans above your plans. For as the rain or snow drops from heaven and returns not there, but soaks the earth and makes it bring forth vegetation, yielding seed for sowing and bread for eating, so is the word that issues from My mouth: It does not come back to Me unfulfilled, but performs what I purpose, achieves what I sent it to do. Yea, you shall leave in joy and be led home secure. Before you, mount and hill shall shout aloud, and all the trees of the field shall clap their hands. (Isa. 55.6–12)

Moses recited God's prophetic poem about Israel's future betrayals, God's awesome power and terrible vengeance. God then told Moses to ascend Mount Nebo to see the Promised Land before he died.

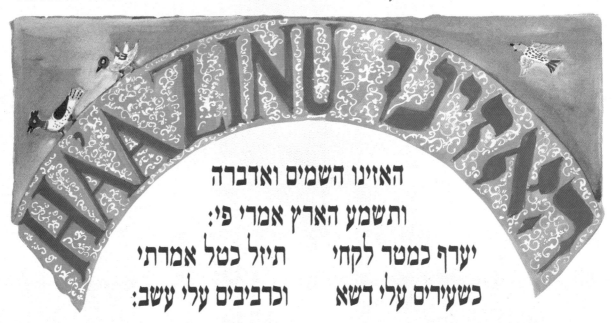

האזינו השמים ואדברה

ותשמע הארץ אמרי פי:

יערף כמטר לקחי תיזל כטל אמרתי

כשעירים עלי דשא וכרביבים עלי עשב:

Give ear, O heavens, let me speak;
Let the earth hear the words I utter!
May my discourse come down as the rain,
My speech distill as the dew,
Like showers on young growth,
Like droplets on the grass. (Deut. 32.1–2)

For the name of the Lord I proclaim;
Give glory to our God!

The Rock!—His deeds are perfect,
Yea, all His ways are just;
A faithful God, never false,
True and upright is He.
Children unworthy of Him—
That crooked, perverse generation—
Their baseness has played Him false.
Do you thus requite the Lord,
O dull and witless people?
Is not He the Father who created you,
Fashioned you and made you endure!

Remember the days of old,
Consider the years of ages past;
Ask your father, he will inform you,
Your elders, they will tell you:
When the Most High gave nations their homes
And set the divisions of man,
He fixed the boundaries of peoples
In relation to Israel's numbers.
For the Lord's portion is His people,
Jacob His own allotment.

He found him in a desert region,
In an empty howling waste.
He engirded him, watched over him,
Guarded him as the pupil of His eye.
Like an eagle who rouses his nestlings,
Gliding down to his young,
So did He spread His wings and take him,
Bear him along on His pinions;
The Lord alone did guide him,
No alien god at His side.

DEVARIM

Ha'azinu

He set him atop the highlands,
To feast on the yield of the earth;
He fed him honey from the crag,
And oil from the flinty rock,
Curd of kine and milk of flocks;
With the best of lambs,
And rams of Bashan, and he-goats;
With the very finest wheat—
And foaming grape-blood was your drink.

So Jeshurun grew fat and kicked—
You grew fat and gross and coarse—
He forsook the God who made him
And spurned the Rock of his support.
They incensed Him with alien things,
Vexed Him with abominations.
They sacrificed to demons, no-gods,
Gods they had never known,
New ones, who came but lately,
Who stirred not your fathers' fears.
You neglected the Rock that begot you,
Forgot the God who brought you forth.

 The Lord saw and was vexed
And spurned His sons and His daughters.
He said:
I will hide My countenance from them,
And see how they fare in the end.
For they are a treacherous breed,
Children with no loyalty in them.
They incensed Me with no-gods,
Vexed Me with their futilities;
I'll incense them with a no-folk,
Vex them with a nation of fools.
For a fire has flared in My wrath
And burned to the bottom of Sheol,
Has consumed the earth and its increase,
Eaten down to the base of the hills.
I will sweep misfortunes on them,
Use up My arrows on them:
Wasting famine, ravaging plague,
Deadly pestilence, and fanged beasts
Will I let loose against them,
With venomous creepers in dust.

EIN
SION Antennas
Filters

Deuteron
Azinu
-361
UL 5708
Samuel
22 →
00 • www.kathrein.c

And say, "Our own hand has prevailed,
None of this was wrought by the Lord!"
For they are a folk void of sense,
Lacking in all discernment.
Were they wise, they would think upon this,
Gain insight into their future:
"How could one have routed a thousand,
Or two put ten thousand to flight,
Unless their Rock had sold them,
The Lord had given them up?"
For their rock is not like our Rock,
In our enemies' own estimation.

Ah! The vine for them is from Sodom,
From the vineyards of Gomorrah;
The grapes for them are poison,
A bitter growth their clusters.
Their wine is the venom of asps,
The pitiless poison of vipers.
Lo, I have it all put away,
Sealed up in My storehouses,
To be My vengeance and recompense,
At the time that their foot falters.
Yea, their day of disaster is near,
And destiny rushes upon them.

For the Lord will vindicate His people
And take revenge for His servants,
When He sees that their might is gone,
And neither bond nor free is left.
He will say: Where are their gods,
The rock in whom they sought refuge,
Who ate the fat of their offerings
And drank their libation wine?
Let them rise up to your help,
And let them be a shield unto you!
See, then, that I, I am He;

There is no god beside Me:
I deal death and give life,
I wounded and I will heal:
None can deliver from My hand.
Lo, I raise My hand to heaven
And say: As I live forever,
When I whet My flashing blade
And My hand lays hold on judgment,
Vengeance will I wreak on My foes,
Will I deal to those who reject Me.

I will make My arrows drunk with blood
As My sword devours flesh—
Blood of the slain and the captive
From the long-haired enemy chiefs

O nations, acclaim His people!
For He'll avenge the blood of His servants,
Wreak vengeance on His foes,
And cleanse the land of His people.
(Deut. 32.3–43)

Moses came, together with Hosea son of Nun ... He said to them: Take to heart all the words with which I have warned you this day. Enjoin them upon your children, that they may observe faithfully all the terms of this Teaching ... That very day the Lord spoke to Moses ... You may view the land from a distance, but you shall not enter it—the land that I am giving to the Israelite people. (Deut. 32.44–52)

Haftarat Ha'azinu

(2 Samuel 22.1–51)

David addressed the words of this song to the Lord, after the Lord had saved him from the hands of all his enemies and from the hands of Saul. He said: O Lord, my crag, my fastness, my deliverer! O God, the rock wherein I take shelter: My shield, my mighty champion, my fortress and refuge! My savior, You who rescue me from violence! All praise! I called on the Lord, and I was delivered from my enemies. For the breakers of Death encompassed me, the torrents of Belial terrified me; the snares of Sheol encircled me, the coils of Death engulfed me. In my anguish I called on the Lord, cried out to my God; in His Abode He heard my voice, my cry entered His ears. (2 Sam. 22.1–7)

Vezot Ha-Berachah 33.1–34.12

וזאת הברכה

Moses recited a farewell song before he died, blessing each tribe and recalling signal details of his history. Then he ascended Mount Nebo and looked out over the land that he was forbidden to enter. Moses died on the mountain and God buried him in a secret grave. The people mourned his death for forty days.

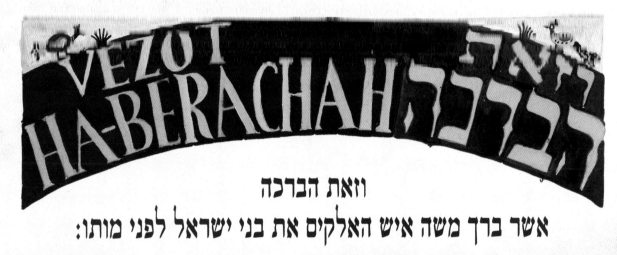

וזאת הברכה
אשר ברך משה איש האלקים את בני ישראל לפני מותו:

This is the blessing with which Moses, the man of God, bade the Israelites farewell before he died. (Deut. 33.1)

He said:
The Lord came from Sinai;
He shone upon them from Seir;
He appeared from Mount Paran,
And approached from Ribeboth-kodesh,
Lightning flashing at them from His right.
Lover, indeed, of the people,
Their hallowed are all in Your hand.
They followed in Your steps,
Accepting Your pronouncements,
When Moses charged us with the Teaching
As the heritage of the congregation of Jacob.
Then He became King in Jeshurun,
When the heads of the people assembled,
The tribes of Israel together.
May Reuben live and not die,
Though few be his numbers.
And this he said of Judah:
Hear, O Lord the voice of Judah
And restore him to his people.
Though his own hands strive for him,
Help him against his foes.

And of Levi he said:
Let Your Thummim and Urim
Be with Your faithful one,
Whom You tested at Massah,
Challenged at the waters of Meribah;
Who said of his father and mother,
"I consider them not."
His brothers he disregarded,
Ignored his own children.
Your precepts alone they observed,
And kept Your covenant.
They shall teach Your laws to Jacob
And Your instructions to Israel.
They shall offer You incense to savor
And whole-offerings on Your altar.
Bless, O Lord, his substance,
And favor his undertakings.
Smite the loins of his foes;
Let his enemies rise no more.
Of Benjamin he said:
Beloved of the Lord,
He rests securely beside Him;

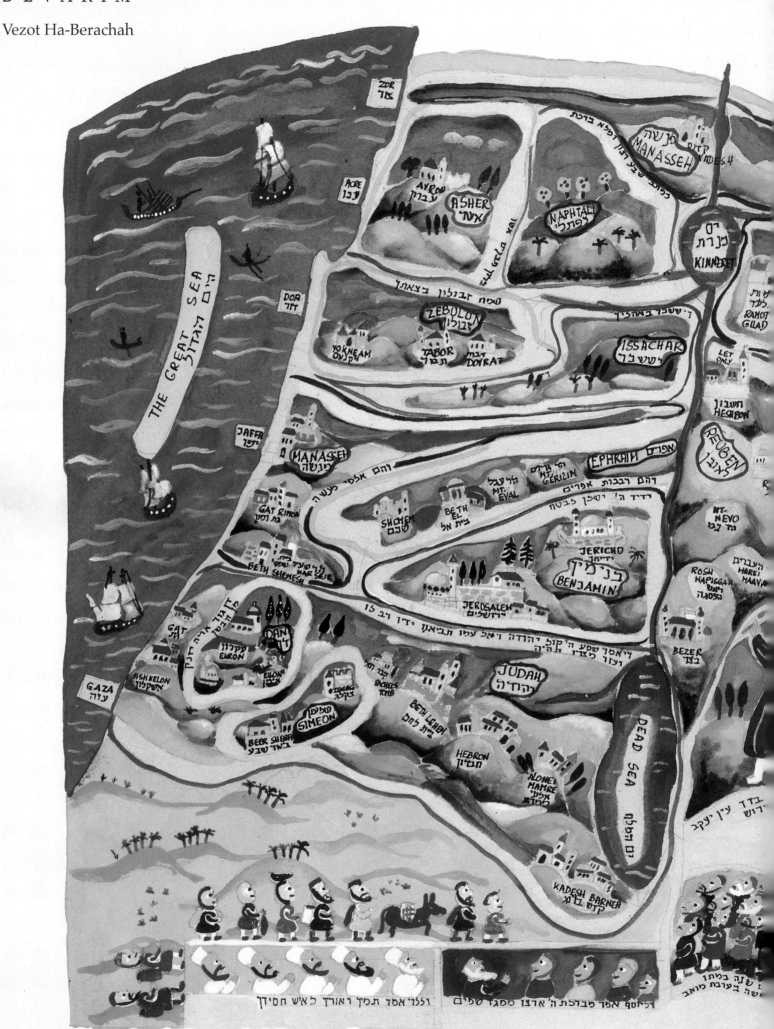

Ever does He protect him,
As he rests between His shoulders.
And of Joseph he said:
Blessed of the Lord be his land
With the bounty of dew from heaven,
And of the deep that couches below;
With the bounteous yield of the sun,
And the bounteous crop of the moons;
With the best from the ancient mountains,
And the bounty of hills immemorial;
With the bounty of earth and its fullness,
And the favor of the Presence in the Bush.
May these rest on the head of Joseph,
On the crown of the elect of his brothers.
Like a firstling bull in his majesty,
He has horns like the horns of the wild-ox;
With them he gores the peoples,
The ends of the earth one and all.
These are the myriads of Ephraim,
Those are the thousands of Manasseh.
And of Zebulun he said:
Rejoice, O Zebulun, on your journeys,
And Issachar, in your tents.
They invite their kin to the mountain,
Where they offer sacrifices of success.
For they draw from the riches of the sea
And the hidden hoards of the sand.
And of Gad he said:
Blessed be He who enlarges Gad!
Poised is he like a lion
To tear off arm and scalp.
He chose for himself the best,

For there is the portion of the revered chieftain,
Where the heads of the people come.
He executed the Lord's judgments
And His decisions for Israel.
And of Dan he said:
Dan is a lion's whelp
That leaps forth from Bashan.
And of Naphtali he said:
O Naphtali, sated with favor
And full of the Lord's blessing,
Take possession on the west and south.
And of Asher he said:
Most blessed of sons be Asher;
May he be the favorite of his brothers,
May he dip his foot in oil.
May your doorbolts be iron and copper,
And your security last all your days.
O Jeshurun, there is none like God,
Riding through the heavens to help you,
Through the skies in His majesty.
The ancient God is a refuge,
A support are the arms everlasting.
He drove out the enemy before you
By His command: Destroy!
Thus Israel dwells in safety,
Untroubled is Jacob's abode,
In a land of grain and wine,
Under heavens dripping dew.
O happy Israel! Who is like you,
A people delivered by the Lord,
Your protecting Shield, your Sword triumphant!
Your enemies shall come cringing before you,
And you shall tread on their backs. (Deut. 33.2–29)

Moses went up from the steppes of Moab to Mount Nebo, to the summit of Pisgah, opposite Jericho, and the Lord showed him the whole land: Gilead as far as Dan; all Naphtali; the land of Ephraim and Manasseh; the whole land of Judah as far as the Western Sea; the Negeb; and the Plain—the Valley of Jericho, the city of palm trees—as far as Zoar. And the Lord said to him, "This is the land of which I swore to Abraham, Isaac, and Jacob, 'I will assign it to your offspring.' I have let you see it with your own eyes, but you shall not cross there." So Moses the servant of the Lord died there, in the land of Moab, at the command of the Lord. He buried him in the valley in the land of Moab, near Beth-peor; and no one knows his burial place to this day. Moses was a hundred and twenty years old when he died;

his eyes were undimmed and his vigor unabated. And the Israelites bewailed Moses in the steppes of Moab for thirty days. The period of wailing and mourning for Moses came to an end. Now Joshua son of Nun was filled with the spirit of wisdom because Moses had laid his hands upon him; and the Israelites heeded him, doing as the Lord had commanded Moses. Never again did there arise in Israel a prophet like Moses—whom the Lord singled out, face to face, for the various signs and portents that the Lord sent him to display in the land of Egypt, against Pharaoh and all his courtiers and his whole country, and for all the great might and awesome power that Moses displayed before all Israel. (Deut. 34.1–12)

Haftarat Vezot Ha-Berachah

(Ashkenazim read Joshua 1.1–18) (Sephardim read 1.1–9)

After the death of Moses the servant of the Lord, the Lord said to Joshua son of Nun, Moses' attendant: "My servant Moses is dead. Prepare to cross the Jordan, together with all this people, into the land that I am giving to the Israelites. Every spot on which your foot treads I give to you, as I promised Moses. Your territory shall extend from the wilderness and the Lebanon to the Great River, the River Euphrates [on the east]—the whole Hittite country—and up to the Mediterranean Sea on the west. No one shall be able to resist you as long as you live. As I was with Moses, so I will be with you; I will not fail you or forsake you. Be strong and resolute, for you shall apportion to this people the land that I swore to their fathers to assign to them. But you must be very strong and resolute to observe faithfully all the Teaching that My servant Moses enjoined upon you. Do not deviate from it to the right or to the left, that you may be successful wherever you go. Let not this Book of the Teaching cease from your lips, but recite it day and night, so that you may observe faithfully all that is written in it. Only then will you prosper in your undertakings and only then will you be successful. I charge you: Be strong and resolute; do not be terrified or dismayed, for the Lord your God is with you wherever you go." (Josh. 1.1–9)

At the new month

Sabbath and Rosh Chodesh

(One day only or second of two days) Additional reading: Weekly portion and Num. 28.9–15

(Isaiah 66.1–24)

Thus said the Lord: The heaven is My throne and the earth is My footstool: Where could you build a house for Me, what place could serve as My abode? All this was made by My hand, and thus it all came into being declares the Lord ... And out of all the nations, said the Lord, they shall bring all your brothers on horses, in chariots and drays, on mules and dromedaries, to Jerusalem.... (Isa. 66.1–20)

Sabbath and thirtieth of the month

(First of two days of Rosh Chodesh) Additional reading: Weekly portion and Num. 28.9–15

(Ashkenazim read Isaiah 66.1–24, see text above)

(Sephardim read Isaiah 66.1–24; 1 Samuel 20.18–42)

Jonathan said to him, "Tomorrow will be the new moon; and you will be missed when your seat remains vacant." ... David hid in the field. The new moon came, and the king sat down to partake of the meal ... but David's place remained vacant. That day, however, Saul said nothing ... But on the day after the new moon, the second day, David's place was vacant again. So Saul said to his son Jonathan, "Why didn't the son of Jesse come to the meal yesterday or today?" Jonathan answered Saul, "David begged leave of me to go to Bethlehem. He said, 'Please let me go, for we are going to have a family feast in our town and my brother has summoned me to it. Do me a favor, let me slip away to see my kinsmen.' That is why he has not come to the king's table." (1 Sam. 20.18–29)

Sabbath if day before Rosh Chodesh Elul

Additional reading: Weekly portion and Num. 28.9–15

(Ashkenazim read Isaiah 54.11–55.5) (Sephardim read 1 Samuel 20.18–42, see text at page bottom)

Unhappy, storm-tossed one, uncomforted! I will lay carbuncles as your building stones and make your foundations of sapphires. I will make your battlements of rubies, your gates of precious stones, the whole encircling wall of gems. And all your children shall be disciples of the Lord, and great shall be the happiness of your children; you shall be established through righteousness. You shall be safe from oppression, and shall have no fear; from ruin, and it shall not come near you ... Ho, all who are thirsty, come for water, even if you have no money; come, buy food and eat: Buy food without money, wine and milk without cost. Why do you spend money for what is not bread, your earnings for what does not satisfy? Give heed to Me, and you shall eat choice food and enjoy the richest viands. Incline your ear and come to Me; hearken, and you shall be revived. (Isa. 54.11–55.3)

Sabbath if day before other Rosh Chodesh

Additional reading: Weekly portion

(1 Samuel 20.18–42)

Jonathan said to him, "Tomorrow will be the new moon; and you will be missed when your seat remains vacant. So the day after tomorrow, go down all the way to the place where you hid the other time, and stay close to the Ezel stone. Now I will shoot three arrows to one side of it, as though I were shooting at a mark, and I will order the boy to go and find the arrows. If I call to the boy, 'Hey! the arrows are on this side of you,' be reassured and come, for you are safe and there is no danger as the Lord lives! But if, instead, I call to the lad, 'Hey! the arrows are beyond you,' then leave, for the Lord has sent you away. As for the promise we made to each other, may the Lord be [witness] between you and me forever." (1 Sam. 20.18–23)

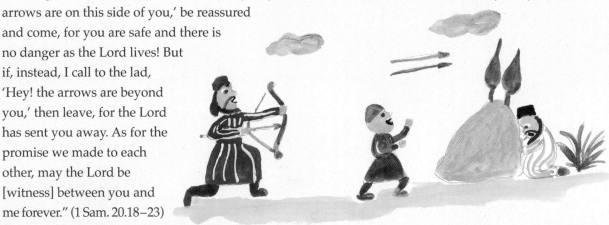

With "The Four Special Torah Portions" (Near Purim and Pesach in early spring)

Shekalim

Additional reading: Weekly portion and Ex. 30.11–16

(Ashkenazim read 2 Kings 12.1–17) (Sephardim read 2 Kings 11.17–12.17)

And Jehoiada solemnized the covenant between the Lord, on the one hand, and the king and the people, on the other—as well as between the king and the people—that they should be the people of the Lord. Thereupon all the people of the land went to the temple of Baal. They tore it down and smashed its altars and images to bits, and they slew Mattan, the priest of Baal, in front of the altars ... Jehoash said to the priests, "All the money, current money, brought into the House of the Lord as sacred donations—any money a man may pay as the money equivalent of persons, or any other money that a man may be minded to bring to the House of the Lord— let the priests receive it, each from his benefactor; they, in turn, shall make repairs on the House, wherever damage may be found." (2 Kings 11.17–12.6)

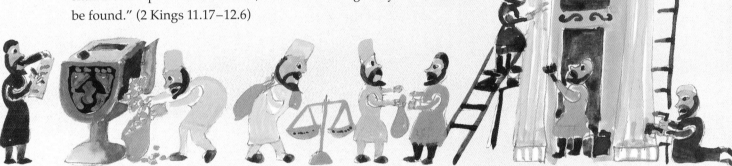

Zakhor

(Afternoon) Additional reading: Weekly portion and Deut. 25.17–19

(Ashkenazim read 1 Samuel 15.2–34) (Sephardim read 1 Samuel 15.1–34)

Samuel said to Saul, "I am the one the Lord sent to anoint you king over His people Israel. Therefore, listen to the Lord's command! Thus said the Lord of Hosts: I am exacting the penalty for what Amalek did to Israel, for the assault he made upon them on the road, on their way up from Egypt. Now go, attack Amalek, and proscribe all that belongs to him ... Saul destroyed Amalek from Havilah all the way to Shur, which is close to Egypt, and he captured King Agag of Amalek alive. (1 Sam. 15.1–8)

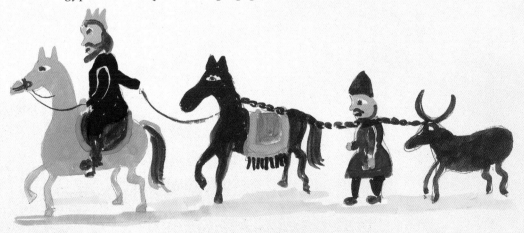

Parah

Additional reading: Weekly portion and Num. 19.1–22

(Ashkenazim read Ezekiel 36.16–38)

(Sephardim read Ezekiel 36.16–36)

The word of the Lord came to me: O mortal, when the House of Israel dwelt on their own soil, they defiled it with their ways and their deeds ... I punished them in accordance with their ways and their deeds. But when they came to those nations, they caused My holy name to be profaned, in that it was said of them, "These are the people of the Lord, yet they had to leave His land." Therefore I am concerned for My holy name ... I will sanctify My great name which has been profaned among the nations among whom you have caused it to be profaned and ... I will take you from among the nations and gather you from all the countries, and I will bring you back to your own land. (Ezek. 36.16–24)

Ha-Chodesh

Additional reading: Weekly portion and Ex.12.1–20

(Ashkenazim read Ezekiel 45.16–46.18) (Sephardim read Ezekiel 45.18–46.15)

In this contribution, the entire population must join with the prince in Israel ... On the fourteenth day of the first month you shall have the passover sacrifice; and during a festival of seven days unleavened bread shall be eaten. On that day, the prince shall provide a bull of sin offering on behalf of himself and of the entire population; and during the seven days of the festival, he shall provide daily—for seven days—seven bulls and seven rams, without blemish, for a burnt offering to the Lord, and one goat daily for a sin offering. (Ezek. 45.16–23)

Ha-Gadol

(Before Pesach) Additional reading: Weekly portion

(Malachi 3.4–24)

Then the offerings of Judah and Jerusalem shall be pleasing to the Lord as in the days of yore and in the years of old. But [first] I will step forward to contend against you, and I will act as a relentless accuser against those who have no fear of Me: Who practice sorcery, who commit adultery, who swear falsely, who cheat laborers of their hire, and who subvert [the cause of] the widow, orphan, and stranger, said the Lord of Hosts. For I am the Lord I have not changed; and you are the children of Jacob you have not ceased to be ... Turn back to Me, and I will turn back to you said the Lord of Hosts. But you ask, "How shall we turn back?" ... Bring the full tithe into the storehouse, and let there be food in My House, and thus put Me to the test said the Lord of Hosts. I will surely open the floodgates of the sky for you and pour down blessings on you. (Mal. 3.4–10)

After the Fast of 17 Tammuz and before the Fast of 9 Av: "Three Haftarot of Admonition"

First Haftarah of Admonition

(Jeremiah 1.1–2.3)

The words of Jeremiah son of Hilkiah, one of the priests at Anathoth in the territory of Benjamin ... The word of the Lord came to me: Before I created you in the womb, I selected you; before you were born, I consecrated you; I appointed you a prophet concerning the nations. I replied: Ah, Lord God! I don't know how to speak, for I am still a boy. And the Lord said to me: Do not say, "I am still a boy," but go wherever I send you and speak whatever I command you. Have no fear of them, for I am with you to deliver you—declares the Lord. (Jer. 1.1–8)

Second Haftarah of Admonition

(Ashkenazim read Jeremiah 2.4–28; 3.4) (Sephardim read Jeremiah 2.4–28; 4.1–2)

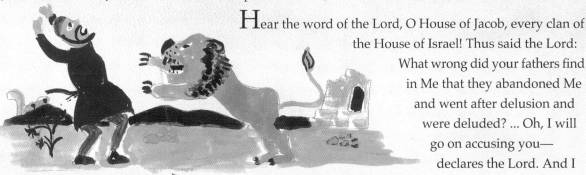

Hear the word of the Lord, O House of Jacob, every clan of the House of Israel! Thus said the Lord: What wrong did your fathers find in Me that they abandoned Me and went after delusion and were deluded? ... Oh, I will go on accusing you— declares the Lord. And I will accuse your children's children! ... They have forsaken Me, the Fount of living waters, and hewed them out cisterns, broken cisterns, which cannot even hold water. Is Israel a bondman? Is he a homeborn slave? Then why is he given over to plunder? Lions have roared over him, have raised their cries. They have made his land a waste, his cities desolate, without inhabitants. (Jer.2.4–15)

Third Haftarah of Admonition

(Isaiah 1.1–27)

The prophecies of Isaiah son of Amoz, who prophesied concerning Judah and Jerusalem in the reigns of Uzziah, Jotham, Ahaz, and Hezekiah, kings of Judah. Hear, O heavens, and give ear, O earth, for the Lord has spoken ... "My people takes no thought." Ah, sinful nation! People laden with iniquity! Brood of evildoers! Depraved children! They have forsaken the Lord ... Why do you seek further beatings, that you continue to offend? ... Every head is ailing, and every heart is sick. From head to foot no spot is sound: All bruises, and welts, and festering sores—not pressed out, not bound up, not softened with oil. (Isa. 1.1–6)

229

After the Fast of 9 Av and before Rosh Ha-Shanah: "Seven Haftarot of Consolation"

First Haftarah of Consolation

(Isaiah 40.1–26)

Comfort, oh comfort My people, says your God. Speak tenderly to Jerusalem, and declare to her that her term of service is over, that her iniquity is expiated; for she has received at the hand of the Lord double for all her sins. A voice rings out: "Clear in the desert a road for the Lord! Level in the wilderness a highway for our God! Let every valley be raised, every hill and mount made low. Let the rugged ground become level and the ridges become a plain. The Presence of the Lord shall appear, and all flesh, as one, shall behold—for the Lord Himself has spoken." (Isa. 40.1–5)

Second Haftarah of Consolation

(Isaiah 49.14–51.3)

Zion says, "The Lord has forsaken me, my Lord has forgotten me." Can a woman forget her baby, or disown the child of her womb? Though she might forget, I never could forget you. See, I have engraved you on the palms of My hands, your walls are ever before Me. Swiftly your children are coming; those who ravaged and ruined you shall leave you. Look up all around you and see: They are all assembled, are come to you! As I live—declares the Lord—you shall don them all like jewels, deck yourself with them like a bride ... Thus said the Lord God: I will raise My hand to nations and lift up My ensign to peoples; and they shall bring your sons in their bosoms, and carry your daughters on their backs. Kings shall tend your children, their queens shall serve you as nurses. They shall bow to you, face to the ground, and lick the dust of your feet. And you shall know that I am the Lord—those who trust in Me shall not be shamed ... Truly the Lord has comforted Zion, comforted all her ruins; He has made her wilderness like Eden, her desert like the Garden of the Lord. Gladness and joy shall abide there, thanksgiving and the sound of music. (Isa. 49.14–51.3)

Third Haftarah of Consolation

(Isaiah 54.11–55.5)

Unhappy, storm-tossed one, uncomforted! I will lay carbuncles as your building stones and make your foundations of sapphires. I will make your battlements of rubies, your gates of precious stones, the whole encircling wall of gems. And all your children shall be disciples of the Lord, and great shall be the happiness of your children; You shall be established through righteousness. You shall be safe from oppression ... No weapon formed against you shall succeed, and every tongue that contends with you at law you shall defeat. (Isa. 54.11–17)

On day before Rosh Chodesh Elul, Ashkenazim read the above selection. Sephardim read the selection below.

(1 Samuel 20.18–42)

Jonathan said to him, "Tomorrow will be the new moon; and you will be missed when your seat remains vacant. So the day after tomorrow, go down all the way to the place where you hid the other time, and stay close to the Ezel stone. Now I will shoot three arrows to one side of it, as though I were shooting at a mark ... and I will order the boy to go and find the arrows. If I call to the boy, 'Hey! the arrows are on this side of you,' be reassured and come, for you are safe and there is no danger as the Lord lives! But if, instead, I call to the lad, 'Hey! the arrows are beyond you,' then leave, for the Lord has sent you away. As for the promise we made to each other, may the Lord be witness between you and me forever." (1 Sam. 20.18–23)

Fourth Haftarah of Consolation

(Isaiah 51.12–52.12)

I, I am He who comforts you! What ails you that you fear man who must die, mortals who fare like grass? You have forgotten the Lord your Maker, who stretched out the skies and made firm the earth! And you live all day in constant dread because of the rage of an oppressor who is aiming to cut you down. Yet of what account is the rage of an oppressor? Quickly the crouching one is freed; he is not cut down and slain, and he shall not want for food. For I the Lord your God—who stir up the sea into roaring waves, whose name is Lord of Hosts—have put My words in your mouth and sheltered you with My hand; I, who planted the skies and made firm the earth, have said to Zion: You are My people! (Isa. 51.12–16)

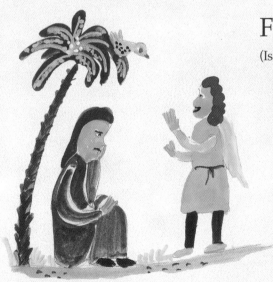

Fifth Haftarah of Consolation

(Isaiah 54.1–10)

Shout, O barren one, you who bore no child! Shout aloud for joy, you who did not travail! For the children of the wife forlorn shall outnumber those of the espoused—said the Lord ... Fear not, you shall not be shamed; Do not cringe, you shall not be disgraced. For you shall forget yhe reproach of your youth, and remember no more the shame of your widowhood. For He who made you will espouse you—IIis name is Lord of Hosts. The Holy One of Israel will redeem you—He is called "God of all the Earth." (Isa. 54.1–5)

Sixth Haftarah of Consolation

(Isaiah 60.1–22)

Arise, shine, for your light has dawned; The Presence of the Lord has shone upon you! Behold! Darkness shall cover the earth, and thick clouds the peoples; But upon you the Lord will shine, and His Presence be seen over you ... And I will add glory to My glorious House. Who are these that float like a cloud, like doves to their cotes? Behold, the coastlands await me, with ships of Tarshish in the lead, to bring your sons from afar, and their silver and gold as well— for the name of the Lord your God, for the Holy One of Israel, who has glorified you. (Isa. 60.1–9)

Seventh Haftarah of Consolation

(Isaiah 61.10–63.9)

I greatly rejoice in the Lord, my whole being exults in my God. For He has clothed me with garments of triumph, wrapped me in a robe of victory, like a bridegroom adorned with a turban, like a bride bedecked with her finery. For as the earth brings forth her growth and a garden makes the seed shoot up, so the Lord God will make victory and renown shoot up in the presence of all the nations ... Nevermore will I give your new grain To your enemies for food, nor shall foreigners drink the new wine for which you have labored. But those who harvest it shall eat it and give praise to the Lord; and those who gather it shall drink it in My sacred courts. (Isa. 61.10–62.9)

233

Hanukkah
First Sabbath during Hanukkah
Additional reading: Weekly and Hanukkah portions

(Zechariah 2.14–4.7)

Shout for joy, Fair Zion! For lo, I come; and I will dwell in your midst—declares the Lord. In that day many nations will attach themselves to the Lord and become His people, and He will dwell in your midst. Then you will know that I was sent to you by the Lord of Hosts. The Lord will take Judah to Himself as His portion in the Holy Land, and He will choose Jerusalem once more. (Zech. 2.14–16)

Second Sabbath during Hanukkah
Additional reading: Weekly and Hanukkah portions

(1 Kings 7.40–50)

Hiram also made the lavers, the scrapers, and the sprinkling bowls. So Hiram finished all the work that he had been doing for King Solomon on the House of the Lord ... All those vessels in the House of the Lord that Hiram made for King Solomon were of burnished bronze. The king had them cast in earthen molds, in the plain of the Jordan between Succoth and Zarethan. Solomon left all the vessels [unweighed] because of their very great quantity; the weight of the bronze was not reckoned. And Solomon made all the furnishings that were in the House of the Lord: the altar, of gold; the table for the bread of display, of gold; the lampstands—five on the right side and five on the left—in front of the Shrine, of solid gold; and the petals, lamps, and tongs, of gold; the basins, snuffers, sprinkling bowls, ladles, and fire pans, of solid gold; and the hinge sockets for the doors of the innermost part of the House, the Holy of Holies, and for the doors of the Great Hall of the House, of gold. (1 Kings 7.40–50)

Wedding
Sabbath after wedding

(Ashkenazim read no special *haftarah*) (Sephardim, after closing blessings for the usual *haftarah*, read Isaiah 61.10–62.5)

I greatly rejoice in the Lord, my whole being exults in my God. For He has clothed me with garments of triumph, wrapped me in a robe of victory, like a bridegroom adorned with a turban, like a bride bedecked with her finery ... Nations shall see your victory, and every king your majesty; And you shall be called by a new name which the Lord Himself shall bestow. You shall be a glorious crown in the hand of the Lord, and a royal diadem in the palm of your God. Nevermore shall you be called "Forsaken," nor shall your land be called "Desolate"; But you shall be called "I delight in her," and your land "Espoused." For the Lord takes delight in you, and your land shall be espoused. (Isa. 61.10–62.5)

For the *Haftarah* for the Sabbath before Rosh Chodesh Elul, see page 226. For the *Haftarah* for the day before Rosh Chodesh Elul, see page 231.

Sabbath before Rosh Ha-Shanah

(Isaiah 61.10–63.9)

I greatly rejoice in the Lord, My whole being exults in my God. For He has clothed me with garments of triumph, Wrapped me in a robe of victory, Like a bridegroom adorned with a turban, Like a bride bedecked with her finery ... Nations shall see your victory, And every king your majesty; And you shall be called by a new name Which the Lord Himself shall bestow. You shall be a glorious crown In the hand of the Lord, And a royal diadem In the palm of your God. Nevermore shall you be called "Forsaken," Nor shall your land be called "Desolate"; But you shall be called "I delight in her," And your land "Espoused." For the Lord takes delight in you, And your land shall be espoused. (Isa. 61.10–62.5)

Rosh Ha-Shanah

(First day) Additional reading: Gen. 21.1–34; Num. 29.1–6

(1 Samuel 1.1–2.10)

There was a man from Ramathaim ... whose name was Elkanah ... He had two wives, one named Hannah and the other Peninnah. Peninnah had children, but Hannah was childless ... After they had eaten and drunk at Shiloh, Hannah rose. The priest Eli was sitting on the seat near the doorpost of the temple of the Lord ... She prayed to the Lord, weeping all the while. And she made this vow ... If You will grant Your maidservant a male child, I will dedicate him to the Lord for all the days of his life ... As she kept on praying before the Lord, Eli watched her mouth ... So Eli thought she was drunk. Eli said to her, "How long will you make a drunken spectacle of yourself? Sober up!" And Hannah replied, "Oh no, my Lord! I am a very unhappy woman. I have drunk no wine or other strong drink, but I have been pouring out my heart to the Lord. Do not take your maidservant for a worthless woman; I have only been speaking all this time out of my great anguish and distress." "Then go in peace," said Eli, "and may the God of Israel grant you what you have asked of Him." (1 Sam. 1.1–17)

Rosh Ha-Shanah

(Second day) Additional reading: Gen. 22.1–24; Num. 29.1–6

(Jeremiah 31.1–19)

Thus said the Lord: The people escaped from the sword, found favor in the wilderness; when Israel was marching homeward the Lord revealed Himself to me of old. Eternal love I conceived for you then; therefore I continue My grace to you. I will build you firmly again, O Maiden Israel! Again you shall take up your timbrels and go forth to the rhythm of the dancers. (Jer. 31.2–4)

Sabbath of Repentance

(Before Yom Kippur) Additional reading: Weekly portion

(Ashkenazim read Hosea 14.2–10; Joel 2.15–27) (Sephardim read Hosea 14.2–10; Micah 7.18–20)

Return, O Israel, to the Lord your God, for you have fallen because of your sin. Take words with you and return to the Lord. Say to Him: Forgive all guilt and accept what is good; instead of bulls we will pay the offering of our lips. Assyria shall not save us, no more will we ride on steeds; nor ever again will we call our handiwork our god, since in You alone orphans find pity! I will heal their affliction, generously will I take them back in love; for My anger has turned away from them. I will be to Israel like dew; he shall blossom like the lily, he shall strike root like a Lebanon tree. (Hosea 14.2–6)

(Continued)

Blow a horn in Zion, solemnize a fast, proclaim an assembly! Gather the people, bid the congregation purify themselves. Bring together the old, gather the babes and the sucklings at the breast; let the bridegroom come out of his chamber, the bride from her canopied couch. Between the portico and the altar, let the priests, the Lord's ministers, weep and say: "Oh, spare Your people, Lord! Let not Your possession become a mockery, to be taunted by nations! Let not the peoples say, 'where is their God?'" (Joel 2.15–17)

Who is a God like You, forgiving iniquity and remitting transgression; who has not maintained His wrath forever against the remnant of His own people, because He loves graciousness! He will take us back in love; he will cover up our iniquities, You will hurl all our sins into the depths of the sea. You will keep faith with Jacob, loyalty to Abraham, as You promised on oath to our fathers in days gone by. (Micah 7.18–20)

Yom Kippur

(Morning) Additional reading: Lev. 16.1–34; Num. 29.7–11

(Isaiah 57.14–58.14)

The Lord says: Build up, build up a highway! Clear a road! Remove all obstacles from the road of My people! ... And I will heal them. But the wicked are like the troubled sea which cannot rest, whose waters toss up mire and mud ... To the House of Jacob their sin ... "Why, when we fasted, did You not see? When we starved our bodies, did You pay no heed?" ... No, this is the fast I desire: To unlock fetters of wickedness, and untie the cords of the yoke to let the oppressed go free; to break off every yoke. It is to share your bread with the hungry, and to take the wretched poor into your home; when you see the naked, to clothe him, and not to ignore your own kin. Then shall your light burst through like the dawn and your healing spring up quickly; your Vindicator shall march before you, the Presence of the Lord shall be your rear guard. (Isa. 57.14–58.8)

Yom Kippur

(Afternoon) Additional reading: Lev. 18.1–30

(Jonah 1.1–4.11) (Micah 7.18–20, see text above)

The word of the Lord came to Jonah son of Amittai: Go at once to Nineveh ... For their wickedness has come before Me. Jonah, however, started out to flee to Tarshish from the Lord's service. He went down to Joppa and found a ship going to Tarshish ... But the Lord cast a mighty wind upon the sea ... In their fright ... The men said to one another, "Let us cast lots and find out on whose account this

misfortune has come upon us." ... And the lot fell on Jonah. They said to him, " ... What is your business? Where have you come from? What is your country, and of what people are you?" "I am a Hebrew," he replied. "I worship the Lord ..." The men were greatly terrified ... "What have you done?" And when the men learned that he was fleeing from the service of the Lord—for so he told them— they said to him, "What must we do to you to make the sea calm ... ?" He answered, "Heave me overboard ... " Nevertheless, the men rowed hard to regain the shore, but they could not ... Then they cried out to the Lord: "Oh, please, Lord, do not let us perish on account of this man's life. Do not hold us guilty of killing an innocent person! For You, O Lord, by Your will, have brought this about." And they heaved Jonah overboard, and the sea stopped raging ... The Lord provided a huge fish to swallow Jonah; and Jonah remained in the fish's belly three days and three nights. Jonah prayed to the Lord his God from the belly of the fish. He said: In my trouble I called to the Lord, and He answered me; from the belly of Sheol I cried out, and You heard my voice. You cast me into the depths, into the heart of the sea ... and my prayer came before You, into Your holy Temple ... The Lord commanded the fish, and it spewed Jonah out upon dry land. (Jonah 1.1–2.11)

The word of the Lord came to Jonah a second time: "Go at once to Nineveh, that great city, and proclaim to it what I tell you." Jonah went at once to Nineveh in accordance with the Lord's command ... Jonah started out and made his way into the city the distance of one day's walk, and proclaimed: "Forty days more, and Nineveh shall be overthrown!" The people of Nineveh believed God. They proclaimed a fast, and great and small alike put on sackcloth ... God saw what they did, how they were turning back from their evil ways. And God renounced the punishment He had planned to bring upon them, and did not carry it out. This displeased Jonah greatly, and he was grieved. He prayed to the Lord, saying, "O Lord! Isn't this just what I said when I was still in my own country? That is why I fled beforehand to Tarshish. For I know that You are a compassionate and gracious God, slow to anger, abounding in kindness, renouncing punishment ..." Now Jonah ... found a place east of the city. He made a booth there ... Until he should see what happened to the city. The Lord God provided a ricinus plant, which grew up over Jonah, to provide shade for his head and save him from discomfort. Jonah was very happy about the plant. But the next day at dawn God provided a worm, which attacked the plant so that it withered. And when the sun rose, God provided a sultry east wind; the sun beat down on Jonah's head, and he became faint. He begged for death, saying, "I would rather die than live." Then God said to Jonah, "Are you so deeply grieved about the plant?" "Yes," he replied, "so deeply that I want to die." Then the Lord said: "You cared about the plant, which you did not work for and which you did not grow, which appeared overnight and perished overnight. And should not I care about Nineveh, that great city, in which there are more than a hundred and twenty thousand persons who do not yet know their right hand from their left, and many beasts as well!" (Jonah 3.1–4.11)

Sabbath between Yom Kippur and Sukkot

(2 Samuel 22.1–51)

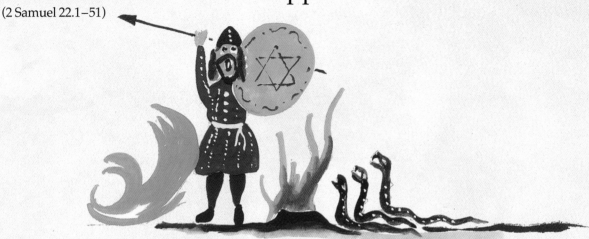

David addressed the words of this song to the Lord, after the Lord had saved him from the hands of all his enemies and from the hands of Saul. He said: O Lord, my crag, my fastness, my deliverer! O God, the rock wherein I take shelter: My shield, my mighty champion, my fortress and refuge! My savior, You who rescue me from violence! All praise! I called on the Lord, and I was delivered from my enemies. For the breakers of Death encompassed me, the torrents of Belial terrified me; the snares of Sheol encircled me, the coils of Death engulfed me. (2 Sam. 22.1–6)

HAFTAROT FOR THE FESTIVALS

הפטרות למועדים

Sukkot (Tabernacles)

(First day) Additional reading: Lev. 22.26–23.44; Num. 29.12–16

(Zechariah 14.1–21)

Lo, a day of the Lord is coming when your spoil shall be divided in your very midst! For I will gather all the nations to Jerusalem for war: The city shall be captured, the houses plundered, and the women violated; and a part of the city shall go into exile. But the rest of the population shall not be uprooted from the city. Then the Lord will come forth and make war on those nations as He is wont to make war on a day of battle. On that day ... there shall be neither sunlight nor cold moonlight, but there shall be a continuous day only the Lord knows when of neither day nor night, and there shall be light at eventide. In that day, fresh water shall flow from Jerusalem, part of it to the Eastern Sea and part to the Western Sea, throughout the summer and winter. (Zech. 14.1–8)

Sukkot

(Second day) Additional reading: Lev. 22.26–23.44; Num. 29.12–16

(1 Kings 8.2–21)

All the men of Israel gathered before King Solomon at the Feast, in the month of Ethanim—that is, the seventh month. When all the elders of Israel had come, the priests lifted the Ark and carried up the Ark of the Lord. Then the priests and the Levites brought the Tent of Meeting and all the holy vessels that were in the Tent. Meanwhile, King Solomon and the whole community of Israel, who were assembled with him before the Ark, were sacrificing sheep and oxen in such abundance that they could not be numbered or counted. The priests brought the Ark of the Lord's Covenant to its place underneath the wings of the cherubim, in the Shrine of the House, in the Holy of Holies; for the cherubim had their wings spread out over the place of the Ark, so that the cherubim shielded the Ark and its poles from above. The poles projected so that the ends of the poles were visible in the sanctuary in front of the Shrine, but they could not be seen outside; and there they remain to this day. (1 Kings 8.2–8)

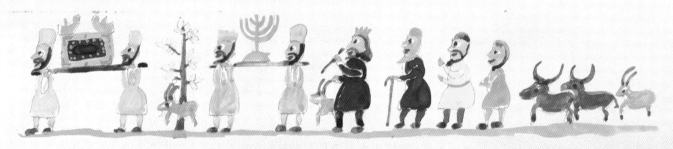

Sukkot intermediate Sabbath

Additional reading: Ex. 33.12–34; Daily portion from Num. 29

(Ezekiel 38.18–39.16)

On that day, when Gog sets foot on the soil of Israel—declares the Lord God—My raging anger shall flare up. For I have decreed in My indignation and in My blazing wrath: On that day, a terrible earthquake shall befall the land of Israel. The fish of the sea, the birds of the sky, the beasts of the field, all creeping things that move on the ground, and every human being on earth shall quake before Me. Mountains shall be overthrown, cliffs shall topple, and every wall shall crumble to the ground. (Ezek. 38.18–20)

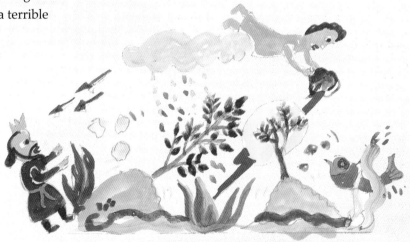

Shemini Atzeret

Additional reading: Deut. 14.22–16.17; Num. 29.35–30.1

(1 Kings 8.54–66)

When Solomon finished offering to the Lord all this prayer and supplication, he rose from where he had been kneeling, in front of the altar of the Lord, his hands spread out toward heaven. He stood, and in a loud voice blessed the whole congregation of Israel: "Praised be the Lord who has granted a haven to His people Israel, just as He promised; not a single word has failed of all the gracious promises that He made through His servant Moses. May the Lord our God be with us, as He was with our fathers. May He never abandon or forsake us. May He incline our hearts to Him, that we may walk in all His ways and keep the commandments, the laws, and the rules, which He enjoined upon our fathers." (1 Kings 8.54–58)

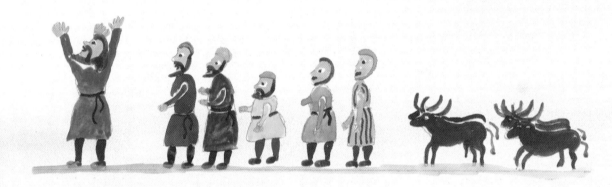

Simchat Torah

Additional reading: Deut. 33.1–34.12; Gen. 1.1–2.3; Num. 29.35–30.1

(Ashkenazim read Joshua 1.1–18) (Sephardim read Joshua 1.1–9)

After the death of Moses the servant of the Lord, the Lord said to Joshua son of Nun, Moses' attendant: My servant Moses is dead. Prepare to cross the Jordan, together with all this people, into the land that I am giving to the Israelites. Every spot on which your foot treads I give to you, as I promised Moses. Your territory shall extend from the wilderness and the Lebanon to the Great River, the River Euphrates on the east the whole Hittite country and up to the Mediterranean Sea on the west. No one shall be able to resist you as long as you live. As I was with Moses, so I will be with you; I will not fail you or forsake you. Be strong and resolute, for you shall apportion to this people the land that I swore to their fathers to assign to them. But you must be very strong and resolute to observe faithfully all the Teaching that My servant Moses enjoined upon you. (Josh. 1.1–7)

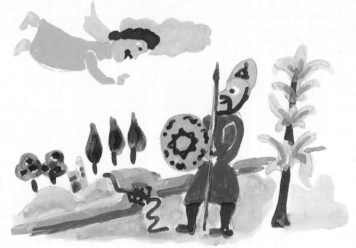

Pesach (Passover)

(First day) Additional reading: Ex. 12.21–51; Num. 28.19–25

(Joshua 5.2–6.1; 6.27)

At that time the Lord said to Joshua, "Make flint knives and proceed with a second circumcision of the Israelites." So Joshua had flint knives made, and the Israelites were circumcised at Gibeath-haaraloth. This is the reason why Joshua had the circumcision performed: All the people who had come out of Egypt, all the males of military age, had died during the desert wanderings after leaving Egypt. Now, whereas all the people who came out of Egypt had been circumcised, none of the people born after the exodus, during the desert wanderings, had been circumcised. For the Israelites had traveled in the wilderness forty years, until the entire nation the men of military age who had left Egypt had perished; because they had not obeyed the Lord and the Lord had sworn never to let them see the land that the Lord had sworn to their fathers to assign to us, a land flowing with milk and honey. But He had raised up their sons in their stead; and it was these that Joshua circumcised, for they were uncircumcised, not having been circumcised on the way. After the circumcising of the whole nation was completed, they remained where they were, in the camp, until they recovered. (Josh. 5.2–8)

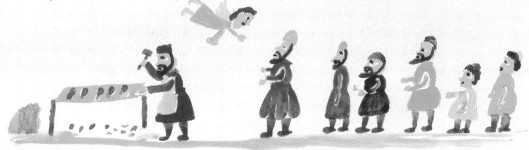

Pesach

(Second day) Additional reading: Lev. 22.26–23.44; Num. 28.19–25

(2 Kings 23.1–9; 21–25)

At the king's summons, all the elders of Judah and Jerusalem assembled before him. The king went up to the House of the Lord, together with all the men of Judah and all the inhabitants of Jerusalem, and the priests and prophets—all the people, young and old. And he read to them the entire text of the covenant scroll which had been found in the House of the Lord ... Then the king ordered the high priest Hilkiah, the priests of the second rank, and the guards of the threshold to bring out of the Temple of the Lord all the objects made for Baal and Asherah and all the host of heaven. He burned them outside Jerusalem in the fields of Kidron, and he removed the ashes to Bethel. (2 Kings 23.1–4)

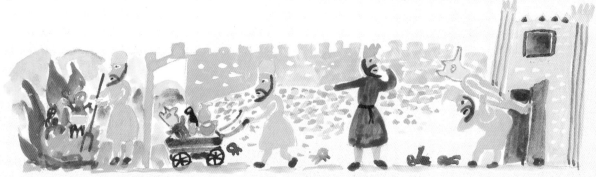

Pesach intermediate Sabbath

Additional reading: Ex. 33.12–34.26; Num. 28.19–25

(Ezekiel 37.1–14)

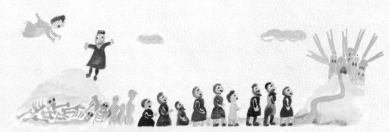

The hand of the Lord came upon me. He took me out by the spirit of the Lord and set me down in the valley. It was full of bones. He led me all around them; there were very many of them spread over the valley, and they were very dry. He said to me, "O mortal, can these bones live again?" I replied, "O Lord God, only You know." And He said to me, "Prophesy over these bones and say to them: O dry bones, hear the word of the Lord! Thus said the Lord God to these bones: I will cause breath to enter you and you shall live again. I will lay sinews upon you, and cover you with flesh, and form skin over you. And I will put breath into you, and you shall live again. And you shall know that I am the Lord!" (Ezek. 37.1–6)

Pesach

(Seventh day) Additional reading:
Ex. 13.17–15.26; Num. 28.19–25

(2 Samuel 22.1–51)

David addressed the words of this song to the Lord, after the Lord had saved him from the hands of all his enemies and from the hands of Saul. He said: O Lord, my crag, my fastness, my deliverer! O God, the rock wherein I take shelter: My shield, my mighty champion, my fortress and refuge! My savior, You who rescue me from violence! All praise! I called on the Lord, and I was delivered from my enemies. For the breakers of Death encompassed me, the torrents of Belial terrified me; the snares of Sheol encircled me, the coils of Death engulfed me. (2 Sam. 22.1–6)

Pesach

(Eighth day) Additional reading:
Deut. 15.19–16.17 (On Sabbath,
Deut. 14.22–16.17); Num. 28.19–25

(Isaiah 10.32–12.6)

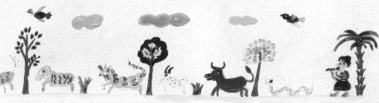

This same day at Nob he shall stand and wave his hand ... Lo! The Sovereign Lord of Hosts will hew off the treecrowns with an ax: The tall ones shall be felled, the lofty ones cut down ... But a shoot shall grow out of the stump of Jesse, a twig shall sprout from his stock. The spirit of the Lord shall alight upon him: A spirit of wisdom and insight, a spirit of counsel and valor, a spirit of devotion and reverence for the Lord ... The wolf shall dwell with the lamb, the leopard lie down with the kid; the calf, the beast of prey, and the fatling together, with a little boy to herd them. The cow and the bear shall graze, their young shall lie down together; and the lion, like the ox, shall eat straw. A babe shall play over a viper's hole, and an infant pass his hand over an adder's den. (Isa. 10.32–11.8)

Shavuot (Pentecost)

(First day) Additional reading: Ex. 19.1–20.23; Num. 28.26–31

(Ezekiel 1.1–28; 3.12)

In the thirtieth year, on the fifth day of the fourth month ... I looked, and lo, a stormy wind came sweeping out of the north—a huge cloud and flashing fire, surrounded by a radiance; and in the center of it, in the center of the fire, a gleam as of amber. In the center of it were also the figures of four creatures ... They had the figures of human beings. However, each had four faces, and each of them had four wings; the legs of each were fused into a single rigid leg, and the feet of each were like a single calf's hoof; and their sparkle was like the luster of burnished bronze. They had human hands below their wings. The four of them had their faces and their wings on their four sides. Each one's wings touched those of the other. They did not turn when they moved; each could move in the direction of any of its faces. Each of them had a human face at the front; each of the four had the face of a lion on the right; each of the four had the face of an ox on the left; and each of the four had the face of an eagle at the back ... With them was something that looked like burning coals of fire. This fire, suggestive of torches, kept moving about among the creatures; the fire had a radiance, and lightning issued from the fire. Dashing to and fro among the creatures was something that looked like flares. As I gazed on the creatures, I saw one wheel on the ground next to each of the fourfaced creatures. As for the appearance and structure of the wheels, they gleamed like beryl. All four had the same form; the appearance and structure of each was as of two wheels cutting through each other. And when they moved, each could move in the direction of any of its four quarters; they did not veer when they moved. (Ezek. 1.1–17)

Shavuot

(Second day)

Additional reading: Deut. 15.19–16.17 (On Sabbath, Deut. 14.22–16.17); Num. 28.19–25

(Ashkenazim read Habakkuk 3.1–19) (Sephardim read Habakkuk 2.20–3.19)

But the Lord in His holy Abode—be silent before Him all the earth! A prayer of the prophet Habakkuk. In the mode of *Shigionoth*. O Lord! I have learned of Your renown; I am awed, O Lord, by Your deeds. Renew them in these years, Oh, make them known in these years! Though angry, may You remember compassion. God is coming from Teman, The Holy One from Mount Paran. *Selah*. His majesty covers the skies, His splendor fills the earth ... Yet will I rejoice in the Lord, exult in the God who delivers me. My Lord God is my strength: He makes my feet like the deer's and lets me stride upon the heights. For the leader; with instrumental music. (Habak. 2.20–3.19)

Ninth of Av

(Morning) Additional reading: Deut. 24.25–40

(Jeremiah 8.13–9.23)

I will make an end of them—declares the Lord: No grapes left on the vine, no figs on the fig tree, the leaves all withered; whatever I have given them is gone. Why are we sitting by? Let us gather into the fortified cities and meet our doom there. For the Lord our God has doomed us, He has made us drink a bitter draft, because we sinned against the Lord ... Assuredly, thus said the Lord of Hosts, the God of Israel: I am going to feed that people wormwood and make them drink a bitter draft. I will scatter them among nations which they and their fathers never knew ... Let them quickly start a wailing for us, that our eyes may run with tears, our pupils flow with water. For the sound of wailing is heard from Zion. (Jer. 8.13–9.18)

Ninth of Av

(Afternoon) Additional reading: Ex. 32.11–14; 34.1–10

(Isaiah 55.6–56.8)

Seek the Lord while He can be found, call to Him while He is near. Let the wicked give up his ways, the sinful man his plans; let him turn back to the Lord, and He will pardon him; to our God, for he freely forgives. For My plans are not your plans, nor are My ways your ways—declares the Lord ... "I will bring them to My sacred mount and let them rejoice in My house of prayer. Their burnt offerings and sacrifices shall be welcome on My altar; for My House shall be called a house of prayer for all peoples." Thus declares the Lord God, who gathers the dispersed of Israel: I will gather still more to those already gathered. (Isa. 55.6–56.8)

Public fast day (fixed)

(Afternoon) Additional reading: Ex. 32.11–14; 34.1–10

(Isaiah 55.6–56.8)

Seek the Lord while He can be found, call to Him while He is near. Let the wicked give up his ways, the sinful man his plans; let him turn back to the Lord, and He will pardon him; to our God, for he freely forgives. For My plans are not your plans, nor are My ways your ways—declares the Lord ... Yea, you shall leave in joy and be led home secure. Before you, mount and hill shall shout aloud, and all the trees of the field shall clap their hands. Instead of the brier, a cypress shall rise; instead of the nettle, a myrtle shall rise. These shall stand as a testimony to the Lord, as an everlasting sign that shall not perish. (Isa. 55.6–13)

Public fast day (ad hoc)

Afternoon (Additional reading: Ex. 32.11–14; 34.1–10)

(Isaiah 55.6–56.8)

Seek the Lord while He can be found, call to Him while He is near. Let the wicked give up his ways, the sinful man his plans; let him turn back to the Lord, and He will pardon him; to our God, for he freely forgives. For My plans are not your plans, nor are My ways your ways—declares the Lord ... "As for the foreigners who attach themselves to the Lord, to minister to Him, and to love the name of the Lord, to be His servants—all who keep the sabbath and do not profane it, and who hold fast to My covenant— I will bring them to My sacred mount and let them rejoice in My house of prayer." (Isa. 55.6–56.7)

Acknowledgments

This is the anti-climax page, the last page of the volume, the page that seals the work and carries a feeling of joy and emptiness; this is the page where all dues are paid in good faith and with a warm heart. I wish to thank Dr. Ellen Frankel, Editor-in-Chief of The Jewish Publication Society, for discerning with The Studio in Old Jaffa and Gefen Publishing House, Ltd. the hidden potentials and deciding—despite the uncharted waters—to go ahead with this project and work with unknown odds. My gratitude to Steve Berman whose assistance during the initial stages was crucial to the success of the project. I am indebted to Sydelle Zove and other members of the editorial staff of the Society; it has been a real pleasure to work with them and to enjoy their professional experience.

Thanks with a capital *T* to Ilan and Dror Greenfield of Gefen Publishing House, Ltd. A bear hug to Ilan for being there and putting up with all the Italian aspects of my character, and for offering all his hard-gained Israeli experiences in order to publish—against all odds—this volume in Israel.

Mattie Tuviahu, our graphic designer; what a wonderful right hand to have on the team. I am grateful to Mattie's team—Orly and Hezi for their help, patience, and understanding, and thanks to Inbar and Hadar for their silent support. Many thanks to Zvi Sheier from Shekef Or; his friendship and professional work have been invaluable. To Vladimir Godnik for the beautiful transparencies; "What you see is what you get," and in this case the praise goes to the professional team of Keter Press Enterprises, Ltd., Jerusalem.

Special thanks to Rachel Shaw and Jocelyn Elbaz from The Studio in Old Jaffa. They were always there to help when most needed. Without their motivation, effort, and dedication this work would have seen the light of day under harsher and different conditions.

Last but not least, to Ed Ruzinsky, a real friend and a true admirer of Michal's work whose expertise was fundamental in getting us to where we are today. I can only hope to continue to enjoy his knowledge and wisdom.

And a big expression of gratitude to the so-called lost tribe—all the unspecified friends and associates who remain unnamed. This is the place to thank them and to apologize. It seems there is always a lost tribe, no matter how much one is trying not to lose anybody. But not to worry, we plan to go ahead with other books of the Tanakh and we will have plenty of occasions to acknowledge their contributions.

Alon Baker